SACRED
MONSTERS,
SACRED
MASTERS

SACRED MONSTERS, SACRED MASTERS

Beaton, Capote, Dalí, Picasso,
Freud, Warhol, and More

JOHN RICHARDSON

RANDOM HOUSE

NEW YORK

All rights reserved under International and Pan-American Copyright
Conventions. Published in the United States by Random House, Inc., New York,
and simultaneously in Canada by Random House of Canada Limited, Toronto.

RANDOM HOUSE and colophon are registered trademarks of Random House, Inc.

Grateful acknowledgment is made to the following for permission to reprint previously
published material: *Farrar, Straus & Giroux, LLC:* "The Artist as an Old Man," from
Boss Cupid, by Thom Gunn. Copyright © 2000 by Thom Gunn. Reprinted by
permission of Farrar, Straus & Giroux, LLC.

Page 364 constitutes an extension of this copyright page.

Library of Congress Cataloging-in-Publication Data
Richardson, John.
Sacred monsters, sacred masters : Beaton, Capote, Dalí, Picasso,
Freud, Warhol, and more / John Richardson
p. cm.
Includes index.
ISBN 0-679-42490-3
1. Arts, American—20th century. 2. Arts, French—20th century. 3. Celebrities—
United States—Biography. 4. Celebrities—France—Biography. I. Title.
NX504 .R53 2001 920.073—dc21 2001031623

Random House website address: www.atrandom.com
Printed in the United States of America on acid-free paper
24689753

Book design by J. K. Lambert

For my friends
JoAnn Chuba, Rui Lopes,
and Priscilla Higham

PREFACE

After going through hundreds of articles written over the last thirty years or more, I have decided to reprint the ones that are about people I have known, or would like to have known, either because their genius or quirkiness or villainy intrigued me or because I had wanted to rescue their reputations from oblivion or, in one or two cases, excessive adulation. Another reason for reprinting these articles: I feel that they are records of a vanished past—a past whose witnesses are mostly dead.

A very early start in London's world of arts and letters explains why my reminiscences of it go back so far—well over half a century. I was lucky in that around the corner from my family's house in London lived a woman—the wife of a curator at the British Museum—called Viva King, who presided over a salon that could best be described as polymorphous. It included such people as Norman Douglas, Ivy Compton-Burnett and her learned friend Margaret Jourdain, Compton Mackenzie and his wife, Faith, Cecil Beaton, Oscar Wilde's son, Vyvyan Holland, Nancy Cunard, various Sitwells, and many more. Viva had the genial habit of encouraging her younger friends to entertain her older ones. Thus, from the age of eighteen, I was part of a circle whose memories stretched back well into the nineteenth century. Since my grandfather had been born in 1814, I saw nothing unusual in this.

Besides constituting a finishing school, Viva's erudite if somewhat raffish salon launched me on my career as a writer. Margaret

Jourdain soon had me writing entries on subjects I knew nothing about—intaglios, cameos, and engraved gems—for *Chambers Encyclopedia*. Next, I graduated to being a ghost. I researched a book about women's underclothes for Compton Mackenzie that never saw the light of day, wrote a piece on maquillage from ancient Egypt to *cinquecento* Venice for Sacheverell Sitwell, and did everything but sign the reviews for an indolent, alcoholic film critic. I was eventually saved from hack work by T. C. Worsley of the *New Statesman and Nation,* who taught me and so many others of my generation the rudiments of literary journalism. Later, thanks in part to Viva, I met Douglas Cooper, the eminent collector of Cubism, and settled down with him in Provence. Through Cooper, I made friends with Picasso and many of the other painters and writers who figure in these pages. Inevitably, I started writing about them, especially about the ways in which their lives and work impinged. Hence two books on Braque and my ongoing biography of Picasso, as well as many of the essays in the present volume. Instead of reprinting these pieces as they originally appeared, I have tried to bring myself into the picture as a witness and, whenever possible, pursue the story to its end. To that extent this collection is intended to serve as a sort of prolongation of the memoir, *The Sorcerer's Apprentice,* that I published in 1999.

Sacred monsters are sacred monsters only insofar as the public sees them as such. Salvador Dalí, the Sitwells, and Truman Capote relished the role and encouraged the media's heightened perception of them, much as Madonna or the late Princess of Wales did in more recent years. But there are others—Picasso and Lucian Freud, for instance—who hated having this fallacious role thrust on them by the press, notwithstanding a touch of Dionysiac darkness to their work.

If I have refrained from reissuing my more academic essays, it is because they were written primarily for other art historians. I have also left out major articles about Picasso on the grounds that I have published so much about him elsewhere. However, I have included an article about his great friend Eugenia Errázuriz, who has been undeservedly forgotten, although she played an enormously

important role in his life—"his other mother"—and exerted an incalculable influence on the development of minimalist design. I have incorporated two other Picasso pieces that fall outside the scope of my biography: one on the tragedy of the artist's grandson Pablito's suicide and the other about Merchant Ivory's stab at making a film about the artist's affair with Françoise Gilot.

I would like to acknowledge some of the books that I have drawn upon in preparing these essays: William Schack's *Art and Argyrol;* John Pearson's *Façades: Edith, Osbert and Sacheverell Sitwell;* Hugo Vickers's *Cecil Beaton;* Florence Trystram's *La Dame au grand châpeau: L'histoire vrai de Domenica Walter-Guillaume;* Nigel Nicolson's *Portrait of a Marriage;* Peggy Guggenheim's *Out of This Century: Confessions of an Art Addict;* Jan Morris's *Conundrum;* Gerald Clarke's *Capote: A Biography;* Edward Jay Epstein's *Dossier: The Secret History of Armand Hammer;* Ian Gibson's *The Shameful Life of Salvador Dalí;* and Marina Picasso's *Les enfants du bout du Monde.* I am also grateful to Thom Gunn for permission to quote lines from "The Artist as an Old Man," from his *Boss Cupid: Poems,* and I would like to thank the A. A. Milne estate for permission to quote lines from "Vespers."

The redrafting of these essays has involved far more work than I had originally thought—particularly on the part of my assistants, Rui Lopes and JoAnn Chuba, to whom I am tremendously grateful. I would also like to thank the original editors of most of these pieces: Robert B. Silvers, editor of *The New York Review of Books,* Shelly Wanger, formerly features editor of *House and Garden,* and Wayne Lawson, my editor at *Vanity Fair.* Thanks also to Inez van Lamsweerde for her generosity in taking the photograph on the jacket; Susanna Porter and Janet Wygal of Random House; Mark Holborn of Jonathan Cape; my agent, Andrew Wylie, and his associate Jeff Posternak. And, as always, I am greatly indebted to my beloved collaborator, Marilyn McCully, and her husband, Michael Raeburn.

—JOHN RICHARDSON

CONTENTS

AFTERMATH

FIN DE SIÈCLE

ILLUSTRATIONS

BETWEEN
THE WARS

———

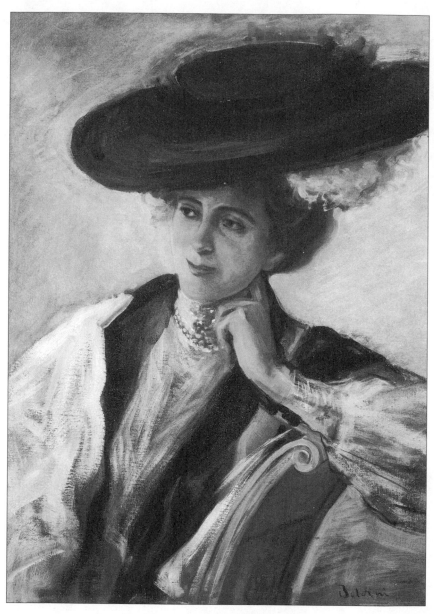

Giovanni Boldini, *Portrait of Eugenia Errázuriz,*
oil on canvas, c. 1895, private collection

Picasso's Other Mother

Some time ago, I wrote an article about a Chilean woman of singular originality and discernment called Eugenia Errázuriz. I wrote about her because she had been undeservedly overlooked, eclipsed by her "friend," the manipulative Polish patroness Misia (Godebska-Natanson-Edwards) Sert ("Princesse Youbeletieff" in Proust)—the subject of a deservedly popular biography by Arthur Gold and Robert Fizdale. Whereas Misia was known to Jean Cocteau and Erik Satie as "*Tante Brutus*" for her back-stabbing proclivities, Eugenia was supportive and reticent and endowed with a distinctive eye for modernism. Besides being one of Picasso's most perceptive patrons—the owner of some of his greatest, late-Cubist paintings—she managed to exert, in her subtle way, a more radically modernizing influence on mid-twentieth-century taste than most of those who were indebted to her realized. One of the few who did realize was the elegant Dutch furniture designer and decorator Jean-Michel Frank (uncle, incidentally, of that iconic Holocaust victim Anne Frank), who singled Eugenia out for her "indispensable influence." Cecil Beaton made even greater claims for Eugenia:

"Her effect on the taste of the last fifty years," he wrote, "has been so enormous that the whole aesthetic of modern interior decoration, and many of the concepts of simplicity . . . generally acknowledged today, can be laid at her remarkable doorstep." These opinions do Beaton the more credit, given that Eugenia anathematized the very thing—Edwardian clutter and kitsch—that he elevated into a camp cult and ultimately a career as a set designer.

Years later, while doing research in the Picasso archives, I came upon a cache of unpublished letters from Eugenia. These revealed that she had played an even more central role in Picasso's life than I had originally realized. Further information materialized in Jean-François Larralde and Jean Casenave's evocative book, *Picasso à Biarritz* (1995), which focused on the artist's honeymoon chez Eugenia at Biarritz in 1918. More recently, a shortish biography by Alejandro Canseco-Jerez appeared, *Le Mécénat de Madame Errázuriz* (2000), which contains a lot of new information about Eugenia's family and the sadness of her later years.

Eugenia's letters to Picasso testify to a very close friendship lasting over thirty years. Eugenia's only rival for the artist's affections—in the realm of friendship rather than sex—was Gertrude Stein, whom he liked to call "Pard," as in a Western, much to her irritation. In 1915, however, Gertrude and her friend Alice Toklas had left Paris to spend the rest of the war driving an ambulance—"Auntie," it was callled—around France. In their absence, it was Eugenia who took over as Picasso's consoler and collector and a surrogate for Doña María, the stalwart, nurturing mother back in Barcelona whom he seldom saw. Canseco-Jerez maintains that Stein and Toklas were so jealous of Eugenia that they gave "a reception in honor of Picasso" in order to meet their rival and size her up. However, his account of this event and Gertrude's "jealousy" is far from convincing. By the time Eugenia entered Picasso's life, Gertrude had ceased collecting his work, and their paths had temporarily diverged. To the extent that Gertrude had come to see Picasso and herself as twin peaks of genius, Eugenia simply did not impinge.

Who was this paragon? Eugenia Huici was born on September 15, 1860, in Bolivia, where her Chilean father had made a fortune

mining silver. Civil war drove him, his Bolivian wife, and his two daughters, Eugenia and Rosa, back to his estates near Valparaíso. Picasso believed that Eugenia had inherited more than a drop of Inca blood; so did another of Eugenia's protégés, the poet Blaise Cendrars, who used to call her *"L'Indienne."* A girl of considerable beauty, Eugenia was brought up in the archaic conventions of Spanish colonialism. English nuns in Valparaíso supervised her education: they dinned into her the tenets of a faith that, like the superstitions of her Indian forebears, she would always cherish. Her schooling left her fluent, if not always comprehensible, in French and English and only a little more so in Castilian. *"Une étrange sharabia"* (gibberish) is how friends described her way of speaking. At the age of twenty, Eugenia married José Tomás Errázuriz, whose father and grandfather had both been presidents of Chile. Tomás's aspirations to be an artist horrified his family, so he was packed off to Europe to be a diplomat—a métier that left him free to paint. Relations of one or the other of the Errázurizes were *en poste* in virtually every capital.

The Errázurizes spent their honeymoon in Venice, where their cousin Ramón Subercaseaux—Chilean consul general in Paris and an amateur painter—and his wife had rented a palazzo on the Grand Canal. Among the other guests was a young painter, whom Subercaseaux had been one of the first to discover, John Singer Sargent. When not engaged on a portrait of his hostess, Sargent did oil sketches of Eugenia, for whom he is said to have fallen. Unlikely. Sargent was more interested in his gondolier.

Summer over, the Errázurizes settled in Paris, where they spent the next twenty years. He painted; she raised children (a son, Maximiliano, and two daughters, Carmen and María, known as "Baby") and repeatedly sat for her portrait—to Boldini, Helleu, Orpen, and many more. Eugenia stood out from the run of *le tout Paris* by disdaining fin-de-siècle froufrou and adopting a low-key style that set her off from the rest of her friends, not least Misia Sert. Although she would bring a small swatch of antique stuff, dyed the "Inca pink" of her native Andes, to the attention of Schiaparelli, who exploited it as "Shocking Pink," Eugenia's most important achieve-

ments had nothing to do with fashion; they had to do with avant-garde patronage and a minimalist vision of the decorative arts. By 1910, she already stood out for the unconventional sparseness of her rooms, for her disdain of poufs and potted palms and too much *passementerie*. No less discriminating was Eugenia's taste in people, including many of Proust's favorites (Madrazos, Bibescos, Helleus, Morands), and above all for her support of new developments in art, literature, music, and ballet.

Around 1900, the Errázurizes settled in London, first in Bryanston Square. Later, they moved to Chelsea. Tomás contracted TB and spent more and more time in Switzerland, to the relief of Eugenia, who was beginning to tire of her husband and his tedious landscapes. They would eventually separate. In London, Eugenia saw much of her old friend Sargent, who likewise lived in Chelsea, and through him she absorbed the Whistlerian aestheticism still associated with this Thames-side stretch of London, but without becoming contaminated by it. She also made friends with a new generation of artists: Augustus John, who painted her portrait, and, rather more to her credit, Walter Sickert, whose work she proceeded to collect. In England, Eugenia learned to appreciate things that were very fine and very simple—above all, things made of linen, cotton, deal, or stone, whose quality improved with laundering or fading, scrubbing or polishing. This acute sense of patination and texture allied to color would one day endear her to Braque.

In the absence of her husband, Eugenia took up with her bright young nephew, the diplomat Don Antonio de Gandarillas, who had a house overlooking the Thames on Cheyne Walk. Tony had married Juanita Edwards, the daughter of the Chilean ambassador to the court of Saint James's, but after discovering that he was homosexual and addicted to opium, she had retired to Chile. Eugenia would take over as his consort. Together they would attend the Ballets Russes and make friends with Diaghilev, who would become very dependent on Eugenia. So would Artur Rubinstein. The great pianist would credit her with all manner of miraculous interventions in his career.

Thanks to his diplomatic immunity and charm and his large round eyes like a lemur's, Eugenia's neat little nephew managed to

survive brush after brush with scandal. Besides a house in London, Tony had an apartment in Paris. And there on May 29, 1926, he and Eugenia gave a dinner to celebrate the première of *Pastorale*—one of Diaghilev's weaker ballets—which was attended by "everyone from Picasso to the Duchess of Alba." Also present was the brilliant surrealist poet René Crevel, who would soon become one of Tony's young men. Tony was also involved with the rising young painter Christopher Wood, the only British artist of his generation to be taken seriously in Paris and become a friend of Picasso's and Braque's as well as of Cocteau's. Tony supposedly got Kit (as Wood was familiarly known) hooked on drugs. When Kit threw himself under a train in 1930, Tony was blamed. Five years later, Crevel would also commit suicide. This time, the Surrealists were supposedly the cause.

Later in life, Tony would surprise his fellow diplomats by allowing himself to be photographed in court dresses and widow's weeds—he was by then in his sixties—as Baroness von Bülop, the heroine of Cecil Beaton's spoof memoir, *My Royal Past*. World War II would make life difficult for Tony—opium was hard to get and he was separated from Eugenia—but he bounced back when it was over. His daughter, Carmen, liked to paint, and she and I sometimes shared a model in the studio at the top of the Cheyne Walk house. Tony would occasionally reminisce about the old days with Eugenia, which is what triggered my interest in her.

Eugenia's taste for modernism was a relatively late development, as it was for her friend Diaghilev. She had always been way ahead of her friends—way ahead above all of Misia Sert, who, as Cocteau said, "rejects this era and judges impressionistically with verve but without form, in the same way that Bonnard and Vuillard paint." Eugenia needed a more advanced catalyst, and, like Diaghilev, she found one in Jean Cocteau, the ambitious young poet she had met with her nephew Tony. Cocteau had been so eager to involve himself in modernism that he had laid siege to Picasso in the hope of getting him to collaborate on *Parade,* the modernist ballet with music by Erik Satie that he was desperate for Diaghilev to produce. However, Picasso took no interest in ballet—if anything he despised it—until Cocteau introduced him to Eugenia, who would in

turn bring the artist together with Diaghilev. As usual, Misia did her backstabbing best to foil Cocteau's plans, but Eugenia, who had instantly endeared herself to Picasso, was able to persuade him to go to Rome and work on *Parade*. Some of Picasso's former followers were resentful. They felt that Picasso was betraying Cubism at Cocteau's behest. Where might this leave them?

Eugenia came into Picasso's life at a time (1916) when he was lonely and unhappy. His mistress, Eva, had just died; another mistress, Gaby Lespinasse, had refused to marry him. Also, his two closest friends, Braque and Apollinaire, had been badly wounded; and the rest of the *bande à Picasso,* his gang of friends, were stuck in the trenches. The artist soon became very dependent on this generous Spanish-speaking woman who bought his paintings, gave him handouts, and kept him in tobacco. Eugenia was as obsessed by magic and superstition as Picasso was and had a seemingly magical understanding of his work. This was the more welcome at this difficult juncture, when he was emerging triumphantly but also a touch warily from Cubism. In the course of comforting Picasso, Eugenia fell in love with him, but as a mother rather than a mistress. He responded with filial devotion, which lasted until they were separated by World War II.

A few months after meeting Picasso, Eugenia met the man who would become her composer—Stravinsky. Once again, Cocteau seems to have been responsible. Since Eugenia's ear proved every bit as perceptive as her eye, the composer allowed himself to be adopted as one of her geniuses. "Her friendship touched me deeply," Stravinsky writes in his memoir. "She had a subtle understanding of modern art, which was unparalleled in anyone of her generation." Stravinsky even took Eugenia's criticism to heart. On one occasion, she is said to have held up her hand and stopped him when he was trying out a new composition on the piano and announced, "Up to this point, it's fine. The rest is too much." The composer supposedly did what she said. By contrast, Misia's criticism gave him great offense. "I do not understand your rage," Stravinsky wrote in answer to one of her presumptuous attacks: "Really, my dear, you should have been able to understand before

pouncing on this poor quartet (which was composed for you . . . do you remember?) that my works are always very difficult and before being played they require my personal supervision, which was not available this time." Misia's reservations did not prevent Stravinsky, who was in dire financial straits as a result of the revolution in Russia, from playing her off against Eugenia when money was short. Informed by Stravinsky that Eugenia had not sent him the promised money—war made such transfers difficult—Misia scored off her rival by promptly mailing him a large check.

Cocteau would once again play the role of catalyst—or Mercury, as he liked to think of himself (he never wore anything but a Mercury costume to fancy-dress balls)—when he provided Eugenia's pantheon with a writer, the French-Swiss poet-novelist-cinéaste Blaise Cendrars. As with Picasso and Stravinsky, her rapport with Cendrars had a spiritual rather than a worldly—a Misia-esque—side to it. Eugenia, we should not forget, was an exceedingly devout woman: a tertiary Franciscan (a lay nun, who, on penitential occasions, would wear a minimal black habit by Chanel). Her letters to Picasso make frequent references to spiritual matters; she loved to discuss religion with Stravinsky and mysticism and astrology with Cendrars. The self-denial, even mortification, in Eugenia's minimalism should, I think, be seen as a reflection of her resolutely austere taste in art, as well as of her "black" Spanish faith. She did not see herself as a maecenas, or even a muse, so much as a secret sharer in the sacred fire of her protégés' art. If she provided them with financial aid, she did so in the spirit of almsgiving.

In her letters, Eugenia fusses over Picasso almost as much as she fusses over her own woes. When he goes off to join Diaghilev in Rome in 1917, she uses the Spanish ambassadress as a courier for the allowance she sends him, and arranges to have a blue suit ready for him on his return. When he moves on to Madrid with the ballet, including Olga Khokhlova, the ballerina he would eventually marry, Eugenia joins him there so that she can groom him for his audience with her friend the King of Spain. When he returns to Paris, she orders a comfortable fireside armchair for him and has it upholstered in tapestry. (The chair would figure in many of his por-

traits.) When Picasso gets married, she insists that he and his Russian wife, Olga, spend their honeymoon with her at Biarritz, where she is remodeling a house—a *"cabane,"* called La Mimoseraie. Eugenia turns out to have lived far more simply than her plutocratic friends. "If you want to bring your maid she can do the cooking for us, because the house is still not finished, and we'll stay here at the pension which is extremely cheap." So much for the artist's supposedly grandiose summer.

The Picassos ended up spending two and a half months with Eugenia, during which the artist frescoed the walls of one of the rooms in her house with lighthearted decorations of naked nymphs disporting themselves under a star-spangled ceiling amid lines from a poem by Apollinaire. "But the house is only rented," she cried when she first saw the frescoes. Fortunately, Eugenia's son, Max, eventually bought La Mimoseraie for her. (Thirty years later, the frescoes would be removed from the walls and sold; at one point they would belong to Andy Warhol's manager, Fred Hughes.) Eugenia also arranged for Picasso to do portrait drawings of her aristocratic Spanish and South American friends: Marquesa Villa-Urrutia (wife of the Spanish ambassador to France), Marquesa Villavieja, and the seductive Argentinian beauty Diadamia Patri. But the finest of his Biarritz portraits is the handsome drawing he did of Eugenia's attractive young daughter, "Baby," a likeness that is always mistaken for Eugenia, although the latter would have been fifty-eight at the time. No less important, Eugenia introduced Picasso to Georges Wildenstein, who had a villa at Biarritz, and his then partner, Paul Rosenberg. They would soon become the artist's dealers. Picasso drew an Ingresque portrait of Madame Wildenstein and did a large painting of Madame Rosenberg and her baby daughter.

For her part, Olga was pleased to find that Chanel had bought the neighboring Villa Larralde and installed a boutique in the *dépendances,* where she sold the *outré* new bathing suits, sleeveless and clinging, that are such a prominent feature of Picasso's brilliant little painting of bathers on the Biarritz beach. However, Olga didn't care for Biarritz. The following summer, Eugenia tried and failed to get the Picassos to move back in with her. They went to Saint-

Raphaël on the Riviera instead. Again, in 1920, Eugenia found them a house at Biarritz, but despite her tirade against the dangers of the arctic weather of northern France—"the climate is bad and it always rains"—Picasso, or rather Olga, chose dull, damp Dinard. I suspect there was another aspect to this situation: Eugenia surrounded herself with her own elitist ilk, and they would have seen through Olga's social pretensions. Not surprisingly, Olga gave Eugenia's coterie an increasingly wide berth and seldom went to the weekly Saturday or Sunday luncheons she gave for Picasso. The new wife seems to have been as jealous of the mother figure as the mother figure was jealous of the new wife. Picasso would have liked that. When he and Olga finally separated very acrimoniously in 1935, who moved into the Paris apartment to look after the disconsolate artist but Eugenia, who was then aged seventy-five. Eugenia, who had never liked Olga, proceeded to praise her successors, Marie-Thérèse Walter and Dora Maar, to the skies.

The austerity of the great Cubist Picassos on Eugenia's walls was reflected in the austerity of the settings that Eugenia devised for herself. Although frequently asked to help her friends decorate their rooms, Eugenia would, as a rule, confine her suggestions to "throw it out." She never decorated any rooms but her own. Her example percolated down through admirers such as Jean-Michel Frank and Van Truex (later director of Tiffany's design department). But none of her followers shared her passion for modernism, and none of them was as ruthless as she was in eliminating not just color and decorative flourishes but the whole panoply of "ghastly good taste." Eugenia's rich conventional neighbors, who mostly lived in elaborate villas filled with *dix-huitième* repros, were shocked when she had the walls of her Biarritz villa whitewashed and the floors paved with terra-cotta tiles as in a peasant house. She was also decades ahead of her time in combining living and dining rooms, as borne out by Cecil Beaton's description of La Mimoseraie: "A long wooden shelf, scrupulously scrubbed, ran the length of the wall; and on it for decoration as well as practicality, she placed a still life of hams, huge cheeses, and loaves of bread under large bell jars. Her table was always set very informally, though napkins were of the

heaviest linen and knives and forks of the best . . . French eighteenth century silver."

As discriminating about the outside as the inside of her house, Eugenia would spend most mornings at Biarritz working in her garden—barefoot, for just as she liked to drink either the purest spring water or champagne with luncheon, she either went without shoes or wore the highest heels. Rather than plant flower beds as her neighbors did, with canna lilies and dainty borders of pink begonias and lobelia, she gave over her entire garden to vegetables impeccably set out in rows and rectangles. By the same token she abhorred elaborate flower displays and liked cut flowers only if they were of the simplest variety, simply arranged: a basket full of daisies or wildflowers or, as Beaton writes, "a simple cream-colored Devonshire pot with a dozen white tulips rammed into it, sticking out to one side and not splayed in the manner usual to flower arrangements." Virtually the only houseplants of which Eugenia approved were aromatic ones—rose geranium, lemon verbena, lavender, jasmine—in terra-cotta flowerpots rather than fancy cachepots.

Eugenia's successive Paris apartments caused as much of a stir as La Mimoseraie. Just as Jean-Michel Frank's article, Jean Hugo's memoirs, and Blaise Cendrars's preface to his best novel, *Moravagine,* evoke the spareness of her rooms, photographs taken seventy years ago reveal how up-to-date they still look: the hall with everything plonked down on the scrubbed floor, the plain gray coatrack with a basket and umbrella hanging from it, the ordinary wooden stepladder against the wall, the laundry basket on top of a wicker hamper, the modern deal cupboard found in a street market, and the ugly, uncamouflaged radiator. One of Eugenia's favorite buys was a set of folding metal garden chairs, which had been stolen from the Bois de Boulogne. "They are for my salon," Eugenia told the dealer who sold them to her; he was as shocked as her friends would be. Thanks to her ruthlessly exacting eye, her rooms looked refreshingly down-to-earth and made the other ladies' luxurious interiors seem stuffy and ostentatious.

Another of Eugenia's principles was that a room constantly had to change. "A house that doesn't alter," she used to say, "is a dead

house. One must change the furniture . . . rearrange it continually."
And so the visitor never knew quite what to expect, apart from such
fixtures as a sofa and some disparate armchairs (never a three-piece
suite) upholstered in plain-colored crash—whitish or her favorite
indigo. Eugenia was as fastidious about the cut of her *housses* (slip-
covers) as she was about that of her clothes; she never went any-
where but chez Leitz, "the Balenciaga of upholsterers." She even
used ticking for her clothes. The literary French diplomat Paul
Morand records her "resolutely more advanced chic . . . [she]
looked like a van Dongen in her blue straw hat, her dress of black-
and-white mattress ticking, and a slash of carmine on her lips."

In addition to the slipcovered furniture the visitor might find an
electric slide projector on top of a Riesener *bureau plat*. But in the
last resort the décor was subordinated to the marvelous Picassos,
Man in a Bowler Hat of 1915 (now in the Art Institute, Chicago) or
the great *Seated Man* of 1915–1916 (hidden away for years in a very
private collection), which stands in much the same relationship to
the end of Cubism as *Les Demoiselles d'Avignon* does to the start of it.
Even Proust pays tribute to Eugenia's discrimination. In the last
volume of his great novel he refers to society ladies, "touched by art
as if by heavenly grace," dwelling "in apartments filled with Cubist
paintings, while a Cubist painter lived only for them, and they lived
only for him." Proust was writing from personal experience. He
had been present when Eugenia unpacked the Cubist paintings and
portrait drawings that Picasso had given or sold to her. The artist
had arranged for them to be shipped to safety in Biarritz. As soon as
the war was over, she had them shipped back to Paris.

Eugenia's ability to lead fashion rather than follow it attracted a
number of disciples—*la colonie* these ladies were called—on whom
she imposed her rigid standards. "Throw out and keep throwing
out," she would say. "Elegance means elimination." "*Pas de vivélots*"
(her mispronunciation of *bibelots*) was another maxim, and the
friends who hung on her words would be obliged to follow her
example and banish their cherished knickknacks. For her part,
Eugenia relegated her *objets* to the shelves of two large red-lacquer
cupboards that were usually kept shut.

Zeal for control saved Eugenia from saintliness. She never tried her tricks on Picasso or Stravinsky, but she did not hesitate to do so on Cendrars. On his first visit to Eugenia's house (around 1918), the poet had been so struck by the subtlety and simplicity of the décor, the soft-footedness of the servants, the reticence of everything, that he devoted a sequence of poems, *From Ultramarine to Indigo,* to the famous lacquer cupboards. Besides financing Cendrars when he was needy and cosseting him when he was sick, Eugenia set aside the room frescoed by Picasso for him to work in. And to keep him by her side, she used to light votive candles—the wrong end (she was that much of a witch)—to Saint Anthony of Padua. On one occasion, her spells were powerful enough to prevent Cendrars from starting his famous car—an aging Alfa Romeo that had been designed and "color-coordinated" by Braque—but not powerful enough to prevent him from returning to Paris by train. Her excuse for hexing his car? He had lost an arm in the war and was a reckless driver. Possessiveness, compounded by loneliness, is also likely to have sparked Eugenia's spells.

Cendrars's daughter, Miriam, was often the butt of Eugenia's displeasure. In her biography of her father, Miriam describes how the old lady, who prided herself on her taste in toques, took a dislike to a hat the younger, prettier Miriam was wearing. "Much too big," Eugenia said and sliced away at the brim with a pair of shears until there was only "half a bonnet" left. Loath to relinquish her shears, Eugenia proceeded to do the same to Miriam's hair. "Much too much," she decreed and chopped a lot of it off. Cendrars introduced Eugenia to the last addition to her pantheon, the architect Le Corbusier: an old friend who came from the same part of Switzerland as he did. In 1931 she commissioned Le Corbusier to design a simple but spacious beach house at Viña del Mar back in her native Chile. In the end the project lapsed for lack of money. One of Le Corbusier's pupils saw to it that the "Villa Errázuriz" eventually materialized—not in Chile but Japan and improbably roofed with thatch.

Simplicity can be very costly. In her lifelong pursuit of the finest linen, the clearest crystal, the heaviest towels, the purest farmhouse

butter, the rarest jams, not to mention her lifelong pursuit and sup-
port of genius, Eugenia, who had little idea of the value of things,
eventually used up most of her capital. By the mid-1930s, she found
herself dependent on handouts from rich relations, notably her
great-niece Patricia, who had married the Chilean magnifico Arturo
López-Wilshaw. Hearing of her difficulties, Picasso, who was infi-
nitely generous to his friends, less so to his family, arranged secretly
for an emissary to buy back a screen—originally painted for his
friend Max Jacob—that she had acquired many years before. Ac-
cording to Dora Maar, this was only one of Picasso's ingenious ways
of giving Eugenia secret help. Other friends chipped in. Her fellow
maecenas Count Étienne de Beaumont had lent her a *pavillon* in the
courtyard of his grandiose *hôtel particulier* on rue Masseran so that
she could continue to have a pied-à-terre in Paris. During the war,
however, she was obliged to move out. She gave her furniture away
to Parisian friends—Picasso got her round table, Dora Maar the fa-
mous Bois de Boulogne chairs.

During the German occupation, Eugenia stayed on at La Mi-
moseraie, reduced to living in one heatable room and subsisting on
whatever she could grow in her garden. Money from Chile was
slow in coming; and then, in 1942, it stopped altogether. Eugenia's
adored son, Max, who looked after the family properties and doled
out the cash, had been killed in a riding accident back in Chile. The
daughters were either unable or unwilling to communicate with
their mother, so she was obliged to sell, little by little, most of her
paintings and furniture. She was fortunate in having a faithful maid,
Jeanne, to share her hardships. Besides Jeanne, her best friends, the
two elderly marquesas, Anita Villa-Urrutia and Tolita Villavieja
(whom Picasso remembered from his honeymoon), and a priest
came every week to look after Eugenia, who was by now well into
her eighties and very frail.

Out of superstition rather than foresight, Eugenia had hung on
to a few bits of good jewelry: a large diamond ring that she wore
nightly on her thumb (apparently a Chilean or Bolivian supersti-
tion) and a rope of pearls she wore only in bed. One night a gang of
armed and masked thieves took advantage of the house's isolation

and broke into La Mimoseraie. They held Eugenia and her maid at gunpoint while they ransacked the house and stole everything of value except her one great treasure, Picasso's Cubist masterpiece, the huge *Seated Man*. Penniless after her burglary, Eugenia decided to part with the painting. And although aged eighty-five, she wrapped all seven feet of the canvas in cardboard, took it by train to Paris, and sold it to Étienne de Beaumont. Étienne would leave it to his nephew, Henri de Beaumont, who would eventually sell it to a collector friend. It was on the occasion of her disposal of this painting that meant so much to both of them that Eugenia had her last meeting with Picasso. This took place at a luncheon given by Madame Cuttoli, the collector who had arranged for the artist to design tapestries. According to Philippe Jullian, "[Eugenia] arrived wearing a headscarf and carrying a basket under her arm as though she were shopping at Biarritz. She treated [Picasso] as she always had, like a wonderful child who is forgiven everything."

After disposing of La Mimoseraie, frescoes and all, and putting her affairs in order, Eugenia returned to her roots. In her eighty-eighth year, she flew—for the first time—back to her native Chile, which she had not seen in over sixty years. She took with her what was left of her papers and books as well as a small talisman, a gold unicorn, clutched in her hand. It did not bring luck. A few years later, she was badly injured in a motor accident. "I am tired of living," she said. "I wish to help God to take me out of this life." And so Eugenia Errázuriz stopped eating and died in 1954—a minimalist to the end.

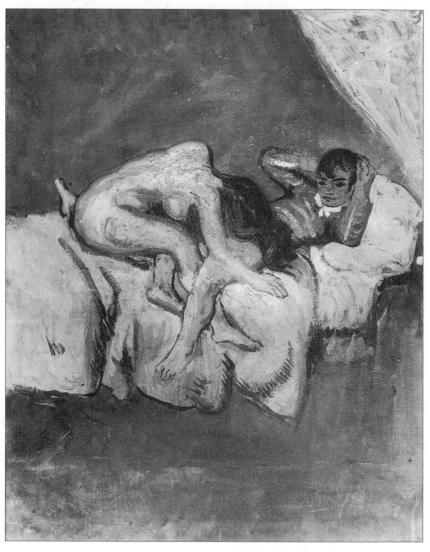

Pablo Picasso, *Portrait of the Artist Making Love,* oil on canvas, 1903,
Metropolitan Museum of Art (bequest of Scofield Thayer, 1984)

The Madness
of Scofield Thayer

———

Those cultivated American playboys of the 1920s who drew upon sizable trust funds to support their forays into the avant-garde and a lavish bohemian lifestyle tended to end sadly or badly. Genial Gerald Murphy, whose family owned Mark Cross, blossomed into an accomplished hard-edge painter—thanks largely to his friendship with Fernand Léger—but his life was shattered by the deaths of his two sons. Handsome Harry Crosby, J. P. Morgan's nephew, whose Black Sun Press in Paris published Hemingway, Lawrence, and Pound, ended his life in a double-suicide pact. Their stories have been exhaustively recorded. Less familiar is the story of yet another doomed, rich, avant-garde WASP: that queer dark prince of arts and letters, Scofield Thayer. The patronage of this Jazz Age *des Esseintes* (Huysmans's iconic aesthete) was wider-ranging than Murphy's or Crosby's in that he owned *The Dial* magazine and formed a collection of modern art to go with it. His life was even more of a nightmare than theirs.

That Thayer should be forgotten is hardly surprising. He spent the last fifty years or more of his long life totally out of his mind,

shut away in one or another of his comfortable houses—in Martha's Vineyard; Florida; Worcester, Mass.—in the care of attendants who aged along with him. His name, such a stellar one in the 1920s, did not resurface until he died at the age of ninety-two in 1982, and then only because his collection of six hundred works— including two or three Matisse paintings (notably the beautiful 1912 *Nasturtiums with "La Danse" I*), a sensational group of sexy Egon Schieles (twenty-three watercolors and drawings), thirty-six Toulouse-Lautrecs, and fifteen Munch prints—became the cause of litigation on the part of distant cousins. For better or worse, the distant cousins lost out to the Metropolitan Museum of Art.

Who exactly was Thayer? The only son of a very rich wool manufacturer (Compton Loom Company) from Worcester, he attended Milton Academy and Harvard and then went on to Oxford at the same time as T. S. Eliot. While at Oxford, Thayer introduced Eliot to a girlfriend of his sister's, the highly strung Vivien Haigh-Wood. The poet made the mistake of marrying her. Ironically, Vivien Eliot went out of her mind about the same time Thayer did.

After leaving Oxford, Thayer settled in New York. In 1916, he took a fancifully decorated top-floor apartment overlooking Washington Square in a building called the Benedick, which had a reputation for "sybaritic luxury" and resembled London's Albany in that only bachelors were permitted to live there. Thayer lined his walls with a collection of first editions and an array of twenty-two drawings by Audrey Beardsley (now in the Fogg Art Museum), which suggests that Beardsley's *Yellow Book* was one of the inspirations for *The Dial*. Like Proust, whom he greatly admired, Thayer loathed noise and paid a monthly sum to whoever lived below on the condition he turn off his Gramophone when asked to do so. Later, he would bribe owners of motorboats near his house on Martha's Vineyard to muffle their engines. Fastidious to the point of mania, Thayer was looked after by an impeccable if peculiar manservant, a Japanese intellectual who subscribed to *The Nation* and was apt to enter a room backward so as not to lose face. The paradox of Socialist views and antiquated ceremonial was much to Thayer's taste. He, too, held staunch Socialist views; he was also celebrated for humor that was twisted and black.

Besides being exceedingly rich, Thayer was brilliant, witty, elegant, tasteful, generous, erudite, and very, very handsome—strikingly pale with coal-black hair, black eyes veiled and flashing, and lips that curved like Lord Byron's. Alas, these qualities were shadowed by acute paranoia, which took the form of extreme suspiciousness and what a friend described as Tiberian imperiousness. There was something weird about the "carriage of his head and the timbre of his voice." "Ice on the surface and molten lava underneath," Alyse Gregory, one of the editors at *The Dial,* claimed. And as if this were not enough, he was an obsessive pedophile, whose taste ran to boys rather than girls. Nevertheless, he lost no time in getting married to the only slightly less rich and beautiful Elaine Orr, one of the three orphaned daughters of a prosperous paper manufacturer—"a Henry James heroine."

Because of Thayer's psychosis and sexual problems, the marriage did not prosper; neither did it exactly fall apart. Shortly after their honeymoon in October 1917, they agreed to live under separate roofs: the husband in his bachelor digs at the Benedick; the wife in a charming apartment around the corner at 3 Washington Square North, which Thayer decorated with exotic hangings, brocaded curtains, also a piano. Elaine toyed with the idea of going on the stage; instead she found fulfillment in becoming a cult figure—an available goddess—who captured the hearts of the young *littérateurs* her husband gathered around him, principally John Dos Passos and e. e. cummings. Separately or together, the young, rich, glamorous Thayers soon established themselves as leading patrons of art and letters.

Like many another writer manqué, Thayer decided to become an editor, and he set his sights on *The Dial,* a magazine that had enjoyed several reincarnations since its founding in 1840. After Emerson's editorship, it went out of business for forty years or so. Resuscitated around 1880 in Chicago by the enterprising Francis Browne, *The Dial* fell into a decline after his death. A young man called Martyn Johnson, who contrived to be both a radical and a decorator, reestablished the magazine in Greenwich Village in 1918, at which point Thayer bought a controlling interest. A catastrophic divergence of views soon developed. Johnson saw the magazine as a

forum for postwar polemics; Thayer, as an aesthetic adventure—a means of "consciousness-raising." After much backstabbing and Thayer's temporary resignation, big bucks prevailed, and Thayer and his rich friend from Rochester, Dr. James Sibley Watson, took over. The first number to be published under the new auspices appeared in January 1920. It did more than celebrate the start of the new decade; it set the pattern for the dandified intellectual attitudes of the twenties and thirties.

Thayer's greatest coup (November 1922) was the publication of T. S. Eliot's "The Waste Land," albeit in a somewhat incomplete form. It would have been an even greater coup if Thayer, who neither liked nor understood the poem, had paid a bit more for it. He failed to do so, and *The Dial* had to share the honor of being first in the field with Eliot's London-based *Criterion*. To its credit, *The Dial* also published much of Yeats's finest later verse and a selection of Pound's *Cantos,* as well as contributions by writers as diverse as George Moore, Gertrude Stein, e. e. cummings, George Santayana, Kahlil Gibran, Edmund Wilson, Marianne Moore, Bertrand Russell, William Carlos Williams, and James Joyce (alas, Thayer turned down the wonderful "Anna Livia Plurabelle" section of *Finnegans Wake*). *The Dial* was no less adventurous in its choice of foreign writers. Proust was so delighted at the review's publication of an excerpt from *À la recherche du temps perdu*—his debut in America—that he wrote *"au très cher Dial"* that it had "understood me better and supported me more warmly than any other review." *The Dial* also published Thomas Mann's *Death in Venice* and Cocteau's *Cock and Harlequin*. When Thayer moved to Vienna to be treated by Freud, the magazine featured writers such as Schnitzler, Hofmannsthal, and Hauptmann, not to mention painters such as Klimt and Schiele, who were unheard of in America at the time. Marianne Moore, who would become the magazine's principal editor, turned down the thirty-page article that Thayer extracted from Freud.

After "rousing" (Thayer's word) the American public to develop a taste for modern literature, the idealistic proprietor turned to his second major task: rousing the American public to appreciate modern art. Thayer set out to achieve this by forming a collection of

paintings, drawings, sculpture, and prints by the best contemporary artists. These acquisitions served three purposes: they would provide the magazine with black-and-white and, occasionally, color illustrations; they would be the basis of a folio of reproductions to be published on the side; and they would enable Thayer to organize a series of promotional exhibitions that, he optimistically hoped, would tour galleries and museums all over the country. The perceptive choice of American artists—Demuth, Lachaise, and Nadelman, among others—was probably less Thayer's than the more progressive Watson's. For the selection of European artists he consulted a kindred spirit, a young British critic of literature rather than art called Raymond Mortimer. He and Thayer did the rounds of galleries and studios in London, Paris, and Berlin, and, in the space of a few months in 1923, put together a collection that included many fine things by stars such as Picasso, Braque, Bonnard, and Matisse; and lesser lights such as Chagall, Derain, Vlaminck, Lehmbruck, and Laurencin.

Thayer's taste was safe, with a slight soft-porn taint. Had he really wanted to be perceived as a modernist, he would not have excluded Cubism, Futurism, and Abstraction and included so many insipid, male as well as female, nudes. One of the more singular items in the collection is a self-portrait of Picasso being fellated by a girl, which dates back to what the artist described as the lowest period of his entire life—his visit to Paris in 1903. So destitute was he that he agreed to paint a pornographic scene for some "vile and repugnant" Spaniards, who took advantage of his hunger and desperation. For once, an erotic subject failed to kindle Picasso's imagination. Maybe he felt degraded by the commission. Maybe he was too depressed to get into the mood. At all events, the resultant painting, which has been clumsily repainted, is uniquely uninspired.

Thayer was a manic perfectionist. To accommodate a last-minute alteration by Yeats, he pulped an entire issue of *The Dial* when it was all ready for the newsstands, and he was very insistent that his folio of the Dial Collection, called *Living Art* (published in 1923), should be of the finest quality. *Living Art* did not sell well (sixty dollars was

a lot of money then), but it had considerable influence on the taste of the time, specifically on that other rich up-and-coming luminary Lincoln Kirstein, whose magazine, *Hound and Horn,* would owe much to *The Dial.* When the *Living Art* originals were shown at the Montross Gallery in New York, they helped cater to a cultural need that would not be adequately filled until the Museum of Modern Art opened five years later. The collection did not find favor in Worcester, and Thayer never forgave his native city for refusing to hang a Braque nude or a Picasso drawing when the Dial Collection was exhibited there in 1924. The Worcester Art Museum subsequently made amends by putting much of the collection on permanent exhibit, but to no avail. In a fit of paranoid pique Thayer made a will leaving everything formerly destined for Worcester to New York. All the Worcester Art Museum got to keep was the papers pertaining to the collection. The rest of the Dial archive is in the Beinecke Library at Yale.

Thayer's manic involvement with modern literature has to be seen in the light as well as the shade of his peculiar relationship with his beautiful wife, Elaine. Despite staid Jamesian beginnings, their story (admirably told in Richard Kennedy's biography of e. e. cummings, *Dreams in the Mirror*) took on a Scott Fitzgerald raffishness and ended in drama verging on the oedipal. Frustrated by Thayer's inability to function as a husband, Elaine encouraged the attentions of John Dos Passos, and then moved on to her husband's "arch-discovery," handsome young e. e. cummings—in those days as much a painter as a poet (there are some seventy-four of his paintings and drawings in the Dial Collection). Cummings was at first wary, but when he realized that Thayer was complaisant to the point of active encouragement, he had no further compunction about having an affair with Thayer's wife. Elaine soon found herself pregnant, and on December 20, 1919, she gave birth to cummings's child, a girl eventually named Nancy.

By now obsessively involved with *The Dial* and its collection, Thayer had less and less time for his wife, whom he urged on cummings. But the painter-poet blew alternately very hot and very cold. There would be months together with Elaine in Paris, followed by

long periods of separation. Thayer, meanwhile, was spending most of his time in Vienna being analyzed by Freud—a process that he somehow managed to reconcile with strict, if remote, control of *The Dial*. Since Thayer's condition was pathological rather than psychological, there was nothing much Freud could do for his patient except encourage him to leave his wife. An amicable divorce ensued, and Elaine became Mrs. cummings on March 19, 1924.

Marriage brought the cummingses' six-year relationship to an end. Two months after the wedding, Elaine decided to visit England. Cummings did not accompany her. A mistake. On the boat she met a handsome young Irishman, Frank MacDermot. They fell wildly in love, and within three months of the wedding Elaine was asking cummings to give her a divorce. Much against his will, he obliged her.

Impecunious cummings found himself outmaneuvered by the rich, ruthless MacDermots. They tricked him out of his right to visit his child. Whisked off to Europe, little Nancy soon forgot all about her real father and grew up believing that she was the daughter of "the late Mr. Thayer." Attempts to transform her into a conventional English debutante would not be successful. In June 1940, Nancy—by now aged twenty—decided to leave Europe and spend the war years in America. Fearful that Nancy might discover the truth about her birth, Elaine announced that her "father" had not died but "suffered a mental breakdown and was under private care." Back in the United States, Nancy tried to track her "father" down, but the Thayer family's lawyer refused to let her see him.

It was only some years later, when Elaine MacDermot casually divulged the fact—hitherto kept secret—of her marriage to cummings, that the scales began to fall from Nancy's eyes. She started to ask awkward questions—questions that were brushed aside by her mother. As she herself had started to write verse, she was determined to meet the poet her mother had married. Given the situation's Jamesian overtones ("What Nancy didn't know"), it was indeed appropriate that she should have chosen the novelist's nephew William James to act as a go-between, especially since he and his wife knew all about the parental link. In the fall of 1946 they

took Nancy to visit the curmudgeonly cummings and his "difficult" mistress, the beautiful Marion Morehouse. At the first sound of cummings's voice—a voice that stirred the sediment of memory—Nancy said she felt eerie, her hand shook, but she "had no place to put this feeling."

Thenceforth cummings and Nancy saw each other regularly, but he never told her that he was her father, nor did she have any suspicion that this might be the case. With the possessive Marion perpetually hovering, it was difficult for Nancy to ask intimate questions. In any case she was preoccupied by her own faltering marriage to Willard Roosevelt. As cummings painted successive portraits of her, Nancy began to wonder why her mother had walked out on someone who was so fascinating that she found she herself was falling in love with him. In the hope of saving her marriage, Nancy decided to end the relationship. On what was intended to be a last visit, she could not resist asking cummings a question about "my father," meaning, of course, Thayer. There was a traumatic break in the conversation. Finally cummings said, "Did anyone ever tell you that I was your father?" Later Nancy was to discover that everyone, except herself, knew she was cummings's daughter. It made her feel the center of a vast conspiracy. Sadly, cummings could not adjust to the parental role that was now thrust on him.

What, meanwhile, had happened to Thayer? Around 1930, his mental state—the principal reason for the demise of *The Dial* in 1929—deteriorated, and he was put in the charge of attendants. Some people blamed his collapse on Freud: they said he had driven Thayer around the bend by obliging him to confront his incurable pedophilia. Others maintained that his madness was voluntary: an attempt to redeem his soul from the Mephistophelian Freud and thus "demonstrate the inefficacy of his system." Ironically, Thayer's persecution mania had some basis in fact. According to Edmund Wilson, "Thayer thought the art collector in Philadelphia [Dr. Albert Barnes] had paid all the taxi drivers in New York to spy on him. Somebody asked him how much he thought that would cost: 'eleven thousand nine hundred and twenty dollars.' " Thayer was not entirely deluded. It turns out that the manipulative Dr. Barnes

was determined to "direct the artistic policy of *The Dial,* and hence of America." Knowing Thayer's weaknesses, he decided to play on them and blackmail him into collaboration. Barnes rather than Freud seems to have been to blame for aggravating Thayer's mental condition.

Pampered lunatics often reach a great age. Thayer was no exception. Thanks to salubrious seclusion in one or another of his residences, he lived on and on, finally dying at the age of ninety-two in 1982. Nobody visited him—not that there would have been much point. Marianne Moore, who had been *The Dial*'s last editor, told a friend that she had gone to see friends in Worcester, sometime in the fifties or sixties, and who did she cross in the street but Thayer? She saluted him, but he had no idea who she was.

After Thayer's death, his 1925 will leaving the Dial Collection to the Metropolitan Museum was contested by four distant cousins. At issue was Thayer's stipulation that everything should be "on permanent exhibition." The museum's lawyers argued that the works on paper (and most of the works in the Dial Collection are on paper) would suffer serious damage if they were to be constantly exposed to light; how, then, could the collection be put "on permanent exhibition"? After prolonged litigation, the ruling went in favor of the Metropolitan Museum. The bequest, which enriched the museum's print department in some very crucial areas, commemorates one of the oddest and least familiar American patrons of the avant-garde.

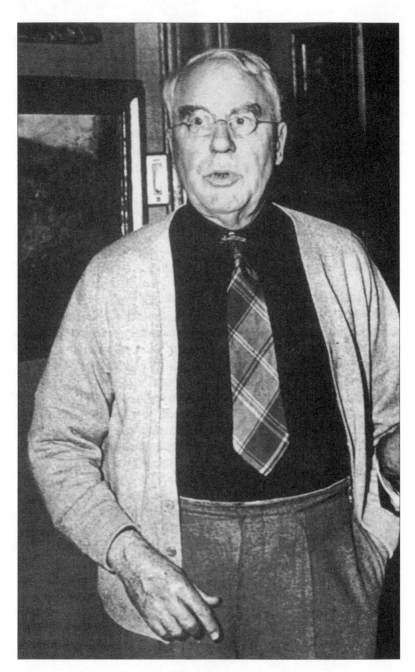

Dr. Albert Barnes, 1945

Beastly Dr. Barnes

D r. Albert Barnes's magnificent museum of Impressionist and Postimpressionist paintings in Merion, Pennsylvania, is the by-product of an acute case of paranoia: an inferiority complex so severe that it could be appeased only by barrage after barrage of pathological one-upmanship. Barnes stockpiled more modern masterpieces than any other collector anywhere in the world and then made them virtually inaccessible, above all to members of the art world. That way, he felt he had the last laugh.

Typical of his many victims was the distinguished Philadelphia collector Sturges Ingersoll, who told me that he had encountered Barnes on a suburban train and had asked to see his paintings. The doctor was most accommodating: "How about next Tuesday?" A day or two later, Ingersoll received a letter from Barnes, warning him that a disgusting old bum masquerading as him was importuning passengers on the local trains—shouldn't he do something about it? When Walter Chrysler, Jr., a collector and rogue of a very different stripe from Barnes, asked to visit, he was put off with a letter from a fictitious secretary, who claimed that the doctor had given

"strict orders that he is not to be disturbed during his present efforts to break the world's record for goldfish swallowing." As another of Barnes's victims said, "There's no use going into a pissing competition with a skunk."

By the time he died in 1951, Barnes was resented way beyond the confines of Philadelphia for having antagonized virtually everyone who wanted to see his collection, which included 171 Renoirs, 57 Cézannes, 54 Matisses, several major early Picassos, and master-pieces by Seurat, van Gogh, and "Le Douanier" Rousseau. Many of them eclipse anything by the same masters in the National Gallery in Washington or the Metropolitan Museum of Art. Even the less popular works—such as the much-maligned late Renoirs of cel-lulitic nudes, which Picasso and Matisse also collected—play an important supportive role, enhancing the great jewels of the collection in the way that lesser diamonds do.

The Barnes collection has been valued at between $3 billion and $6 billion. I would put the figure even higher. Besides being the most valuable collection of its kind in the country, it is also one of the least visited, because the doctor's will perpetuated the obstacles he had set up in his lifetime. The collection might be better known if Barnes had not left his foundation to Lincoln University, a small black college in rural Pennsylvania. Barnes chose Lincoln, which has no credentials in the field of art, partly because he had always taken an interest in black culture—especially gospel singing and tribal sculpture—and partly because he wanted to vent his spite on the white establishment.

There was good reason for the mammoth chip on Barnes's shoulder. His Irish forebears had been among the original settlers of Pennsylvania, but in two centuries they had never risen above the level of laborer. His father was a drunkard who allowed his family to slither to the bottom of the heap: a rat-infested section of Philadelphia known as the Neck or the Dumps. The Barnes boys were routinely beaten up and robbed by local thugs until they took up boxing. The wounds received in the gutter never healed.

Nevertheless, Barnes was a classic American success story: the demonically driven dead-end kid—complete with an ambitious mother—whose rocketlike ascent left him twisted but smart as hell.

He financed his tuition for medical school by playing semiprofessional baseball. He was only twenty when he got his M.D. and became an intern in an insane asylum. With his pugilistic build, beetle brow, reddish eyes, and eerie interest in abnormal psychology, Barnes must have been almost as fearsome as Dr. Hannibal "the Cannibal" Lecter.

Like Armand Hammer a few years later, the young doctor soon realized that manufacturing medicine would earn him more money than practicing it. Since most pharmaceutical discoveries were made in Germany, Barnes headed for Berlin. Back in Philadelphia eighteen months later, he got a job with a pharmaceutical manufacturer. At the same time he conquered the heart of Laura Leggett, a genteel blonde from Brooklyn. She liked Al's diamond-in-the-rough masterfulness; he liked her oldish lineage (a niece married Winston Churchhill's great friend the Tory politician Lord Margesson), and wholesale-grocery money. They were married in 1901, and set up in style just off Philadelphia's Main Line. According to William Schack's excellent biography, the doctor purportedly held the typically turn-of-the-century view that "marriage is a cheap and wholesome substitution for prostitution." Despite his constant infidelities, Laura Barnes always stood by him.

To realize his dream of inventing a vastly profitable drug, Barnes joined forces with Hermann Hille, a German chemist he had met in the course of his studies. Barnes arranged for Hille to have a job alongside him, and urged him to develop a multipurpose silver compound that, in the form of eyedrops, would prevent blindness in babies. Argyrol, they called it. Barnes soon had it accepted by medical authorities; later its use was even made mandatory in certain states for newborn babies. Since it was inexpensive and easy to manufacture, Argyrol rapidly enriched its inventors.

Money exacerbated Barnes's rapaciousness and paranoia. He brought his drunken father in to spy on Hille, who had sensibly kept the formula a secret. After threatening his partner with his fists, Barnes assailed him in court, had the partnership dissolved, and squeezed Hille out of the business, including the formula, for $350,000. Barnes's later insistence that he had invented Argyrol gave rise to all sorts of dire rumors: Hille had been eliminated, peo-

ple said, packed off back to Germany, driven to suicide, even murdered. Nonsense. Hille went on to become a successful chemist in Chicago.

Now that he was rich, Barnes thrust himself forward so aggressively that he seemed actually to court the snubs of Philadelphia's snobbish Main Liners. The hunting field was his undoing. Besides shoving ahead of everybody else, he kept falling off his horse. Worse, he had his groom to lunch at the hunt club. Years later, an old Philadelphian lady told me, "You might as well have taken Groucho Marx out hunting as Dr. Barnes. He was too chippy for the Main Line."

Barnes quit hunting, but the damage had been done. Patrician Philadelphians closed their doors; thenceforth the doctor wasted much of his enormous energy trying to turn the tables on them. In future he would keep to "real" people, he said: his employees, whom he alternately indulged and tyrannized, and the local fire brigade, many of them shanty Irish like himself. In their company he would tear through Merion at top speed, making a huge din. Rather surprisingly, the black gospel singers whom he had loved as a boy did not figure among the "real" people. However, he became very friendly with a couple of stars: Katherine Cornell and Charles Laughton. They loved the old monster, but then, they were monsters, albeit sacred ones, like him.

The doctor had once fancied himself an amateur painter, but after 190 botched canvases, he decided to be a collector instead. Realizing the need for professional advice, he turned to a former schoolmate, William Glackens, who had recently made a name as a realist painter. Early in 1912, Barnes gave Glackens $20,000 and sent him to Paris. Three weeks later, Glackens was back with works by Renoir, Degas, van Gogh, and also probably Manet, Gauguin, and Cézanne. The paintings were not to Barnes's liking—at first at least. Try living with them, Glackens said. After changing and rechanging the frames and subjecting the paintings to days of intense scrutiny, the doctor decided to keep them. He would never employ an adviser again.

Six months later, Barnes arrived in Paris, alone, on the first of countless buying trips—waving his checkbook in the air, Gertrude

Stein complained. This was hypocritical of her, considering she had forced two of her Matisses on him when he wanted to buy only one. A conceited exhibitionist, Barnes said of her. He preferred her brother, Leo, who had been, albeit briefly, the most discriminating collector of modern art in the world. His were indeed brains to pick. The artists Barnes proceeded to collect with such perspicacity were mostly ones that Leo had bought and in some cases discovered.

World War I put an end to European travel, but Barnes went on buying—mostly Renoirs—from photographs sent by Parisian dealers. After the war, he found himself better placed than ever to make wholesale acquisitions. A glut of great art on the market kept postwar prices way down. In 1920 he took advantage of this to snap up thirteen fine Cézannes and the best of what was left of Leo Stein's collection. He also expanded into other fields. Paul Guillaume, the brilliant young dealer who became his principal Paris agent, introduced Barnes to African tribal sculpture, and he bought some superb examples. Through other sources he acquired fine Greek and Egyptian antiquities. Most of the pre-nineteenth-century paintings he "discovered" prove that he had little or no eye for old masters.

With some justice, Barnes saw himself as an enlightened boss out to galvanize his workers with his own zeal for self-advancement. Since 1916 he had obliged Argyrol's poorly educated staff to spend two hours a day studying philosophy, psychology, and art appreciation, especially the works of John Dewey. These seminars might have been more beneficial if the pedagogical Barnes had not insisted on policing the thoughts of his captive "students." It was like the Inquisition; everyone had to embrace the doctrines imposed from on high or suffer the consequences. In 1922, Barnes transformed this informal study group into a foundation for adult education. The staff consisted mostly of former Argyrol employees—notably two fearsome Irish biddies, Nelle and Mary Mullen—whom Barnes had brainwashed with his theories of psychology and aesthetics. They screened applicants to his school for the right attitude—eagerness tempered with docility—and in due course brainwashed suitable students into becoming brainwashers themselves.

In the face of Barnes's megalomania and his staff's amateurish-

ness, qualified teachers from outside seldom lasted long at the foundation. When the doctor finally succeeded in luring a star, the British philosopher Bertrand Russell, to Merion, it was a disaster. Unlike Barnes's pet guru, the amenable Dewey, Russell was exceedingly forthright; he was not only a genius, he had been born into a family of great wealth and political power. Despite the brilliance of the lectures, Barnes fired him. For remaining loyal to Russell, Barrows Dunham, another of the teachers, incurred the doctor's undying wrath. Barnes denounced him to the FBI. Long after he had left the foundation, Dunham was hauled before Senator Joseph McCarthy's committee and stripped of his professorship. (Years later, his university made him professor emeritus.)

To endow his foundation, Barnes came up with $6 million. To house it, he set about building a museum, which would also serve as a private educational institution, in a vaguely French Renaissance style. The limestone had to be the finest, so in December 1922 he embarked on a tour of French quarries. When he returned to the United States a month later, Barnes had purchased nine hundred tons of limestone and also spent around half a million dollars on more than a hundred paintings. Besides numerous Impressionists and Postimpressionists, the hoard included virtually everything the still-little-known Lithuanian Jewish painter Chaim Soutine had painted up to then—around eighty or ninety canvases. Barnes got the Soutines for a mere three thousand dollars.

On this visit Barnes took a liking to yet another soon-to-be-famous Jewish artist, Jacques Lipchitz. He purchased a number of his sculptures and commissioned a series of stone carvings to fill niches in the new building. Lipchitz was very wary of presuming on the close friendship that had sprung up between him and Barnes until, one fateful day, a painter friend of no great distinction asked him to intervene on his behalf: his wife was dying because they had no money for an operation. Could Barnes take a look at his work? The doctor fumed at this suggestion, but finally gave in and bought two paintings for two hundred dollars. "I'll never forgive you," Barnes berated Lipchitz. "You made me confound art with philanthropy. I never want to see you again."

That "a collector is a king" was Barnes's pet delusion, one that he was determined to have Philadelphians accept. In May 1923 he took justifiable pride in exhibiting seventy-five of his latest acquisitions (great Matisses, Modiglianis, and Soutines) at the august Pennsylvania Academy of Fine Arts. Bursts of philistine laughter and mockery on the part of the local art establishment ("the glorification of awfulness," according to one of the critics) were just what Barnes's paranoid psyche craved. He could now harass his fellow citizens, starting with the critics, to his black heart's content. Edith Powell of the *Public Ledger*—who had found Soutine's vision "diseased and degenerate"—was told by Barnes that her criticism would never have any value until an iceman screwed her in certain very specific ways. "Do you think there's something in the iceman idea?" Powell asked a colleague, and took extended leave in Paris.

Three years later, the doctor gave his hometown yet another chance to reject him. He proposed that his foundation become part of his alma mater, the University of Pennsylvania. The provost did not even reply to this generous offer. Barnes suffered—or should one say invited?—similar rebuffs from Philadelphia's Museum of Fine Arts. Given the doctor's explosive nature, these collaborative schemes might not have succeeded. Nevertheless, the Philadelphians were almost as much to blame as Barnes. Their negligence, hauteur, and philistinism had triggered his paranoia; they should have shown more generosity of spirit and ingenuity in neutralizing it.

Rejection goaded Barnes into collecting with even more manic persistence. In the modern field, his finest acquisitions were not so much by Picasso as Matisse, above all the latter's early masterpiece *Le Bonheur de Vivre*. Once his private museum was built, Barnes looked around for an artist to decorate a vast, empty space in his main gallery. His first choice—Renoir's ceramist son, Jean— confirms that Barnes's taste was subject to peculiar lapses. Jean Renoir's floral pots and vases in the Barnes collection reveal that he was a rotten potter. In the end young Renoir wisely refused the commission; he had decided to become a film director—a métier in which he would triumph. "Then I'll just have to get Matisse," Barnes said. Fortunately, this artist was about to make his first trip

across the Atlantic. When he visited Barnes, he was so overwhelmed by what he saw on his walls that he agreed to do the decoration: three lunettes, forty-five feet long and more than eleven feet high. For most of the next year, Matisse concentrated on this vast commission. When he had just about finished, he discovered that he had taken incorrect measurements. He had to start all over again. In May 1933, *La Danse*—a stylized group of interlocking nudes—was finally installed. A masterpiece! Barnes had yet another treasure— the greatest wall decoration in America—over which to gloat. Henceforth Matisse would do his best to see as little as possible of his patron.

Barnes's craziness manifested itself in obsessive scatology. His knowledge of chemistry inspired such epithets as "skatol," after an ingredient that gives shit its distinctive smell. And he would invent disgusting names—Graf Lekmir im Arsch, Phallus Leucorrhea, Bella Donna van Byttsche—with which to sign abusive letters. When Philadelphia's postmaster refused to handle the letters on the grounds that they were "lewd, lascivious, and obscene," Barnes had them delivered by his chauffeur.

The wretched young secretary who was obliged to type this stuff later recalled her first morning at work: taking dictation from Barnes in his bathroom as he cooked in a steam cabinet. Besides sweat, obscene invective poured from him—invective that he had the ladylike secretary read back so that he could make it much, much nastier. When he was through, he ordered her to turn on the shower, into which, lobster red and naked, he jumped. And yet, when she was eventually fired, both the secretary and Barnes burst into uncontrollable sobs.

Besides yes-women from Argyrol, Barnes's teaching staff included a mysterious, self-invented Belgian woman whose real name was Yetta but who called herself Violette de Mazia. The doctor had promoted her from the ranks of his students to become an instructor, the coauthor with him of a series of leaden books on Matisse, Renoir, and Cézanne; also his constant traveling companion and mistress, ultimately his alter ego. After the doctor's death, de Mazia did far more to fill her master's boots than Mrs. Barnes did. She re-

fused to allow color reproductions to be made of the paintings, she did not hesitate to banish a student for skipping classes because of her husband's death, and she fought like a cornered dodo to keep the collection closed to anyone known to take a serious interest in modern art. This coquettish wraith, who was seldom seen without dark glasses, a flower in her thinning hair, Mexican jewelry, and a jingling thumb ring, did not die until the age of eighty-nine, in 1988.

Limiting visits almost entirely to blacks, working-class whites, and the foundation's students was less a matter of altruism than of getting back at the establishment. Few things gave Barnes greater pleasure than writing "Nuts" to T. S. Eliot when he sought admittance; keeping an eminent collector out but letting his dog in; dumping a bucket of water on an innocent visitor; bidding an art historian come at three A.M., but only if the moon was out; telling a local publisher's wife that, as a whore and ignoramus, she would be chased off his property; barring some faculty members of the prestigious local academy from the foundation because they always arrived "in a state of profound alcoholic intoxication."

Given Barnes's exclusionist policy, people involved in the arts were prepared to go to almost any lengths to see his collection. During World War II, A. Hyatt Mayor—then a naval officer, later one of the Metropolitan Museum's most imaginative curators—found himself stationed in Philadelphia. Knowing that an officer's uniform made him persona non grata, he borrowed an enlisted man's bell-bottoms and was instantly admitted. Other museum curators resorted to assumed names, childish spelling, illiterate writing, odd scraps of paper, phony slum addresses.

Alfred Barr, Jr., founding director of the Museum of Modern Art, told me that he had to join a teachers' organization from another state and use an assumed name when he needed to study Barnes's Matisses for his celebrated monograph. He was spotted. A painting he was examining turned out to be hanging on the back of a door, which opened a crack to reveal an eye—Barnes's eye. The crack suddenly widened, and out popped the doctor like a jack-in-the-box, coated and hatted and madly glaring. Fortunately, Barr had

once written kindly about one of the doctor's books, so there was no confrontation. Instead, Barnes—followed by a fascinated Barr—raced through the galleries and down the steps into a waiting car, which took off like a fire engine.

Favored visitors would have the luxury of two hours alone with the greatest private accumulation of modern masterpieces in America. Barnes's equal in fiendishness, the British collector Douglas Cooper, developed a perverse admiration for "the good doctor" and was made welcome by him. Whiskey would be served, Cooper told me, which Barnes would insist on diluting with an exact amount of distilled water measured from a pipette. In the course of one of their meetings, Lord Rothschild was let in and then almost immediately kicked out. "Showing off," Cooper said. "There was no knowing what surprises Barnes might spring." People who asked him whether they could smoke in the galleries were told of course they could—as long as they used their pockets as ashtrays. Whereupon he would ostentatiously light up and use his own special ashtray, the contents of which he would somehow manage to ignite.

To demonstrate that the works of art in the collection belonged to him—"fuck posterity," he said—Barnes was not above mistreating them. A visiting painter was appalled to see him spit on his finger and rub an offending bit of paint off an early Picasso. No less worrying was the fact that the conservation of his masterpieces was entrusted to Albert Nulty, a former fireman, whom Barnes had promoted from driver to odd-job man to restorer. (He ultimately became a trustee.) Nulty is said to have received some technical training, but it must have been most unorthodox. When some pigment fell off the foundation's finest Manet, Nulty simply glued it back on.

At one time Barnes put the wind up his snooty neighbors by threatening to donate his collection to the Metropolitan Museum and transform the foundation into an institution for the study of black culture. He said he wanted "to make the native qualities of the Negro contributory to a richer and more intelligent civilization in America." Like his announcement that he was going to have his paintings cremated with his body, this was more of a threat than a

promise. And then, in 1950, after fiendishly rattling his will at the University of Pennsylvania one last time and embarking on an abortive flirtation with Sarah Lawrence College, Barnes switched back to "Negroes." Dr. Horace Mann Bond, the first black president of Lincoln University, had made a clever move: he had invited the doctor to teach some of the students art appreciation. Barnes said that if Jon Longaker, one of his teachers, could hold a weekly course for Lincoln students at the foundation, he, too, would give an occasional lecture.

The students were apparently bewildered by their first exposure to modern art, bewildered by Barnes's rambling tirades about black and white culture. And then, the doctor's manner was so belligerent. "He had piercing eyes under bushy, black brows," Longaker was quoted as saying in Howard Greenfeld's *The Devil and Dr. Barnes*.

> He got red in the face as he spoke, and white gobs of spittle appeared at the corner of his mouth if he spoke too long. On one occasion he worked himself up to a climax: "Don't ever forget you are Negroes," he thundered. I was flabbergasted, because it sounded like the most virulent racist remark. Then, of course, I realized what he meant, that they should be proud of their heritage.

Let us hope that Longaker's interpretation is right. For Barnes was not pleased with the way things were going. As he told a Lincoln administrator, he was very disappointed by the lack of progress made by its students. "This year the experiment at Lincoln failed," he wrote. Nevertheless, hatred of the white establishment kept him on course. He went ahead and left his precious foundation, subject to very specific conditions, under the guardianship of Lincoln. Rumors circulated that Barnes had done so because he had an illegitimate half brother who was black. Someone even pointed out to me the antique shop this man supposedly owned. There was also a rumor that he had a taste for young black boys. Most unlikely, I would have thought.

The doctor had always driven his cars as ferociously as himself. On the way to his house in the country one summer afternoon in 1952, he ran through a stop sign at a notoriously dangerous intersection. A ten-ton trailer crashed into his Packard, killing him instantly. He was mourned by his long-suffering wife, his mistress, his fanatically loyal staff, and his buddies at the firehouse. Philadelphians were more inclined to mourn the loss of the collection to Lincoln. Barnes would have changed his mind, they said. They were probably right. Mrs. Barnes told a friend, a year or two after her husband's death, that he had lived to regret his decision. But what was done was done. Years later, it would be undone, but only after much litigation and scandal and wringing of Philadelphian hands.

Sibyl Colefax, photographed by Cecil Beaton, c. 1935

Sibyl Colefax, Lion Hunter

In its half century of existence, the firm of London decorators
known as Colefax and Fowler has become synonymous with the
"English country house look"—a look that is almost as popular in
New England as it still is in old England. The historical role that
John Fowler played in the rehabilitation and dissemination of this
look and the influence that it has exerted on many of America's
most prestigious designers are no secret. But how about Lady Cole-
fax, who founded the business?

Although Sibyl Colefax earned her living as a decorator, she was
more celebrated as a hostess. And in that capacity she should have
fallen victim to the oblivion that descends on hostesses when they
go broke or drop dead. However, the stratagems that her social ob-
session necessitated provided writers such as Evelyn Waugh, Aldous
Huxley, and Osbert Sitwell, not to mention Lord Berners—a minor
English composer; a major English wit—with an irresistible target.
To that extent this dim woman deserves resuscitation.

Sibyl saw herself as a social catalyst, an impresario who would
bring together celebrities of all kinds: royal personages, politicos,

geniuses, aristocrats, stars of stage and screen. Rightly or wrongly, however, she came to be perceived as a self-promoting operator, who would use anyone or anything in the interests of social advancement. Lord Berners, who spent a weekend in a bedroom next to hers, complained to friends that her incessant climbing had kept him awake. Sibyl was also the subject of one of Berners's pastiches of Gertrude Stein, called "Portrait of a Society Hostess." "Are you there? Are you there? There! There! Are you not all there? Many are not quite all there but royalty are there and lots and lots and lots . . . She praises and embarrasses she praises and embarrasses she confuses cabinet ministers. Some will not go . . . Squashed bosh is her favorite meringue."

Social ambition usually turns out to stem from a need to exorcise origins that are humble or shameful; or from some other taint that society has to be mesmerized, bribed, or bludgeoned into overlooking or accepting. Sibyl's problem was different. Her background was infinitely respectable, but she lacked fortune, looks, wit, and charm—particularly by comparison with her principal London rival, the Californian Lady Cunard—but she made up for it in her energy and single-mindedness. She was a terrible chatterbox; she was also a celebrity addict. As Nancy Lancaster, her successor at Colefax and Fowler, said, you accepted Emerald Cunard's invitations because she was such an entertaining hostess. You accepted Sibyl's invitations because she had such entertaining guests. Emerald "glittered"; Sibyl "would sink into the woodwork." Like most addicts, Sibyl could be quite vindictive, as Kenneth Clark reported. "If a guest fell out at the last moment or a celebrity left early—[Lady Colefax] would suffer a physical change, and the upper part of her face would turn black. She literally gave one a black look, and it was very alarming." A further disadvantage was her husband, Arthur, an eminent patent lawyer, who, as the American diarist Chips Channon wrote, was "deaf, and unfortunately the very reverse of dumb . . . boring beyond belief"—so boring that, according to Lord Berners, Sir Arthur had been offered £30,000 a year to bore the Channel Tunnel.

Besides the bossiness and thick, snub-proof skin that a lion-hunting hostess is obliged to develop, Sibyl had a genuine love not

so much of art as of art experts and connoisseurs, among them Bernard Berenson as well as Kenneth Clark. She also had a flair for backing the right literary horses: among them writers as varied as H. G. Wells, Max Beerbohm, Somerset Maugham, the Sitwells (until Osbert caricatured her in one of his stories), T. S. Eliot, Christopher Isherwood, and, most surprising of all, the hypercritical Virginia Woolf. Mrs. Woolf had originally complained that Sibyl was silly, hard, shiny, and "glittering as a cheap cherry," but came to accept her as a friend. Sibyl was too skillful a snob to pick her lions only for rank or wealth.

Sibyl had an endearing and enduring reverence for America and Americans. After visiting the United States in 1926, she returned to London with scores of American scalps dangling from her belt, those of Alexander Woollcott, Thornton Wilder, Anita Loos, and Condé Nast in particular. Despite Aldous Huxley's assertion that in Hollywood Sibyl's attentions had reduced Douglas Fairbanks and Mary Pickford "to the verge of the tomb," most of her American friends seem to have taken her to their hearts, and surprising though it might seem, there is some merit to Sibyl's claim that the inclusion of so many Americans in her lunches and dinners helped to narrow the Atlantic.

Sibyl's American connections were almost her undoing. The savings that she had transferred, on the advice of a New York friend, from London to Wall Street evaporated in the crash. Meanwhile, deafness had obliged her hitherto well-paid husband to retire from legal practice. Poverty prompted Sibyl to harness her social addiction to a modest gift for doing up houses and go into business as a decorator. The best that can be said for her taste is that it was very, very safe—ladylike without being feminine. The new venture was inspired by the example of her next-door-neighbor-but-one, Somerset Maugham's ex-wife, Syrie, who was an old hand at this game. Syrie, too, needed cash to replenish Wall Street losses and to eke out what she regarded as a none-too-generous divorce settlement. How dare Sibyl poach on her preserves? Mutual friends derived much fun from the unladylike recriminations of these fashionable shopkeepers.

Although Syrie Maugham is credited with being a more innova-

tive decorator, she had in fact pinched her principal gimmick—the all-white look—from an *à la page* friend, Mrs. Winkie Philipson. According to Somerset Maugham, his ex-wife cooked accounts and peddled fakes. According to Cecil Beaton, "she bleached, pickled, or scraped every piece of furniture in sight. White sheepskin rugs were strewn on the eggshell-surfaced floors, vast white sofas were flanked with cracked white incidental tables, white ostrich and peacock feathers were put in white vases against white walls . . . It was unearthly . . . Mayfair drawing rooms began to look like albino stage sets. The craze wasn't to subside for a decade, whereupon Mrs. Maugham switched gears and introduced the vivid colors of a lobster salad"—much to the relief of her clients, for white-on-white was impractical and costly to maintain, requiring constant cleaning and repainting. Unlike Lady Colefax, Mrs. Maugham would not allow her clients to include their family things in her decors—no money in it for her—unless she could subject their mahogany chairs or gilded consoles to a lot of costly and vandalistic sizing and whitening.

Sibyl was less iconoclastic and more accommodating. Thanks to her mentors in the museum world, she had acquired enough respect for the artifacts of the past not to want to tamper with them. Since she had no understanding of modernism, and would have thought Art Deco vulgar—"actressy!"—she wisely limited herself to the traditional Georgian country house look. At the same time she widened the scope of her new venture by roping in a couple of younger society women who had far more taste and social clout than she had: the American-born Mrs. Ronald Tree (subsequently Mrs. Nancy Lancaster), who stocked the shop with her serendipitous finds; and Countess (Peggy) Münster, who drummed up trade and kept an eye on things while her boss relentlessly compiled guest lists. Sibyl could not have chosen better. Both women were known for their discrimination and for having superb houses and gardens to their credit (the former at Kelmarsh and Ditchley, the latter at Schloss Wasserleonburg and Send Grove).

In 1938, Peggy Münster came up with a great discovery: an unassuming young man called John Fowler, who had abandoned the life of a farmer's boy for a career painting furniture, first in the Peter

Jones department store, then in his own house a stone's throw from Sibyl's. Both Sibyl and Syrie were eager to employ this artisan of genius. He chose Sibyl because he thought her the less dominating personality. At first the two of them did not hit it off—Fowler's mousiness concealed a whim of iron—but little by little Sibyl came to understand that the style Fowler called "humble elegance" was a vast improvement on her boring, brown furniture.

After Fowler's arrival, Sibyl concentrated less on decorating than on entertaining, which provided Colefax and Fowler with a steady stream of clients. As Brian Masters says, "Lady Colefax the hostess and Lady Colefax the businesswoman overlapped and complemented each other." Indeed, Sibyl pioneered the use of social connections as a lure to catch upwardly mobile people who expected a decorator to provide not only a smart new dining room but also smart new friends to fill it. Anyone who purchased enough lime green sofas or Fowler's "signature" *objet de luxe,* mattresses stuffed with white horsehair, would be pointed in the right direction and introduced to some of Sibyl's nobs. In this respect she had a great many imitators on both sides of the Atlantic.

Besides being the butt of jokes—many of them put about by Lord Berners, who would also lampoon her as the awful Adelaide Pyrex in his play *The Furies*—Sibyl played a major comic role in many a roman à clef of the period. She was the model for the deadly decorator Mrs. Beavor (as, allegedly, her son Michael was the model for Mrs. Beavor's son John) in Evelyn Waugh's masterpiece *A Handful of Dust;* for the rapacious Mrs. Aldwinkle in Aldous Huxley's *Those Barren Leaves;* and for Osbert Sitwell's nasty but far less sharply etched caricatures Lady Flinteye and Mrs. Kinfoot.

Did Sibyl realize what a figure of fun she had become? And if she realized, did she resent her guests (Huxley and Sitwell had both given readings in her house) for not just biting but mauling the hand that had fed them? Or did she choose to regard the treachery of her "friends" as motivated by envy and thus a tribute to her skill as a lion hunter? Who else had been able to stalk so many remarkable specimens and display them like trophies in her dining room? However, as even her critics admitted, her food was good in a conventional way. Nancy Lancaster has described Sibyl's thoughtful

habit of sending people who had stayed late "home with a hot cup of bouillon and the very thinnest sandwiches. She even sent her old parlor maid around to Queen Anne's Gate to show my cook how to make the thin sandwiches. One slice of brown bread and one slice of white bread with butter in between. They were very, very simple and very good."

Sibyl reached her apogee in the mid-1930s. By assiduously cultivating Mrs. Simpson, she managed to entice the Prince of Wales to her parties, and she is even said to have deluded herself into believing that she could negotiate a peace between Mrs. Simpson and Queen Mary. When the Prince of Wales became King, Sibyl made her shop available for clandestine trysts. Mrs. Simpson would come in the front door and fiddle with fringe until the monarch materialized via the back door. The shopkeeper's courtship of the royal couple became something of a joke. Lord Berners could not resist inviting Sibyl to dinner and scrawling "the P. of W. is coming" on the bottom of the card. After supposedly chucking some other arrangements, she was dismayed to find herself confronted with the Provost of Worcester.

When the cost of living, or rather entertaining, obliged Sibyl to sell Argyll House—Leone's eighteenth-century gem on the corner of Oakley Street and the King's Road—and move to smaller quarters in Westminster, she decided that her swan song should be a carefully orchestrated dinner for the King and the woman she was convinced would become Queen. According to Kenneth Clark, who was one of the guests, the dinner was very nearly a disaster. Artur Rubinstein, who had been pressed against his will to play some Chopin, announced a barcarole. As the piece proceeded, the King looked irritated and continued talking. Finally he said, "That isn't the one we like," meaning that it wasn't the hackneyed intermezzo from Offenbach's *Tales of Hoffman*. Rubinstein then played a Chopin prelude. The King rose to leave. "It was 10:15. Consternation. Sibyl on the verge of tears." The evening was saved only when Noël Coward "put his artistic scruples in his pocket" and played "Mad Dogs and Englishmen." The King returned to the drawing room and stayed to a late hour.

In the last year of World War II, Sibyl sold her business for £15,000 to Nancy Lancaster, who called the firm Colefax and Fowler. Beyond keeping an office there, Sibyl did virtually no decorating. Thanks to Nancy Lancaster's flair for the grand Anglo-American manner and John Fowler's artistry and technical brilliance, the new firm was very successful. And as soon as rationing and postwar shortages permitted, the decorating business gained a new lease on life. London residences that had been blitzed or neglected, country houses that had been requisitioned by the military or some other authority were all in desperate need of decoration. Colefax and Fowler came to the rescue of those who could afford them. And the working rapport—tensions and all—that developed between Nancy Lancaster, with her Virginian panache and transatlantic notions of modern comfort, and John Fowler, with his taste and intuitive understanding of eighteenth-century craftsmanship and color, enabled the fabric of English country houses to regain much of its past splendor.

Although reduced in influence and affluence—her new house was tiny—Sibyl continued to deluge people with virtually illegible invitations of which as many as fifty would be dashed off before breakfast. According to Mark Amory (Berners's biographer), the illegibility of these invitations inspired another of Lord Berners's practical jokes. In the summer of 1940, shortly after Winston Churchill became prime minister, Berners sent Sibyl a note:

Dear Sibyl,

I wonder if by any chance you are free to dine tomorrow night? It is only a tiny party for Winston and GBS [George Bernard Shaw]. I think it important they should get together at this moment. There will be nobody else except for Toscanini and myself. Do please try and forgive this terribly short notice.

Yours ever
Eight o'clock here and—of course—any old clothes.

Beverly Nichols takes up the story:

There was only one thing wrong about this heaven-sent epistle, which was written in longhand; the address and the signature were totally illegible. The address looked faintly like Berkeley Square, but it might equally have been Belgrave Square and the number might have been anything from 11 to 101. As for the signature she could not tell whether it was male or female.

During the war, Sibyl dwindled. As a young man, I would see her at first nights, doubled over like one of Saul Steinberg's anthropomorphic question marks, waiting impatiently for the curtain to come down so that she could badger any halfway celebrated member of the audience into attending her "Ordinaries." These were the dinners at the Dorchester Hotel that a diminishing income and the war had obliged her to put on a paying basis: half a guinea a head. Fashionable people claimed to loathe these functions, but a lot of them went, not least because Sibyl had usually succeeded in browbeating so many distinguished Americans—Walter Lippmann, Averell Harriman, the Lunts—into attending them.

Although Fowler ultimately became the greatest expert on the sumptuous techniques of eighteenth- and early nineteenth-century decoration, his own taste gravitated toward the more modest manifestations of early nineteenth-century vernacular, which he dubbed, somewhat condescendingly, "P.P.F." (Poor People's Furniture). Fowler's work is already vanishing, so it is fortunate that, in collaboration with John Cornforth, he published the fruits of a lifetime's research before he died. *English Decoration in the Eighteenth Century* tells us all we need to know about everything from dressing a state bed to gauffrage and gimp. Sibyl, too, has a monument of sorts: a gallery of caricatures whose cruelty may have been redeemed in her eyes by the celebrity of the writers responsible for them.

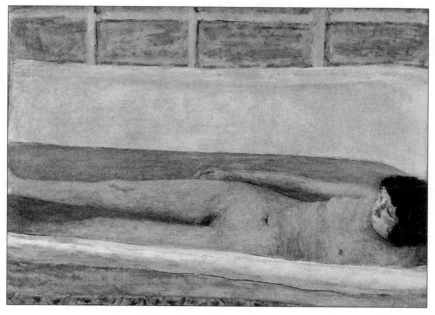

Pierre Bonnard, *The Bath,* oil on canvas, 1925, Tate Gallery, London

Bonnard's Amphibious Wife

The story of Bonnard's amphibious wife, Marthe, who spent much of her life soaking in a bathtub, has never yet been told. This is the more surprising since her fabrications would have such disastrous consequences for the fortunes of the artist's family as well as the fate of his work. The twenty-six-year-old Bonnard met the birdlike Marthe one day in 1893, when he helped her cross the busy Boulevard Haussmann. She made paper flowers for a living and answered to the fictitious-sounding name of Marthe de Meligny. Bonnard soon made her his mistress. This deluded *midinette*—part muse, part Ondine—told him she was sixteen years old, the daughter of uncaring but genteel parents of Italian lineage who had handed her over to an indulgent grandmother to raise.

That this was a pack of novelettish lies would not emerge until Bonnard married Marthe some thirty years later. The birdlike girl's real name was Maria Boursin, she was one of three daughters of a carpenter from the neighborhood of Bourges, and she had been twenty-four, not sixteen, when Bonnard picked her up. These false-hoods would not have surprised him. Paranoid delusions had long

been symptomatic of the terrible health Marthe enjoyed: apparently some form of tubercular dementia. She mistrusted virtually everyone and in later life kept herself and, insofar as she could, her husband shut away from the world in one house or hotel suite after another, where she would spend hours on end in the bath, soaping, sponging, soaking the demons out of her system. Her tub might be said to have constituted both caul and coffin, depending on whether one sees the eerie fluid in which her body was immersed as amniotic or embalming. Compassion for Marthe's inert state combined with a certain twisted relish of it would inspire some of her husband's greatest images. By the time of her death she would have figured some 385 times in his paintings. Marthe's passive presence and consequent availability as a model may have been God's gift to the artist, but it was a very mixed blessing to the man.

Marthe was *jolie-laide* rather than pretty. Large furtive eyes peer out from a snouty face under a bird's nest of brownish hair. However, she had fine long legs and a slim body, the more attractive for not conforming to the hourglass look of the day. Shortly after they met, the artist and his new model photographed each other in the nude—as much for his work as his pleasure. Bonnard's early nudes of Marthe are explicitly pre- or postcoital—notably, the ones of her looking as rumpled as the bed on which she squats with black stockings half on, half off. Same with the magnificent *Siesta* of 1900: Bonnard portrays her lying provocatively with her face buried in a pillow like the famous marble hermaphrodite in the Louvre: a pose her dog mimics amid the underclothes she has dropped on the floor. In the magnificent, self-referential *Man and Woman* of the same year, sex is once again just over: Bonnard has risen from the hurly-burly of the bed to get a towel, leaving Marthe to lie back and attend to the pussycats who have jumped up to take his place. Intimations of Eric Fischl!

A year or two younger than his friend Toulouse-Lautrec and a year or two older than his even greater friend Matisse, Bonnard claimed that he wanted "to take Impressionism further" and get more out of color than Renoir or Monet had done. These aspirations set him apart from the Parisian avant-garde—above all the

Cubists—who were in violent reaction against Impressionism and regarded Bonnard as old hat. And who can altogether blame them? By 1914 the revolutionary rigor and iconoclasm of Cubism must have made Bonnard's gorgeous paintings look as obsolete and froufrou as the can-can. Bonnard was too intelligent not to be aware of this. He complained that modernism had whizzed past him and left him dangling; Picasso, who was fourteen years younger, was one of the reasons this had happened. And he made no bones about condemning Bonnard's sumptuous interiors and paradisial gardens as too *"cuisiné"* (cooked up) and "a potpourri of indecision"—a phrase that the artist's lesser works tend to confirm. Picasso also joked that he had caught his fear of melting in the bath like a piece of soap from Bonnard's paintings of his wife in the tub. There might be a touch of envy to these denunciations.

I used to think along similar lines. Bonnard's color seemed so iridescent, the lighting so incandescent, and the compositions so modishly Japanese that I, too, was tempted to dismiss much of his work as art for art's sake. But the great retrospective at London's Tate Gallery and New York's MOMA in 1998 concentrated on the second half of Bonnard's career, when he used his brilliant sense of color, structure, and design to play all manner of tricks on our visual perceptions and make us see things anew in a subtly skewed and blurred way. Bonnard emerged as a great deal more than the Colette of painting: a distiller of genius. He enables us to savor his intimate little world in essence much as the perfume distilleries behind his Riviera villa enable us to savor in essence the profusion of jasmine and orange blossom, roses and carnations in the neighboring flower farms. Hence the vaporousness at the heart of Bonnard's art—also the mystery. Why, for instance, does he so often relegate a key element—usually an image of his passive-aggressive wife—to the periphery of a composition, where often as not he chameleonizes it into virtual invisibility? It was as if he had to hide Marthe away in his work just as he had to hide her away in his life from his distinguished, ever-so-disapproving family.

Twenty-five years after meeting Marthe, Bonnard, who was in his mid-fifties, tried to escape from the terrible tendrils of his

Ondine. An attractive young blonde called Renée Monchaty, who had been living with an American painter, became his model and, later, his adored and adoring mistress. At some point, possibly during a prolonged trip to Rome in 1921, the two of them decided on marriage—something that Bonnard had never offered the *petite bourgeoise* Marthe for fear of upsetting his *haut bourgeois* family. Trust Marthe to blackmail the artist with her frailty. She put her little wet foot down and insisted the engagement be broken off, whereupon Renée conveniently committed suicide in a Paris hotel. It was Bonnard who found her body—supposedly in a bath. The scar caused by her death would never quite heal. In his last year of life (1947) he reworked a touching 1923 painting of his two loves: Renée in a dazzle of light eclipsing Marthe, who is off in a shadowy corner.

A year after Renée's suicide, Bonnard finally married Marthe—in great secrecy: the news had to be kept from his family. By now he knew Marthe's real name and age, but was still in ignorance of her siblings. As much as marriage, the death of Renée seems to have united the Bonnards once and for all in their folie à deux. Henceforth Marthe would impose her own antisocial, invalidish regime on her husband, who, in the words of a friend, "looked after her, feared her, put up with her, loved her." Their modest homes—a rarely visited Paris studio, a house called Ma Roulotte (My Caravan), near Monet's Giverny, and a pink stuccoed villa at Le Cannet, near Cannes—became places of self-imposed exile from the world. For company there were a maid, a cat or two, and a succession of basset hounds—as a rule, no man except for the artist himself. When she was not soaking in the tub, Marthe did naive still lifes, which she signed Marthe Solange, or worked away at the sewing machine on the dining-room table. She was one of those women who hate to attract attention but nevertheless wear attention-catching clothes.

Since Marthe's health necessitated frequent trips to spas or sanatoriums or secluded villas in the quieter, more salubrious resorts, the Bonnards were often away from home for months on end. Wherever they went, they kept to themselves and never allowed the outside to impinge. Given his preference for tacking his canvas to

the wall, Bonnard did not necessarily need an easel or for that matter a studio. Nor did he need models apart from his wife and, no less important, himself (his self-portraits are among his masterpieces). When the enforced togetherness, which is reflected in so much of his work, became intolerably claustrophobic, the artist would tell Marthe he was taking the dog for a walk and escape to see forbidden friends, including women with whom he supposedly had affairs, but he would always return to his desperately needy wife.

The first paintings of Marthe in the tub date from the year of their marriage, when she was in her mid-fifties and sicker than ever in body and soul. To judge by one of the very few photographs of her to have survived—it dates from around this time—disease had taken a toll. Even her voice had degenerated into a raucous croak. And yet, although the face in the tub paintings is often a mere blur (might these works memorialize the dead Renée as well as the living Marthe?), the slender, girlish body is as fresh as the peaches in the artist's famously appetizing still lifes. Bonnard evidently chose to remember Marthe as she had been in the early days of their relationship. As he wrote in his diary, "A work of art: a stopping of time."

After weeks of appalling trauma, Marthe finally died in January 1942. Bonnard, who had tended her with obsessive solicitude, was distraught. Henceforth he would keep her bedroom locked up. Work was his only catharsis. Marthe makes a ghostly appearance in one or two paintings, including one of the finest and weirdest of his bathtub compositions, but the most haunting works of these last years are the self-portraits in which Bonnard looks flayed or scorched, as if by some atomic flash, and at the same time amazingly ordinary—the consequence, perhaps, of a note he once made in his diary, "paint a man who looks like Mr. So-and-So."

Although the Bonnards' marriage agreement had stipulated a joint estate, Marthe never bothered to make a will leaving her share of their communal property to her husband. It was not until the authorities announced that they would have to lock up his studio and inventory the contents so that a *déclaration de succession* could be drawn up that Bonnard realized his oversight might have dire con-

sequences. To protect his sacrosanct oeuvre, and privacy, he did something that was not only illegal but also foolish. He had a local lawyer draw up a phony will in which Marthe left her half-share to him. This he duly signed (in Marthe's name and his own undisguised writing) and dated nine months after her death. So far as he knew, his wife had been alone in the world, so Bonnard saw no harm in this deception. Alas, he had had the bad luck to employ an exceptionally unscrupulous lawyer, called Blanchardon, who had set things up, criminally, to his own as opposed to the Bonnard family's future advantage. Even more ominous, the lawyer turned out to be in cahoots with a no less unscrupulous local dealer—the up-and-coming Aimé Maeght—who had wormed his way into Bonnard's (also Matisse's) favor by bartering black-market butter and eggs from his wife's parents' dairy business for their work.

Bonnard died in 1947, almost five years to the day after Marthe. He believed that he had left his enormously valuable estate to the offspring of his brother, Charles, who had settled in Algiers, and of his sister, Andrée Terrasse, whose son Charles was the leading expert on Bonnard's work and the apple of his eye. Within days of the artist's death, Maeght went into action. Aided by Blanchardon, he tried with short-lived success to drive a wedge between the eminently respectable Terrasses and their cousins in Algiers. The Algiers heirs had better cooperate with Blanchardon, who had acted as their uncle's lawyer, Maeght said, otherwise their cousins, the Terrasses, might take advantage of them. Meanwhile, the Terrasses had authorized as their representative a well-established modernist dealer named Louis Carré, who was an old and trusted friend of Bonnard's. Carré helped stave off the depredations of Maeght, who lost no time in "sequestering" 300 paintings from the artist's studio. When obliged to return them, he pretended that there were only 150. Maeght was soon unmasked, but he did not lose hope of controlling the Bonnard estate. He and Blanchardon still had Marthe's fake will up their sleeve.

After this was disclosed, both parties were obliged by Napoleonic law to check whether or not Marthe had left any relatives. The genealogist that Blanchardon employed had no difficulty coming up

with four middle-aged nieces, including two spinsters who lived in Paris (one of them was still alive at the age of 101 in 1998), daughters of one of Marthe's sisters and an English-born inventor, Adolphe Bowers. The Bowers sisters had never heard of Bonnard and knew nothing of their aunt's life, but the moment they laid hands on a book about his work, they realized that he must indeed have been married to their aunt, Maria Boursin, and that they were going to be very, very rich.

At first the Bowers sisters agreed to negotiate with Bonnard's heirs, but the more they learned about their rights and the vast amount of money at stake—hundreds of millions of dollars at today's prices—the greedier they grew. Instead of being content with the prospect of inheriting their aunt Marthe's share, they laid claim to the entire estate on the grounds that, under French law, "any spouse who diverts or conceals effects belonging to a joint estate is deprived of his share of the said effects." The Bonnard-Terrasse families were appalled at the prospect of forfeiting their birthright to outsiders, whom Marthe had been at such pains to disown and whose existence she had never divulged—the more so since these outsiders would be beholden to the unspeakable Maeght. Nor was it simply a question of money. To Charles Terrasse in particular, the guardianship of his uncle's treasures was in the nature of a sacred trust, which must not be allowed to fall into unworthy hands.

Litigation lasted sixteen years. The first round went against the Terrasses. They stood to lose everything. However, their silver-tongued lawyer, the celebrated Maître Garçon, won an appeal. The Bowerses fought back, whereupon both sides geared up for a prolonged battle. In the end, the artist's designated heirs were vindicated to the extent that they were awarded 62.5 percent of the works painted before Marthe's death (the remaining 37.5 percent went to the Bowerses) as well as the totality of works painted after her death.

Exactly what happened next is unclear. According to the March 28, 1963, edition of the newspaper *Le Monde,* the partitioning of Bonard's 600 paintings and 4,000 drawings and watercolors took

place over six weeks in the Chase Bank's Paris headquarters. The beneficiaries drew straws for the various lots; whoever got the short straw won. As Michael Conil Lacoste, *Le Monde*'s art critic, recounted, 150 paintings were of top quality, 150 were of lesser importance, 150 were sketches, and 150 were simply unworthy of the artist. A number of croquis and working drawings were destroyed. Some of the unfinished oil sketches are rumored to have been finished at a later date.

Again according to *Le Monde,* the legal costs were so heavy that the beneficiaries were obliged to liquidate a large part of their holdings. Parisian dealers gathered around like so many vultures. Maeght may have triggered this whole Balzacian business, but he profited little from his deviousness, for he had quarreled with the Bowerses. The sisters had recourse to other outlets, not least in New York, where dealers were prepared to pay higher prices than in Europe. In their wisdom the two crafty old sisters approached the Acquavellas in New York and supplied them with some thirty paintings for a beautiful small show in 1964. It was a sellout, and it boosted Bonnard's prices as well as his name. (Almost half the paintings were snapped up by Paul Mellon.)

As for the Terrasses, they disposed of most of their holdings. A substantial part went to Louis Carré's American associate, Charles Zadok, an art speculator as well as a vice president of Gimbel's department store. Surprisingly, the Terrasses would eventually forgive their former foe Maeght. He had become an extremely powerful dealer, and in view of his wartime friendship with Bonnard and the fact that he had organized a show of the artist's work at his foundation in the South of France, the Terrasses let him have some major works.

However, the lion's share of the Terrasses' holdings went to the world's most formidable art dealers, Wildenstein's. As a result, the firm has dominated the Bonnard market ever since. Unfortunately, Wildenstein's suitability as a guardian of Bonnard's flame would come under scrutiny. On June 30, 1967, Alfred Ayrton, a British metal trader and broker by profession, who lived in Paris but operated out of Switzerland and Liechtenstein, brought a lawsuit in

New York against Daniel Wildenstein, the head of the firm, for commissions that he claimed were owed him. According to Ayrton's complaint, Wildenstein had failed to pay him $500,000 on the $5 million sale of Leonardo da Vinci's portrait of Ginevra de' Benci from the Prince of Liechtenstein's collection to Paul Mellon for donation to the National Gallery in Washington.

Ayrton went on to make a second claim against Wildenstein's. He stated that he had performed additional services for the dealers for an agreed value of $75,000, and that in lieu of payment he, or rather his ex-wife, Kyra—who continued to live with Ayrton, as did her new husband, Rolf Gerard—had accepted a Bonnard painting of the Place de la Concorde, which was said to be worth an equivalent amount. Ayrton contended that although this painting had come directly from the artist's estate, it had started life as "a preliminary rough sketch on canvas by Bonnard, over which there had been painted by a person or persons unknown a complete work in the style of Bonnard." Hence Ayrton's claim that a valueless "forgery" had been foisted off on him. Since all the paintings in the artist's studio, finished or unfinished, had been photographed for the record in connection with the litigation over Bonnard's estate, Ayrton's contention was easy enough to verify.

Instead of trying to establish the painting as a finished work by Bonnard, the defendant's lawyers took the line that Ayrton was owed no commission whatsoever on the Leonardo deal (Wildenstein claimed to have done this pro bono) or, for that matter, on various other deals, which were cited: "the Trujillo affair," "the Van Dongen affair," "the Samuel Montagu flotation," "the proposed exhibition at the Villa Hugel." Wildenstein's lawyers insisted that *Place de la Concorde* "was a gift from him personally (to Ayrton) rather than compensation for plaintiff's fruitless endeavors in the art field." In other words, Ayrton should not have been such a fool as to look a gift horse in the mouth, especially one from the owner of what is sometimes said to be the world's greatest racing stable.

The outline of the case is set out in the plaintiff's complaints and the defendant's replies, which are on file in the U.S. District Court, Southern District of New York. Since the case was ultimately set-

tled out of court (supposedly to Ayrton's satisfaction) and the papers not only sealed but the participants and their lawyers subjected to a confidentiality agreement, we may never know whether the contrast between the before-and-after "restoration" photographs of *Place de la Concorde* is as disturbing as that between the before-and-after-surgery shots of Daniel Wildenstein's former daughter-in-law, whose anthropomorphic transformation into the likeness of a jungle cat earned her the name "Bride of Wildenstein." To judge by photographs of this unfortunate woman posing in the "Bonnard room" of the Wildensteins' New York mansion, the family's plastic surgeon was as heavy-handed as the gallery's restorer.

William Odom, early 1920s

The Sad Case of Mr. Taste

Whereas modernist interior design has been chronicled in meticulous detail, the development of high-style decoration has been mostly ignored by historians—dismissed as kitsch or pastiche, which much of it indubitably was. Now, however, perceptions are changing. In the wake of postmodernism and the Art Deco revival, students of the period between World Wars I and II are taking another look at what used to be thought of as too trivial to bother with. They are discovering that white-gloved pioneers like Elsie de Wolfe and Syrie Maugham, Ruby Ross Wood and Eleanor Brown deserve recognition for imposing their smart taste not only on rich clients but also, via magazines and films, on Middle America. These white-gloved ladies and their bevy of mostly male followers did not set out to be trailblazers; their job was to enhance the rooms and lives of people who would have been unable to function in the austere white containers ordained by modernism.

True, a lot of fashionable decoration in the twenties and thirties was trivial or vulgar, but the best of it had a cool elegance that has stood up remarkably well. The lack of fussiness and the emphasis

on architectural grammar was partly due to an arbiter elegantiae—teacher, connoisseur, undercover dealer—William Odom. Odom's prestige stemmed primarily from the courses in interior design that he gave in the early days of the Parsons School in New York as well as at this institution's "finishing school" in Paris, which he set up and directed. Since Odom was also the éminence grise behind McMillen Inc., in those days the largest and most fashionable decorating business in America, his influence spread far beyond the confines of Parsons. Indeed, he can be said to have created the high-style vernacular—a pared-down, up-to-date form of neoclassicism that is still, ninety years after it all began, in demand if not exactly in fashion. You know the look from back numbers of *House & Garden:* Directoire or Regency furniture (painted rather than gilded); mirrored walls hung with decorative paintings or architectural drawings; colorful needlework rugs set off by white carpeting; and Empire chimneypieces garnished with cachepots, obelisks, tole urns—all in all what Osbert Lancaster, the British cartoonist, mocked as "ghastly good taste."

According to *House & Garden* of 1946, "there is hardly a decorator practicing today [who did not] at some time, directly or indirectly, [fall] under the spell of William Odom." Later, this influence would be disseminated by his disciple, and for many years lover, Van Day Truex, who followed Odom as head of Parsons, first in Paris, then in New York, and subsequently directed Tiffany's design department, as well as by his collaborator, Eleanor Brown, who created McMillen Inc. Conspicuously impervious to Odom's spell was New York's top decorator, Billy Baldwin—surprising since this designer's elegant, understated work conformed to the canons of Odom's taste. Despite many shared interests and friends, these two stylish men never became friends. Baldwin, who was far more genial and also more supple in his taste, found Odom "a bit of a stick." Besides, as he said, "I worked exclusively with Ruby Ross Wood and Odom worked exclusively with Eleanor Brown, who was Ruby's greatest rival. However, I had the greatest respect for Odom's sense of style. I was also amazed by his elegance and will never forget him and his valet arriving for a weekend with two Rolls-Royces."

Odom's mask of urbane reclusiveness discouraged intimacy. According to his nephew, Robert Rushmore, he was "reserved, seemingly disdainful; his nostrils flared as though offended by distasteful odors. He was much admired by grand ladies, such as Harriet (Sumner) Welles and Julia Weldon"—for his taste rather than his wit or charm. A native of Columbus, Georgia, William Odom was born in 1886 to an impoverished Southern gentleman—a speculator on the cotton market who had a sideline in trotters—and a charming Italian woman who was kept out of sight because her father had started life as a Genoese cobbler. Odom would have followed his two brothers onto the trotting track, where both made names as jockeys and trainers, had he not suffered an appalling riding accident as a child. Five years of convalescence decided him on a musical career, and, around 1904, he came to New York to study conducting under Stokowski. Told that he lacked the necessary stamina, Odom enrolled at the New York School of Fine and Applied Arts—soon to change its name to the Parsons School in honor of its enterprising director.

From the start Frank Alvah Parsons realized the potential of this fragile but fiercely ambitious young student with his instinct for the finer points of antique furniture, and he groomed Odom to join the faculty, which he did after graduating in 1909. At the same time Odom started work on a project of his own: an ambitious two-volume *History of Italian Furniture* (published 1916; reprinted 1966), which is still one of the most authoritative works on the subject. Europe had always been Odom's goal, and in 1920 he persuaded Parsons to let him move to Paris and set up a branch of the school at 10 Place des Vosges, a handsome seventeenth-century house in the heart of the Marais. Here students who had completed the two-year course in New York could spend their third year studying French and, to a lesser extent, Italian decoration. The huge house also provided Odom with quarters in keeping with his *folie de grandeur.* The salon was lined with fine Louis XVI *boiserie,* the paneled library with shelves of rare architectural books (the collection is now at Yale) interspersed with ubiquitous architectural drawings. Colors were rich but muted; furniture and objects (especially those

made of opaline) were arranged with fanatical respect for symmetry. Everything was discreetly grand. However, due partly to Odom's narcissistic passion for mirrors, the gentlemanliness of it all was a touch ladylike. "The only trouble with his taste," according to a fellow expatriate, "was that it was too studied, too glacially good." Another thing, Odom's taste did not take much account of paintings. He preferred decorative pictures by minor figures to works of any real merit. They would have upstaged the décor.

For all his dandified disdain, Odom was a canny operator who knew how to harness connoisseurship to social contacts and generate enough income to maintain a lavish *train de vie.* Too shy and snobbish to be overtly in trade, he preferred to deal through others, above all the aforementioned McMillen Inc. In her book, *Sixty Years of Interior Design: The World of McMillen,* Eleanor Brown, who headed the firm, confirms that the success of her business depended to a very considerable extent on Odom's precepts and the unending supply of fine furniture and objects—late-eighteenth- and early-nineteenth-century for the most part—that he shipped over from France. For stripping their country of so much decorative art, the French awarded Odom the Légion d'Honneur in 1938.

As he grew older, Odom tended to keep his students, like his less distinguished clients, at one remove from himself. Rather than comment on their work to their faces, he would, whenever possible, pass on his observations through an instructor. This oblique way of teaching did not, apparently, dismay students. On the contrary, distance seems to have lent not so much enchantment as charisma to this chilly man. In prewar Paris, Odom was an exemplar to be reckoned with, not just for his taste in art and music, but for his supposedly comme il faut taste in suits (Huntsman), pets (blue-gray Bedlingtons), and no less pedigreed guests.

Most summers, Odom would rent the *piano nobile* of the magnificent Palazzo Barbaro on the Grand Canal from his friends the Curtises, hosts, earlier in the century, to Henry James and John Singer Sargent, and fill it with guests he regarded as *sortable*—presentable. Some of his better-looking, better-dressed, better-born students, preferably male, would also be invited for a crash course in Venetian

culture and the ways of the world. England originally played a lesser role in Odom's pantheon. He disliked standard British eighteenth-century furniture as too stuffy and boardroomy and did not warm to the Regency revival engendered by his friend Edward Knoblock (author of *Kismet*)—too academic—until it lightened up and became the dernier cri.

Odom visited London ever more frequently and prided himself on close friendships with the Sitwells, Cecil Beaton, and, above all, Sir Robert Abdy, an anti-Semitic baronet who dealt in fine French furniture and vetted his friends for him ("You can have Jews to luncheon in a restaurant, but not to dinner in your house, unless they're Rothschilds.") Far from repudiating this shameful advice, Odom took it to heart. It ensured his popularity with Nancy Astor and her nefarious "Cliveden Set." Surrounded by Fascist appeasers, he felt very much at home. These new connections inspired Odom's ill-fated project—the more surprising in such a committed Francophile—of leaving Paris and retiring to London. Blinded by political prejudice to the imminence of war, he went ahead and in 1939 rented an important pilastered house in Chester Terrace (Regent's Park) and decorated it in the height of Regency taste as a setting for his by now remarkable collection of French and Italian furniture. But no sooner had he moved in than war was declared and he had to close the house down. The furniture was repacked and stored at Sacheverell Sitwell's house, Weston Hall, in Northamptonshire. I stayed at Weston once or twice during the war and remember Georgia Sitwell's covetous attitude to the treasure stashed away in their stables. Did they get something for saving the collection from the direct hit on Chester Terrace? Odom's nephew thought they did rather well out of it. I hope so.

In 1940 Odom returned to New York with the barest necessities: two hundred suits, some good gold boxes, and a new valet. His old one, William Dickman—almost the only person he seems ever to have loved—had recently died, and Odom's brittle heart was broken. Back in New York, he continued to operate behind the scenes for McMillen. He also did some teaching at the Parsons School, where he was still president and his brother-in-law, George Rush-

more, was vice president. The latter's son—a drawing-room bari-
tone, who wrote an excellent book on the singing voice—remem-
bered how his uncle William used to pay surprise visits on Sunday
afternoons, rearrange the furniture, and then drive off in the indis-
pensable Rolls, leaving the family to shove everything back into
place.

Odom failed to acclimatize to his native country. He pined for
Europe, above all for the deceased Dickman, with whose spirit he
communicated via mediums. His health, which had always been
precarious, began to deteriorate. There seemed to be nothing left
for him to live for. After Odom's death at the age of fifty-six in 1942,
a noble con woman, Maria Hugo (born Princess Ruspoli, later
Duchesse de Gramont, later still married to the silversmith
François Hugo, and finally Elizabeth Arden's great love), made a
claim on the estate on the unlikely grounds that Odom had courted
her and promised her a sable coat and some of his treasures. The
claim was disallowed. Meanwhile, the burial had to be postponed
indefinitely because of the dead man's wish to be laid to rest beside
his valet in a London cemetery.

The Odom story did not end until after World War II, when
ships carrying the mortal remains of "Mr. Taste" (as somebody once
dubbed him) and his marooned collection (except for the opaline
vases that he had bequeathed to the Musée des Arts Décoratifs)
crossed each other in mid-Atlantic. In 1946, Odom's sister, Mrs.
Rushmore, arranged for his more desirable possessions to be sold at
McMillen Inc., which redecorated its showrooms to look as Odom-
like as possible. The sale was a great success. The proceeds as well as
the pieces that were unsold went to his sister, whose husband had
abandoned her, once Odom was out of the way, for a secretary at the
Parsons School.

A dead ringer for one of Tennessee Williams's lethally genteel
Southern women, Mrs. Rushmore took her resentment out on her
charming, self-destructive son, Robert. Far from letting him have
any of the Odom cash, she gave 10 percent of it to the Parsons
School and made a large contribution to a college where her son
had been particularly unhappy. Worse, she obliged him to share her

bedroom. This was too much for Robert. One night he drugged his mother's coffee with a view to heaving her out of the window. After two attempts he gave up and instead took to the bottle. Eventually Mrs. Rushmore died and her son inherited what was left of his uncle's fine things. They did not bring him luck. Robert died of drink in the 1980s, after divesting himself of everything except for two large, heavy crystal lamps that had been an Odom trademark. His inheritance had gone on tattoos and gin and opera tickets. Good riddance, Robert said. Uncle William's icy elitism, he claimed, had been an attempt to obliterate the fact that the Odom family had black blood—something in which Robert took rebellious pride.

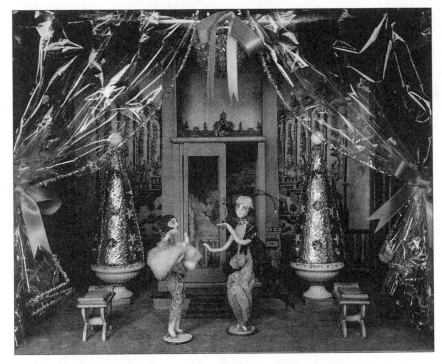

The Stettheimer dollhouse, c. 1923. The dolls representing Baroness
de Meyer and Carrie Stettheimer were made by John Darcy Noble.
Museum of the City of New York.

The Stettheimer Dollhouse

In the twenties and thirties, New York could boast of a high bohemia that was as eccentric and every bit as gifted as Bloomsbury, its British counterpart, but less uptight and intellectually snobbish—hence more fun. The press called it "the streamlined intelligentsia." It included the artists O'Keeffe, Hartley, Demuth, Duchamp, Nadelman, Tchelitchev, Archipenko, and Cornell; the photographers Stieglitz, Steichen, and the Baron de Meyer; such luminaries as Virgil Thomson, Adolph Bolm, Carl Van Vechten, and, on occasion, Gertrude Stein and Alice B. Toklas. At the epicenter of this dizzy, mandarin world was a precious trio, the Stettheimer sisters—Carrie, Florine, and Ettie—members of a rich banking family related to the Warburgs, Seligmans, and Lewisohns. Just how and why the lives of these extraordinary women are enshrined in a dollhouse requires a little family history.

After Joseph Stettheimer abandoned his family (sometime before 1900), never to be seen again, his wife and three youngest daughters closed ranks and formed a matriarchal unit as tightly knit as it could be—short of incest. It left little room for the solitary

brother, Walter, who went off to California, or for the eldest sister, Stella, who was treated as a traitor for daring to marry. Rich relations saw to it that the Stettheimer women did not have to worry about money. Because of the scandal of Papa's defection, the Stettheimers spent most of their time in Europe, sashaying around Italy and Spain, France and Germany, in pursuit of culture—opera and ballet, especially. Diaghilev's Ballets Russes made such an impression on Florine, the artist member of the family, that she would later envision a ballet, *Pocahontas,* set in an infinite desert of pink velvet. Following a grand tour lasting for some ten years, the ladies were finally driven back to New York by the outbreak of World War I. In 1915 they settled on West Seventy-sixth Street, then in 1925 moved to a large apartment in the ornate Alwyn Court building on West Fifty-eighth Street, which became a shrine to their collective femininity. One of their earliest visitors was Marcel Duchamp, who had just arrived, penniless, in New York. The sisters supported him by paying him two dollars an hour for French lessons. "I probably learned more English than my pupils learned French," he later remembered. "I was not a good teacher—too impatient . . . The sisters were inveterate celibates entirely devoted to their mother. They were so funny and so far out of what American life was like then." "Duche," they called him.

Impressionable visitors found the apartment "palatial": masses of gilt and brocade, fringe and lace. Others thought it "ditsy." However, the atmosphere was so giddy and the parties so well done—great crystal bowls of champagne punch filled with strawberries and cucumber—that this trio of vestal virgins became a New York institution. Not that their festive gatherings, usually in honor of some person or occasion, constituted a salon. Virgil Thomson was firm on this point. The Stettheimers, he said, "have no salon. They entertain their friends, most of whom happen to be celebrated."

Since Florine was on the way to being a most original painter (in an amusing eye-catching style compounded of *fausse naïveté,* high camp, and burlesque) and Ettie on the way to being a most unoriginal writer, the onus of running the household and looking after an invalidish mother fell on Carrie's shoulders. Far from being a Cin-

derella, she had closets crammed with dresses from Callot Soeurs; and it was a very elegant *maîtresse de maison* who taught one German cook after another how to make her famous oyster salad and "feather soup," whatever that might have been.

For all her expertise, Carrie resented her domestic chores. As soon as possible, she took a nearby studio, and when not bathing her mother's temples with eau de cologne or firing the kitchen maid, she devoted her energies and imagination to building and furnishing a dollhouse: a surrogate for a ménage of her own. For fifteen years or so this project was an obsession. Carrie was forever sewing minuscule needlepoint rugs, carving chairs out of chalk, giving banal dolls' furniture from toy shops the Elsie de Wolfe treatment, and discreetly coaxing Duchamp and other friendly artists to contribute miniature sculpture and paintings. Once her mother died (1935) and Florine departed permanently to a studio in a Beaux Arts building overlooking Bryant Park, Carrie *never* touched her dollhouse again. She was now mistress of her own ménage—to hell with substitutes.

Florine's way-over-the-top taste influenced her sister's fantasy rooms. Visitors to Florine's studio were dazzled by the glitter and sparkle of everything. Billowing curtains—made of the exotic new material cellophane—trailed on the carpet and framed huge double-decker windows. Other windows were swathed in layers of antique Nottingham lace; gold draperies looped to white-and-gold columns set off a lot of white-and-gold chairs. There were even gilded flowers, while, according to Parker Tyler's biography of Florine, "Across the foot of the little red-carpeted staircase leading to [the boudoir] a wide white satin—or was it cellophane?—ribbon, tied in a gorgeous bow, forbade access to the cocoon of lace upstairs." Given her virginal calling, it comes as no surprise that Florine was at pains *not* to sell her work, for fear that "one of my paintings [might] hang in the bedroom of some man."

Florine's fetish for ostrich feathers, lace, and cellophane—miles and miles of it in assorted colors—inspired her famous sets (her first public success) for *Four Saints in Three Acts* (1934), the delightful and surprisingly successful opera that Virgil Thomson wrote to

Gertrude Stein's libretto. Given her experience with the dollhouse, Carrie may well have helped her sister with the models for this décor—palm trees made out of huge pink tarlatan bows were the focal feature. Ettie, the literary sister, maintained that the dollhouse, which she arranged to be given to the Museum of the City of New York, was a "substitute for the work Carrie was eminently fitted to adopt as a vocation, had circumstances been favorable—stage design."

Although Carrie had planned to create a family of dolls who would reside in the exquisite rooms she had devised, she failed in the end to do so. Since she was thought to have envisaged dolls resembling the epicene figures in Florine's paintings, and there was also to have been a family group by Florine over the ballroom fireplace, John Darcy Noble, curator emeritus of toys at the museum, decided to create a set of suitably Stettheimerish dolls. After months of experimentation, he came up with wire armatures wrapped in crepe paper for the bodies, lightly modeled epoxy clay over large wooden beads for the heads, and all kinds of chiffon, tulle, and other fabrics of the period for the clothes. The occasion for the dolls' display is a Christmas party such as the Stettheimers might have thrown in honor of some of their famous and fashionable friends. It makes for a diverting museum exhibit, but it introduces a mundane cocktail party element that plays against the vestal magic of Carrie's Lilliputian world.

Nevertheless, let us tour the dollhouse, which is two stories high, with sixteen rooms (it is scaled one inch to a foot, and is fifty-six inches long, twenty-nine inches high, and thirty-seven inches deep). On the way we will meet the family and their camp followers. In the foyer Carrie is busy being a hostess—a role she enjoys. She is something of a clotheshorse, and takes special pride in her resemblance to Queen Mary—hence the tiaras and dog collars and *grandes toilettes,* with absurd little trains edged with miniver. Unlike Queen Mary, however, she wears too much mascara and wisps of black lace and, as in the portrait by Florine, a beaded skullcap surmounted by two aerial-like feathers plucked from the tail of a lyrebird.

Baroness Olga de Meyer, whom Carrie is greeting, occupies an equivocal position in society: her illustrious godfather, King Edward VII, was also her actual father. She has other claims to fame and notoriety. She is a fencing champion, a first-class shot, a cocaine addict, and also the inspiration for Henry James's *What Maisie Knew.* Meanwhile, her gay husband, the Baron, has made such a name as a fashion photographer that Condé Nast has given him a record-breaking contract at *Vogue* and his other more elitist magazine, *Vanity Fair.* Alas, the Baron is too busy to make the Stettheimer party; on the side he manages a cabaret called the Persian Garden, and he lectures nouveau riche women on the pitfalls of social climbing. ("One of the most difficult things in life," he tells them, "is to find an intelligent second footman.")

At the back of the foyer, Pavel Tchelitchev, the painter, is about to enter the Dadaist elevator—a machine without a mechanism—which fascinated Marcel Duchamp. As early as 1919, he wrote asking Carrie to tell him about her plans for it, and again in 1921 he anxiously asked Florine if Carrie had "installed the elevator." "The Ibsenite Carrie," he calls her in an ironical allusion to Ibsen's *A Doll's House:* Carrie was very much the opposite of Nora. Next to the foyer is the chinoiserie library, complete with books by the sisters' friends. The decoration is the latest thing: red-and-black lacquer furniture, gold tea-chest wallpaper, saffron-colored wall-to-wall carpeting. Here we find the writer and photographer Carl Van Vechten, as good a friend to the Stettheimers as he was to Gertrude Stein. He is about to play mah-jongg (the tiny tiles were made by Carrie) with Isabel Lachaise, the sculptor's wife.

Upstairs, in the Italian Provincial master bedroom, tiresome Juliette Gleizes (the Cubist painter's wife) is dabbing her nose with a huge marabou puff, while pretty Marguerite Zorach (the sculptor's wife) is waiting her turn at the dressing table. Piles of presents in silver wrappings indicate how seriously the Stettheimers take Christmas, also birthdays and anniversaries of all kinds. Like Florine's paintings, the sisters' social life is a succession of intimate galas.

A room or two away, the nursery reveals Carrie's decorative in-

genuity at its best. The walls are covered in collage: confettilike wallpaper and a cut-paper frieze of Noah and his family on the steps of the ark. They are equipped for forty days and forty nights of rain with umbrellas, sou'westers, raincoats, galoshes, and, in the case of one of Noah's daughters-in-law, a striped bathing dress. The boy in the sailor suit trimming the Christmas tree is no less than Walter Wanger (son of the eldest Stettheimer sister, Stella), who was later to become a celebrated movie producer (*Queen Christina, Stagecoach, Invasion of the Body Snatchers*) and the husband of the beautiful star Joan Bennett. As for the little girl, Walter's sister, Beatrice, she will make a name as an Isadora Duncan–ish dancer. And don't miss a touch that Duchamp would have enjoyed, the children's minuscule toys: dolls' dollhouse furniture.

Each of the bedrooms embodies a different aspect of smart taste of the twenties, but make no mistake, it is mandarin taste—nothing to do with Art Deco, which the Stettheimers would have thought *moderne*—vulgar. The "Rose" bedroom is up-to-date in its references to the Victorian revival, which will soon be the rage, to the horror of the fashionable decorator resting on a chair in this room—Elsie de Wolfe, dressed in feathered mules and a boudoir cap. Her passion for things *dix-huitième* leaves no room for what she calls "tatt." One wonders whether Gertrude Stein and Alice Toklas approve of the "Chintz" bedroom, in which they find themselves. There is not a modern painting in sight, but the charming pattern-on-pattern concept is fifty years ahead of its time. And how wittily Carrie has "done" the bathrooms, in one of which a crisp little maid in a cap with streamers is attending to the dogs.

Downstairs, in the ballroom, the star of the family, Florine, is talking to Henry McBride, the most perceptive American art critic of the period. In 1946 he would write the preface to the catalogue of her posthumous retrospective at the Museum of Modern Art. Behind them are two perfectly scaled sculptures made specially for Carrie's dollhouse: William Zorach's bronze *Mother and Child* and Gaston Lachaise's white alabaster *Standing Nude*—some of the tiniest examples of modern art.

The ballroom is hung floor to ceiling with the rest of the collec-

tion. The masterpiece is the miniature that Duchamp made in 1918 of his *Nude Descending a Staircase*—all the more important for being an ever so slight variant. A birthday present for Carrie, this little treasure was a quid pro quo for the sisters' many kindnesses to him: the garden party that they gave in his honor at their country house in 1917 as well as Florine's painting *La Fête à Duchamp* and the portrait of him that commemorates their friendship. Duchamp reciprocated by doing a very conventional portrait drawing of Florine, which he inscribed to Virgil Thomson, the composer who would commission her to design the décor for his opera ten years later. In addition to the Duchamp, the ballroom contains a tiny Gaston Lachaise of three very fat women, a cubist *Femme Assise* by Gleizes, and a nude by Archipenko. Above the fireplace is a colorful ballet scene by Carl Sprinchorn; scattered around are works by some of these artists' wives. Of the family's close friends, only O'Keeffe and Nadelman failed to contribute. The two principal donors, Duchamp and Lachaise, can be seen talking at one end of the room, while at the other end Virgil Thomson plays the piano for Fania Marinoff, Carl Van Vechten's wife.

The décor of the drawing room hints at the eclectic grand manner of the Stettheimers' apartment in the Alwyn Court. No less stylish is the dining room, where we meet Ettie, the most outgoing of the sisters, who sported a red wig on dull occasions. Described by a friend as coming into a room "like a gypsy with a tambourine," Ettie also writes novels (including a roman à clef, *Love Days,* about Duchamp and Nadelman) under the weird nom de plume Henrie Waste (HENRIEtta WAlter STEttheimer). She is conferring with the butler to make sure that all is well. All, indeed, *is* well, except in the servants' quarters. The upstairs maid has dropped a tray with all the tea things on it, alarming the page, who had been kissing one of the kitchen maids under the mistletoe.

Despite the intruders, Carrie Stettheimer's dollhouse is a touching little monument to a trio of three eccentric flappers who found themselves at the center of an enormously gifted, cultivated, and, yes, elitist coterie of artists, writers, composers, photographers, and *gens du monde* who kept New York in the vanguard of the modern

movement. Duchamp, who owed so much to the Stettheimer sisters, was making more than a pun when he described Carrie as "Ibsenite." She also puts me in mind of Duchamp's friend and admirer Joseph Cornell. Thanks to a fastidious disposition of bits and pieces, relics and fragments, Cornell's boxes perform the miracle of encapsulating memory, and sometimes even love—hence their poignancy. The same with Carrie's touching little shrine to herself. Like many of Cornell's boxes, the dollhouse is a portrait: in this case a self-portrait of a mother-fixated spinster—whimsical, talented, narcissistic—who chose to live in a beautiful, cellophane bubble and spend her days shrinking and prettifying a world whose phallocentric menace she so deeply feared.

MIDCENTURY

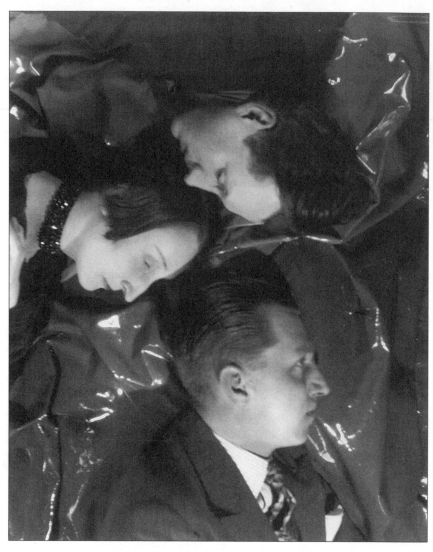

Sacheverell (top), Edith, and Osbert Sitwell,
photographed by Cecil Beaton, 1927

The Sitwells

———

Around the age of fifteen, I developed a crush on the three Sitwells, Osbert, Edith, and Sacheverell. This flamboyant triumvirate had managed to persuade themselves and the more impressionable members of the literary establishment that, besides being ineffably aristocratic, they were the latter-day equivalents of Chateaubriand (Osbert), Pope (Edith), and Shelley (Sacheverell). As a schoolboy, I had been so bowled over by the Sitwells' sophistication and panache that I begged, borrowed, and, on occasion, stole copies of their books until I owned almost their entire oeuvre. I memorized many of Edith's poems, and when a with-it school friend quoted "The Waste Land" at me, I silenced him with Edith's patter-song line from *Façade:* "Thetis wrote a treatise noting wheat is silver like the sea. The lovely cheat is sweet as foam. Erotis notices that she will steal the wheat king's baggage like Babel"—gibberish, but catchy as a nursery rhyme. As adolescent fans do, I cut out the Sitwells' photographs, especially the fanciful ones that Cecil Beaton, their self-appointed image maker, had taken of them, doing their best to look charismatic—Edith in a turban in a four-poster bed, or lying on the floor like a *gisante* on a gothic tomb.

It took three or four years to recover from Sitwellitis. All of a sudden the scales fell from my eyes and the trio, not to mention their work, struck me as meretricious and, in Osbert's case, pompous and mean-spirited—a perception that a meeting with him did nothing to allay. How dare these impostors claim to personify modernism? Gertrude Stein, Edith's former friend, struck me as having far better credentials, although she, too, would eventually have to be booted out of my pantheon. Her incessant blowing of her own trumpet was as irritating as Edith's. Geniuses? An authentic genius would not have to make such a to-do about being one. Of the two, Gertrude had more right to the label than Edith. The American woman's inherent vanguardism and iconoclastic clout were preferable to the English woman's indulgence in the quaint, the mandarin, and the macabre.

Although they saw themselves as noble ornaments of the British caste system, they were in fact victims of it, as John Pearson recounts in his extremely entertaining biography of them, *Façade* (1979), to which I am deeply indebted. Like many people who bang on about their antecedents, the Sitwells were not quite as grand as they would have liked, but that did not deter them from pulling rank. On the strength of his heavy Hanoverian features, Osbert, who used to hint with no justification whatsoever at illegitimate descent from George IV, once wrote of his more remote ancestors: "In the distance can just be discerned Robert Bruce, King of Scotland, Wallace the Patriot, the gleaming golden armour of [the] kings of England and of . . . France." Edith meanwhile would invoke John of Gaunt and fatuously proclaim, "I . . . I am a Plantagenet."

"We all have the remote air of a legend": this line from her autobiographical poem "Colonel Fantock" was nearer the mark than Edith intended, for the Sitwells would not have been Sitwells at all if the founder of the family fortunes had not changed his name from Hurt to Sitwell, when he was after a baronetcy. He had even gone so far as to christen his son Sitwell Sitwell. (Why didn't the oversensitive Osbert revert to the old family name, Evelyn Waugh once suggested, and call himself Hurt Hurt?) As for the family seat, the fabled Renishaw, this grimy "Gothick" pile, on the outskirts of industrial Sheffield, is too close to the ancestral iron mines and coal

pits for comfort or charm, let alone the romantic beauty vaunted by Osbert.

Osbert and Edith squeezed almost as much mileage out of parental hatred as they did out of ancestral pride. In his best-selling, four-volume autobiography, *Left Hand! Right Hand!,* Osbert inflated the character of his father, Sir George, the fourth baronet, whom he nicknamed "Ginger," into a comic monster of inhumanity and all the more of a gentleman for being so. Osbert had less fun at his mother's expense; though every bit as vacuous and heartless as her husband, and far worse tempered, the beautiful Lady Ida was better connected. That she was the daughter of an earl and the grand-daughter of a duke and, in her benighted view, had married beneath her is something her children were never allowed to forget. "A baronet is the lowest thing on God's earth," young Osbert, who would eventually become one, learned at his mother's knee. Not that Lady Ida was in a position to cast aspersions. As aristocrats go, her parents, the Londesboroughs, were parvenus. And then, in 1915, Lady Ida, who had no sense of money, was to bring shame on the Sitwells—above all on Osbert, a young Guards officer at the time, by going to jail for swindling, or rather, being duped by a swindler. The fact that the cold-blooded Sir George could easily have saved his wife from this fate was a further reason for Osbert and Edith's hatred of him.

How could the Sitwells regild the family escutcheon? While Lady Ida gave herself up to drink and cards and running up debts, Sir George planned baroque gardens on a grandiose scale, or re-searched the history of the fork, or delved into assize rolls and local charters for a work of dubious scholarship on the medieval origins of his family. And then, in 1909, he indulged his *folie de grandeur* to the full by buying the enormous dilapidated castle Montegufoni ("Hill of the Screech-owls"), between Florence and Volterra, and spending the rest of his life on its restoration. "I shall be known as the Italian Sir George," he once told Osbert. Like father, like son. The next generation was even more obsessed with posterity. Osbert and Edith outstripped Sir George in their determination to glorify the Sitwell name.

At the outset of his career, Osbert did not see himself as a writer

so much as a noble patron of the arts, but Sir George was damned if he was going to underwrite his son's career as a Derbyshire Diaghilev. Osbert next tried to transform himself into a Cocteau-like Pied Piper who would conjure out of very thin air an English avant-garde, headed, of course, by him. Osbert's genius for self-promotion generated a lot of attention, not much of it artistic or literary. In the end he was obliged to reinvent himself as an Olympian chronicler of his life and times in the manner of Chateaubriand—later still, as a royal hanger-on who reveled in being the Queen Mother's pet author. Although he had the perception to be an early admirer of Picasso, Stravinsky, and Eliot, Osbert was loyal not to the present, which he increasingly loathed, but to an idealized past, and although he always mocked Sir George for his genealogical obsessions, his autobiography reveals that he could not help inheriting these obsessions any more than he could avoid the gout.

From a very early age, Edith, the most gifted of the trio, aspired to be a genius, and she would announce this to any unsuspecting person foolish enough to ask "little E." what she wanted to be. The very idea of such a thing appalled her ghastly parents, who never forgave their eldest child for being a girl—worse, a very plain one. They obliged their peculiar-looking offspring—who grew to be six feet tall, deathly pale, lank-haired, with an anteater's nose—to wear a heavy veil "like some leper daughter, just in case some villager should see how hideous she was." Or was this another of Edith's tall stories? Her assertions that Sir George shuddered when he looked at her, or that Lady Ida sent her out to pawn parental false teeth when the brandy needed replenishing, are hard to credit.

Childhood rejection hardened Edith's resolve to escape from home. Every obstacle, including the stoppage of her tiny allowance, was put in her way. But in 1913, at the age of twenty-six, she sold a diamond pendant and, accompanied by her governess and lifelong mentor Helen Rootham, left Renishaw for London. There, on a hundred pounds a year—"enough for soup and beans and buns"—she took a crummy little flat in Bayswater and by dint of fanatical self-discipline set out to fulfill her dream of becoming a poet genius. Already Rimbaud had replaced Swinburne as a formative

influence, but she soon found her own voice. And by 1914 she was writing poems that have the inimitable Edith Sitwellian ring— toy-town imagery, lots of arcane words, and emphatic rat-a-tat-tat or lullaby rhythms:

> *Houses red as cat's meat, steam*
> *Beautiful as in a dream*

Sacheverell, the youngest of the three, had a less miserable childhood: he actually liked his father and mother. Nevertheless, while still at Eton, Sacheverell decided not to follow in their patrician footsteps but rather to commit himself, like his sister, "to the poet's calling." And he proved to have the same elitist aspirations as his siblings. Sacheverell's first book of poems, *The People's Palace,* published when he was twenty-one, prompted Aldous Huxley, who should have known better, to hail Sacheverell, who was nothing of the sort, as "*le Rimbaud de nos jours.*" After the failure of his ambitious book of verse *Canons of Giant Art,* in 1933, he increasingly took to prose, and it is primarily as a prose writer that he is remembered. At his best Sacheverell's enthusiasm for the bizarre and the beautiful is contagious; at his worst he churns out gushy travelese. (I once ghosted an article for him and was surprised at how easy it was to mimic his style, even more surprised that Sacheverell made no changes in the text.)

———

With animosity and scandal poisoning the air at Renishaw, mendacity became a Sitwellian way of life. Osbert's and Edith's accounts of their lives are both equally suspect. Fortunately for posterity, their antics inspired a number of romans à clef. Wyndham Lewis, the mischievous near genius who invented Vorticism and painted a masterly portrait of Edith, hit home with his grotesque Finnian Shaw family in *The Apes of God.* (Osbert never forgave the portrait of himself as "the vacillating and easily discomfited" Lord Osmund, "dedicated to . . . Free Verse-cum-Soda-water.") But who, until John Pearson published his well-documented biography, had real-

ized that Osbert was the origin of D. H. Lawrence's cuckolded, cas-
trated baronet, Sir Clifford Chatterley, in the third and final version
of *Lady Chatterley's Lover*? The merciless accuracy of Lawrence's
portrait of Sir Clifford/Osbert, based on no more than a two-hour
meeting, is partly explained by the fact that Lawrence grew up at
Eastwood, a few miles from Renishaw. Clifford, Lawrence wrote,

> had taken to writing stories; curious, very personal, stories about
> people he had known. Clever, rather spiteful, and yet, in some
> mysterious way, meaningless. The observation was extraordinary
> and peculiar. But there was no touch, no actual contact. It was as
> if the whole thing took place in a vacuum . . .
>
> Clifford was almost morbidly sensitive about these stories. He
> wanted everyone to think them good, of the best, ne plus ultra.
> They appeared in the most modern magazines, and were praised
> and blamed as usual. But to Clifford the blame was torture, like
> knives goading him. It was as if the whole of his being were in his
> stories.

"Clever . . . spiteful . . . meaningless," these stories are all that
Lawrence said, for Osbert—originally known as a satirical poet and
pamphleteer—took up fiction out of desire for literary revenge. His
erstwhile friend Aldous Huxley had had the impudence to portray
him as Lord Badgery ("Behind the heavy waxen mask of his face,
ambushed behind the Hanoverian nose, the little lustreless pig's
eyes, the pale thick lips, there lurked a small devil of happy malice")
in "The Tillotson Banquet." Osbert retaliated by casting Huxley as
"Erasmus" in his first story, "The Machine Breaks Down." Osbert's
second story, "Friendship's Due," pilloried Louis McQuilland, who
had denounced what he called the Sitwells' "Asylum School of
Poetry," while his third, "Triple Fugue," was a pompous put-down
of Edward Marsh, onetime editor of *Georgian Poetry*. Unlike the
others, Marsh had never done the Sitwells any harm; he was simply
a sitting target. No question about it, the Sitwells were bullies, all
three six feet tall or over and, except for Sacheverell, ever ready to
attack. Osbert once confessed that he never got used to not being
saluted.

To believe Osbert, he was never the attacker, always the attacked. As he once explained with a grandiose contempt for syntax, "My heredity, coming as I do on all sides of stock that for centuries have had their own way, and have not been inured to suffer insolence passively, made it hard for me, and for my brother and sister, not to fight back." Fight back? The Sitwells were always the first to shoot their quills—sometimes out of paranoia, often out of malice, but always to keep themselves in the public eye. According to Osbert's closest friend, the composer William Walton, Osbert "was willing to do absolutely anything for publicity."

Osbert and Edith's first battle was with the "Squirearchy," a group of tweedy Georgian poets who rallied around J. C. Squire and his literary review, *The London Mercury.* Much din ensued as they proceeded to take on one literary coterie after another, dubbing them "The Pipsqueak Poets" or "The Jaeger School of Poetry" (a reference to the woolen underwear that these wholesome poets supposedly favored). They also took on the press for its failure to subscribe to the Sitwells' cult of the Sitwells as a cut above the rest of the world in genius as well as birth. To the press the trio were merely good comic "copy." Anything less than total allegiance was regarded as impertinence (pronounced "im*part*inence") and punished with the kind of *de haut en bas* outrage that Margaret Dumont used on Groucho Marx. In addition, the Sitwells were forever taking offense at imaginary slights and detecting envy and malice in others when *they* were the culprits. The unfortunate C. K. Scott Moncrieff, for example. Asked why he refused to shake his hand, Osbert replied, "Because I have for a long time disliked you, and because you have been impertinent"; not that this stopped Osbert (an execrable linguist) from subsequently using Scott Moncrieff's translation of Proust as a source of stylistic inspiration for his autobiography.

Osbert's history of sexual frustration, literary disappointment, and family dysfunctionalism explains his persecution mania and paranoia, but does not justify his pride in it. At an earlier period of his life, he had kept a supply of cheap, smashable crockery by him on which to vent his pique. As Osbert grew older, however, people replaced plates as the targets of his tantrums, and he would bully

and bait rival writers with a vindictiveness that he was the first to condemn in his schoolfellows or brother officers.

"Do not spare [your opponent's] feelings," he wrote in his "Rules for Being Rude"; "in this way the wound you have given him will fester and scar him for life." Osbert also had a penchant for sending people anonymous letters and playing spiteful, snobbish jokes on friend and foe alike. A typical "joke" was to mail a socially insecure young writer a fake invitation to stay in a ducal house. And yet, when he wanted to charm or impress, Osbert could also be avuncularly genial, particularly after he finally faced up to his sexual orientation and settled down, in 1930, with a male lover.

Edith never slackened in her hatreds, above all when she was worsted, as she was in her feud with F. R. Leavis, most formidable of literary gurus, which lasted from the mid-1930s until her death. In his *New Bearings in English Poetry,* Leavis accused the Sitwells of belonging "to the history of publicity rather than poetry." Given the justice of this accusation, it was most unwise of Edith to crib sections of her *Aspects of Modern Poetry* from the offending book. As David Garnett commented, "Disliking Dr. Leavis does not seem to us a good reason for borrowing extensively from his work without acknowledgment."

Central to any history of the Sitwells is the first public performance (June 1923) of *Façade,* a recital of some twenty of Edith's campy poems to a deft orchestral accompaniment by the Sitwells' discovery, William Walton. The show was a combined operation: the program proclaimed that "Osbert Sitwell presents Miss Edith Sitwell." Sacheverell was involved to the extent of concealing Edith and the orchestra behind a painted curtain, and equipping her with a Sengerphone: a large papier-mâché megaphone that had been invented by a Swiss bass called Senger, to enable him to sing the role of Wagner's cave-bound dragon, Fafner, with greater resonance.

Most of the heroic legends that Osbert subsequently spun about this entertainment—"the scandal of the century," he had the nerve to call it—were downright lies. Far from constituting a major confrontation between the old guard and the avant-garde, like Stravinsky's *Sacre du Printemps,* the 1923 production of *Façade* was so

amateurish that it scarcely made a ripple. London's Aeolian Hall was far from full; not a boo or catcall was heard; and as for the "old women with umbrellas raised to smite [Edith]," these were delusions. Osbert had simply pinched an arrow from Jean Cocteau's quiver. Cocteau had tried to establish *Parade,* the ballet that he, Picasso, Satie, and Massine had created six years earlier, as a defining event in the history of modernism by maintaining quite untruthfully that its first performance had created a riot. Osbert would have been aware of this. Old women brandishing umbrellas were the same phantoms who had attended the first night of *Parade.*

The public would have soon forgotten the *Façade* show if Noël Coward, who was far smarter and sharper than Osbert, had not taken Osbert up on a condescending invitation: "I hear you're doing a review. What fun! Why don't you come and see *Façade*? It might give you some ideas." It did. Coward entitled the hit number of his new revue, *London Calling!,* "The Swiss Family Whittlebot," in which a poetess, Hernia Whittlebot (played by the pop-eyed Maisie Gay), accompanied by her brothers Gob and Sago, recited some doggerel that was, in a favorite twenties' phrase, "madly bogus." Although the skit was a measure of the Sitwells' celebrity, Osbert behaved as if it were lèse-majesté of the direst kind. While Edith took refuge in a nervous collapse, Osbert was foolish enough to fire off a snobbish, Colonel Blimp–ish letter to Coward: "Insulting my sister is a fine beginning for you . . . Have you tried cheating at cards?" He also wrote a poem, which he was wise not to publish:

> *In one smug person, Coward sums*
> *Up both the suburbs and the slums;*
> *Before both, nightly boasts his race*
> *By spitting in a lady's face.*

Façade's next performance (April 1926) was better rehearsed and, according to the eminent music critic Ernest Newman, "the jolliest entertainment of the season," but its success was short-lived. *Façade* did not really catch on for another ten years, until Frederick Ashton's delightful ballet based on William Walton's score, which was

geared to the recital of Edith's poems, became a staple of the Sadler's Wells (now the Royal Ballet) repertory. Originally Edith had done her best to discourage the project. But when she discovered that the entertaining choreography and amusing record of *Façade* (issued at about the same time) were bringing her and by osmosis the other Sitwells' work into favor with the younger generation, she changed her tune and took full credit for Ashton's idea. Indeed, *Façade* relaunched the Sitwell circus, which, though somewhat dormant in the thirties—the clowns were off, working up new acts—came into its own in the forties and fifties, not least in a succession of barnstorming public appearances by Edith and Osbert in the United States, which helped bring poetry readings back into favor and made Edith something of a star.

The anticlimax of the original production of *Façade* had put paid to the Sitwells' hopes of establishing themselves at the head of an English avant-garde, with Osbert as a cross between Cocteau, André Breton, and Gertrude Stein. True, the trio's promotional stunts appealed to British journalists hard up for a story, but compared to the high-diving Dadaists and Surrealists, the Sitwells were splashing around in the shallow end of a very small pool. Osbert's ideas were too mandarin, too tainted with Ballets Russes aestheticism to shock or be taken seriously by anyone but his foes, "the Philistines." Sitwellism was furthermore doomed to failure by the cultural apathy of the British and the lack of suitable troops. Highbrow writers as well as readers had mostly rallied to Bloomsbury—alien, if not actually enemy, territory to the Sitwells. (When asked by the doyen of Peking's Imperial College of Eunuchs whether an equivalent institution existed in England, Osbert had replied, "Yes, . . . we call it Bloomsbury.") Camp followers like Harold Acton, Cecil Beaton, Tom Driberg, and Brian Howard constituted a Sitwellian fan club, certainly not a modern movement.

Thanks in large part to Ashton's choreography and Walton's music, *Façade* represented a high-tide mark for the Sitwells. From now on, rather than flirt halfheartedly with the vanguard, they would bring up the rear. Sacheverell, whose pathfinding study *Southern Baroque Art* had a considerable succès d'estime, led the re-

treat back from modernism. Osbert followed suit in something of a pet. Instead of backing the artists of the School of Paris as they had up to now, the Sitwells launched what amounted to a postmodernist cult of the baroque. Sacheverell—the only one of the trio with an original eye, albeit a backward-looking one—had already adopted the little-known mannerist painter Magnasco, as "almost a personal possession," and had founded an exhibiting society around him. And it is a measure of Sacheverell's eloquence that he soon managed to make the baroque—the very antithesis of the modernism the Sitwells had hitherto espoused—into a fashionable new fad, which would burgeon into a serious reappraisal. Sacheverell's successors in the baroque field would decry his cavalier attitude to facts, but we should not let this blind us to his importance as a pioneer. Half the charm of his books about the more picturesque manifestations of art and architecture, music, and ballet lies in their freedom from history's dust.

In falling back, the Sitwells also fell asunder. Although the trio continued to be thought of as a tightly knit, mutual admiration society that only death would dissolve, they were nothing of the sort. Deep disapproval combined with jealousy of one another's lovers—often masquerading as affectionate concern—made for constant trouble. Not surprisingly, Sacheverell, who sometimes seemed embarrassed by the eye-catching antics of his brother and sister, was the first to defect. This occurred in the spring of 1924, when he fell in love with the Canadian beauty Georgia Doble. Far from being "very, very highbrow," as she later claimed, Georgia was a go-getting good-time girl, more suited to Osbert's "fun brigade" (his name for his parents' philistine friends) than marriage to an impecunious younger son, who was all the poorer for being a poet. Years later, the "very, very highbrow" Georgia boasted to me of her war work in World War I: mailing white feathers, once a week, to Montreal's illustrious art collectors the Hosmer brothers. Disapproval of her Canadian provenance united the entire family, except Sacheverell, for the first and last time but strengthened the lovers in their resolve. A year later, they were quietly married in Paris. Both of them would soon go their separate ways (Sacheverell had a penchant for

ballerinas), but their mutual permissiveness made for a surprisingly happy marriage. Although Georgia ultimately became in some respects more Sitwellian than the Sitwells, Osbert and Edith would never really forgive her for taking Sacheverell, by far the gentlest and least assertive of the family, away from them and obliging him to lead what one of Osbert's boyfriends described, a touch enviously, as a *"pêche Melba* life."

One of the side effects of Sacheverell's marriage was his brother's cautious, crablike emergence from the closet. Hitherto Osbert's homosexuality had consisted of brief encounters, which the long shadow of the Oscar Wilde case obliged to be furtive. But in the course of 1925 Osbert surprised his friends by going off to Amalfi with a handsome young art historian called Adrian Stokes. The formidably brilliant, happily married Stokes of later years, whose insights into the nature of great art (*The Stones of Rimini*) make Sitwellian perceptions look all too shallow, is hard to envisage in the role of Osbert's ephebe. This relationship, which did not last long, helps to explain Stokes's subsequent breakdown and salvation at the hands of Melanie Klein.

The next affair was more lasting. David Horner, whom Osbert had first met in 1921, was "suitable"—a cousin by marriage of the Asquiths and other prominent liberal families—and good-looking in a prissy way. For some years unresponsive to Osbert's overtures, Horner finally went to live with his besotted admirer in 1930. The arrangement lasted for over thirty years, but—trust Osbert!—there is no mention of the love of his life in his autobiography. "I leave the skeletons in their cupboards," he announced in his preamble to *Left Hand! Right Hand!,* and foisted the reader off with talk of a very unconvincing girlfriend. The Sitwells' biographer, Pearson, makes up for this omission by publishing extracts from Osbert's love letters and poems to Horner, which are nauseatingly coy ("May every wish you have come true / in 1935 / May Pussy's eyes become more blue, / His tail still more alive"), and by chronicling the end of the affair in grisly Gothic detail.

Trouble broke out in 1950, when Osbert was stricken with Parkinson's disease. Horner had never been very faithful, but he

now went off to set up house in the United States with a young painter. Always quick to identify with Osbert in rejection, even when it was a consequence of what she referred to as "piggy things," Edith became so incensed with Horner that she converted to Catholicism—the only thing that would stop her murdering him, she said. But not even the church could appease the violence of Edith's feelings when, to her horror and Osbert's delight, Horner returned to England. Henceforth there would be grim summers *à trois* at Renishaw, grimmer winters at Montegufoni. Everyone drank, especially Edith, who took to describing herself as a "worn-out electric hare." From time to time there would be a crash as one of them measured his or her length on the overwaxed floors. Horner grew ill and crochety, and in 1962 suffered an almost fatal fall—he claimed he was pushed—down a back staircase at Montegufoni. Brain damage aggravated Horner's misery, which in turn fueled Osbert's guilt. Forty-four years after they first met, Osbert threw Horner out. "You unspeakable swine," the wife of Osbert's lawyer Philip Frere exploded, "only the most unutterable cad will hit a man who is broken in mind and body . . . May God's curse be upon you."

Meanwhile, Osbert found a new companion—a middle-aged Maltese nurse called Frank Magro—with whom he retired to Montegufoni and there spent the few years left to him rattling his will at his relations. Just as Sir George had had the last laugh on Osbert, disinheriting him on the fatuous grounds that he had joined the Labour Party ("a fearful lie," Osbert fumed), now it was the next generation's turn to have some posthumous fun. Neatly contriving to dissatisfy every member of his family, Osbert left Montegufoni— the apple of Sacheverell's eye, as well he knew—to Sacheverell's son Reresby, and the considerable fortune upon which the upkeep of the castle depended to Sacheverell, who, in true Sitwellian tradition, was on bad terms with his son and daughter-in-law.

Only the Maltese, Magro, got his wish: the rococo wing of Montegufoni for his lifetime, which naturally complicated any future sale of this white elephant. Sacheverell felt so betrayed that he was unable to work for eighteen months, but then he turned his feelings of

loss and rejection to excellent account by writing the only book that gives us any glimpse of his private emotions. *For Want of the Golden City* is the most moving of Sacheverell's works—far more moving than anything of Osbert's. The unattainable Montegufoni "becomes a symbol for the golden city of earthly happiness which he had been seeking from his earliest childhood" (Pearson).

Edith's love life was much more repressed and tormented than Osbert's. Although wrongly accused of lesbian tendencies ("I write in the rhythms of Sappho, though I do not share the lady's unfortunate disposition"), Edith shared Osbert's penchant for good-looking young men. If they were homosexual, so much the better: she had no intention of relinquishing her virgin status. The love of her life was the Russian émigré artist Pavel Tchelitchev, whose twisted egotism and paranoid aggressiveness were a match for her own. They were also well matched in other ways. Both had convinced themselves and each other that they were supreme geniuses in their respective spheres and that they shared an intensely tragic view of the world. Unfortunately, they expressed this with such relentless artifice that critics have failed to take either of them at their own valuation. And yet, despite their similarities, poet and painter made each other unutterably miserable. Indeed, Edith's partial eclipse as a poet in the thirties was a reaction to her "beloved Boyar's" alternately neglecting, exploiting, torturing, and only very occasionally worshiping his "Sitvouka," his "Dame Blanche."

To be near Tchelitchev, Edith left an ugly little flat in London for an even uglier little apartment in Paris. And there she remained until World War II broke out, with only her dying ex-governess, Helen Rootham, and Rootham's odious sister for company. In the face of misery, poverty, and the Boyar's callousness, Edith behaved nobly, but she could not resist stirring up trouble by playing off Tchelitchev's successive boyfriends, Allen Tanner and Charles Henri Ford, one against the other. Let us hope that her love- and hate-filled correspondence with Tchelitchev—Edith could be a hilarious letter writer when she came off her high horse—which was supposedly sealed until the year 2000, will now be published.

Edith gave other women writers, even those she personally liked,

short shrift. "Women's poetry," she wrote, "with the exception of Sappho and . . . *Goblin Market* and a few deep but fearfully incompetent poems of Emily Dickinson, is *simply awful* . . . floppy, whining, arch, trivial, self-pitying . . . ghastly wallowing." The only female writer she feared was Gertrude Stein, who took Edith up when she first came to Paris but dropped her quicker than you can say "genius" for having the temerity to trespass on Stein's avant-garde turf. Her relationship with another dear old friend, Virginia Woolf, was even more ambivalent: Edith liked her but dismissed her as "a beautiful little knitter." When she told Virginia that Vita Sackville-West's tedious eclogue, "The Land," was "conceivably of use to farmers as a help to counting ticks on sheep," Virginia, who was Vita's lover at the time, disloyally replied, "Edith, must one always tell the truth?" At other times Edith could sound frighteningly like her Edwardian mother, as when she accused the worthy Kathleen Raine of "writing lady's maid poetry—underbred, undervitalized, undertechniqued, messy and *déplaisant.*"

Edith's feelings for male writers were also totally subjective. They were either fan or foe, but her loves and hates were liable to abrupt changes. Auden, for instance: for years Edith had inveighed against him as "the leader of those left-wing boy-scouts, who had stolen all her thunder in the thirties," and she would delightedly quote Tchelitchev's appraisal of Auden's verse ("counting mackintoshes in large warehouse") and appearance ("large disaster, badly carved Roquefort cheese"). And yet after the war she became Auden's passionate supporter. Likewise her relationship with Louis MacNeice or Roy Campbell, the pugilistic South African poet. From dismissing Campbell as "a typhoon in a beer bottle," Edith hailed him as "one of the very great poets of our time," for no better reason than that he had supposedly slapped one of her enemies in the BBC canteen.

And then the myths that Edith spun about Dylan Thomas: "how she had discovered, helped and championed his lonely genius"! With her, "he was like a son to his mother," she later claimed. Sheer hyperbole. Far from discovering Thomas—her arch-enemy, Geoffrey Grigson, had been responsible for that—Edith did not at first

react favorably to his work; and although she soon became his most fervent fan, Thomas found her patronage stifling. There was a period of eight years when they did not speak. With the exception of Dylan Thomas and the doomed, gay author Denton Welch, whom she had indeed discovered, Edith had little time for young British writers. She sentenced John Wain "to be skinned alive. It would be a nasty messy job, but I am not sure I shan't do it." Likewise, that excellent poet Thom Gunn: "I am going to make of him the mincemeat (or thick soup) that I made of Mr. Alvarez."

T. S. Eliot, on the other hand, was a hero to the Sitwells; he could also be a thorn in their side, to judge by droll accounts of their relationship, which were found only after Osbert's death. These cast unexpected light on Eliot's peculiar private life. The story starts toward the end of World War I, when Osbert and Edith first befriended the young American poet—then employed in a London bank—and his deranged wife, Vivienne. The Sitwells were in the habit of treating the Eliots to muffins in a "dank Oxford Street teashop." But try as they might—they upgraded the teas to weekly dinners in a Piccadilly restaurant—the Sitwells never succeeded in persuading Eliot to contribute to the magazines and anthologies that they edited.

Thanks to Vivienne's mad mischief-making, a certain coldness developed between the Eliots and the Sitwells. So it was with some glee that Osbert recorded how Vivienne's eccentricity was rubbing off on her husband, how he had suddenly insisted on being addressed as "the Captain." Here is Osbert's description of a dinner given by Eliot in 1922, in a small flat he had taken so as to be able to get away from his wife:

> Noticing how tired my host looked, I regarded him more closely, and was amazed to notice on his cheeks a dusting of green powder—pale but distinctly green, the color of a forced lily-of-the-valley. I was all the more amazed at this discovery, because any deliberate dramatization of his appearance was so plainly out of keeping with his character, and with his desire never to call attention to himself . . . I should probably have come myself to disbe-

lieve in what I had seen, had I not gone to tea with Virginia Woolf a few days later. She asked me . . . whether I had observed the green powder on [Eliot's] face—so there was corroboration! . . . Neither of us could find any way of explaining this extraordinary and fantastical pretense; except on the one basis that the great poet wished to stress his look of strain and that this must express a craving for sympathy in his unhappiness.

Still odder was another dinner, this time in 1927, given by the Eliots to celebrate Vivienne's emergence from a mental home. It was attended by the publisher Geoffrey Faber and his wife, the James Joyces, and Osbert:

Our hostess was in high spirits, but not in a good mood . . . [Eliot] was being very *difficult,* she averred; only one human being seemed now to interest him, an ex-policeman of about seventy years of age, who acted as odd-job man and was an habitual drunkard . . . After dinner . . . while Joyce was talking to us of Italian opera, which he so greatly loved, and was even singing passages to us of his favorite works, a door in the further wall of the passage suddenly swung back, and out stepped the figure of an elderly man in a dark suit with white hair and moustache, blinking as if he had suddenly emerged from darkness into a strong light, and—rather singularly inside a house—crowned with a bowler hat . . .

I had at once identified this rather tortoise-like individual as the ex-policeman of whom Vivienne had spoken. Silence now fell on the company. The newcomer stopped in the doorway opposite us for a moment, and made to each of the three of us— Joyce, Faber and me—a sweeping bow with his hat, saying as he did so, "Goo' night, Mr. Eliot!" "Goo' night, Mr. Eliot!" "Goo' night, Mr. Eliot!" and then . . . went on his way humming to himself.

A letter (January 1957) from Edith to John Lehmann describing her reactions to the news that Eliot had walked out on his crippled

roommate, John Hayward, in order to marry his secretary provides an epilogue:

> Oh, what a *beast* Tom is!!! . . . You wait! I'll take it out of that young woman! I'll frighten her out of her wits before I've done. As for Tom—he will, of course, be punished. He will *never* write anything worthwhile again. And indeed hasn't for a very long time now. *The Four Quartets* are, to my mind, infinitely inferior to his earlier work, completely bloodless and spiritless. It makes me quite sick to think of the pain John [Hayward] has endured . . . to be told that his greatest friend, on whom he depended in his unspeakable physical helplessness and humiliation, had done him this sly, crawling, lethal cruelty. I feel I never want to see Tom again!

Edith evidently equated Eliot's "betrayal" of Hayward with Horner's "betrayal" of Osbert.

———

If the Sitwells now suffer from a measure of the oblivion that they were forever wishing on others, they have only themselves to blame. All that self-adulation did them in. Now that they are no longer around to blow their own and one another's Sengerphones, it is self-evident that Osbert had no merit as a poet and little distinction as a novelist. His 600,000-word-long autobiography—intended, so Osbert said, to be "gothic, complicated in surface and crowned with turrets and pinnacles"—which was so adulated when it came out at the end of the war, is seldom read. Apart from the caricatural portraits of his father and his father's servant Henry Moat—memorable comic creations—it is intolerably puffed up and pretentious: gout-stool stuff.

There is also a lot of wind at the heart of Edith's work, but she is more entertaining than Osbert. Compared to his tin ear, hers was *vermeil;* and it sometimes helps to redeem Edith's prose works, which were mostly written as potboilers or for reasons of catharsis. Her feeble life of Pope, for instance, falsifies the facts in order to

turn the damaged poet into an extension of her own damaged self. Likewise her bizarre novel, *I Live Under a Black Sun,* purports to recount the love life of Jonathan Swift against a background of World War I, but is in fact all about Edith's relationship with Tchelitchev. The same with her fustian study of Queen Elizabeth I and Mary Stuart, *The Queens and the Hive.* It is yet another adulation of herself.

Edith's verse is another matter. The colossal claims that the poetess and her reverential coterie advanced for it have not helped its reputation. But give Edith her due, the early experimental poems, especially *Bucolic Comedies* and *Façade,* are still fun to read—even more so to hear in her *Façade* recording—for their rhythmic dexterity and dotty Edward Lear–ish wit. What a good rapper she would have made! Edith's macabre "masterpiece," *Gold Coast Customs* (1929), might justify Yeats's high praise of it, if only it did not strain so. The same with her famous war poems, which people found so moving ("craggy, mysterious, philosophic," according to Kenneth Clark) in the thick of the London Blitz. Sixty years later, they creak.

> *There was great lightning*
> *In flashes coming to us over the*
> *Floor:*
> *The Whiteness of the Bread*
> *The Whiteness of the Dead*
> *The Whiteness of the Claw—*
> *All this coming to us in flashes*
> *Through the open door.*

The effect of these poems depended largely on the formidable sibyl-like presence of Edith in recital. Thanks to drama lessons she had taken from a retired Comédie-Française actress, she knew how to conjure her public into accepting as jewels of the first water not just the huge semiprecious baubles that adorned her Byzantine bosom and Gothic hands, but also the semiprecious verses that she declaimed with such overweening authority. Edith never let her audience forget that she was now an Honorary Doctor of Letters as well as a Dame of the British Empire.

Just as Edith's poetry is akin to Tchelitchev's painting, Sacheverell's "entertainments of the imagination"—a succession of books that evoke exotic cultures, places, crimes, buildings, performances, and works of art, the more bizarre the better—are a visual equivalent of the vast Tiepolesque compositions with which the démodé decorative artist José María Sert covered the walls and ceilings of cathedrals and ballrooms, not to mention Rockefeller Center, in the 1920s and '30s. Sacheverell likewise ransacked the baroque and rococo, but he went further afield and sought inspiration in such phenomena as false messiahs from seventeenth-century Smyrna, castrati singers from eighteenth-century Naples, forgotten cities like Noto and Lecce, the Black Death, the Djemaa el Fna—anything that lent itself to picturesque interpretation, and if possible panoramic treatment. Aside from his achievements as a writer, Sacheverell's influence on the history of taste, as well as on such mandarin travel writers as Bruce Chatwin, should not be overlooked. His forays into the backwoods of the decorative arts flushed out some very odd geese; it is our gain that so many of them proved to be swans.

If the Sitwells had not turned their backs so adamantly on the present, they might have helped extricate British art from its provincial torpor. Although they kidded themselves that they had done so, they did nothing of the kind. Their magazine *Wheels* was self-serving; they perversely discouraged young poets who were good and actively encouraged others who were bad. As for art, they *nearly* acquired the contents of Modigliani's studio for a hundred pounds; they *nearly* purchased the dealer Zborowski's stock of great modern paintings for a thousand pounds; they *nearly* persuaded Picasso to fresco the great hall at Montegufoni. In the end, who got the seal of Osbert's approval? The Futurist minimaestro Gino Severini and England's tame romantic John Piper. Piper's tasteful watercolors of Renishaw and Severini's commedia dell'arte frescoes at Montegufoni are a measure of the patron who commissioned them.

Wyndham Lewis's assessment of the Sitwells, or rather his caricatures of them, in *The Apes of God* are right on target. For them, "everything—art, friendship, even enmity—was all part of an enor-

mous game." They were, Lewis wrote, "a sort of ill-acted Commedia dell'Arte . . . Their theater was always with them. Their enemies—Pantalones, comic servants, detestable opponents (whose perfidy disrespect malice or cabal they would signally frustrate—unmask them, knaves and coxcombs to a man!)—always this shadowy cast was present." Right on target, except that it takes no account of that endemic British trait the class syndrome, for which the Sitwells could not, indeed did not want to, find a cure. Feelings of social inferiority have generated some of the finest English fiction (not least Evelyn Waugh's), but delusions of social superiority condemn a writer's work to that unreachable, topmost bookshelf where oblivion lurks.

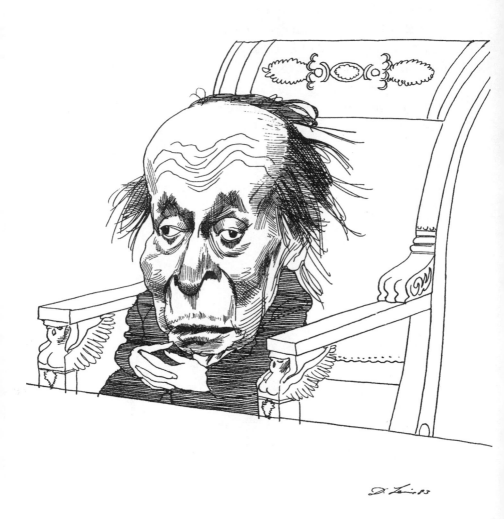

Mario Praz, by David Levine, 1983

Mario Praz's Kindly Eye

M ario Praz, who died in 1982, had one of the quirkiest minds in
the field of nineteenth-century cultural history. This learned
Florentine aesthete began his academic career teaching Italian at an
English university and ended it teaching English at an Italian uni-
versity. Besides being one of the world's greatest authorities on the
literature of the Romantic movement, Praz was an indefatigable
historian and collector of the decorative arts, whose bibelot-filled
apartment in the gloomy Palazzo Ricci—later in the more cheerful
Palazzo Primoli—has been likened to a "superb sepulcher." As John
Russell wrote in a commemorative essay, "Praz had read everything,
looked at everything, forgotten nothing . . . He knew all that there
was to know about painting, furniture, bronzes and porcelains . . .
He had by heart the intimate history of every great family in Eu-
rope. He was immensely, impossibly, almost unbearably learned."

If the name of this "unbearably learned" man has become more
celebrated than one might expect in the world of high fashion, it is
on the strength of one specific book, *An Illustrated History of Interior
Decoration: From Pompeii to Art Nouveau,* which is all the more inter-
esting for being nothing of the sort. Its original Italian title, *La*

filosofia dell'arredamento (inspired by an obscure essay of Edgar Allan Poe's, "Philosophy of Furniture"), gives a clearer idea of its scope. Far from plodding conscientiously through the centuries, as the publisher's subtitle suggests, Praz picks and chooses and ultimately bogs down—to the delight of readers like myself who share this predilection—in his special field of interest: neoclassicism, especially in its Empire, Regency, and Biedermeier, rather than its earlier, Louis XVI or Adam, manifestations.

What made this book of Praz's so popular was his decision to eschew photographs and confine his illustrations—all four hundred of them—to paintings and watercolors of the period under discussion, mostly by minor artists or gifted amateurs. This device enables us to see the decoration of the past through the eyes of the past. Once and for all Praz established that the neoclassical style was incomparably colorful, elegant, and versatile—daringly fantastical as well as dauntingly austere. And in doing so he exerted a formative influence on late-twentieth-century taste. Thanks in part to Praz, the bornes and banquettes, the passementerie and pilasters of the First and Second Empires came back into fashion; and, somewhat to his surprise, this "unbearably learned man" found himself a hero not only to art historians and connoisseurs, but also to decorators and designers for stage and especially film. Visconti's great costume movies, such as that masterpiece, *Senso,* owe much to Praz.

But, first, a word about the author. In his life as in his ideology, Praz belonged more to the nineteenth than the twentieth century. Balzac's obsessed collector, Cousin Pons, comes to mind. However, Praz is closer in spirit to one of those tormented souls in that great romantic storyteller E. T. A. Hoffmann's *Erzählungen*—one thinks of Dr. Coppelius or Spalanzani—whose vainglorious attempts to turn automata into human beings are set in the pared-down interiors of Praz's beloved Biedermeier period. Like Hoffmann, who was famously ugly, Praz was cursed with a squint and a clubfoot and, as a consequence, further cursed by being credited with *malocchio,* the evil eye. In Italy this fate is as abhorrent as leprosy. For Praz it meant being shunned by a great many people who should have known better. Even so enlightened a man as the philosopher Benedetto

Croce would not allow Praz's books to darken his shelves. And although Praz died at the age of eighty-six, many of his compatriots—and not just superstitious old fogies, either—still refer to the professor by his initials and then only if the first and fifth fingers are extended or the requisite amulets are within reach.

This ostracism was the sadder in that there is far more evidence of Praz's scholarly charm and benevolence than there is of malefic powers. True, he is said to have caused a large Empire vase to explode by giving it a covetous or disparaging look, and to have brought an immense chandelier crashing down merely by entering a Roman drawing room (people credited with these powers are supposedly immune from harm). But these stories are not to be taken seriously, except insofar as they justified superstitious witch-hunters in treating poor Praz as a pariah. Small wonder that the inanimate took precedence over the animate in his affections and that his only love objects were just that—objects.

Over the years, Praz would carry his passion for furniture and decoration to the point of fetishism. Just as fetishists direct their passions toward a specific thing or garment or body part, so Praz developed passions for such diverse objects as wax portraits, military knickknacks, silhouettes, framed fans, pelmet poles, and above all early-nineteenth-century watercolors of domestic interiors from which human beings, including the intrusive owners, have mostly been banished. These spaces were thus *his*—at least in imagination. They allowed this painfully unattractive man to become a narcissist, to see himself reflected in these faultlessly handsome roomscapes, as in a mirror. Again, in true fetish fashion, the objects of Praz's desire had to conform to a very specific pattern—the Empire style in all its neoclassical severity. Hence the panoply of eagles, swans, sphinxes, and fasces that gave his apartment the air of Scarpia's chambers in the Palazzo Farnese, as seen in traditional productions of *Tosca*. Praz's sublimation had its own reward. By the time he died, he had formed a rather more interesting collection of Empire art and artifacts than Rome's other repository of this style, the Museo Napoleonico, above which—no coincidence—he ended his unhappy days.

Some fifty years earlier, after being appointed Professor of Italian at Liverpool and later at Manchester University, Praz had married one of his students, a brave young woman called Vivien Eyles, who hailed from the Brighton area. At first she had encouraged his mania for furniture and objects, but after ten years with a husband who found it easier to relate to an Empire bed than its occupant, Vivien ran away, it is said, with a curator from the Vatican Museum. She took their daughter with her and left Praz all alone with his things. To pile insult on injury, she wrote a roman à clef about her former husband, accusing him of leading "a dead life."

Partly as a rejoinder to his wife's charges, Praz entitled his autobiography *The House of Life* (1958). Trust the author to conceive his life story in terms of decoration: a detailed description of his apartment in the Palazzo Ricci and its various collections. The memoir evokes anything but life. It is like having the significance of each funerary object in Tutankhamen's tomb explained by the occupant. The same is true of Praz's later apartment in the Palazzo Primoli, which he bequeathed to the city. It is more mausoleum than museum—fascinating to visit in that it is still suffused with the owner's nostalgic anality. Alas, it is all too seldom open.

The ill fate that blighted Praz's life afflicted his literary reputation. Because of the fears that his name evoked, he was hardly regarded as a prophet in his own country. Elsewhere in Europe, young Professor Praz was hailed by students of nineteenth-century literature as a near genius. When *The Romantic Agony,* by far his most profound and original book, first appeared in 1933, the Surrealists made a cult of it. And with good reason. This revolutionary and exhaustive study of the pathology of Romanticism revealed that the Romantic movement owed far more to the subversive ideas of the Marquis de Sade and other such princes of darkness than had hitherto been realized. But it is typical of Praz's bad luck that this pathfinding classic has been eclipsed in popularity by his more diverting but much less profound *Illustrated History of Interior Decoration;* and that over the years he has come to be revered by students of decoration rather than students of literature. No less typical of his luck, the abundance of attractive and unfamiliar illustrations has

doomed this *History* to be one of the most looked at but least read books of its kind: a decorator's crib instead of his bible.

We ignore the text of this *Illustrated History of Interior Decoration* at our peril. True, Praz's preciosity and nostalgia can be wearisome, but, with the exception of Praz's hero, the incomparable Walter Benjamin, he is the only great mind to have given serious thought to the subject of decoration. Inspired by Benjamin's concept of the interior as representing "the universe for the private individual . . . [whose] living room is a box in the theater of the world," Praz came up with a "philosophy of furniture" that boils down to the notion that "the house is the man" (as opposed to "the style is the man"), and that a house is nothing but an expansion of a person's own body.

The surroundings become a museum of the soul, an archive of its experiences . . . the surroundings are the resonance chamber where its strings render their authentic vibration. And just as many pieces of furniture are like moulds of the human body, empty forms waiting to receive it (the chair and the sofa are its pedestals, the bed a sheath, the mirror a mask that awaits the human face in order to come to life, and even in those pieces where the integration with the human counterpart is less evident, like the wardrobe or the chest of drawers, a symmetry similar to that of the human body still dominates, for handles and knobs are aligned like eyes and ears on the head) so finally the whole room or apartment becomes a mould of the spirit, the case without which the soul would feel like a snail without its shell. . . . The time-hallowed lion's paw on an antique piece still retains some vestige of its primitive, ritual significance, which was to transmit its nobility and strength into the person who sat on a chair. . . . The ultimate meaning of a harmoniously decorated house is, as we have hinted, to mirror man, but to mirror him in his ideal being; it is an exaltation of the self.

Nowadays, people who are prepared to spend a fortune on décor are unlikely to go for Praz's spiritual "exaltation of the self" con-

cept. Most of them are primarily concerned that their rooms should reflect their social distinction, good taste, and wealth in the hope of impressing their peers or, better still, arousing their envy. Back in the early nineteenth century things had been very different. The tasteful interiors that Praz extols for their "exaltation of the self" were the setting for such civilized pastimes as reading aloud, drawing, sewing, and making music; and they were the creation of the lady or gentleman of the house, working with an architect, cabinetmaker, and upholsterer. As Praz points out, the day of the decorator had yet to come.

The figure who best embodies Praz's ideals is that universal genius Karl Friedrich Schinkel (1781–1841), the architect, painter, and designer who was equally at home working in the neoclassical and the Gothic styles, and whose greatest work is to be found in Berlin. The simplicity and practicality of Schinkel's furniture anticipated modernism—hence Mies van der Rohe's respect for him—while, paradoxically, the noble serenity of his interiors has also inspired much of today's high-style decoration. Praz's description of Schinkel's long-forgotten *Zimmerlaube*—aristocratic ancestor of the room divider—helps to explain the author's interest:

> . . . a fashion of the Biedermeier period which was employed by Schinkel in all the apartments which he designed for feminine royalty. [It] consisted of a row of poles or lances (generally of alder wood, stained dark and polished) set in a green tin flower box base from which ivy or other trailing plants grew, their tendrils curling around the poles . . . Generally these domestic arbours were in front of . . . windows but if the room had two central columns . . . the arbours were set in the spaces between the columns . . . [thus] a small apartment was created inside the larger, a fanciful corner where the lady of the house could write.

Since Praz wrote his *History* in the shadow of World War II, his text is shot through with despair at the ravages suffered by European buildings. Hence the tragic light in which he bathes everything, also his imprecations against Hitler's "Baedeker" bombing of

cities famed for their beauty and the no less disastrous depredations behind the Iron Curtain caused by totalitarian brutality and economic shortage.

The only menace Praz chooses not to address is the way changes in fashion have condemned so many fine rooms to transformation or replacement. The built-in obsolescence on which the decorating trade thrives means that few fashionable interiors survive once the owner has died or lost his money or moved on to another spouse. Even the few good interiors that have survived—for instance, the great rooms that Jean-Michel Frank did for the Vicomtesse de Noailles's Paris mansion in the 1930s—usually turn out to have lost their *Stimmung,* their atmosphere, the quality that Praz prized above all. When I recently revisited the Noailles's magical rooms, which had once, for me at least, been a fount of Prazian "exaltation," intellectual and spiritual as well as social (why else would Picasso, Giacometti, Duchamp, Cocteau, Man Ray, and Beckett, to name but a few, have felt at home there?), I was appalled to find that the great squares of creamy parchment that covered the walls like blocks of soft masonry and gave the huge salon its special glow had been bleached white and the floor covered in white wall-to-wall carpeting. As a result the place has come to have the *Stimmung* of a parking lot. The only glimmer of hope for the future is Praz's belief that decoration is in a constant state of flux and reflux and that, one of these days, we will be able to return, if only in imagination, to this author's sublime vision of humanism.

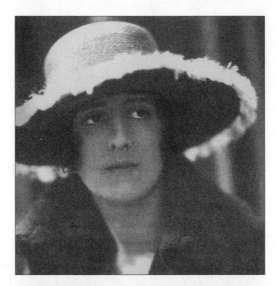

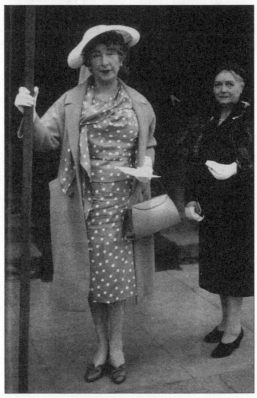

(above) Vita Sackville-West, 1919,
(below) Violet Trefusis with her maid, c. 1955

Vita's Muddles

The core of *Portrait of a Marriage* is a memoir that Vita Sackville-West—creator of Sissinghurst, one of England's most celebrated gardens—wrote in 1920–21, when she was extricating herself from a messy affair with another married woman, Violet Trefusis. Instead of showing this document to her compliant husband, Harold Nicolson, as she had originally planned, Vita locked it away in a Gladstone bag, whence it emerged only after her death in 1962. After pondering the matter for ten years, during which time Violet obligingly died, Vita's publisher son, Nigel Nicolson, decided that these confessions had been written with publication in mind. So here they are verbatim, except that the real names have been substituted for pseudonyms, and they are divided into two parts interspersed with sections of pious exegesis by Nigel Nicolson. The result is a tasty, not to say gamy, club sandwich of a book.

The memoir begins with an outline of Vita's family background that unwittingly hammers home a crucial point: had she been born the only son instead of the only daughter of Lord Sackville, Vita would have inherited a historic title, a considerable fortune, and

Knole, one of the largest and most romantic country houses (four acres of buildings) in the British Isles. As it was, Knole eventually went to a cousin—another literary invert—and Vita came into the relatively modest inheritance that is the lot of the daughters and younger sons of English noblemen. No wonder she grew up aching to be a boy and liked to quote Queen Elizabeth's phrase "Had I been crested not cloven, my Lords, you had not treated me thus." No wonder she took to calling herself Julian, staining her aristocratic face and hands brown, and dressing as a man (in later life she settled for jodhpurs, sometimes topped by an old Etonian sweater of her son's).

But Vita was not merely a peer manqué. The soccer-playing tomboy was also a shy and sensitive "soul" (a favorite word of Vita's), and she proudly admits to veering between these two personae. Too proudly, perhaps. She mars the frankness of her confession by insisting on seeing her sexual orientation as a badge of class distinction. "Since 'unnatural' means removed from nature, only the most civilized, because the least natural, class of society can be expected to tolerate such a product of civilization." Only the upper classes, it seems, are sufficiently "civilized" to be worthy of this privilege. Vita carries her special pleading even further when she claims that "cases of dual personality do exist, in which the feminine and masculine elements alternately preponderate. I advance this in an impersonal and scientific spirit . . . I am qualified to speak with the intimacy a professional scientist could acquire only after years of study . . . because I have the object of study always to hand, in my own heart."

Since Vita's theory of dual personality provided Virginia Woolf with the donnée for one of her two bestsellers, that trying, transsexual saga *Orlando,* it is of some literary interest. But what a euphemistic way of dignifying good old common-or-garden lesbianism, a word Vita never uses for what she doubtless thought a shamefully middle-class condition. And this from someone who thought other people's euphemisms genteel. Before marrying Harold Nicolson—a gifted homosexual who never quite made it as a diplomat or politician, but wrote far better than his wife—Vita had had several affairs with girls. Besides seducing one of her brides-

maids, Rosamund Grosvenor, she and Violet Keppel (later Trefusis), the bad hat of this story, had fancied each other since childhood. Nevertheless, nothing happened between them until Vita had been a wife and mother for some four years. And then, in April 1918, Vita revealed herself to Violet in a brand-new landgirl's outfit, breeches, gaiters, and all. "I ran, I shouted, I jumped, I climbed, I vaulted over gates, I felt like a schoolboy ... Violet followed me across fields and woods with a new meekness ... never taking her eyes off me." The breeches did it. Despite the meekness, Violet proved to be a wily seductress who set in motion a succession of escapades and elopements—Harold Nicolson called them "Vita's muddles"—which are the main subject of *Portrait of a Marriage*.

The two women had more in common than a kink for male attire. They were desperately romantic, desperately literary. At the same time they were both victims of philistine Edwardian society, which frowned on that sort of thing, just as they were both victims of peculiar family backgrounds. Vita's father had been a typical Edwardian ladies' man—charming and gentlemanly on the surface, arrogant and sullen underneath—who was forever traveling north in pursuit of feather, fur, or fin. But Lord Sackville was not nearly as dreadful as Vita's mother, the illegitimate daughter of a Spanish dancer, the half-gypsy Pepita, by a previous Lord Sackville. Lady Sackville was unpredictable, bitchy, bizarre. As a girl at the British embassy, she had captured Washington—above all President Arthur, whose proposal of marriage she claimed to have refused—with her charm and looks. In middle age she turned into a canny old coquette (she permitted Rodin "liberties but not license") who squeezed a sizable fortune out of Sir John Murray Scott and preyed on other millionaires—Pierpont Morgan, W. W. Astor, Henry Ford, and Gordon Selfridge. After successfully defending her pile in a sensational lawsuit brought by the heirs of John Murray Scott, Lady Sackville spent the rest of her life squandering it.

Poor Vita! She understandably came to distrust the Edwardian values—or lack of them—that her parents represented, as witness her best novel, *The Edwardians*. And much the same is true of *Pepita*, a fascinating account of her Spanish forebears that includes a matricidal portrait of the odious Lady Sackville. Yet Vita never entirely

outgrew these values. In one respect—her anti-Semitism—she even exceeded the Edwardians, who were inclined to follow the King in accepting Jews so long as they were good shots (or, better still, had good shoots) and were very, very rich.

Violet Trefusis was even more of an Edwardian—louche, arch, and not quite as grand as she would have had us believe. Her mother, "the beautiful Mrs. Keppel," had been the last mistress of Edward VII, such an official mistress indeed that Queen Alexandra summoned her to the King's deathbed. On the strength of this relationship, Violet would in later years try to convince herself and anyone who would listen—you always knew when she was romancing: she would frantically powder her nose—that she was the daughter of the dear King and not of that cuckold Colonel Keppel. Poor—no, awful—Violet! She was unable to reject the worldliness and ostentation of Edwardian life, as Vita ultimately did, but rather came to personify it. ("Next time you come to Paris," she once said to me, "call the Ritz and ask for Madame *'trois-fois-six.'* They always know where I am.") Nigel Nicolson aptly compares her to a pinnace that turned into a galleon—propelled Ritzward through life, I always felt, by high winds from Sandringham. Too bad she did not live to see her great-niece, Diana Spencer, marry the Prince of Wales.

Social snobbery, as opposed to the intellectual snobbery of Bloomsbury, tightened the bonds between Vita and Violet. "We talked chiefly about our ancestors," Violet wrote of their childhood meetings. As Nigel Nicolson readily admits, Vita was indeed a snob: "She attached exaggerated importance to birth and wealth, and believed that while the aristocracy had much in common with working people, particularly those who worked on the land, the middle classes [or *bedints* in the Sackville family's arcane slang] were to be pitied and shunned, unless there was money in the offing. When Vita was twelve years old, she anxiously asked her mother, 'The little Gerard Leghs are not "bedint," are they?' . . . She never quite rid herself of this complex."

Nigel Nicolson goes on to imply that Vita's snobbery—like her lesbianism?—was a consequence of her dual personality. "She was a

conforming rebel, a romantic aristocrat . . . gypsy and grandee." Once again this won't really wash, largely because we have to take the gypsy and the grandee on trust. The gypsy never manifests him(her?)self in these pages, nor for that matter does the grandee. If anything, Vita's description of an opulent dinner recalls Dickens's Mrs. Veneering: "I liked it because it was so rich and un-'bedint' and ambassadorial; and because I am snob enough to love long dinner tables covered with splendid fruit, orchids and gold plate."

Despite her antiquated set of values, Vita eventually came into her own as a great gardener and an eloquent writer on the subject. The magnificent garden she created at Sissinghurst reveals her to have had the equivalent of perfect pitch in her layouts and planting. Vita's enormously beneficial influence on horticultural taste continues to this day. White gardens based on Sissinghurst's are to be found the world over. Inevitably, certain flowers would turn out to be "bedint." I will never forget Harold showing me around Sissinghurst and apologizing for some showy roses (harlequin ones, I seem to remember), varigated maples, and the like—presumably gate-crashers.

Violet's vulgarity comes across in the show-off, novelettish style of her love letters to Vita:

We're different—gypsies in a world of landed gentry. They've taken and burnt your caravan . . . but they haven't caught me yet! Come! Come away! I'll await you at the cross-roads.

If Vita had been blessed with an ear (her poetry settles that point) she might have been proof against the purple prose of her relentless seductress. However, meet at the crossroads they did, and under the cover of collecting local color for a novel—a cover they used more than once—the two hoydens eloped to Hugh Walpole's cottage in Cornwall. "And I was yours, yours to bend over and kiss as the fancy seized you," Violet later wrote. Violet's giddy girlishness brought out the manliness in Vita, who took to dressing as a wounded tommy (a khaki bandage helped hide her hair). "Julian," or "Mitya," as Violet preferred to call her, would then escort his "Lushka" on

nocturnal strolls up Piccadilly, or in Paris around the Palais-Royal. "I never felt so free," Vita wrote. Once in Monte Carlo the masquerade was so convincing that a French couple tried to interest "Julian" in their daughter. Vita was obliged to improvise some war reminiscences to explain her "wound."

Should they or shouldn't they leave their families for a vestal villa in the sun? Violet was all for it, but Vita held back, more for the sake of her husband than her two young sons. Meanwhile, people started to talk, particularly Lady Sackville, who wrote to all her friends that her daughter had been bewitched by a sexual pervert, "thus spreading still more widely the news she was anxious to suppress." As the scandal percolated, the men in the ladies' lives behaved ever more cravenly. Though much in love, Violet's war-hero fiancé, Denys Trefusis, condoned her affair and agreed to her proviso that their marriage be one in name only—social camouflage. The Trefusises were to have a honeymoon *à trois* with Vita, but there would be no sex for Denys. This surrender made Violet the more contemptuous. "Wretched man," she wrote a week after the announcement of their engagement, "he cares for me drivellingly. His one *chic* was that I thought he didn't."

Harold Nicolson emerges as only slightly less craven, but then, like his wife, he was leading an active, albeit closeted homosexual life. Was he perhaps relieved to have the voracious Vita taken off his hands? True, he whimpered a lot: "poor little Hadji," he describes himself; his "heart feels like a *pêche Melba*." And he made botanical remonstrations: "I wish Violet was dead . . . she is like some fierce orchid—glimmering and stinking in the recesses of life, and throwing cadaverous sweetness on the morning's breeze." But in the last resort Harold, too, condoned the situation. It suited him fine. "I love you," he wrote to Vita, "in a mad way because of it all." "You could at any moment have reclaimed me," Vita later reproached him, "but for some extraordinary reason you wouldn't. I used to beg you to. I *wanted* to be rescued and you wouldn't hold out a hand."

So things continued until February 1920, when, badgered by Violet ("Fly, fly, fly"), Vita finally left her husband and children for a

new life abroad, nobody was quite sure where—Greece, Sicily, a sugar plantation in Jamaica. In the boat-train Vita scribbled a few lines of defiant doggerel:

> *Here we come swinging along;*
> *We will lead you such a dance*
> *If in Belgium or in France,*
> *But we aren't going to trifle very long.*

The dénouement, which was not long in coming, was straight out of Feydeau—a farcical succession of comings and goings, rows and reconciliations—and where else but in a provincial hotel? Hotly pursued by their husbands in a flying machine, not to mention Violet's furious father, the lovers fetched up at Amiens. Colonel Keppel, who had instructed Scotland Yard to have "the ports watched to prevent them leaving the country," huffed and puffed while the girls laughed. The husbands cajoled and threatened; the girls, Violet especially, became abusive. "The upshot of it was we refused to leave one another."

And then for a change "poor little Hadji" did something effective: he told his wife, whom he had taken to calling "Wry Vita," that Violet had been deceiving her—with her own husband. Vita was outraged and insisted on confronting the guilty pair. "Have you ever been really married to Violet?" she asked Trefusis. While the husband hedged, Violet stammered out a confession—yes, she had slept with Denys—which she later retracted. Too late. The affair creaked on through the summer, but Vita's eyes had at last been opened to the falseness, the fecklessness, the sheer Edwardian awfulness of Violet. As a catharsis Vita immediately started writing her confessional memoir.

Thirty years later, Harold avenged himself on Violet in a review of her vapid autobiography, *Don't Look Round*:

> Many readers will derive the impression that they have been invited to meet several famous and intimidating people, only to find that their hostess is absent-minded and that the conversation

is conducted in epigrams or French. Others may be irritated by this story of a spoilt child of fortune, drifting from Ritz to Ritz, from French castles to Italian villas . . . by their disregard of the English custom of understatement and self-deprecation, by the interest she takes in social values that are today irrelevant.

In her memoir, Vita tells her queer tale straightforwardly, even touchingly, and her son rounds it off with an account of her subsequent life that is more filial than frank. On the rebound from Violet, Vita had a halfhearted affair with Geoffrey Scott (author of that influential book *The Architecture of Humanism*)—once again Harold was "pleased." This in turn was followed by a romance with Virginia Woolf, who had at first found Vita not much to her severe taste: "florid, mustached parakeet colored with all the subtle ease of the aristocracy but not the wit of the artist. She writes fifteen pages a day . . . knows everyone. But could I know her?" Months and months would go by before their affair was consummated. The result was *Orlando*. Harold thought they "were very good for each other," and they probably were. "But Vita had friends," as we know from Quentin Bell's biography of his aunt Virginia, "a Sapphist circle—which Virginia found decidedly unsympathetic . . . second-rate; they engendered a school-girl atmosphere, and although she was conscious of being unkind to Vita she was unable to resist the temptation of telling her what she thought . . . And so their friendship was for a time agitated." Nigel Nicolson passes over this Sapphist circle in silence. Some of the people involved are still around: one of them still boasts of the marks Vita's earrings made on her thighs.

The son is likewise reticent about his father's boyfriends—which is regrettable in that it blurs an important part of the record. Like Vita, Harold found lovers in the purlieus of Bloomsbury, but we do not learn what repercussions his affairs with up-and-coming young writers had on Vita. Nigel Nicolson obliges one to raise this point, because he prefaces his book with the claim that his parents' marriage was "the strangest and most successful union that two gifted people have ever enjoyed." He claims too much. The Nicolsons, it

is true, had much in common: both were writers, both inverts, both gardeners, both riddled with upper-class hang-ups, and, despite Harold's intermittent liberalism, they shared many reactionary views. They were anti–modern life, anti-American, anti-Semitic. (A Jewish friend who roomed with the Nicolsons' art-historian son, Ben, when wartime rationing was still in force, told me that Vita threatened to cut off the precious supply of Sissinghurst butter if Ben continued to share it with "the Jew so-and-so.") As for their championship of contemporary literature, we have only to read the incensed letters they wrote their publisher son, Nigel, when his firm brought out Nabokov's "lascivious," "disgusting" *Lolita.* "It will do you infinite harm in Bournemouth (Nigel Nicolson was Conservative MP there) and possibly in any future constituency and surely it will tarnish the bright name of Weidenfeld and Nicolson," thundered the erstwhile seducer of her own bridesmaid. As for Harold, who but he would write biographies of Swinburne and Verlaine in which the special sexual tastes of these two poets are camouflaged under the heaviest veils?

On the evidence of this book, the Nicolsons' union was successful only insofar as both parties demanded so little of it and of each other. It was a most convenient weekend arrangement, as well as a cover for homosexual affairs on the side. Nicolson's further claim that this book should be seen as a "panegyric of marriage" is equally difficult to accept, for Vita's confession begins as a mea culpa and ends on a panic-stricken note, "in the midst of great unhappiness which I try to conceal from poor Harold." The only panegyrics come from Nigel Nicolson. So excessive are they that the reader wonders whether he feels somehow obliged to atone—granted, he had Vita's implicit permission—for revealing her secret to the world.

Now that I know everything, I love Vita more, as my father did, *because* she was tempted, *because* she was weak. She was a rebel, she was Julian, and though she did not know it, she fought for more than Violet. She fought for the right to love, men and women, rejecting the conventions that marriage demands exclu-

sive love, and that women should love only men, and men only women. For this she was prepared to give up everything. Yes, she may have been mad, as she later said, but it was a magnificent folly. She may have been cruel, but it was cruelty on a heroic scale. How can I despise the violence of such passion? How could she regret that the knowledge of it should now reach the ears of a new generation, one so infinitely more compassionate than her own?

Vita's penitential tale does not live up to her son's claims. Far from being "a rebel" in the fight for homosexual rights—like Radclyffe Hall, for instance—she was too class-conscious to admit to being a lesbian and emerges from this book as a weak and reckless creature who was foolish enough to be led astray by a femme fatale even more self-indulgent than herself. She was a distant mother—especially to her son Ben, who told a friend that he could not bear to be in the same room with her—and anything but supportive of her husband in furthering his career as a diplomat. As for her contributions to literature, Vita wrote some readable books—notably *Pepita,* the story of her partly gypsy grandmother—but her most memorable work concerns gardens. Harold, on the other hand, wrote one book of near genius, *Some People*—a collection of lightly disguised profiles of real people. But that is no reason to indulge this family's romantic mythmaking about itself, not to mention marriage.

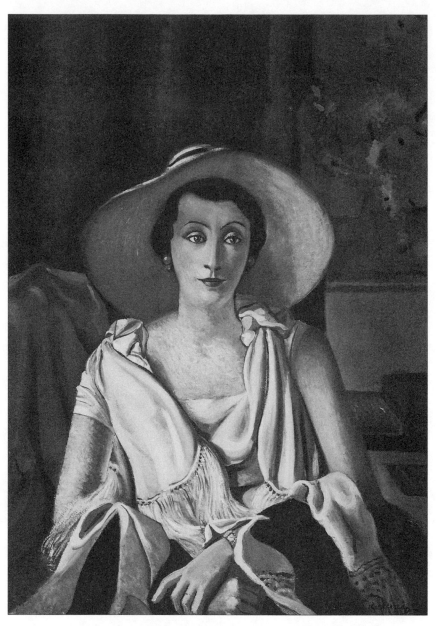

André Derain, *Portrait of Madame Paul Guillaume in a Wide-Brimmed Hat,*
oil on canvas, 1928–29, Musée de l'Orangerie, Paris

Killer Collector

While that beautiful little museum the Orangerie in the Tuileries Gardens was being restored in the year 2000, its spectacular collection of modern masters went on a transatlantic tour. Besides commemorating its creator, the phenomenally successful art dealer Paul Guillaume (1891–1934), who put most of this magnificent collection together, it also commemorates one of France's most sensational art scandals. Twenty-five years after Guillaume's death, his lethal widow, Domenica, her no less lethal lover, Dr. Maurice Lacour, and her conniving brother, Jean Lacaze, would be accused by her adopted son, Jean-Pierre, of plotting to murder him. Besides attempted murder, the case involved charges of blackmail, entrapment, forgery, will tampering, and what the French call *proxénétisme*—pimping.

There were also overtones of political skullduggery. Lacour was a right-wing fanatic with a militant past, and some of his coconspirators shared his extremist views. When the scandal broke, he spent several months in jail, whereas Lacaze was out in a matter of days. The mastermind, Domenica, proved unsinkable. ("We are like the

pharaohs," she once said.) Her ratlike ruthlessness, her affairs with men in high places (one of them a prime minister), and, above all, her possession of a fortune in modern masterpieces meant that she was never even charged. She was, however, obliged to cede her collection—sixteen Cézannes, twenty-three Renoirs, five Modiglianis, twelve Picassos, ten Matisses, twenty-seven Derains, and twenty-two Soutines—which might well fetch a billion dollars today, to the French state for a pittance. The Musée de l'Orangerie, a subsection of the Louvre, was remodeled to receive it. At the time of the *affaire*—which made headlines, day after day, for the first few months of 1959—I was living in France, and on one occasion met this monster. A ringer for Joan Crawford, I remember thinking—one part steel, one part asbestos, one part nylon. This feeling was confirmed when I read a frightening book about Domenica, *La Dame au grand chapeau*, "The Woman in the Wide-Brimmed Hat," by Florence Trystram, a lifelong friend of Jean Walter, the second of the two husbands Domenica managed to enslave. When a lawyer who acts for the Walter family made the press cuttings available to me, I decided to write about the case.

Before scrutinizing Domenica, let us take a look at her first husband, who was no less self-invented than she was. Shame at being the son of a uniformed bank messenger was the propelling force in Paul Guillaume's upward mobility. By the time he was seventeen, in 1908, this baby-faced entrepreneur had left home and carved out a unique niche for himself in Paris. Although he aspired to write and paint, and even schooled himself to do a bit of both, Guillaume was in too much of a hurry to take the time and trouble that those vocations necessitate. Instead, he pretended he was studying law and got a job in a garage—not any old garage, but one with a *clientèle de luxe,* which permitted him tantalizing glimpses of the Parisian beau monde he was hell-bent on crashing. Guillaume's garage imported rubber for its tires directly from Africa, and one day the rubber cargo included a bonus: a tribal mask from Gabon. It was a revelation. After devoting all his spare time to studying similar artifacts in museums, Guillaume set about importing further examples from African traders.

Guillaume had a knack for being in the right place at the right time. Living as he did in Montmartre, he hung out in the bohemian cafés frequented by Picasso's band of friends, among them the poets Guillaume Apollinaire and Max Jacob, who were always eager to make money on the side. Picasso, who had endowed his master-piece *Les Demoiselles d'Avignon* with tribal masks a year or two ear-lier, was one of his first clients. *Art nègre* would soon become the rage in avant-garde circles. With Apollinaire's encouragement, Guillaume developed into the leading purveyor of tribal art to mod-ernist painters and collectors. Since artists liked to use their work as currency, Guillaume found himself with enough Picassos, Braques, Derains, Matisses, and Vlamincks to open a small gallery. He would soon prove to have an almost infallible eye for the new young painters and, no less important, the new young poets, who would ferret them out for him.

Guillaume was just the man, Picasso and Apollinaire felt, to launch their new Italian discovery, Giorgio de Chirico, so they arranged for this unknown dealer to take this unknown artist's en-tire output for one hundred francs a month. The outbreak of war in 1914 shut down Guillaume's first gallery and whisked him in and out of the army and in and out of a second gallery before he finally settled into lavish premises on rue La Boëtie. Meanwhile, Max Jacob had put him onto the proprietress of a Montmartre cabaret, La Belle Gabrielle, who for years had fed Maurice Utrillo in ex-change for art. Guillaume paid her 1,500 francs for thirty-five can-vases, which he would later sell for around 200,000 francs apiece.

Jacob also introduced the dealer to another undiscovered Italian, Amedeo Modigliani. Besides acquiring a number of his finest works for a few hundred francs, Guillaume would inspire some of this artist's most perceptive portraits: subtly mocking images of a plumpish little fellow with a tiny rosebud mouth and a Charlie Chaplin mustache, trying but failing to mask his ordinariness under a look of assumed disdain. To flatter the sitter, Modigliani inscribed the best of these portraits with the words *Novo Pilota* (New Pilot)—an identity that this driven young dealer was desperately eager to project. To boost his artists and his gallery, not to mention himself,

Guillaume started a magazine, *Les Arts à Paris*. He would write most of the puff pieces himself, under fanciful pseudonyms—Dr. Allainby, Colin D'Arbois, Captain W. Redstone, Colonel Bonardi, Le Nègre Bleu. By the age of twenty-five he had promoted himself into a celebrity.

And then, in 1920, Guillaume decided to marry. He chose an utterly unscrupulous, dynamically sexy young beauty from a dim, glove-making town in southwestern France. Like Guillaume, Juliette Lacaze was deeply ashamed of her background. Although from a respectable family, her father had lost all his money and ended up working as a lawyer's clerk. She would later destroy all documentary and photographic evidence of her early years. After her father's death, she and her handsome, subservient brother, Jean, left the boondocks for Paris in quest of affluence, fame, and fashionable friends. Jean went to work for Shell Oil, where he eventually did very well for himself, but his sister's early career is a mystery. She is thought to have started off selling gloves in a department store, and also to have done a stint as a hatcheck girl in a nightclub, but in view of her striking looks and her aversion to petit bourgeois life, she is likely to have been dependent on the favors of generous admirers. One of these men must have taken her to Nice, for it was there, one Sunday in 1920, that Paul Guillaume picked her up. They proved to be a perfect match.

After their marriage, Guillaume would memorialize the occasion of their encounter in Nice by changing her name to Domenica, which fitted this dominatrix like a sheath. Years later she had a wall of her chalet at Megève frescoed with a garish mural of Saint Dominic and the words *Domenica ora pro nobis* (Domenica pray for us).

Like her husband, Domenica spent the next few years styling and restyling herself—her look, her accent, her persona. We can follow the process in successive portraits by André Derain, Guillaume's best-selling artist. In the first portrait—started in the year of her marriage and finished in 1925—Domenica still has a trace of the anxiety and awkwardness of a small-town girl who has come up the hard way. In the second, much flashier one, in a huge, halolike straw hat, finished in 1929, she is all artifice. Since Derain was having an

affair with her, he was able to catch to perfection her cold, calculating gaze and overgroomed, movie star look. The painting—so overtly flattering, so subliminally mean—is a lie that tells the truth.

Underneath the mask, Domenica was miserly and manipulative—loathed by the servants she overworked and underpaid, loathed by the hairdressers and manicurists she never tipped, loathed by the women whose husbands she tried to seduce. (On a summer's day, if there were men around, she would fan her thighs with her frock and murmur how hot she was.) Women said she was vulgar; men said that was what made her so peppy. Guillaume did not seem to mind as long as she kept his clients happy. Domenica's Olympic skill and stamina at social and political climbing and her ability to disarm and beguile clients as devious and demanding as the gallery's biggest buyer, Dr. Albert Barnes of Philadelphia, would prove to be a huge advantage to her husband.

Guillaume's early success had stemmed from his rapports with the painters and poets of Montmartre and Montparnasse—rapports that enabled him to buy works of exceptional interest and quality. After marrying Domenica, he distanced himself from bohemia and concentrated on public relations and sales strategies: how to unload his treasures onto clients who wanted to be "with it" but were generally ambivalent about modernism and primitivism. "I like it," the wife would typically say, "but it won't go with the *boiserie* or the Sèvres or the Tanagra figurines Mother collected." As a result, the husband would leave without buying the Fauve Matisse or the Benin bronze.

Tired of missing out on sale after sale, Guillaume took to sticking his contemporary paintings into seventeenth- and eighteenth-century frames. Tastefully pickled or otherwise patinated, these served as buffers between modernist imagery and period décor. Nothing provided one of Utrillo's seedy backstreet views with more of what dealers call "wall power" than a handsome Régence frame. The same with the naïve paintings of "Le Douanier" Rousseau. On a tip from Apollinaire, Guillaume had snapped these up for next to nothing, and after framing them as lavishly as he would a Manet, he sold them for two hundred times their cost. Guillaume was likewise at pains to have his tribal sculptures beauti-

fully mounted by a Japanese craftsman. Serious collectors denounced these tricks as packaging. They also denounced the dealer's cynical exploitation of the former modernist André Derain, whose prices had soared as the quality of his work had plunged. Guillaume's promotion of Édouard Goerg, a facile painter of salable flower pieces and winsome clones, was also held against him. Gone was the instinctive modernism of Guillaume's earlier days. His gallery catered increasingly to the modish nouveaux riches with whom he and Domenica had come to identify.

Chirico's brother, Alberto Savinio, has described Paul Guillaume at his apogee in 1926:

> When he entered the Hôtel Drouot [the principal Parisian auction house] majestically enveloped in a fur coat, his appearance would trigger an audible murmur from the assembled collectors and dealers. The auctioneer would stop auctioning, his hammer in the air. A small bisexual army of assistants and secretaries would hang on Guillaume's every word, obeying his slightest sign with military precision. Two superb Hispano-Suizas would be parked at the curb, the chauffeurs motionless at the wheel, dressed up like generals in the Tsar's Imperial Guard.

The bank messenger's son had come to see himself as a cross between the American collector Henry Clay Frick and the British dealer Joseph Duveen, who would be ennobled by the King of England for skimming the cream off many an ancestral collection. Guillaume now behaved as if he were not so much a merchant as a maecenas, who might eventually deign to give his magnificent collection to the Louvre or a subsidiary, thereby demonstrating that he had a more discriminating and adventurous eye than France's fuddy-duddy museum directors. A major exhibition of works from his collection at a Paris gallery in 1929 revealed what treasures he had accumulated, but in typical fashion he overplayed his hand. "The only serious private collections today," Guillaume boasted, "belong to a few particularly perceptive dealers." His vanity made the art world cringe.

In 1930, Guillaume opened a London branch; he also appointed Mrs. Averell Harriman, who had recently opened a New York gallery, to be his U.S. representative. Thanks to the Depression, neither of these outlets prospered, and the Guillaumes had to cut back on their lifestyle. He began to look more and more puffy and depressed. Both he and his wife were having affairs: he reportedly with Jeanne Castel, an art dealer with whom he had long been associated; she with Jean Walter, a powerful businessman and architect who had designed the building overlooking the Bois de Boulogne where he and the Guillaumes lived. Although their huge, luxurious apartments were separated by several floors, this was still too close for Guillaume's taste. As he grew sadder and sicker, he seems to have realized that he had sold out, and in conversation he would hark back to the great days of his youthful discoveries. And then all of a sudden, on October 1, 1934, Paul Guillaume died at the age of forty-two, perhaps of a burst appendix.

Domenica had allegedly had her tubes tied before the marriage. And so, in the absence of children, she was Guillaume's principal heir. Of late, however, he had threatened her: "I have changed my will. Unless you bear me a child, I will leave my collection to a foundation." He may well have done so. Why else would Domenica have been so fearful of losing the collection that she shoved a cushion under her dress and announced that she was pregnant? The cushion had a way of slipping from its moorings, but such was her sangfroid that she got away with the charade. In due course Domenica managed to procure a newborn infant—said to be a foundling of unknown parentage—at the cost of five thousand francs on the baby market. However, there were also persistent rumors that, before he died, Guillaume had arranged for a mistress to have his baby, so it may well have been fathered by him. The child was christened Jean-Pierre and nicknamed Polo. The press would refer to him as *"l'enfant du miracle."*

As things turned out, the cushion business may have been a waste of the widow's time. A will eventually materialized, leaving Domenica everything. The fact that a codicil had been filed ten days after Guillaume's death was not thought suspicious—at the time.

According to the catalogue of the exhibition in 2000, there was also a mysterious letter to his widow, which supposedly clarified Guillaume's intentions regarding his collection but was never made public. Meanwhile, Domenica continued to carry on her very public affair with Jean Walter, who had fallen besottedly in love with her. Besides three children, Walter had an exemplary wife, who refused to give him a divorce. Apart from this adulterous lapse, he was famously ethical—so unlike Domenica in this respect that friends were amazed at his tolerance of her. As long as Walter was unable to marry her, she insisted on her right to have other lovers. It was only when his first wife's death in 1941 enabled them to wed that Walter was in a position to put his foot down and impose fidelity.

For some years, Walter's career as an architect had been eclipsed by an involvement of a very different nature. In 1925, in settlement of a bad debt of 75,000 francs, he had accepted the mining rights to a tract of land in eastern Morocco. In the course of inspecting this barren terrain, Walter, who knew a bit about geology, noticed that the rocks were speckled with galena, which indicated the presence of lead and zinc. Back in Paris, he raised one million francs and with the help of his son, Jacques, started mining on a small scale. Within a year the price of lead had fallen so low that they had to shut down their operation, but in 1936 the threat of war sent the price soaring again, and the Walters reopened what had come to be called the Zellidja Mining Corporation. They soon discovered they were sitting on the richest deposit of lead in North Africa.

During the war the German occupiers pressured Walter to turn the mines over to them. Passionately anti-German like most Alsatians, he refused, whereupon the Gestapo threw him in jail and threatened to kill him. According to Domenica's chauffeur, she had a German lover on the side, and allegedly bartered her body for her husband's life. Walter is unlikely to have countenanced such a quid pro quo. However, she is thought to have used her connections to arrange preferential treatment for him. While in jail, Walter managed to write a treatise on hospital architecture and conceive plans for the village of Bou Beker, which he would later build to house his ten thousand Moroccan employees. Walter was not freed until

the Liberation. Trust Domenica to make the young officer desig-
nated to release her husband wait for hours while she dolled herself
up for the jeep trip to the jail.

Meanwhile, *"l'enfant du miracle,"* whom Walter had insisted that
Domenica officially adopt, had spent the war years with a nanny in
Cannes. According to Florence Trystram's book, he had seen virtu-
ally nothing of his mother. Just as well: when he was returned to her
in Paris, she found him both an embarrassment and an encum-
brance. There was no room for him in the magnificent new apart-
ment the Walters had taken on the Avenue Gabriel, a block away
from the presidential Palais de l'Élysée. As long as he lived at home,
Jean-Pierre had to sleep on a mattress under the dining-room table.
If she was giving a dinner, he would sleep in her bathtub. Hell for
the boy; hell, too, for Domenica, who was maniacally finicky about
domestic details. Every piece of furniture had a sticker indicating
exactly where it should be placed; the same with objects. For disre-
garding Madame's injunctions, servants were fired.

Domenica could not very well fire Jean-Pierre, but she could
most certainly torture him for being a misfit in her overmanicured,
over-regimented household, where the brooms were numbered
and labeled and the maids had to wear overshoes so as not to mess
the floors. She also became ever more morbidly stingy with the boy.
The chauffeur remembered supplying him with the pocket money
she failed to provide, and if he needed a pair of shoes, she would
give him one shoe and make him wait for the other. His clothes
were hand-me-downs from his Walter cousins. No wonder he
failed his final exams twice, dropped out of the prestigious Lycée
Henri IV, and spent his time hanging out and chasing girls. As Jean-
Pierre grew up, Domenica found new ways to humiliate him. She
made him wear overalls to protect his one suit, and when he got to
be as tall as she, she made him wear an old camel-hair overcoat of
hers, which buttoned up the wrong way for a man.

One dire day, Domenica's resentment of Jean-Pierre finally cur-
dled into rage. She attacked him for disgracing her house. He was
not even her or Paul Guillaume's son, she said, adding that his real
mother (according to Trystram) "must have ended up on the streets

after being knocked up by some wretched delivery boy." He was a foundling she had adopted out of kindness. In despair Jean-Pierre fled to the apartment of Walter's son, Jacques. He worked briefly in a Paris nightclub, in a pharmaceutical factory, and as a film extra. In 1955 he enlisted in the army as a parachutist and was soon commissioned. Jean Walter saw him off to the war in Algeria and made him promise that he would come back and live at home after his military service. His thoughtful mother reportedly asked her friend General Massu, who was in command of the troops in Algeria, to expose Jean-Pierre to active combat and make a man of him. Since she sent him no money, he was reduced to bouncing checks—a transgression that would later be used to justify the conspiracy she mounted against him.

Domenica would always take much too much credit for preserving the integrity of her first husband's collection—"It is my raison d'être," she used to say. In fact, she had never liked the *art nègre,* which had been Guillaume's first love. After promising his collection of tribal art to the Louvre, she auctioned it off. No less regrettable is the absence from the collection of de Chirico, whom Guillaume had helped discover. Domenica was legally entitled to sell whatever she wanted, but one wishes she had deaccessioned some of her husband's mistakes—those late Renoir nudes painted in shades of apricot jam, or the pretty-pretty Marie Laurencins, or the ghastly Goergs—instead of eliminating his best modernist paintings, including all but one of his great early Picassos and his two most important Matisses, the magisterial *Bathers by a River* (1909–16), now in Chicago's Art Institute, and *The Piano Lesson* (1916), now in New York's Museum of Modern Art.

As it stands today, the collection commemorates Guillaume as a man of discernment but hardly as the avant-garde pioneer he prided himself on being. True, his widow would later buy some fine Cézannes, including the beautiful *Still Life with Apples and Biscuits,* for which she paid the then record price of just under $100,000 at auction in 1952, thereby tripling or quadrupling the value of her other Cézannes. However, the second-rate Impressionists, among them a dubious Renoir, which she acquired around the same time,

raise questions about her eye for art. As for the schlock realist Bernard Lorjou, whom Domenica tried her best to promote, his work did her discernment as much credit as a Leroy Neiman might today.

Although she had supposedly put a stop to her extracurricular affairs, Domenica embarked, in 1955, on a romance with a mysterious doctor in his forties named Maurice Lacour—as cold-blooded and self-seeking a creature as herself. Lacour came from a notoriously reactionary family. He and his father had both been members of an ultra-right-wing group known as the Cagoules, and he continued to meddle in Fascist intrigues. His medical credentials were equally disturbing. He claimed to be a homeopathic practitioner, a psychiatrist, an acupuncturist, a "hypnoanalyst," and a guardian of "the secrets of Siberian shamanism." These mystical skills were rumored to be a cover for the drugs that made this Doctor Feelgood very popular with rich, frustrated women. No doubt about it, the drugs he prescribed for Domenica alleviated the pain of rheumatoid arthritis, which would eventually cripple her. She was soon so hooked on Lacour's services that she arranged for him to move into the building on Avenue Gabriel and travel with her and her husband on their seasonal moves to a chalet in Megève, the Hôtel Mamounia in Marrakech, and the Hôtel du Cap in Antibes. Jean Walter objected ("I'd willingly throw him out of the window," he told friends), but to humor his wife—or, more likely, to ward off her terrifying rages—he agreed to the arrangement and even allowed Lacour to treat him for his cardiovascular ailments. Walter's chauffeur later reported that Lacour's medications had made his boss so anemic that his blood pressure had dropped to a dangerously low level.

Domenica also became very friendly with an exceedingly rich philanthropist named Margaret Biddle. Mrs. Biddle, who had been born around 1900, was the only daughter of Colonel William Thompson, a mining promoter of genius from Alder Gulch, Montana. After his death in 1930, she inherited a major slice of the Newmont Mining Corporation, one of the largest producers of lead and zinc in the United States. Her mother had brought Margaret up to

be "a perfect lady," and she had succeeded almost too well. Impeccably dressed and jeweled, and installed in one of the most stylish houses in Paris—the work of the celebrated decorator Stéphane Boudin—Mrs. Biddle belonged to a tight little band of expatriate fashion addicts who worshiped at the shrine of Parisian chic. Unlike most of her ilk, she was a nice enough woman and no fool. She had two children by her first husband, Theodore Schulze, and none by her second, Anthony Drexel Biddle, a former U.S. ambassador to Poland. Jean Walter had become Mrs. Biddle's business partner when the Newmont Mining Corporation acquired 49 percent of the Zellidja Mining Corporation's shares.

Domenica seldom let Mrs. Biddle out of her sight. The two women talked of launching a Paris newspaper together. They patronized the same couturiers as well as the antiques dealers and decorators who were advising Mrs. Biddle on the "Vermeil Room"—an antechamber given over to a display of silver-gilt beakers and dishes—that she was presenting to the White House. They also went to the ballet and opera together. On June 8, 1956, Domenica and her brother, Jean Lacaze, took Mrs. Biddle and Dr. Lacour to a gala at the Opéra in honor of the King and Queen of Greece. Mrs. Biddle seemed in excellent health and spirits. It was all the more shocking, then, that after returning to her house on the rue Las Cases—escorted, possibly, by Lacour—she fell into a coma and died of a cerebral hemorrhage. Her office had been ransacked and a dossier stolen, so foul play was suspected, but no action was taken. Three years later, when Dr. Lacour was accused of conspiring to murder Domenica's adopted son, there would be an investigation into Margaret Biddle's death and an autopsy. Nothing criminal would emerge.

The next victim would be Jean Walter. This self-made man had inherited little from his Mennonite father, a small-time builder, but puritanical principles and a passion for work. He had made his first fortune as an architect of hospitals, housing developments, and luxury apartment buildings, before becoming an even more successful mining magnate. To give other poor kids a start in life, Walter set up a foundation that made three hundred annual grants of 20,000

francs each to young men "with a taste for adventure." The more enterprising ones were then given larger grants and, eventually, jobs in the Zellidja Mining Corporation. Walter hoped that the children of his first marriage (a son and two daughters) would prove as much of a credit to him as he had proved to his exemplary father, and in return for generous settlements he asked them to cede their shares in the Zellidja corporation to his foundation. The daughters—one of them the wife of Philippe Lamour, a brilliant entrepreneur whom Walter had appointed to the Zellidja board—would do so and live to regret it. The son, Jacques, who had spent much of his life in Morocco directing the mine, was more obdurate. He retained his share. Although anything but philanthropic, Domenica welcomed these dispositions. She would later manipulate them to her advantage.

Events would all too soon play into her hands. On June 11, 1957, she and Jean Walter, accompanied by Lacour, drove from their country house in Dordives to lunch at nearby Souppes-sur-Loing, where Walter planned to go fishing. After parking the car, he crossed the busy Route Nationale 7 to buy a newspaper and was blindsided by a car. The impact threw Walter into the air, and he came down heavily on his head, cracking his skull. He was still alive when Domenica and Lacour ran out of the restaurant. Lacour took charge. Weakened by a recent heart attack, Walter died while being attended by him in the ambulance. Inevitably, there was talk. Walter had been much loved, and Domenica's affair with the creepy Cagoulard doctor was common knowledge.

The widow went fast-forward into action. A day or two after Walter's death, she and her elegant, obedient brother, accompanied by his secretary and Lacour, arrived at the Zellidja offices at a time when there was nobody around but a doorman. They shut themselves in Walter's sanctum and literally took over. A few weeks later, Domenica came up with an unconvincing testamentary letter, supposedly written by Jean Walter, but probably written by her. (Their handwriting was very similar, and she had often forged his signature on checks.) The letter dismissed his trusted son, Jacques, and son-in-law Philippe Lamour from the board of

the well-endowed foundation, in which Walter had taken so much pride, and appointed Lacour, whom he had loathed, in their place. The devious doctor turned out to have political aspirations. In his new capacity, he proposed a philanthropic enterprise—a dormitory for Algerian students at the Cité Universitaire in Paris. This project would promote his prospects in a forthcoming election and also, it was rumored, provide a cover for drug trafficking. Nothing came of it.

Now that Jean-Pierre's principal protector was out of the way, Domenica and her lover decided to have her adopted son murdered. He was coheir to the Guillaume fortune and collection, and who could blame him for wanting to assert his rights? Jean-Pierre was also inconveniently close to Walter's children, who hated their stepmother for having cheated them out of much of their inheritance. Given Lacour's contacts with militant fanatics, he was well placed to find a gun for hire. He approached a friend by the name of Armand Magescas, who was the managing director of the right-wing magazine *Jours de France,* and explained to him that it was their patriotic duty to eliminate a disreputable young man who was causing his distinguished family much grief. Magescas was most accommodating. Far from being the least bit shocked at the idea, he, too, it turned out, had a notoriously unsatisfactory son. Magescas had just the right man for the job: a former Resistance hero, the much-bemedaled Commandant Camille Rayon, who had won fame during World War II as "the Archduke."

Rayon had recently opened a fish restaurant in Antibes, La Maison des Pêcheurs, and was in desperate need of extra backing. He was delighted to meet Lacour, who claimed to be acting on behalf of a very powerful family. The blood money for killing this boy, who was such a disgrace to his parents, his country, and the army that he did not deserve to live, would be 10 million francs (about $24,000 at the time). If one can believe Rayon, which is not always possible, he was horrified at the notion of killing a young parachutist who had been fighting for his country in Algeria. However, instead of reporting the matter to the police, he decided to string Lacour along while he worked out a way of exploiting the situation to his own ad-

vantage. He requested an advance of 3 million francs on a payment
of 20 million francs, plus a further 20 million francs for a mortgage
on his restaurant. Lacour made a counteroffer of 30 million francs.
The haggling continued. Although as yet unaware of the principals'
identities, Rayon realized that, whoever they were, they could not
afford a scandal and would pay to avoid one. And so he agreed to go
along with Lacour's plan without any intention of acting on it.

As long as Jean-Pierre was serving in the army, the murder was to
take place in Algeria. After his demobilization, the venue was
switched to Paris, where the victim was staying with Jacques Walter
while training to be an airline steward at Orly airport. Rayon came
up with various scenarios. A hunting accident at Philippe Lamour's
country estate—too dicey. Drowning at sea—too complicated.
They finally agreed in January 1958 that Rayon would tail Jean-
Pierre as he drove back from a training session at Orly and find a
pretext for intercepting and killing him. As a precaution, Rayon had
asked an old friend from his Resistance days, Alexandre Trucchi, to
accompany him as a witness.

Then, instead of actually doing away with Jean-Pierre, they took
him to dinner and convinced him that he was in mortal danger, and
that his only hope of surviving and making some money was to go
along with Rayon's plan of a simulated abduction and murder. Jean-
Pierre finally agreed, on condition that Jacques Walter and Philippe
Lamour approved of the scheme. They did. The following day
Rayon consulted a close friend of his, the prominent Gaullist
lawyer René Moatti, who also gave his approval. However, now that
Rayon knew who was involved, he got greedy. Why shouldn't he
shake down Domenica's brother, Jean Lacaze, for many more mil-
lions of francs?

Rayon and Trucchi went ahead and "abducted" Jean-Pierre—
that is to say, they registered him under a false name at the Hôtel
Claridge. Twenty-four hours later, Rayon met Lacour by arrange-
ment outside the *Figaro* newspaper building and informed him that
he had had Jean-Pierre strangled and thrown into the Seine. As
proof, he handed over the "dead man's" revolver and identification
papers. Rayon was shivering so badly with fright that Lacour had to

get him a tranquilizer from a drugstore. The gallant go-between seems finally to have realized that he was double-crossing some very dangerous people. "Bravo, Commandant," Lacour said. "You have done your country a great service. I will run and get you your money." Later that afternoon Lacour handed over 4 million francs, and the following day a slightly smaller sum, all in old bills. He promised to arrange the mortgage payments later in the year in installments of 10 million francs. Only then did Rayon and Jean-Pierre take the Blue Train to Antibes.

Jacques Walter, who was kept informed of every move, let a few days pass before informing Domenica, via her brother, that Jean-Pierre had disappeared. She did not alert the police—"Useless," she said. Instead she took the more cautious step of notifying a highly placed friend in the Ministry of the Interior. The following day, February 7, Jean-Pierre Walter's family gathered for the transfer of his body from Fontainebleau to a Paris cemetery. Philippe Lamour took advantage of the ceremony to inform them (Domenica was not present) that Lacour had paid a hired gun 10 million francs to murder Jean-Pierre, and that the plot had been foiled.

Three days later, on February 10, Maître Moatti convened a meeting at which Jean-Pierre formally accused Lacour of plotting his death—a charge that was immediately submitted to the public prosecutor. Over dinner that same evening, Jacques Walter informed Domenica's brother that her son was in fact very much alive. As a result of Jean-Pierre's charges, detectives appeared at his mother's apartment and took Lacour away for questioning. Domenica was questioned separately at home. Both claimed that, far from being guilty of plotting a murder, they were being set up by Jean-Pierre and Rayon, who, they claimed, were crooks and blackmailers.

A judge by the name of Batigne was put in charge of the case, and for the next eight months he presided over an exhaustive investigation. Apart from Jean-Pierre and the Walter family, most of the people involved turned out to be venal or untruthful or both. Moatti, who was acting for Rayon, did what he could to muddy the waters. Mainly, he drew public attention to Lacour's possible involvement in the deaths of Margaret Biddle and Jean Walter. But, like most of

the people connected to the case, the lawyer had his own agenda, though what exactly it was—beyond earning a very fat fee and advancing his political career—is unclear. Although two other criminal investigators arrived at radically different conclusions, Judge Batigne finally dismissed the charges. There simply wasn't enough hard evidence to support an indictment. However, that was by no means the end of the affair.

After the failed assassination attempt, one might have assumed that Domenica and her henchmen would leave Jean-Pierre in peace. Not at all. In her determination to disinherit him and if possible revoke his adoption, Domenica had yet another go at destroying him. This time she left the dirty work to her blindly adoring brother, Jean Lacaze, instead of Lacour. Once again the plot, which involved suborning Jean-Pierre's dazzlingly pretty, awesomely stupid mistress—a call girl named Maïté (short for Marie-Thérèse) Goyenetch—would blow up in Domenica's face. After Lacaze offered her $30,000 to falsely accuse Jean-Pierre of living on her immoral earnings, Maïté did indeed go to the police—not, however, to implicate her lover but to accuse Lacaze of trying to bribe her. As a result, detectives tapped the telephones of Domenica and Lacaze, who was promptly arrested and jailed.

Although the first scandal—"L'affaire Lacour," as it came to be known—was downplayed by the press, the second scandal, referred to as "L'affaire Lacaze," caused a public furor that would last for more than six months and recycle the dirt from the previous case. Lacaze was soon released from jail on grounds of ill health. Domenica and Lacour prudently fled to the Hôtel Mamounia in Marrakech. Judge Batigne was brought back into the case to start yet another investigation. Maïté's pretty face was emblazoned on the front page of every French newspaper.

As more and more marginal characters became involved and new charges and countercharges were made, the plot did not just thicken; it coagulated. The climax came when Domenica and Lacour returned from Marrakech and told a lot of flagrant lies at a press conference at the Ritz. Once again they claimed that Jean-Pierre was the villain and that the whole matter was an elaborate

hoax on his part to extort money from his mother. This time Judge Batigne believed the son and not the mother, and Lacour was sent to prison, where he remained for six months. Thanks to powerful friends and lawyers, Domenica managed to stay out of jail.

In the end, a deus ex machina materialized in the form of André Malraux, minister of culture in Charles de Gaulle's newly constituted government. An old friend of Domenica's, Malraux was eager to solve her problems, and even more eager to acquire her collection for the nation. Why not kill these two birds with one stone— prevail upon the appropriate division of the Ministry of Justice to drop all the charges in exchange for a gift of the paintings to the Louvre? There was only one obstacle. Malraux's arrangement smacked of the bad old days of the Fourth Republic, when the government had been rife with corruption. De Gaulle and his wife, Yvonne, stood for a new morality, in which rich people were no longer above the law. In accord with Gaullist virtue, the collection would have to be sold—not given—to France. And sold it was, for a fraction of its real value. Malraux offered Domenica the Légion d'Honneur, but to her credit she refused it, saying, "That bit of red ribbon can do as much to ruin a woman's getup as the wrong hat."

Since the judge was denied the prospect of prosecuting the culprits, the whole truth will never be known. Otherwise the principals in the case got pretty much what they wanted. Details of the settlement were never divulged. All we know for certain is that the charges against Domenica and her brother were dropped. As for Lacour, after his release from jail he was kicked out by Domenica. He took up with a ravishing Guadeloupean actress, Judith Aucagne, who soon became his wife. (At the celebrations for the independence of Algeria in 1962, Lacour and his wife would be seated in the front row of the presidential box.)

As soon as the scandal died down, Jean-Pierre became a journalist and photographer and went to work for *Paris Match*. Despite all that had happened, Domenica went ahead and tried to have him fired, but Jean Prouvost, the owner, rallied to his side, and he went on to have a successful career as a freelance press photographer for *L'Express* and other papers. He settled down, married a Dutch

woman, and had a daughter. And then, in 1979, Jean-Pierre decided to make a new life for himself in America. He married an American woman, had two more children, and became a farmer. He also took up flying and bought himself a plane. He currently lives in a small town in North Carolina but contemplates retiring to France. For someone who had narrowly escaped death at the hands of a murderous stepmother and been the innocent victim of an enormous public scandal, Jean-Pierre has remained singularly free of grudges. When, some years after the *affaire,* he was told that Domenica was lonely and wanted to see him, he paid her a visit. It turned out that all she really wanted from him was a repudiation of his adoption in exchange for cash. After Domenica's death, he would finally inherit a part of his patrimony. I say patrimony because Jean-Pierre is convinced that he is Paul Guillaume's son—there is a certain physical resemblance—although he has never been able to establish the identity of his real mother.

As for the Walter family, they sold the Zellidja mines to the King of Morocco for a surprisingly large sum, considering they had been virtually emptied of lead. As a result the town of Bou Beker, which Jean Walter had conjured out of the desert, once again became nomads' land.

Domenica's looks were fading fast, her body twisted with arthritis. Her chauffeur complained of having to drive her up to the Place Pigalle at night to buy cocaine and opium balm for the pain, which had reduced her fingers to claws. Domenica replaced Lacour with someone more respectable, Jean Bouret, a Communist art critic who wrote some not very distinguished books about Picasso and other artists associated with the Communist party.

Meanwhile, Jean Lacaze had suffered a severe stroke and fallen even further under his sister's control. A drooling wraith, he was occasionally glimpsed being pushed around in a wheelchair by a little old lady, pudgy and lame but quite stylish. Domenica! When she died in 1977 at the age of seventy-nine, the Guillaume collection— what was left of it—finally took its place on the walls of the Musée de l'Orangerie. Ironically, the only real winner in this very, very French story was France.

Livia and Felix Klee in front of Paul Klee's *Pyramid* (1930),
photographed by Simon Brown, 1987

Klee's Inheritance

Paul Klee had every reason to loathe the Nazis. They had not only denounced his work as decadent, they had hounded him from his country to exile in Switzerland. Even there he, or rather his property, was at risk. Although he was a Swiss resident of partly Swiss descent and his naturalization papers had finally come through, he was technically a German citizen at his death in Bern in 1940. This meant that when World War II ended in 1945, the Allies had the right to appropriate his estate, including much of his best work, as enemy property. To prevent seizure, a group of Swiss collectors came to the rescue. However, in saving the estate from appropriation, they effectively expropriated the artist's son and heir, Felix, who was still a prisoner of war in Russia. To discover how Felix had won back at least a portion of his inheritance, I went to Bern to interview him and his wife.

Felix Klee did not marry his second wife, Livia, until he was seventy-four; however, they had known each other as children, and in certain respects children they remained. When asked to do a voice test for a tape recorder, the spry eighty-year-old put a finger in

his mouth and popped his cheek loud enough to scare the birds on the windowsill. Apropos nothing in particular, he kept his wife and visitors amused by conjuring up denizens of the zoo or the farm-yard or the Bauhaus with a wealth of whimsical mimicry. In the same spirit, he invoked his father's beloved cats: Bimbo, Negro, and Eskimo, for whom Klee had invented a special Joycean lan-guage.

Goblins guarding goblin treasure, Felix and Livia were both proud of being Bauhaus babies, brought up at the famous German school—founded at Weimar by Walter Gropius in 1919 and stamped out by Hitler in 1933—that was one of the principal cra-dles of the modern movement in art, architecture, industrial design, and much else besides. With Kandinsky, Feininger, and Moholy-Nagy, Paul Klee had been one of the early teachers of art and, no less important, artistic theory at the school. At the age of fourteen, his son, Felix, became the youngest *Bauhäusler* (pupil). Livia was the daughter of Hannes Meyer, the controversial architect who became director of the Bauhaus and, after failing to communize it, skipped to Moscow. No hothead, Livia stayed behind and became a dress-maker in Zurich, and did not get married until 1982, by which time she was nearly sixty. She continued to make her own clothes, she said, and proudly showed me an ingenious dress she had contrived out of two Lanvin towels. With her endearing appearance, like one of those one-within-another Russian dolls, Livia seemed to have stepped straight out of Paul Klee's fantasy world. She and her large, elderly husband behaved as affectionately as teenage honeymoon-ers, billing and cooing in Bärndütsch (Bernese dialect) in a way that evoked any number of the artist's droll titles. *The Inventress of the Nest* came instantly to mind.

In their modest apartment in a modest building in a modest sec-tion of Bernese suburbia, the Felix Klees lived modestly, as befitted these retiring goblins. A fruit dish on their dining-room table con-tained five ancient grapes wrapped in plastic—dessert? Poky rooms were crammed with a jumble of great art and everyday possessions that were sacrosanct by virtue of having belonged to, and above all been used by, the artist himself. Apart from the impedimenta of his

art, musical instruments had been closest to Paul Klee's heart. His grand piano had pride of place in Felix's living room; and perched on top of a cupboard was the violin on which the artist had played—Mozart for preference—every day until he became terminally ill. Arrayed in the kitchen was the artist's no less sacred *batterie de cuisine,* which had occupied almost as important a role in his life, for Klee was a highly professional cook (a métier learned from a French chef who had worked in his aunt's hotel). According to Felix, he would routinely regale his family with five- or six-course meals in the French or Italian manner. This expertise explains the culinary references in Klee's work and his somewhat culinary approach to the ingredients of art, not to mention the recipes in his journal for such things as "Barlotto," a kind of risotto he contrived out of barley and tomatoes, or his excellent Schweinsnieren ("melt butter, add onions, garlic, finely chopped—celery, small turnips, leeks, apples, stew gently in some water, circa ½ hour, at the end add pork kidneys in small pieces, raise the flame for a few minutes").

If the artist had been obliged to become an accomplished cook-housekeeper, it was because his wife was off all day giving music lessons to augment their income. Laundry, he wrote, is "the only household task I haven't tried yet. If I could take it on, I'd be more universal than Goethe." And so, instead of being neglected, like many children of great men, Felix was lovingly brought up—fed, nursed, bathed, exercised—not by his mother but his father, and a very doting mother his father proved to be. Countless entries in the "Felix Calendar"—the "baby book" that recorded the child's development—confirm how obsessively observant the artist was: "[Felix] imitates rotating objects onomatopoeically by *woo-woo-woo;* dogs by *hoo! hoo! hoo!;* horses by *co! co! co!* (with his tongue clicked against the hard palate); ducks: *heh! heh! heh! . . .*" Evidently Felix's little foibles never changed.

What with the demands of the baby, the violin, and the hot stove, it is a wonder that Klee had much time for painting. However, his industriousness matched his powers of organization, and the works piled up, revealing the inordinate variety of his pictorial repertory—botanical, theatrical, geometrical, zoological, topographical, ana-

tomical, musical—as well as the inordinate variety of his techniques. The versatility and virtuosity are astounding. Nevertheless, Klee's limited existence—such as a Swiss watchmaker might lead—made for art that, for all its imagination, variety, and invention, can sometimes reduce human experience to a celestial-toy-town level. The cosmos envisioned in a teacup! The music of the spheres rendered on a glockenspiel! As I see it, Klee kept so far within the limits of his (admittedly great) gifts, and so seldom reached out for the unreachable, that his work is apt to be almost too perfect, too pat, too contrived. It was only at the end, when he was struck down by mortal illness, that Klee gave up looking at life through a watchmaker's lens and devised simpler, more profound imagery that dared to face up to death. That is when his work came ominously, magnificently, into its own.

In the long run Felix probably suffered as much as he benefited from his worship of and identification with his benevolent tyrant of a father. He aspired to be a painter and developed a style that was much like the artist's, to differentiate his work from his father's, he signed himself "Felix," never Klee. However, Klee was too wise not to foresee the traps that lie in wait for the sons of genius and discouraged him from following in his footsteps. For all the encouragement he had lavished on Felix's childhood drawings, even mounting them like his own and exhibiting them, he urged his son to pursue his other avocation, drama—but not, as one might have expected, with the Bauhaus's great dramaturge, Oskar Schlemmer. "My father did not want me wasting my time with a lot of avant-garde bums," Felix says. If he was to make his way in the theater, he could do so only by way of the German equivalent of Broadway. In 1926 Felix left the world of art for the commercial stage.

Paul Klee stayed on at the Bauhaus, where teaching and theory had come to play almost as important a role in his work as the practice of art. Although his students held him in such awe that they called him "the heavenly Father," nobody gained more from the novel ideas that he developed than Klee himself, as the work of his Bauhaus years (1921–31) bears out. Drawing on his mathematical and scientific (primarily botanical) skills, he came up with a re-

markable theoretical text, the *Pedagogical Notebook,* illustrated with studies that are magical as conjuring tricks but precise as equations. In the twenties Klee had his first successes abroad, notably in America, but it was above all in Germany and Switzerland that he won the greatest recognition. He had become such a prophet in his own country that on his fiftieth birthday (1929) aeronautical engineers from the nearby Junkers factory fêted him by flying over his house and dropping flowers and presents onto the roof, which gave way under this benign bombing and caused havoc in the studio.

For all his stardom, Klee also came under violent attack from the Nazis for supposedly being a Galician Jew—he wasn't—and an *"entartet"* (degenerate) artist, which he also wasn't, though he regarded both categorizations as an honor. Then, in 1933, storm troopers broke into his house at Dessau, ransacked it, and made off with some papers, which Frau Klee boldly forced them to return. It was time to emigrate. On December 23, 1933, the Klees left Germany for Bern, where the artist had spent the first twenty years of his life and where his sister and father still lived. Felix and his Bulgarian wife—the singer Efrossina Gréschowa, known as Phroska—foolishly decided to remain in Germany. He says he wanted to pursue his budding career in the theater; I suspect he also wanted to cut the psychic cord that connected him with his father.

Although the artist continued to provide his son with financial support, he was very concerned that he chose to stay on in Nazi Germany. And with good reason. It would turn out to be a disastrous mistake and would cost Felix much of his health as well as much of his inheritance. Not that Klee's son was ever a Nazi—he remembered longing to kill Hitler when he saw him at the opera—but in order to survive in the German theater he was obliged to keep in with the Party. This was especially necessary in Felix's case: besides denouncing his father, the Nazis sequestered 102 Klees in German museums; 17 of the paintings were included in the notorious "degenerate" art exhibition held in Munich in 1937. Who knew what steps they might take against the son? Survive Felix did, thanks to a succession of lowly jobs in the theater and funds sent from Switzerland.

Shortly after moving to Bern, Paul Klee contracted measles, which brought in its train all kinds of complications, including the rare disease of the mucous membrane (scleroderma) that ultimately killed him. "Is Europe limping or am I . . . ?" he asked around this time, as the imminence of death coupled with the imminence of war spurred him on to work more obsessively and on a larger scale than ever before. The great late paintings reveal Klee scaling new heights and plumbing new depths as he wrestled with the angels and devils lying in wait for him. "Like Mozart, [he] wrote his own requiem" is how his biographer, Will Grohmann, put it. When Klee died, on June 29, 1940, at the age of sixty-one, he left not only a neat apartment complete with his sacrosanct grand piano and violin but a neat studio neatly stacked with treasure—most of his best work. There was also a formidable widow, Lili.

Back in Germany, Felix managed to keep out of the army until the last year or so of the war, on the grounds that he was needed on the home front. Despite the birth of a son, Aljoscha, in 1940 (Aljoscha now lives mostly in France and paints under the name Ségard), Felix was drafted in 1944. After being sent to the Russian front, he was taken prisoner on May 8, 1945, but not registered as such. He was listed as missing in action.

Let us, however, leave poor Felix in Russia and return to neutral Switzerland. With victory more or less assured, the Allied powers—especially the Americans—had bludgeoned the Swiss into signing the Washington Agreement (May 1946): a commercial treaty that obliged the Swiss government to turn over to the Allies all German assets held in Switzerland. Anything that was not in the form of cash had to be sold by the Swiss, and the proceeds paid to a *Verrechnungsstelle*—a special department set up for this purpose. Although Klee had been half Swiss, had spent half his life in Bern, and had been fanatically anti-Nazi, he was not legally Swiss—his naturalization papers had come through, but he had been too ill to go and sign them. And so his estate (like that of Kirchner, another famous German artist who died in Switzerland) was subject to the Allies' ruling. That Klee's son and heir had served in the German army cast a further shadow over the case.

The Allies thus had a strong legal claim to whatever moneys could be realized from the sale of Klee's estate. As a further complication, the estate included a great many items that the artist had marked "*Sonder-Classe*" (special category), that is, masterpieces that were *not* to be sold. If this vast accumulation—vast in value as well as quantity—were to be thrown onto the sluggish postwar art market, the artist's work would be cheapened, and the city of Bern deprived of what local art lovers had come to regard as part of their cultural heritage. How could this disaster be circumvented?

A friend of mine, the late Rolf Bürgi—one of the artist's most supportive patrons—came up with an ingenious solution. Armed with a power of attorney from Klee's widow, Bürgi rallied three local collectors—Hermann Rupf, Hans Meyer-Benteli, and Werner Allenbach—and formed a Klee *Gesellschaft* (Klee Society). Thanks partly to some high-powered string pulling by Bürgi's close friend the British minister to Bern, Sir Clifford Norton (whose wife was an ardent Klee fancier), the Gesellschaft was able to acquire the entire estate—besides the Klees, works by Kandinsky, Feininger, and Jawlensky—for some 250,000 Swiss francs (in those days about $60,000). This was paid into a special frozen account set up to legitimize the deal and satisfy any possible claims on the part of the Allies. Given that a top-quality painting would now fetch around $1 million, a top-quality watercolor around $300,000, and a top-quality drawing around $75,000, the value of the estate today would be close to half a billion dollars. This deal was perfectly legal, and morally defensible to the extent that Bürgi and company believed Felix to be dead.

Everybody involved kept the story of the Klee inheritance so secret that rumors abounded: for instance, the Gesellschaft was said to have offered the entire estate for several times the purchase price to a prominent Swiss collector. I doubt it. The partners behaved honorably in setting up a *Stiftung* (foundation), consisting of the cream of the collection—40 paintings, 150 colored works on paper, and 1,500 drawings—which they vested in the Bern Museum, where it remains to this day.

The gang of four behaved less honorably—although quite

legally—when they rewarded themselves for their initiative by acquiring many choice items for their private collections from the Gesellschaft at their own valuation, and by discreetly putting a number of works from the same source on the market. Certain dealers did very, very well out of this situation. So did certain collectors: the British collector Douglas Cooper for one, as I discovered when we went to Bern together around 1950. Of the remarkable watercolors offered to us by Bürgi, Cooper bought four or five, one of which, *Feuerwerke,* he gave me. Three hundred dollars is what it cost, and I regretted some years later having to sell it in order to buy an even more remarkable Braque. Ten times what the *Feuerwerke* had cost seemed like a good profit, until I discovered that the late G. David Thompson, the speculator-collector to whom I had sold it, had employed an unscrupulous restorer to enlarge the background, thus adding one if not two more zeros to its value.

Heinz Berggruen, the celebrated dealer and collector who donated ninety Klees to the Lila Acheson Wallace Wing of the Metropolitan Museum of Art, has an interesting story to add to the Felix Klee saga. "In 1945–46, I was an information-control officer with the U.S. Army," he remembers, "and I was stationed in Munich. Karl Nierendorf, the New York dealer in modern German art, had heard about the Klee Gesellschaft and asked me to keep an eye on things. Communications were chaotic, but Nierendorf had contacts all over Europe and was often better informed in New York than we who were on the spot. All the same, what a surprise, one summer's day in 1946, when Nierendorf called from New York with the news—God knows where he got it—that Felix Klee was not dead, as we all thought, but alive in a Russian prisoner-of-war camp, and about to be released. Nierendorf had managed to get a message to Felix: that as soon as he was repatriated and able to rejoin his wife and child, who were living in the Munich area, he should contact me, and I would give all necessary assistance.... When Felix materialized [September 1946], he was in sorry shape. You never saw anyone so dirty, hungry, and ragged, but we clothed him and fed him and put him up in our luxurious Schwabing villa."

Berggruen says that he cabled the good news to Felix's mother in

Bern. "But to our amazement we got no reply from her. This was puzzling, since she had been worrying herself to death over her son's fate. What could have happened? As usual it was Nierendorf who came up with the explanation. So elated was the ailing Frau Klee to hear her son was alive that she suffered a relapse and died before being able to cable or telephone, let alone see her son again." Like her husband, she died shortly before her Swiss naturalization papers came through. An eerie postscript to this eerie story: a few months later, at a dinner in New York given by Grete Mosheim (a well-known German actress married to an American businessman), Nierendorf had just finished telling his fellow guests about Felix Klee's dramatic reappearance, and his mother's dramatic demise, when he in turn expired.

Felix was horrified to discover on his mother's death that a group of his father's patrons had done him out of his inheritance. After two years of frantic effort, he finally obtained a pass from the Americans and a visa—valid for only three months—to visit Bern and institute legal action. In later years, Felix was still too full of hurt and outrage to be able to discuss this episode with any detachment. He claimed that the sponsors of the Gesellschaft had created difficulties for him with the Swiss authorities, who had been led to believe that he was a former Nazi and member of the SS. Supportive friends helped Felix bring a case against the Gesellschaft—no easy task, given that he was without money and, for some time, work. In the end he managed to support himself and his family and pay legal expenses by directing plays for Swiss radio. After four years of litigation, the case was settled in 1952.

The Swiss courts dissolved the Gesellschaft. In exchange for accepting the existence of the Stiftung and its ownership of all the works in the Bern museum, and for condoning the dispensations made by the gang of four, as well as settling with the Verrechnungsstelle, Felix was awarded everything that remained in the estate. And a great deal did. He was lucky in that his share turned out to include a number of the late masterpieces—"difficult" symphonic works, which in the blinkered fifties were deemed inferior to the intricate chamber music of Klee's earlier period, hence less

popular with the Gesellschaft and its customers. All that was to change. Fifty years after Klee's demise, it was possible to see that in works such as his last masterpiece, *The Angel of Death*, which had a place of honor in Felix's living room, the artist had delved deep into the mystery of death. "All of a sudden everybody wants a late painting," Felix said. "Too bad none of mine are for sale."

Felix was particularly happy to have recovered the set of thirty spooky puppets that his father had made for him out of odds and ends (matchboxes and discarded lamp sockets) when he was teaching at the Bauhaus. If Felix was averse to lending these curiosities to exhibitions, it was because they were still his toys—the dramatis personae of his childhood. To watch this ex-*Bauhäusler* put on a falsetto voice and mimic the shrieks that these puppets once made was to be wafted back seventy years or so to the heyday of German modernism. For all its pedagogical seriousness, the Bauhaus evidently countenanced farce.

Although the 1952 settlement brought an ugly situation to surcease, Felix's resentment never abated. He could not bring himself to forgive Bürgi and company for betraying him at his hour of greatest need any more than he could accept the fact that they had saved his father's oeuvre from confiscation and dispersal. To the end of his life, Felix railed at the injustice of his fate, at not being his father's sole heir. There was indignant talk of swindling and skullduggery, as if the Klee affair had been another Rothko affair, whereas it had been a typical small-town story (though a capital, Bern is very *kleinstädtisch*)—a story of local piety tainted with the smug, self-righteous avarice peculiar to Switzerland. Felix's resentment did not stem from greed—he and his wife were all too evidently unconcerned with material things—it stemmed from a sense of loss, not so much of the cream of his father's crop as of control over it. In diminishing Felix's birthright, Bürgi and company had effectively diminished his role as guardian of his father's genius. Appointment to the presidency of the Klee Stiftung did not exorcise Felix's feelings of deprivation. His only consolation was to keep the sacred flame burning at maximum intensity in his snug suburban shrine.

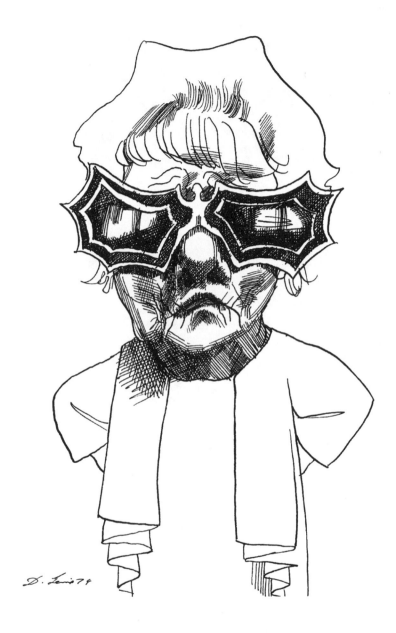

Peggy Guggenheim, by David Levine, 1977

Peggy Guggenheim's Bed

In the 1950s my friend Douglas Cooper, the British collector, and I would stay with Peggy Guggenheim in her palazzo on the Grand Canal every other year for the Venice Biennale. Staying with Peggy was fun—deep down she was a clown: an endearingly sad one of the "He who gets slapped" variety—but it was also a bit of an ordeal. Enjoyable as it was to have a comfortable bedroom a few feet above the Grand Canal, guests had to ready their quarters every afternoon for the tourists who would troop through every room except the kitchen. If you stuck around, people would ask questions. Was the place an annex of the Biennale? Were there rooms to let? Was Picasso Italian? Where was the loo? Was the signora Guggenheim alive, or had she gone down with the *Titanic*? Visitors would be surprised to discover that the woman with the boot-polish-black hair selling catalogues and tickets and greedily counting and recounting the receipts was the lady of the house.

Lunches in the shady garden at the back of the house would have been more delectable had the food been better. As Peggy's curator John Hohnsbeen has described, meals usually consisted of canned

tomato soup followed by an insipid goulash, followed by a dietary chocolate mousse. The wine was so poor that the scarcity did not matter. On the other hand, the long afternoon rides around Venice in Peggy's gondola—the last privately owned one in Venice—were an incomparable treat, not least for Peggy, who enjoyed being the target of tourists' cameras whenever we passed under a bridge. Back at the palazzo we would have the thrill of going through Peggy's stash of Jackson Pollocks, which in those days were a rarity in Europe. Quite a few were for sale very reasonably. Peggy repeatedly offered me a largish drip painting for $10,000—"you'll regret not buying it." She was right; alas, I didn't have the cash.

In the course of our dreamy gondola rides around Venice, Peggy would embroider on the stories that she had published in her memoir, *Out of This Century.* Just as she had in print, she revealed a phenomenal gift for trivializing the tragic or the serious. Like Andy Warhol, she knew how to make inanity work for her. Even her patronage of modernism turned out to have been motivated, primarily, by family one-upmanship and sexual quid pro quos. The artists from whom she bought paintings were expected to include their favors as a bonus. Despite or because of this proviso, she managed to amass a lot of very good art.

Peggy's enjoyable account of life on the fringes of Surrealism recalls the great slapstick moviemaker Mack Sennett. Everything is accelerated to the speed of farce. People race from bedroom to bedroom, studio to studio, vehicle to vehicle for no apparent reason; in the absence of custard pies, bottles of wine and bits of fish hurtle overhead. Those little jackanapes rushing about in the background are not Keystone Cops but Surrealists; what is more, *she* is chasing *them.* As for the solemn Buster Keaton–like character (named Oblomov in the first edition of her memoir) whom Peggy pursues, he is none other than Keaton's great admirer young Samuel Beckett. When cornered, he and another young man would solemnly exchange clothes in front of her.

Peggy had little time for women. "I don't like [them] very much," she says in her memoir, "and usually prefer to be with homosexuals if not with men [*sic*]." But the "Athenians" or "pan-

sies"—her euphemisms date her—whom she tried to convert to heterosexuality had a way of leaving their proselytizer dry and high. "I am furious when I think of all the men who have slept with me while thinking of other men who have slept with me before." By almost the same token Peggy was apt to find even her straight lovers a letdown. But then, in life as in her memoir, she had a way of selling herself short.

Apart from sex, boredom was another driving force in Peggy's art collecting. "In the winter of 1920, being very bored, I could think of nothing better to do than have an operation performed on my nose." Unfortunately her bone structure did not permit a nose "tip-tilted like a flower," and she emerged from hospital in Cincinnati more bored than ever with a nose that swelled up in bad weather. Even the German invasion of France, where Peggy found herself twenty years later, did not deliver her from the ennui endemic to poor little rich people, as she relates with the disconcertingly dead-pan humor—shades of Anita Loos—that gives these memoirs their artless (Gore Vidal says artful) flavor:

> During the summer [1940] I got rather bored and started having my hair dyed a different color every few weeks to amuse myself [*sic*]. First it was chestnut . . . (then) bright orange . . . (then) black. As a result . . . I conceived a sort of weakness for the little hairdresser who worked so hard on my beauty. From re-reading D. H. Lawrence I also got a romantic idea that I should have a man who belonged to a lower class . . . Later . . . I was ashamed of him and kept him hidden . . . Soon this got boring and I needed a change. There was not much choice. The only other man about was an old fisherman, who looked like Brancusi . . . There was also a very amusing pansy who lived on the top of our hill . . .

Before propelling Peggy into hair dyeing, boredom had launched her into art collecting. Around the time of her fortieth birthday a miserable love affair (a young Englishman had jilted her for the Communist party) had left her at a loose end. What sort of therapy

would rekindle her spirits? Hitherto Peggy had favored writers rather than painters. A publishing house? Too expensive. She opted instead for an art gallery, which she provocatively named Guggenheim Jeune (a pun on Bernheim-Jeune, the famous Paris dealer). This had the advantage of enabling Peggy to compete with her "wicked" uncle Solomon and his mistress, Baroness Hilla Rebay, who were in the process of setting up a Museum of Non Objective Art in New York. Peggy wanted to avenge herself on her uncle for edging her feckless father—who had gone down on the *Titanic*—out of the family partnership, thus leaving her and her two sisters the least rich members of the Guggenheim family.

Peggy put a Surrealist jack-of-all-trades called Humphrey Jennings in charge of her gallery. He doubled as a lover. Emily Coleman had offered him to Peggy, "as though he were a sort of object she no longer required. And I took him in the same spirit." Jennings naïvely thought he was on to a good thing: Peggy records how she disillusioned him. She also confesses that she "couldn't distinguish one thing in art from another. Marcel [Duchamp] tried to educate me . . . He taught me the difference between Abstract and Surrealist art. Then he introduced me to all the artists." And indeed Peggy's taste in art was always to some extent dictated by her taste in men. If her pantheon bristled with figures such as Brancusi, Tanguy, and of course Duchamp, it was partly in their capacity as studio studs. On her own admission, lack of concupiscence disqualified Antoine Pevsner—the distinguished Constructivist had conceived a passion for Peggy—from inclusion in her harem: "as he was mouse, not man, I did not in the least reciprocate this feeling."

Art dealing did not keep boredom at bay for long. In March 1939, Peggy decided to further challenge her uncle Solomon and "the B." (for *bitch*, not *baroness*) by opening a museum of modern art in London. Brains were picked—mostly the British art pundit Herbert Read's—lists were compiled, and, as war clouds gathered over Europe, Peggy started to buy "a picture a day," as well as sculptures by Arp, Brancusi, and so on through the alphabet, almost but not quite to Zadkine. A man a day was also on her shopping list, she once told me, "but pictures were easier to obtain." Like a child let loose in a

supermarket, she grabbed whatever caught her rapacious eye, from the sublime to the kooky. With Marcel Duchamp's help she made many brilliant purchases and gradually learned to rely on her own judgment. Peggy's Parisian shopping spree got an extra boost from the outbreak of war. Prices tumbled, and Peggy, fearless as always, was spurred on by the discovery that she had little if any competition. The only problem was shipping her acquisitions out of occupied France to safety in the United States. Not for the first time sex came to the rescue of art: France's foremost shipper, René Lefèvre Foinet, saw to Peggy's twin needs. Sated and crated, collector and collection reached New York safely on Bastille Day, 1941.

Besides an ex-husband, his ex-wife, assorted children, and Surrealist hangers-on, Peggy's entourage included her next spouse: Max Ernst. Ernst was "cold as a snake," Peggy subsequently complained; so, up to a point, was she, at least in her concept of matrimony: "After Pearl Harbor . . . I did not like the idea of living in sin with an enemy alien, and I insisted that we legalize our situation." Deaf to her daughter's remonstrations ("Mama, how can you force the poor thing to marry you?"), Peggy had her way; "the ceremony was very simple and I did not have to promise to obey." The two egotists—three, if we count Duchamp, who sometimes stood in for Ernst—put up with each other for a year of strife, much of it enacted in public. "Peace was the one thing that Max needed in order to paint, and love was the one thing I needed in order to live. As neither of us gave the other what he most desired, our union was doomed to failure." She oversimplifies.

Meanwhile, Peggy buckled down to her "museum." The name, Art of This Century, was an overstatement (Fauvism and Expressionism were not the only major movements conspicuous by their absence), and also a shade pretentious, but Frederick Kiesler's bizarre installation of her collection in a top-floor loft on Fifty-seventh Street ensured instant celebrity. If Kiesler made the exhibits virtually impossible to see, so much the better. People flocked to stare at unframed canvases mounted on baseball bats, tilted at varying angles to the wall, and illuminated by spotlights that went on and off every three seconds. Elsewhere paintings and sculptures

dangled from the ceiling like so much laundry. For 1942 it was very far out, but it left Peggy at a disadvantage some years later when she railed against the building ("my uncle's garage") that Solomon Guggenheim would commission Frank Lloyd Wright to design for *his* collection.

For all Kiesler's inspired gimmickry, the Art of This Century gallery soon established a reputation for sponsoring serious exhibitions. No less important, it became a place where young American artists could mingle with older, more established artists and writers who had fled from Europe: School of Paris luminaries (Léger and Breton), Dutch modernists (Mondrian and van Doesburg), and Surrealists (Masson and Matta). Thanks partly to Peggy, the painters who were soon to be known as Abstract Expressionists would have firsthand contact with some of the pioneers of modernism. This transatlantic fusion would transform Peggy into a canny impresario of the most important art movement to emerge in America. "We had the great joy," she writes with justifiable pride,

> of discovering and giving first one-man shows not only to Pollock, Motherwell and Baziotes, but also to Hans Hoffman, Clyfford Still, Mark Rothko and David Hare. The group shows included Adolph Gottlieb, Hedda Sterne and Ad Reinhardt . . . We also gave one-man shows to Chirico, Arp, Giacometti, Hélion, Hans Richter, Hirshfield, Theo van Doesburg . . .

Peggy was no maecenas. The $150 a month she paid Pollock hardly justifies her frequently reiterated claim that she had been everything to him: impresario and mistress as well as muse. To believe Pollock's widow, Lee Krasner, "The idea of Peggy's dedication to Pollock was fanciful. She wanted him in her bed every night to prove [his gratitude]." As for *her* gratitude, when she closed down the gallery in 1948, she "left him high and dry . . . when other galleries would not take over the contract, she said bye-bye, hope you can swim."

"Much as I loved 'Art of This Century,' I loved Europe more . . . and when the war ended I couldn't wait to go back." Peggy

was wise to settle in Venice. Unlike Park Avenue, where Alfred Barr was encouraging a new generation of collectors to turn their apartments into mini-MOMAs, the Grand Canal was mercifully free of rival collectors. As a potential patron Peggy had the beautiful city and its group of lively if not very gifted artists all to herself. She soon settled into the bungaloid Palazzo Venier degli Leoni on the Grand Canal, of which only the *piano nobile* had ever been completed. More like a New York apartment than a traditional palazzo, this folly had a suitably sensational past. In the twenties, Marchesa Casati had entertained there surrounded by tranquilized leopards, drugged boa constrictors, and live putti coated with gold leaf. In the thirties, the formidably rich, formidably tough Elena Flick Hoffman had bought it and lavishly redecorated it for her girlfriend, Doris, Lady Castlerosse, the wayward beauty who had inspired Amanda in Noël Coward's play *Private Lives;* and who, if one believes Winston Churchill, "could make even a corpse come." Doris's palazzo is evoked in one of Cole Porter's satirical café society ditties:

> *And Venetia who loved to chat so,*
> *is still drinking in her sinking pink palazzo.*

Peggy could not have found a more appropriate setting for her collection and herself. By 1949 she had settled in.

On the great steps leading down to the Grand Canal, where her gondola was moored, Peggy, who knew how to advertise, installed a life-size Marini bronze of a naked equestrian. When nuns called, she would run out and unscrew the rider's detachable erection—"I don't want to overstimulate them," she said—until it was stolen by a desperate guest.

"Daisy Miller with rather more balls." Gore Vidal's description of Peggy in her palazzo period is apt, but she reminds me of a very different Daisy: Daisy Ashford, the Victorian child who wrote that naïve masterpiece *The Young Visiters (sic)*. Tennessee Williams likewise comes to mind, but Peggy had none of the self-destructiveness of the gigolo-obsessed protagonist of his great story *The Roman*

Spring of Mrs. Stone. Peggy's rapaciousness was proof against the most insidious of gigolos. They came to grief, not she. Whereas Rome was the undoing of Williams's Mrs. Stone, Venice was the making of Peggy. By throwing open her palazzo and her collection, not to speak of her person (as she was the first to admit), Peggy turned herself into not just a Venetian but an international landmark, as Vidal says, "a legend"—the perfect sublimation for an exhibitionist.

For a sharply observed glimpse of Peggy at this period in her life, we need only to turn to Mary McCarthy's caustic story "The Cicerone," about a rich American lady, Polly Herkimer Grabbe, going to bed with a not-so-young Italian—"another banana peel on the vaudeville stage of her history." "Miss Grabbe's intelligence was flighty . . . but her estimates were sharp": Peggy was appalled when the author read her the story. "You didn't put in my serious side," she complained. For better or worse, there wasn't one. *Out of This Century* reads as if it were written by a compulsive chatterer. So long as it provides private glimpses of public figures, her chatter holds our interest, but the stories are too often wacky ones about herself, usually with a banana-skin dénouement. Even when real disaster strikes—for instance, the loss of her father on the *Titanic*—Peggy's reactions are, to say the least, inane: "from then on we avoided the White Star Line like the plague." In mitigation we should take into account all the awful things that had happened to Peggy, above all the dramatic deaths of many of her nearest and dearest, including the suicide of her daughter Pegeen and her sister Hazel's Medea-like defenestration of her two little boys. Hence the protective thickness of skin and skull, the juggernaut of an ego, not to mention the goofy heart, which redeemed her.

Venice enabled Peggy to become something of a grande dame as well as more of a celebrity than she would ever have become in New York. The "signature" cigarette holder of the twenties went the way of the "signature" harlequin sunglasses of the sixties; the black of her hair gradually turned a more ladylike gray. Peggy never really aged, except in one significant respect. Blind acceptance of the avant-garde gave way to no less blind rejection of artistic devel-

opments that postdated her period of patronage. After 1950 Peggy bought virtually nothing of importance. Art, she insisted, had "gone to hell, as a result of the financial attitude." In other words, it had become too expensive. She was not the first modernist collector to resent the fact that modernism would outlive her. Far from supporting new developments, she inveighed against them.

> People blame me for what is painted today because I had encouraged and helped this new movement to be born . . . In the early 1940s there was a pure pioneering spirit in America. A new art had to be born—Abstract Expressionism. I fostered it. I do not regret it. It produced Pollock, or rather, Pollock produced it. This alone justifies my efforts . . . The twentieth century has already produced enough . . . Today is the age of collecting, not of creation. Let us at least preserve and present to the masses all the great treasures we have.

And on this proud, wrongheaded note, "L'Ultima Dogaressa," as Italian journalists sometimes referred to Peggy, bowed out of the modern movement. She had no choice; she was no longer a player.

It is easy enough to find fault with Peggy's inanity and starfucking, but there is much to praise in her achievement as not only a collector but also a catalyst and a pollinator. She was present in 1942 when Ernst invented "oscillation," that is to say dripping runny paint from a pierced can suspended above a canvas (for instance, Ernst's *Young Man Intrigued by the Flight of a Non-Euclidean Fly*); she was likewise around three years later when Pollock painted his first "drip" picture. Peggy never appreciated that she was unwittingly a link between these two events any more than she realized that, so long as the nascent New York School was cut off from the Paris School by war, her collection and her surreal bed, made of sterling silver jingle-jangles by Alexander Calder, bridged the Atlantic.

AFTERMATH

Cecil Beaton, *Self-portrait,* 1925

Beaton and Garbo

———

Cecil Beaton's memorial service at Saint Thomas's Church on Fifth Avenue (in March 1980) was tastefully staged—there were trumpets and Palestrina and a valediction by Irene Worth—but it did not play to a very full house. We ushers hung about inside the door waiting for hordes of elegant mourners. In vain. No stars of stage or screen materialized; nor (except for loyal Leo Lerman of *Vogue*) did any representatives of the magazines or theatrical managements or film studios on which Beaton had shed much luster. Likewise, precious few of the *gens du monde* whom he had drawn and photographed, flattered and diverted for fifty years or more made an appearance. I counted thirty-seven people in the church. And then, just as the organist broke into César Franck, a stretch limo drew up. Out stepped two dramatic-looking women—one quite tall, one quite short—each swathed in black, each leaning on the arm of an attendant: Anita Loos and Louise Nevelson. Two more striking mourners could not have been found; if only there had been a large marble urn against which to drape them—as Cecil might have said, "the long and the short of it." Cecil, who set much

store by his image, would have been pleased. However, the far-from-full church did not strike me as auguring well for posterity.

How wrong I was! Someone had simply forgotten to mail the invitations to the memorial service. And far from fizzling out, Cecil's star has been very much in the ascendant since his death, as have his prices. Too often dismissed in his lifetime as a chichi pasticheur, Cecil has emerged as something of a recording angel: like Warhol, an important witness to his time in that he was a natural photographer of great originality and sensibility whose influence crops up again and again in the work of a generation too young to have known him.

Successive auction sales of Beaton's vast stash of photographs and scrapbooks have done much to propagate his reputation; so has Hugo Vickers's biography (1985), which chronicles his life in all its aspects. The sheer volume of his subject's often amusing and scandalous but too often trivial diaries (145 volumes written over more than fifty years) must have been hard for Vickers to digest, but digest them he did, and the result is a fascinating recapitulation of Cecil's ephemeral career—the grit as well as the fluff of social history. However, no book, not even memory, can do justice to the snap, crackle, and hiss of Beaton's queer, dandyish wit: wit that at its best rivaled the firework effects of Jean Cocteau, and which harked back to the paradoxes of Oscar Wilde and the British tradition of high-camp malice whose tone is first heard in Restoration comedy.

Besides wit, artifice and improvisation played a major role in Cecil's makeup. Witness those early photographs in which he adapts the props and clichés of the old-time portraitist—the velvet draperies, the aspidistra on a plinth, the not-ever-to-be-sat-upon chair—to his own evocative purposes; or his sylvan settings in the *dix-huitième* manner, which were conjured out of silver mackintosh, bits of tinsel, and Michaelmas daisies dangling from the ends of billiard cues. The "Picturesque" tradition at its very last gasp. As for those bun-faced girls of good family posing romantically in the foreground, it is hard to believe that they are the very same gin-sodden Bright Young Things whom Evelyn Waugh was simultaneously portraying in *Decline and Fall* and *Vile Bodies*.

And how deftly Cecil set about improving every aspect of his own image, including his family's circumstances. The arbiter elegantiae of later years was entirely self-invented. In his early days he was a pretty, somewhat petulant youth who, when not fooling around with a camera, worked as a stringer for a gossip columnist, another Evelyn Waugh–ish phenomenon called Mrs. Whish. Any calling was preferable to the family timber business, which was run by Cecil's North London daddy, "an annoying old fool and rather a common fool at that," according to his son. Mummie was not much better until Cecil did her over, inside and out, from toque to shoe buckles.

Cambridge had brought Cecil out of the closet with a vengeance. In his pastel accessories, very noticeable makeup, and lacquered fingernails (one of them an inch and a half long), he was the parody of a 1920s sissy, forever swishing around in picture hats, trying to lure inebriated undergraduates—the better born, the better—into bed. "I'm the Gladys Cooper [Lily Elsie, Lillie Langtry, Gaby Deslys] of my time," he would boast in his weary, witty, faintly nasal drawl.

It did not take a social climber as bright and ambitious as Cecil long to realize that the drag had to go. Back to the closet it went, not to reemerge (for example, the bitchy photograph of himself in the guise of Lady Mendl) until he had outgrown the innate sissyness he had come to despise in others as well as himself. "I have always hated fairies collectively," he told the designer Charlie James. "They frighten and nauseate me and I see so vividly myself shadowed in so many of them." Cecil's fears and self-contempt fueled the rocket of ambition that propelled him into social and professional orbit. There were some embarrassing setbacks. During Lord Herbert's coming-of-age party at Wilton—the family's great seventeenth-century house—the twenty-three-year-old Cecil was pounced upon by three drunken "hearties" and thrown, white tie and all, into the river that ran through the park. Cecil returned dripping to the ball, vowing that he would get even with them. Get even he did. By dint of sheer push and wit and charm he soon had the speedier members of the aristocracy, not to mention café society on both sides of the Atlantic, eating out of his hand, vying not just for his

services but also for his company. Similar conflicts involving social and sexual shortcomings helped to propel another gifted North London boy, the aforementioned Evelyn Waugh, into society. How he and Cecil loathed each other!

Beaton's biographer claims that "Cecil will surely be remembered for his work on *My Fair Lady* more than for anything else." This does him an injustice. Compared to décors and costumes by Cecil's master, Christian Bérard, his work for *My Fair Lady* is meretricious kitsch. No, Beaton is historically important because he was an eye-opening recorder of the passing show, a witness to his time. Like Horace Walpole two hundred years earlier and Andy Warhol a generation later, Cecil had a homosexual's flair for seizing on the zeitgeist. Walpole, living as he did long before the invention of the camera, formed and recorded the taste of his day by means of incessant correspondence. Warhol, living as he did in a technological age, did much the same thing not just by painting portraits but also by photographing virtually everybody he met and often taping them, as well as keeping a diary. Beaton falls between these two extremes. Although not nearly as effervescent as his conversation, his diaries and articles (less so his letters) provide a panoramic view of the social scene from the 1920s to the 1970s, as well as a running commentary on changing patterns in fashion and taste from showbiz to gardening. And then what a diverse assortment of people Cecil evokes in profiles almost as sharply focused as his photos—people as disparate as Mae West and Lucian Freud, Truman Capote and Kenneth Clark, Queen Mary and Picasso. By contrast, his drawings are mostly too trite to be of interest, except for his unpublishable caricatures (little known because so libelous), which are masterpieces in the no-holds-barred tradition of Gillray. The ones of Vita Sackville-West and Anne, Countess of Rosse (sister of Cecil's principal rival in the theater, Oliver Messel, and mother of his principal rival as a photographer, Lord Snowdon), are of a fiendishness that is beyond praise.

Photographs are Beaton's main claim to fame. It is easy to dismiss them (as Hilton Kramer did in *The New York Times*) as superficial, uncritical, shamelessly flattering, and technically faulty. But

surely the casualness is what gives Beaton's photographs their spontaneity and life. No other photographer ever caught the British—and not just the top froth either, but the whole social gamut in times of war as well as peace—as coolly and sharply as Beaton. Mostly, he depended on minimal technical resources and maximum improvisation: "Darling, would you stand in front of that horrendous family portrait and aim that *hideous* lamp at Caroline's pearls"—that kind of thing. This hit-or-miss approach stood him in very good stead on the battlefield, where he took hundreds of marvelous pictures, not least the ones in the Libyan desert of burned-out tanks looking like Julio González sculptures. It meant that he and not the camera had the upper hand, and that—so long as he was working in black and white rather than color (which he usually botched)—he could snap away with the speed of a machine gun regardless of all but the most elementary technicalities.

If that empty phrase "I am a camera" applies to anybody, it applies to Cecil and his snapshot reaction to life. But how outraged this touchiest of men would be to find himself identified with the aspect of his work that he regarded as merely breadwinning. For Cecil's dream was to be God's gift to the theater. And not just as a set designer either, but also as a playwright—a role for which his one major attempt (an insipid play called *The Gainsborough Girls,* which he wrote and rewrote for over twenty years) proved that he had not the slightest aptitude. As Kenneth Tynan wrote, *The Gainsborough Girls* revealed that Cecil had "a simple and sentimental heart . . . It was as if an avocado pear had been squeezed and discharged syrup."

Although he first made a reputation in London with photographs of the beau monde, notably some wonderful images of the Sitwell family, Cecil did not achieve real fame and fortune until he came to America in 1928 for the first of many visits, and ended up under contract to Condé Nast. For the next nine years Cecil did brilliantly—covering fashion, theater, personalities, travel—for American *Vogue.* A pretty house in Wiltshire continued to be Cecil's base, but New York was his oyster, until in January 1938 he brought disaster on himself with an act of utmost folly and nastiness. In a composite drawing—cocktail glasses, showgirls, jazz bands, swizzle

sticks, etc.—to illustrate Frank Crowninshield's gossip column in *Vogue,* Cecil made a number of anti-Semitic slurs in trompe-l'oeil newspaper type so small that the naked eye could not decipher them. Alerted, probably by an art editor who loathed Cecil, Walter Winchell challenged his readers to take a magnifying glass and read such sneers as "Mr. R. Andrew's Ball at the El Morocco brought out all the damn kikes in town." Overnight Cecil became anathema, not least to Condé Nast, who insisted on his resignation. Everyone involved, especially the targets of Cecil's malice, behaved with exemplary restraint. Only the perpetrator gave way to shrill pique. "I'm damn glad I did it," Cecil snapped at his friend David Herbert when he was safely back in England.

New York did not forget. Even when he returned to America in 1946, toughened and at the same time mellowed by the war, Cecil was mortified to find that his offense was still remembered. José Ferrer refused to let him do the sets for a production of *Cyrano de Bergerac* because of his "fascist" reputation. And *Vogue* was at first reluctant to take him back to its bosom until Greta Garbo took Cecil back to *her* bosom. That was enough to cleanse his record.

Most of his friends found Cecil's romance with Garbo a bit of a joke, but they welcomed it insofar as he was prepared to share her with them. At first the English fell under her spell, but once the novelty of her beauty wore off, they found her heavy going—"apart from a tin ear, she seems to be made entirely of wood," said Alan Pryce-Jones, who saw a great deal of her. Nor did her moodiness impress Cecil's sporty neighbors. "Cheer up, Garbo, old bean!" one of them said. Few if any of them realized that, thanks to a deep, dark streak of mutual androgyny, this seemingly ill-suited couple was in fact extremely well matched. While Cecil fancied himself as a glamorous actress, Garbo fancied herself as a sexy youth. When they first met in 1932, Garbo (who had evidently never been to Greece) told Cecil, "You are like a Grecian boy. If I were a young boy I would do such things to you . . ." Fifteen years would go by before she got around to doing so. To a friend who asked for details of their courtship, Cecil said, "I simply took off all my clothes and danced and danced and danced." After their affair had been running its

zigzag course for a decade or so, Garbo told Cecil, "I do love you and I think you're a flop. You should have taken me by the scruff of the neck and made an honest boy of me."

Cecil enjoyed playing up to Garbo's masculinity. His stilted love letters are apt to begin, "Dear Sir or Madam" or "Comrade" or "Please, my dear young man, do scratch a few lines to your ardent suitor." Endings are no less telltale: "I remain, dear Sir, your dutiful, humble admirer Beaton." In the long run Cecil's maidenly sensibility was no match for Garbo's love-proof ego. After repeatedly leading him on and reducing him to a very lovesick "sir or madam," Garbo moved on to other pastures.

Around this time, through a friend of Cecil's and mine called Sam Green, I had arranged to rent my flat in the Albany to Garbo, so that she could spend a month or two in London, in seclusion as Miss Brown. So impregnable was her anonymity that the maid, who was a fan of old movies, never cottoned on to "Miss Brown's" identity. "A pity," Sam told me; "if she had saved those long gray hairs from the wastepaper basket, she could have sold them for thirty dollars apiece." Sam also told me the following story.

One winter's day, Sam was accompanying Garbo on one of her interminable walks in Central Park. Her objective was the playground. She adored children and liked to read them Hans Christian Andersen stories from the book she carried around with her, but the kids usually ran away in fear and had to be rescued by mothers or nannies from this weird-looking old lady. As she and Sam were about to enter the park, a large limousine screeched to a stop, blocking traffic and causing considerable consternation. A distraught woman jumped out and rushed toward Garbo, who ran off like a startled hare, leaving Sam to cover her retreat. Sam went through the drill that Garbo had devised for these occasions: politely and lengthily explaining that Miss Brown never talked to anyone. "But you don't realize who I am," the woman kept repeating. "I'm Liv Ullman and I'm playing Anna Christie" (one of Garbo's first great roles). "Sorry," said Sam, "but there is nothing I can do," and off he ran to catch up with Garbo, who was angrily stamping through ice-covered puddles. "And what was all that about, Mr. Green?" "That

was your famous compatriot, Liv Ullman," explained Sam. "Liv Ullman? Never heard of her," said Garbo.

At least that is the way Sam told me the story, and the way I told it to a friend of mine, who repeated it with embellishments to his sister-in-law—in those days Garbo's inamorata—who in turn repeated it back to Garbo, who was furious. "You know, it's not true," she grumbled to Sam. "I'm afraid I misled you about the punch line," Sam told me when we next met. What Garbo actually said was, "Liv Ullman! This will make me the most unpopular man in Sweden." "Man?" "Yes, man," Sam repeated, "she often refers to herself that way." One more confirmation that in some respects Garbo and Cecil were made for each other.

After his romance with Garbo fizzled out, Cecil took up with someone rather more suitable: a very serious, very handsome young art historian, Scandinavian like Garbo, called Kin, whom he met in 1963 in a San Francisco leather bar. They lived together in England for one of the happiest years of Cecil's life, but Kin eventually got homesick—British high life was not for him—and returned to San Francisco. Kin's departure "broke his heart," said another of Cecil's former bedfellows, Truman Capote.

Meanwhile, friendship with Lucian Freud, Francis Bacon, Patrick Procktor, and David Hockney had given Cecil the mistaken idea that he, too, could achieve fame as a painter. In 1966 he showed a large group of big, splashy portraits (the subjects were an odd assortment: among them Queen Victoria, Picasso, and Alec Guinness) at London's Lefevre Gallery. The critics gave Beaton the artist the same well-deserved drubbing they had given Beaton the playwright. Keith Roberts (in the scholarly *Burlington Magazine*) wrote, "There is embedded in [Beaton's] talent a vein of cork, which impels him irresistibly towards the surface of things, no matter how hard he strives to go deeper." Nor did Cecil's attempts to project a swinging new sartorial image—very flared suits of brightly colored stuff worn with sombreros—provoke much more than laughter and a wickedly apt nickname from Cyril Connolly, "Rip-Van-With-It."

And then once again Cecil made a public fool of himself. From

time to time he had been in the habit of publishing excerpts from his diaries—harmless, gossipy pieces that give away little about his own feelings. In November 1971, however, he decided for a change to bare his soul, specifically about Garbo. He did so in a gush of self-serving, self-pitying schmaltz, which appeared in the British as well as American press. Garbo was outraged; friends were appalled, and Cecil mortified. Why had he come out with this maudlin stuff? One of Garbo's intimates accused him to his face of having done it for money. Not true. Cecil did it partly out of a passion for being the center of attention, and partly out of desire to exorcise his sissy past by publicizing his affair with one of the twentieth century's most famously beautiful women. Although distressed at having blundered, he was far from contrite. "All the nicest things about [Garbo] are lost in a haze of her selfishness, ruthlessness and incapability to love," he confided to his diary in justification of his conduct. "Let her stew in her own loneliness."

A knighthood, conferred in 1972, at the height of the Garbo uproar, did much to palliate Cecil's bitterness, but his psyche never really recovered from the opprobrium. The severe stroke that Cecil (aged seventy) suffered in 1974—it left the right side of his body paralyzed and affected his memory, particularly for names—was probably a consequence of it. Ironically, the illness struck at two of Cecil's principal faults: his vanity and his tendency to name-drop. At first he couldn't write or draw or use a camera. "If I had a gun, I'd shoot him," Diana Cooper, who loved him, said. Fortunately she didn't. Thanks to his iron will and courage, Cecil was back at work within a year, using his left hand instead of his right. The clumsiness and pertinacity of the left-handed drawings are an improvement on the gentility and glibness of the earlier right-handed ones. Cecil's photography suffered rather more. He had lost that easy, confident, gestural—one might almost say conversational—way of using a camera that had been peculiarly his.

Sam Green, who was often in attendance, set about reconciling Garbo and Cecil after the bad blood caused by his embarrassing exposé, as well as his use of her as a kind of Trojan horse to get him into the few great houses in England that still held out against him

("Could I bring Miss Garbo to see your beautiful garden?"). These little stratagems had not gone unremarked. Hard old Garbo overcame her resentment sufficiently to visit her former lover in the country. It was decent of her to go, less decent of her to insist on revenge. At first she put on a marvelous performance, chatting away, even sitting on Cecil's knee. And then, as he hobbled painfully into luncheon, she said to his secretary, "I couldn't have married him, could I? Him being like this!" At the end of the visit, Cecil made as if to embrace Garbo. "Greta, the love of my life," Sam heard him say. But Garbo shuddered and shook him off and went over to sign the visitor's book with her full name—something she didn't ordinarily do. They never saw each other again.

And then, in 1977, Sam arranged for Cecil to pay one last visit to New York. We all had lunch together at Quo Vadis. Despite paralysis, Cecil was as funny and sharp as ever. His inability to remember names, while remembering almost everything else, gave the conversation crossword-puzzle overtones. Little by little one learned how to interpret his mnemonics: "hotel named after her family" for Mrs. Astor; "daughter has a very important job," for the Queen Mother; and so forth. When lunch was over, I helped maneuver Cecil into his car. It was quite a task. The paralyzed right leg was recalcitrant—"as unmanageable as a debutante's train," said Cecil in that all-too-inimitable drawl. "Kick it! Like me, it doesn't feel a thing." And with a defiant toss of his sombrero, the old trouper drove off—where else but to *Vogue*.

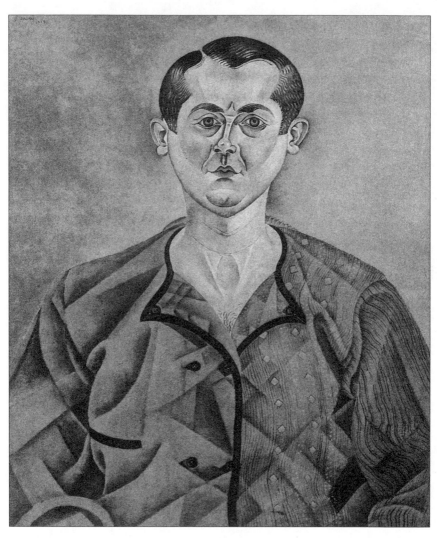

Joan Miró, *Self-portrait,* oil on canvas, 1919, Musée Picasso, Paris

Miró, the Reluctant Surrealist

Intense local piety, known as Catalanisme, is fundamental to Miró's art. Catalanisme imbues his landscapes with their acute and meticulous sense of locality; Catalanisme characterizes Miró's fantasy, which soars skyward while remaining deeply rooted in his native soil, as well as his secretiveness, which expresses itself in arcane codes and riddles. Catalanisme also explains his uninhibited approach to the bodily excretions and emissions that he loved to depict; and not least, it accounts for this diminutive man's touching air of self-importance, which surfaces less touchingly in the meretricious magnification of his later work.

Just as that other raunchy city Brussels has its Maneken Pis, a fountain in the form of a peeing boy, as its emblem, Barcelona has its *caganer*, its defecator: a sort of lay crèche figure that appears all over the city at Christmastime. The *caganer* is always depicted wearing a red *barretina* (Catalonia's emblematic bonnet), his pants around his ankles, "giving back to the soil the nourishment that it supplied to him" (to quote the art critic Robert Hughes's lively 1992 book on Barcelona). After this, the farts and burps of Miró's

Surrealist poems come as no surprise, nor does the bearded, *barreti-na*ed huntsman who is the focal point of his early (1923–24) *The Hunter (Catalan Landscape)*. This allegorical Catalan is depicted puffing on a pipe, a gun in one hand, a dead rabbit in the other, his loyal heart aflame, and his loyal penis rendering nourishment back to the soil. "You can see the hunter's heart," Miró told an interviewer. "He's in the act of peeing. You can see his penis. An airplane flies across the sky [regular flights from Toulouse to Rabat flew over Miró's farm; hence the French and Spanish flags on its fuselage] while a fisherman fishes from a [cone-shaped] boat. There is also a big . . . carob tree [the disk with the leaf sticking out of it] . . . [and] the first letters of the word *sardine,* and a fire for cooking the fish. All that makes up a story."

Carolyn Lanchner, who organized Miró's centennial retrospective at the Museum of Modern Art in 1993, has discovered a secret under the surface of this remarkable painting. Infrared light reveals this secret to be a small nineteenth-century print in a trompe-l'oeil frame. It represents Ferdinand and Isabella welcoming Columbus back from the New World in Barcelona's great Gothic hall, the Saló del Tinell. This hidden reference to his homeland's glorious past suggests that Miró wanted to endow this tribute to Catalonia with an added historical resonance known only to him. It also suggests that this secretive artist identified with Christopher Columbus; for he, too, had recently returned to Catalonia, as Lanchner says, "with treasures accumulated on his voyage of discovery to Paris." Given Miró's Catalan taste for conundrums, it would have been in character to leave this image in subliminal form—just, but only just, visible in outline to the naked eye. Shades of Marcel Duchamp, or for that matter Jasper Johns.

The huge feet that proliferate in his work testify to Miró's obsession with his native soil. These are the feet of the *caganer:* body parts that Miró venerated for their links with the earth. When Miró contrives what he calls a "personage" out of a foot, a sexual organ, and a few pubic hairs, he is not being arbitrary or whimsical; he is being a shaman and he is fashioning the equivalent of a fertility symbol. Like Picasso, Miró saw art as having a magic function. "Remember

that in primitive, nondecadent races," one of his working notes reminds us, "the sex organ was a magic sign of which man was proud, far from feeling the shame that today's decadent races feel."

Despite his artistic daring and genius, there was something mouselike about Miró. Even intimate friends found it difficult to reconcile this Catalan petit bourgeois—he liked to take Sundays off and treat himself to an after-lunch liqueur, a cigarillo, and a long nap—with the manic gnome who would barricade himself in his studio, and, as he confessed, "go completely wild," burning holes in Masonite panels, dipping all ten fingers into the paint and playing with it—"like a pianist"—or one of those prehistoric cave painters who signed their work with handprints.

Impeccably turned out in the impeccably tidy studio that Josep Lluis Sert had built for him on Majorca, and attended by his plump little wife and daughter as well as a bevy of fawning collectors and obsequious dealers, Miró struck me as a very small, very courteous, very reticent man with just a touch of the troglodyte. But then, by the time I went to visit him in 1960, the sacred fire was well nigh extinct—an impression that his later work confirmed. Picasso, who had been one of Miró's first collectors and had known him well for half a century, said that you could live with him for years on end without learning the first thing about him. Mind you, it suited Picasso to see Miró as a child—a little boy in a sailor suit playing with a hoop or riding a scooter (*trottinette*). "*Toujours la trottinette, toujours la trottinette,*" Picasso would say when his name came up; and he would go on to mention that his secretary, Jaime Sabartès, was a cousin of Miró's, but chose to conceal this relationship out of loyalty to his boss.

For a Surrealist artist, Miró led a remarkably conventional life. The only noteworthy event of his early years was a nervous collapse at the age of eighteen. Fortunately, his father had just bought a small farm at Montroig, back from the coast an hour or so south of Barcelona, where Joan could convalesce. Montroig would always be Miró's passion. His early work—above all his first masterpiece, the hallucinatingly sharp-focus *The Farm,* which was Ernest Hemingway's most prized possession—has its roots in the red earth of

Montroig, where the artist spent all his summers until he moved to Palma, on Majorca, in 1956.

Miró's other favorite locale was Paris, which he first visited in 1920. His family tried to scare him away from painting by keeping him very short of money on this trip, but he managed to survive. He took a studio in Montparnasse, next door to the French Surrealist André Masson. Despite very different temperaments, they became close friends. Both men wanted to invoke an element of mystical exaltation: Masson through *"le dérèglement de tous les sens,"* like Rimbaud; Miró through monastic self-discipline and self-denial, disrupted by occasional manic outbursts. To this end he hung a sign on his door that read THIS TRAIN MAKES NO STOPS. Thanks to Masson, Miró was taken up by the Surrealist poets, who had begun to welcome painters into what was originally a literary movement. Although the Surrealists acclaimed Miró's attainments, they were slightly ashamed of his lack of Surrealist nerve and verve and intellectual clout. A leading Surrealist, Louis Aragon, found Miró too fond of his own work—an accusation that could just as well have been leveled at Aragon. Apropos these early days in Paris, Miró told his biographer Jacques Dupin that "Masson lived . . . in the midst of indescribable disorder and filth. But I was a maniac for order and cleanliness . . . I waxed and polished the floor. The studio was perfect, just like a ship's cabin. I lived alone in total poverty, but every time I went out I wore a monocle and white spats."

For recreation Miró jogged—almost unheard of in those days—or boxed at the Cercle Américain training establishment. He even fought Hemingway, who had just purchased *The Farm* and claimed to be working as a professional sparring partner in order to pay for it. "It was rather comical," the artist said, "since I didn't come up any higher than his belly button. There was a real ring, and all around in the stands, a crowd of homosexuals"—rooting, I fear, for Hemingway.

So poor was Miró that in his early Paris years he stayed alive on dried figs and chewing gum, supplemented by the occasional CARE package of sausages from home. Hunger gave him hallucinations, which inspired some of the sharpest, sparsest paintings of his

career—works that consist of little more than calligraphy: part of a phrase or a word, fluttering like a bird or a sliver of ectoplasm in a dense blue sky. Fifty years would go by before these "Dream Paintings," or "Magnetic Fields," as they have come to be called, would be shown together at the Guggenheim Museum, in 1972, and recognized as one of the most imaginative attempts by a modern artist to unite *peinture et poésie,* image and word.

After a trip to Holland in 1928, Miró switched to doing very free variations on the fiddly Dutch genre scenes—merry burghers playing with pets or carousing with local louts—that he had seen at the Rijksmuseum. Those who deplore Picasso's cannibalization of the old masters should take a look at the outrageous tricks that Miró's *Dutch Interior II* plays on Jan Steen's *The Cat's Dancing Lesson.* After toying with the notion of the dancing cat as a ballerina, Miró ends by depicting it as a tiny mobile—such as his good friend Calder might have made—just discernible at the very center of the composition. As for the dog in the foreground, he no longer barks, but farts and pees. This animal serves as a source for two all-enveloping sashes—extensions of the girl's scarf and a feather in the man's hat—which terminate in an arrow-shaped tail and a flying vagina and thus link the wearers erotically together.

The *grande amoureuse* Peggy Guggenheim, who owned this painting, knew exactly what it signified and would gleefully point out lubricious details. In this respect she differed from a great many other owners of Miró's work. When, some thirty years ago, I started checking out American collections, I was amazed to find that Miró owners seldom realized how sexually explicit his paintings are. One particularly genteel collector proudly showed me a painting that abounded in the spiderlike vaginas that are one of Miró's logos. "You know why I bought it?" the collector said. "Spiders bring me luck." Another time, I found myself under attack from a woman who maintained that Miró was an abstract painter, something he had always disclaimed. "How about this?" she said, pointing to the large vermilion splotch in an illustration of *Dutch Interior III.* "Blood," I said, remembering Dupin's explanation of it. "The woman's in childbirth." And the baby? "There isn't one," I replied.

"She's giving birth to a very small goat. You can even see the horns."

After the *Dutch Interiors,* Miró took to doing variations on a very mixed bunch of portraits from the past, *Fornarina* (after Raphael), *Portrait of Mistress Mills in 1750* (after Engleheart), *Portrait of a Lady in 1820* (after Constable). Mrs. Mills is the most inventive. Miró has great fun with her huge feathered hat, which he garnishes with a curlicue antenna and a beribboned erection. It may well have been an epithalamium, for after completing this series Miró went to Majorca to court Pilar Juncosa, the daughter of a family friend. They were married in October 1929. Nine months later, Pilar bore him a daughter, Dolores. Marriage seems to have triggered a period of confusion in Miró's work. He said he wanted to "murder painting"—a melodramatic way of announcing that he wanted to stop doing it. Instead he took to making Surrealist objects, which are seldom as provocative as Man Ray's or Dalí's. By the following year he was back painting at the top of his form, "more aerial, more liberated, lighter than anything I had ever seen before," as Giacometti said.

In the mid-1930s, Miró's radiant blue skies began prophetically to darken. The feeling of impending disaster affected him physically, the artist said, like atmospheric pressure preceding a storm. A year or so before Spain's civil war broke out, his biomorphic "flashers" became more menacing, turning into nasty amoebalike things with gaping, toothy vents. The light turned sulfurous, as in the 1936 painting *A Man and a Woman in Front of a Pile of Excrement.* Miró told an interviewer why he had given it that title: "I was obsessed by Rembrandt's words: 'I find rubies and emeralds in a dung-heap.' " The same malevolent light permeates his masterpiece of the period, *Still Life with an Old Shoe.* "I later realized," Miró told James Soby, the American collector who bought it, "that without my knowing it this picture contained tragic symbols of the period—the tragedy of a miserable crust of bread and an old shoe, an apple pierced by a cruel fork, and a bottle like a burning house that spreads its flames across the entire surface of the canvas." Miró's other major civil-war painting, the huge *Reaper,* which shared the Spanish pavilion at the 1937 Paris World's Fair with Picasso's *Guernica,* has disappeared—presumably destroyed when the pavilion was dismantled.

When World War II broke out, Miró took refuge in Normandy until the German invasion in 1940 obliged him to move on. Faced with a choice between exile in America and an uncertain future in Falangist Spain, he chose Spain, but he was so apprehensive of Franco's tyranny that he returned under his mother's name. To exorcise his fears, Miró embarked on a series of *Constellations*— twenty-three uniformly small (18 by 15 inches) paintings on paper—which constitute a miniature cosmology. Anguish and anger have been distilled into images of the utmost delicacy and complexity, each one a microcosm of the artist's private world. The *Constellations* also codify Miró's repertory of signs—flora and fauna, body parts and body hair, biomorphs, ladders, *barretinas.* The artist portrays his repertory of familiar images more often than not in a state of metamorphosis, turning them into moons and stars, comets and black holes. As Lanchner puts it, "Nowhere else do the aerial and the earthly, the familiar and the cosmic, so seamlessly interweave." The *Constellations* left the artist drained of energy. This, added to the fact that materials were in short supply, meant that little work was done during World War II. Even when he resumed painting, he limited himself to scaled-up and watered-down reprises of the *Constellations.*

Miró lived on for another forty productive years, but as far as I am concerned, the *Constellations* are in the nature of a swan song. During World War II, he wrote a memo to himself: "Don't do excessively large pictures. That could be a sign of mediocrity." If only he had heeded his own advice! The decline started in 1947, when Miró made an eight-month trip to America, in the course of which he fell under the sway of Abstract Expressionism. He told Margit Rowell, who has written so perceptively about his work, that after the revelation of the Pollocks and Kleins and Stills, he said to himself, "You can do it too . . . it is O.K." And that is what he did. Given all that artists of the New York School had taken from him, Miró felt more than justified in taking something in return. The only trouble: Abstract Expressionism affected his work like Miracle-Gro. In no time the hot, heady air of international acceptance and dealer's blandishments caused Miró's art to lose its edge and bloat. His paintings became ever larger, emptier, windier. True, his sense

of color and imagery remained as beguiling as ever, but few of these monumental works pack the punch of the miniature *Constellations*. In the end, gigantism would be this little man's downfall: "I now see things on a grand scale," he wrote megalomaniacally to Pierre Matisse, his New York dealer. "Many of my recent sculptures not only hold up, but *demand* to be set outdoors and enlarged to an *unlimited* scale."

Another factor that left its mark on Miró's work was the colossal rise in his prices after World War II. Coincidentally or not, his studio went into overdrive as he branched out into prints, sculpture, ceramics, and (oh dear!) tapestry. Pierre Matisse had always provided judicious counsel and encouragement. Miró's new Paris dealer, Aimé Maeght, was devoid of sensibility, and he tended to turn his artists into lucrative little factories churning out products that were recognizable to the point of self-parody. Henceforth, mediocre Mirós in Maeght's ornate gold frames (often embellished with a gilt-edged mount) would become a standard item in the art investor's portfolio. International fame took another kind of toll. For the last twenty years of his life, Miró, like the British sculptor Henry Moore, became a major perpetrator of decorative modern monuments for decorous public spaces. Large ceramic walls (done in collaboration with the potter Josep Llorens Artigas), emblazoned with Miró's familiar ciphers, cropped up all over the world, from Harvard to Osaka, from the UNESCO Paris headquarters to Barcelona's airport. They cried out for a medal, and, sure enough, the King of Spain decorated the artist with the Grand Cross of Isabela la Católica in 1978, five years before his death.

In 1966, Miró went to Japan for the first time—an experience that he said turned him upside down almost as much as his first trip to Paris had done. Japanese art fascinated him; his art fascinated them. The result was a brisk new market for his work and a new, "gestural" phase in his painting. "I work almost always in a trance these days," he said. Unfortunately, Surrealist artists tend to burn out long before they die, and Miró's later trances failed to generate the poetry or psychic power that the earlier ones had, when he was a starving young man from Montroig envisioning his "Dream

Paintings." However, Miró's brush never completely lost its magic. He continued to conjure lines on canvas that appear not to be painted, drawn, or incised, but to float on the surface of his colored grounds like twists of thread dropped from those "Magnetic Fields" in the sky.

Jean-Jacques Lequeu, Agdestis, child of Jupiter, who was
both man and woman, engraving, c. 1790

From James to Jan

Little boy kneels at the foot of the bed,
Droops on the little hands little gold head.
Hush! Hush! Whisper who dares!
Christopher Robin is saying his prayers.

A. A. Milne, "Vespers"

Or, as the late David Carrit rephrased the last line, "Christopher Robin is dying his hair." Uppermost in Christopher Robin's prayers, if we are to believe his father, A. A. Milne, were Mummy, Daddy, and Nanny—not, however, in those of the former James Morris. "Please, God," went this little boy's nightly orison, "let me be a girl. Amen." And he made the same prayer whenever he "saw a shooting star, won a wishbone contest, or visited a Blarney well." His persistence was rewarded, but not for forty years. In the summer of 1972, thanks to the intervention of a Moroccan surgeon, this popular British author—ex–cavalry officer, foreign correspondent, mountain climber, father of four—became Jan: a sister-in-law to his wife, "an adoring if interfering" Auntie Jan to his children.

Once her ordeal was over and she had settled down in Bath, Jan Morris decided to tell all, well not quite all, about "the most fasci-

nating experience that ever befell a human being." Sure enough, this award-winning travel writer squeezes maximum mileage out of the most sensational and perilous trip he/she ever took, the crossing from one sex to another. And sure enough, his/her book, *Conundrum,* lives up to its peculiar subject, disarming one with Welsh charm one moment, disconcerting one with genteel exhibitionism the next. For a change, compulsive writing—*Conundrum* has to be seen as the last act, or rather the last curtain call, in Jan's sex change—makes for compulsive reading, despite the fact that it is coyly reticent where it should be frank, whimsical where it should be scientific, and, to male readers at least, implicitly threatening.

For Jan changing sex was a spiritual act—"I equate it with the idea of soul." She claims that *Conundrum* is inspirational, especially in its piety toward women. With all the fanaticism of a convert, she insists on seeing women as inherently virginal beings sanctified by meekness (woman's "frailty is her strength, her inferiority is her privilege"). These antiquated notions go back to the author's boyhood: "A virginal ideal was fostered in me by my years at [school], a sense of sacrament and fragility, and this I came slowly to identify as femaleness—'eternal womanhood,' which, as Goethe says, 'leads us above.' " Elsewhere we read how, as a boy, he had identified with nuns, with the Virgin Mary. He envied the Virgin Birth, and came to see his transsexual voyage as a sacramental or visionary quest. "It has assumed for me a quality of epic, its purpose unyielding, its conclusion inevitable." In further justification of her quest, Jan says, "It still seems to me only common sense to wish to be a woman rather than a man—or if not common sense, at least good taste." Or again, as reported by *The New York Times:* "I like being a woman, but I mean a *woman.* I like having my suitcase carried . . . I would have been happiest being someone's second in command. Lieutenant to a really great man."

Whether or not James harbored these submissive fantasies—were they perhaps the verso of his dashing masculinity?—Jan does not divulge. On the face of things Morris could not have been a more stolid type: part Welsh, part Quaker, he had a conventional middle-class upbringing: Christ Church choir school, a minor pub-

lic school (Lancing), Oxford, and five years in a cavalry regiment. True, he had desultory affairs with men, but Jan claims a bit censoriously that he found homosexuality childish and sterile. In any case he craved to have children, and so at the age of twenty-two he married an understanding woman who sympathized with the problem. "It was a marriage that had no right to work, yet it worked like a dream . . . I hid nothing from Elizabeth . . . I told her that through each year my every instinct seemed to become more feminine, my entombment within the male physique more terrible to me, still the mechanism of my body was complete and functional, and for what it is worth so was hers."

James confesses that he really wanted to be a mother—"perhaps my preoccupation with virgin birth was only a recognition that I could never be one." Faute de mieux he became a father, siring five children, one of whom, a girl, died in infancy. Let me quote the description of this heartbreaking event, because it pinpoints the way Jan embarrasses her readers when she tries too hard to touch them. Note the sound effects—a recurrent device of this writer.

I felt she would surely come back to us, if not in one guise, then in another—and she very soon did, leaving us sadly as Virginia, returning as Susan, merry as a dancing star.

. . . we knew she was very near death. Elizabeth and I lay sleepless in our room overlooking the garden . . . Towards midnight a nightingale began to sing . . . I had never heard an English nightingale before, and it was like hearing for the first time a voice from the empyrean. All night long it trilled and soared in the moonlight, infinitely sad, infinitely beautiful . . . We lay there through it all, . . . the tears running silently down our cheeks, and the bird sang on, part elegy, part comfort, part farewell, until the moon failed and we fell hand in hand into sleep.

In the morning the child had gone.

Mawkishness is no way to commemorate a loss of this magnitude. It trivializes tragedy and stifles the compassion a sensitive reader might otherwise feel. To this extent James was a more effec-

tive journalist than Jan—in his day, a top correspondent for the (London) *Times* and *The Manchester Guardian*. Indeed, *Conundrum* describes how he brought off the biggest journalistic break in mountaineering history, the conquest-of-Everest story. He accompanied the 1953 expedition to 22,000 feet, and organized his means of communication so ingeniously that *The Times* scooped the world with the news of Hillary and Tenzing's triumph. Jan's description of James's heroic role in this exploit is worth quoting:

> How brilliant I felt, as with a couple of Sherpa porters I bounded down the glacial moraine towards the green below! I was brilliant with the success of my friends on the mountain, I was brilliant with my knowledge of the event, brilliant with awareness of the subterfuge, amounting very nearly to dishonesty, by which I hoped to have deceived my competitors and scooped the world . . . my news had reached London providentially on the eve of Queen Elizabeth's coronation, I felt as though I had been crowned myself.
>
> I never mind the swagger of young men. It is their right to swank, and I know the sensation!

Everest was the high point of James's career as a journalist. By putting his masculinity to the test the mountain deepened his sense of duality. Back home he had to fight an increasing sense of isolation from the world: he began to suffer from migraines, distortions of vision and speech "preceded by periods of terrific elation, as though I had been injected with some gloriously stimulating drug." This state was not helped by James's journalistic assignments, which involved "little but misery or chicanery, as I flew from war to rebellion, famine to earthquake, diplomatic squabble to political trial." And, as he admits, his condition even had stylistic repercussions: "the elaboration of my prose . . . which all too often declined into rhetoric, but did have its moments of splendor, owed much to what I was."

James seems to have had little trouble sublimating his sexual appetite, such as it was (would anyone who really enjoyed sex swap a set of functioning organs for a seemingly Rube Goldberg

contrivance?), into sensual feelings for inanimate objects: "buildings, landscapes, pictures, wines, and certain sorts of confectionery . . . whole cities are mine because I have loved them so. So are pictures scattered through the art galleries of the world. If you love something hotly enough, consciously with care, it becomes yours by symbiosis irrevocably." Arabia, Venice, and South Africa are some of the places that James wrote about with increasing success, and, at his best, with a certain contagious rapture. Meanwhile, what about Elizabeth? Was "the incomparable gift of children" consolation enough for the metamorphosis of her husband into her wife?

As James traveled around the world, sating his lust for cities in the purple of his prose, events were being forecast for him "arcanely":

A Xosa wise woman, telling my future in her dark hut of the Transkei, had assured me long before that I would one day be a woman too; a reader of mine in Stockholm had repeatedly warned me that the King of Sweden was changing my sex by invisible rays. As you know, I had myself long seen in my quest some veiled spiritual purpose, as though I was pursuing a Grail or grasping Oneness. There was, however, nothing mystic about the substances I now employed to achieve my ends . . . The pills I now took three times a day . . . were made in Canada from the urine of pregnant mares.

[These] turned me gradually from a person who looked like a healthy male of orthodox sexual tendencies . . . into something perilously close to a hermaphrodite, apparently neither of one sex nor the other, and more or less ageless. I was assured that this was a reversible process, and that if . . . I decided to go no further, I might gradually revert to the male again, but of course the more frankly feminine I became the happier I was, object of curiosity though I became . . . and embarrassment I fear, though they never dreamt of showing it, to Elizabeth and the children.

James says that his "small breasts blossomed like blushes" and his rough male hide took on a nubile girlish glow; he turned into "a

chimera, half male, half female, an object of wonder even to my-self." These physical changes were accompanied by odd feelings of levitation, the emergence of quivering new responses and light-headedness, as when James found himself "talking to the garden flowers, wishing them a Happy Easter, or thanking them for the fine show they made." " 'Was the whole process affecting her mind a little?" asked an editor who had worked on an early draft of *Conundrum.* "But no, I had been talking to my typewriter for years."

James lived only part of the time with his wife and family as a man. Jan had taken a small house at Oxford, where she could occa-sionally try out life as a woman. At the Traveler's Club James had perforce to be known as a man—at least to his face—but the porter at another London club to which he belonged welcomed him as Madam. The pages that describe this in-between phase of James's life are the best part of the book. The earnestness is at last relieved by glints of humor, especially when he evokes some of the confu-sions resulting from his androgynous state, for instance when James visited his son at Eton and a matron mistook the queer-looking father for one of the boys (shades of *Vice Versa,* that marvelous Vic-torian novel in which a pompous father finds he has been changed into his schoolboy son), or when a South African restaurant made him wear a tie at lunch, but would not let her wear pants at dinner.

In Mexico . . . a deputation of housemaids came to my door one day. "Please tell us," they said, "whether you are a lady or a gen-tleman." I whipped up my shirt to show my bosom, and they gave me a bunch of flowers when I left. "Are you a man or a woman?" asked the Fijian taxi driver as he drove me from the air-port. "I am a respectable, rich, middle-aged English widow," I replied. "Good," he said, "just what I want," and put his hand upon my knee.

Americans assumed James to be female and cheered him up with small attentions; while

Englishmen of the educated classes found the ambiguity in itself beguiling . . . Frenchmen were curious . . . Italians . . . simply

stared boorishly . . . Greeks were vastly entertained. Arabs asked
me to go for walks with them. Scots looked shocked. Germans
looked worried. Japanese did not notice.

Mare's urine effectively feminized James, but his body still pro-
duced "male hormones in rearguard desperation." He therefore de-
cided to consult a surgeon. Thanks to the persuasion of an
enlightened endocrinologist, Dr. Harry Benjamin of New York
City, sex change by surgery was no longer considered "a cross be-
tween a racket, an obscenity, and a very expensive placebo," but the
rational solution to most transsexual problems.

England, where James began to make inquiries, had followed the
United States in allowing transsexual operations. *Conundrum* does
not tell us, but a typically British hierarchy had grown up in the no-
man's-land between the sexes. At the top are the *grandes dames* who
at considerable pain and cost have undergone a series of complex
operations involving the removal of penis and testicles and the in-
stallation of a vagina cobbled out of the leftovers—the ultimate in
sex-change therapy. These deep-enders look contemptuously down
on the poor creatures who submit themselves to the National
Health Service's iniquitous "chop job"—free, but merely castrating.
In their turn these castrati are condescending about transvestites—
amateurs who lack the guts to face the knife.

James was determined to have a definitive operation—one that
leaves the patient more or less in the condition of a woman who has
had a total hysterectomy—but there was an unforeseen problem:
English surgeons refuse to change the sex of a married man. Fond
as he was—and still is—of his wife, James saw the eventual neces-
sity of divorce, but he wanted to do this in his own time and not at
the behest of British justice. The only solution was to leave the
country and put himself in the hands of Dr. B—— in Morocco.
And so after an idyllic family summer in his house at Llanys-
tumdwy, James set off to consult the Great Agrippa of Casablanca.
No problems. He handed over a stack of traveler's checks, worked
on the *Times* crossword puzzle, shaved his crotch in cold water
under the eyes of Fatima, "Mistress of the Knives," and, as the anes-
thetic started to work, said goodbye to himself in the mirror: "I

wanted to give that other self a long last look in the eye, and a wink for luck." Sound effects: a street vendor, playing a delicate arpeggio on his flute "over and over again in sweet diminuendo." Bye bye, flute!

Jan awoke pinioned to the bed but astonishingly happy. As soon as her chafed wrists were released, she polished off the crossword puzzle—"well *almost* polished it off—in no time at all." Jan was either lucky, or in starry-eyed gratitude she has glossed over the worst horrors of the Casablanca clinic—known to some alumnae as the "Villa Frankenstein." (One case reported to me woke up with the desired aperture, but the Moroccan plumbers had made a fearful tangle of her tubes.) When the bandages were removed, Jan was conscious of being "deliciously clean" at last. The protuberances she had come to detest had been scoured from her. "I was made by my own lights normal." Feeling a new girl, she sallied forth to meet other new girls. They were a weird lot:

> . . . brunette, jet black, or violent blond . . . butch . . . beefy, and . . . provocatively svelte. We ranged from the apparently scholarly to the obviously animal. Whether we were all going from male to female, or whether some of us were traveling the other way, I do not know . . . Some of us were clearly sane, others were evidently rather dotty . . . Our faces might be tight with pain, or grotesque with splodged makeup, but they were shining too with hope . . . All our conundrums seemed unraveled.

Elizabeth welcomed Jan back home as if nothing had happened. Welsh neighbors likewise put her at her ease by pretending not to notice anything amiss. But I suspect a more drastic change had taken place than anyone had envisaged. The surgeon's scalpel had turned her not so much into a new woman as a demure lady of the old school. Jan is the reincarnation of Mrs. Miniver, that mid-twentieth-century quintessence of middle-aged, middlebrow, middle-class gentility: the heroine of a best-selling book and film that gave solace to so many real-life Mrs. Minivers during World War II. The new Jan was not just an anomaly, she was an anachronism.

The very beginning of *Conundrum* supplies a possible explanation for this Miniverish persona. James's first intimations that he had been born into the wrong body came at the age of three or four, when he was crouched under his mother's piano. All we learn about this woman, who may well have been a role model, is that she was playing Sibelius at the time. The omission of all other information is surely significant. Could it be that a Miniverish mother was at the root of Jan's archaic femininity? Certainly the dates fit: *Mrs. Miniver* first came out in 1939 (the enormously successful movie with Greer Garson followed in 1942), when James was about twelve years old, and was serialized where else but in the (London) *Times*—the newspaper that would later employ him—and over the pseudonymous signature of Jan (Struther), James's new name.

Conundrum is a cautionary tale. Imagine taking all those thousands of milligrams of hormones; imagine the agony of the operations; imagine being responsible for all that family pain and confusion, and then to end up a travesty of pre-1939 gentility! The author is as much a caricature of certain feminine attitudes—"My red and white bangles give me a racy feel"—as those endearingly outrageous drag queens whom Jan dismisses with a shudder as "the poor castaways of sex."

Jan admits that her much-vaunted travel books became increasingly overwritten; purple passages and flights of Celtic fancy proliferated as the author's male hormones lost out to female ones. Since the sex change, however, Jan's writing has taken on a women's-magazine chirpiness that was not there before. Now that she has become a woman, she apparently feels obliged to write for—and down to—other women, as, for example, in this description of a typical day in her new life: Jan goes out shopping and stops for a gossip, but "not at all a feline" one. She is distressed when Mrs. Weathersby tells her that Amanda missed school, sympathetic when Jane complains about Archie's latest excess. No longer interested in food—a depressing development—she briskly buys a bagful of shelled Brazils, where James would have lingered over *langues de chat,* and goes home to find workmen in her neat flat, and oh dearie me!

One of them has knocked my little red horse off the mantelpiece, chipping its enameled rump. I restrain my annoyance, summon a fairly frosty smile, and make them all cups of tea, but I am thinking to myself, as they sheepishly help themselves to sugar, a harsh feminist thought. It would be a man, I think.

Well it would, wouldn't it?

Jan defiantly concludes that there is nobody in the world she would rather be than Jan. Fine, but please lady, spare us all that bridling, all those self-righteous sniffs. They are poor advertisements for your new self and a betrayal of your new sex.

Carlos de Beistegui in costume for his Venetian Masked Ball,
photographed by Cecil Beaton, 1951

Carlos de Beistegui,
the Miserly Magnifico

D ecades after his death, the Mexican maecenas Carlos de Bei-
stegui continues to influence high-style decorating. He
brought back into fashion the sumptuous overscaled look, eclectic
but basically classical, that characterized great houses of the early
nineteenth century from the Wicklow hills to the Crimea. It is a
look that Mario Praz's *Illustrated History of Interior Decoration* also
helped reinvent, one that implies noble birth, vast wealth, fastidious
taste, a modicum of culture, and just a touch of megalomania. Then
as now, a magnificently appointed house magnificently run was a
shortcut to social acceptance.

As Hispano-Mexican families go, the Beisteguis were distin-
guished and, more to the point, exceedingly rich. The father had
done well enough out of silver mines to be appointed Mexican
ambassador to Madrid, where his wife became friendly with
Alfonso XIII. The King decreed that young Carlos (born in 1895)
should have Spanish nationality. Another friend of his mother's,
Edward VII, decreed that Charlie, as the boy was known, should go
to Eton and Cambridge. Sacheverell Sitwell, who was at Eton with

Beistegui, said that he was unlike other boys in that his father insisted he take on a mistress; whereas most Etonians would head for the playing fields or the tuckshop in their spare time, young Charlie would excuse himself: "My father likes me to visit my mistress."

Beistegui ended up a grandee by osmosis. Had he been an heir to an ancestral house full of ancestral things he would probably not have devoted his life to decorating. As compensation, perhaps, for an almost total lack of charm, humor, and physical attraction, Beistegui developed a preposterously grand manner and a preposterously grand lifestyle to match. If he could not do much about his *curé de campagne* appearance, he could sure as hell dazzle his tight little post-Proustian world with splendiferous decor. Fortunately he was a decorator of great flair and he was fortunate in having a single client of great flair: himself.

Besides decorating, Beistegui had two other passions—the nobility and women—passions that he combined in liaisons with ladies of title: duchesses for preference, vicomtesses at a pinch. He supposedly never got married because romance was unthinkable with a mere *Madame* de Beistegui. He got around this problem by fathering the heir to one of the foremost ducal families in Europe— to the eternal shame of the heir in question, who flatly refused to visit Beistegui on his deathbed. An enterprising English friend of mine described the perils of staying with him. The old lecher had put her in a bedroom without a lock. To keep him out, she had to block the door with a baroque armoire. "I put my back out moving the damn thing," she said, "but it was better than being pounced on by that pig."

Venery notwithstanding, life chez Beistegui was stiflingly formal. It would have mattered less if there had been more substance and less show to the host's largesse. Liveried footmen would murmur the name of some rare vintage and pour a minimal quantity of wine into an armorial wineglass. And just as the food was eclipsed by the place settings, the company tended to be eclipsed by the décor: silver chargers arranged in tiers like profiteroles, avenues of baroque busts, acres of paint simulating mahogany and marble, and miles of specially woven silks and brocades.

The decorators who carried on the Beistegui tradition (above all, the late Renzo Mongiardino and more recently François-Joseph Graf) have never lacked for discriminating clients. New money as well as old still aspires to a style that can endow opulence with a patina of taste and breeding, a style that plays things right up but, on occasion, right down. Beistegui knew how to exorcise the throne-room look by slipcovering ornate furniture in humble piqué or the checked gingham known in France as "Vichy" and by mixing the sort of memorabilia to be found in the corridors of other people's country houses—sporting prints and trophies, old maps, genealogical memorabilia—with things of value.

In his early years Beistegui entertained literary and artistic ambitions. In 1914 he published a book of poems illustrated with his own modish drawings. At the end of the twenties he succumbed briefly to modernism and surprised his conventional friends by commissioning a surreal penthouse on the Champs-Élysées from Le Corbusier. Everything in this playhouse was electric. You pushed a button, and walls, windows, and mirrors slid aside. The roof garden was the ultimate folly: a walled room, open to the sky, furnished with a Louis XV fireplace and commode and a carpet of real grass. At the touch of a switch, walls of clipped box parted to reveal the top of the Arc de Triomphe. By the time the penthouse was built, Beistegui had turned against modernism—too bourgeois, he said. And so when he came to decorate this eyrie, he eschewed minimalism for thirties chic: Venetian chandeliers and blackamoors and tufted Second Empire upholstery. Le Corbusier was understandably horrified.

When war broke out in 1939, Beistegui stayed on in France as a neutral with honorary diplomatic status. He had recently acquired the Château de Groussay, near Versailles, and its refurbishment was the nearest he came to doing war work. Instead of an architectural gem that could not be touched, Beistegui settled on a nondescript neoclassical château, where he could give his creative spirit and zeal for self-aggrandizement full rein. Thanks to his diplomatic privileges, he suffered little, if at all, from wartime shortages or Nazi repression. He filled the house with guests, who came down from

Paris by train and were picked up at the station by a coachman with a horse and carriage. Hostilities were never allowed to deflect him from his obsessive decorating or interrupt his way of life. His notion of a wartime disaster was a maid who had the impudence to have her hair permed. Guests at an alfresco luncheon in the park at the height of the war had fun watching the reflection, in the beautifully polished silver dishes on the dinner table, of German bombers returning from a sortie over England.

I once asked the most perceptive of his mistresses what Beistegui was really like. "Ice cold and very soft," she said. "Above all he *adored* women—even his valet was always a woman—and he was very Spanish in his love of pomp and ceremony, very un-Spanish in his lack of machismo." My friend went on to describe how Beistegui had fallen for her when she was very young and eager and ingenuous. "Charlie molded me," she said. "He taught me how to lie." Pygmalion had found his Galatea. She was grateful, but horrified at the high price she had to pay. "Charlie was maniacally jealous and manipulative and utterly heartless—not least in his assumption that his lovers were as heartless as he was." He treated women as if they were precious objects that had to be cherished and polished and shown off to the right friends in the right clothes and the right setting. Then he could feel something akin to love for them. If my friend refused him her favors, he would threaten to tell her husband of her infidelities. If she gave way to him, he would introduce her to interesting people from outside her world—Orson Welles, for instance. "Presents were definitely not his thing."

Although he was only too ready to spend millions on erecting monuments to his own greater glory, Beistegui was in most other respects quite miserly. My friend remembered helping him to buy jewelry for the woman who had sacrificed her life to being his *maîtresse-en-titre*. It was only with the greatest difficulty that he was persuaded to give this woman real as opposed to costume jewelry. (The *maîtresse-en-titre* was expected to celebrate the anniversary of their first meeting by putting on the dress she had worn on that occasion. Sentiment or sadism? As the years passed, the poor woman had more and more difficulty getting the hooks and eyes to fasten.)

On another occasion, when he spotted a nun wearing exactly the stuff he needed for some curtains, he contacted the head of her order (Saint Vincent de Paul) and would not let her be until she had agreed to let him have the requisite length of cloth. As for a donation to the order, "he had to be bludgeoned into sending a check." No less embarrassing was another occasion—this time in church. As the priest was elevating the host, Beistegui nudged his neighbor and said, "Look at that marvelous combination of colors," pointing to the multicolored stockings of the girl kneeling in the pew in front of him, "just what I need for my *antichambre.*"

Beistegui's transformation of Groussay owes much of its success to the ingenuity and imagination of his architect friend Emilio Terry, whose quirky neoclassicism and sense of theater were rooted in his admiration of eighteenth-century visionary architects like Ledoux and Boullée. Beistegui's astute sense of gigantism found its happiest expression in the château's library, formed out of four rooms on two floors. On one side of this lofty *bibliothèque* a pair of faux mahogany staircases spiraled past shelf after shelf of morocco-bound books, bought by the yard, to a gallery just below the ceiling. In the unshelved section of the room, vermilion walls were hung hugger-mugger with smallish, poorish old masters interspersed with classical reliefs. Alas, instead of buying good eighteenth-century Aubusson or Savonnerie carpets, Beistegui made do with garish modern reproductions commissioned from the royal factory in Madrid. They were as shrill as the trumpets of his native Mexico—a provenance he was usually at pains to conceal.

Beistegui owned few works of art of importance. For him, as for most decorators, paintings helped to fill a space, evoke a period, or hint at noble antecedents. And although he acquired some important pieces of furniture, these often as not rubbed arms and legs with reproductions that looked better than they were. However, as befitted a man whose fortune came from silver, Beistegui had a remarkable collection of *orfèvrerie.* He had a canny eye for ceramics, the more monumental, the better. He also had a penchant for Delft tiles, which he used to decorate the interior of one of the more beguiling follies at Groussay, a striped metal tent inspired by

Gustavus III's tin guardhouse at Drottningholm. No less handsome but even more pointless was the gorgeous little baroque theater—inspired by the Margrave's Opera House at Bayreuth—that Beistegui had Emilio Terry build for him in 1957. Pointless, because after a couple of amateurish performances for his grand friends the theater was seldom if ever used.

In 1948 Beistegui bought the Palazzo Labia in Venice, and for the next three or four years its rehabilitation would be his main priority. The Labia was renowned for its spectacular frescoes of Cleopatra by Tiepolo, but it was in a run-down neighborhood. At one point, an army of squatters had moved in, and even though a few rooms had been restored in the 1930s, the palazzo had sunk back into dilapidation. The frescoes had recently been damaged by a munitions explosion. There was, however, an unexpected bonus: some fine furniture turned up under dust sheets in the attics.

To celebrate the restoration of the palazzo—eighteen state rooms and a dozen bedrooms—to the height of *settecento* magnificence, Beistegui held a spectacular masked ball on September 3, 1951. Outfitted as a Venetian procurator in a full-bottomed wig, crimson robes, and the two-foot-high platform shoes that the local nobility had formerly worn at carnival time, Beistegui towered over his guests.

Fêtes such as this traditionally open with a succession of *entrées:* groups of guests who band together to represent a theme. What with wig teasers, dressmakers, and flustered retainers, not to mention mocking friends, in the offing, the only real fun that most of the guests have in the course of a tedious and uncomfortable evening is the dressing-up phase of the festivities. The most elaborate *entrée* at the Beistegui ball was organized by the celebrated Chilean connoisseur and plutocrat Arturo López, who came as the Emperor of China with his wife as Empress and an exceedingly rococo retinue. Caked in enamel, fitted with fingernails inches long, and aflutter with feathers, they had considerable difficulty scrambling out of the chinoiserie junk that brought them up the Grand Canal. The most bizarre *entrée* was "the phantoms of Venice," a group of giraffelike stilt dancers thought up by Dalí in collaboration

with Christian Dior. To placate the populace, Beistegui overcame his stinginess and donated 200 million francs to the local Communist party and organized a *bal populaire* in the piazza. Guests who found the party stultifyingly dull—"like waiting around on the set of a costume movie," one of them told me—said they had much more fun with the hoi polloi in the piazza, which is where poor Marie-Laure de Noailles, who came as one of the lions of Saint Mark's, ended up trapped, the worse for drink, inside a stifling lion skin.

By the time I visited the Labia in the late 1950s, Beistegui seemed a bit seedy—not so much a grandee as someone overplaying the role of grandee. I understood why he had put on those platform shoes for his ball. Without them he seemed dwarfed by the pomp of the palazzo. As I looked down an endless *enfilade*, punctuated at each window embrasure by a huge gilt throne draped in the longest lace curtain ever woven, I expected a dolly with a camera crew to come rolling toward me. Most comical in its grandeur was Beistegui's bathroom, with an enormous portrait of a bewigged procurator above the bathtub pointing majestically toward a loo—a loo, incidentally, he seldom used: he preferred to do everything in the chamber pot he kept under the bed. Friends who were staying in the house complained that Venetians avoided the place: the company was gloomy, the hospitality meager. "If you want a drink," I was told, "bring a bottle of scotch. The palazzo has run out of it."

After suffering financial reverses and a stroke in 1960, Beistegui sold the Labia to a television network and auctioned off the contents. Back at Groussay, he became increasingly morose. His fortune was shrinking, but this did not stop his building more frantically than ever. So long as his pagodas and pyramids were under construction, he was like a man possessed, whizzing about the park in a *faux bois* golf cart, brandishing a cane at the workmen. Once a building was finished, he lost all interest. In 1970, just as he was about to embark on an extensive boxwood maze, he died.

It was a sad end for one of this century's most lavish patrons of the decorative arts. Beistegui had died intestate, and the château went to his nephew Juan de Beistegui, who was known to have disliked his

uncle as well as his entourage of grand hangers-on. Nor did he think much of all his uncle's reproduction furniture and rugs, which he replaced wherever possible with the real thing. He would do the same with his uncle's friends. Family togetherness would take the place of snobbery and gimcrackery. By 1998, Johnny de Beistegui's children had grown up and shown no interest in taking over Groussay, so he put the château and most of its contents up for sale. Deconstructed, the place looked like a stage set that had just been struck. As for the chattels, they seemed not so much antique as about to be secondhand. It was ironical to see people Charlie de Beistegui would never have had to the house poking around in his bits and pieces and carting them home in the hope that whatever luster had rubbed off on him might now rub off on them and, with luck, endow *their* lives with some of Beistegui's spurious social magic.

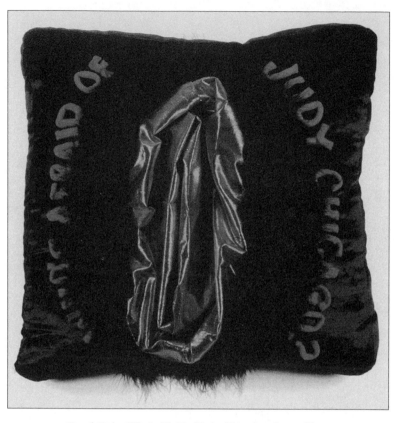

Carol Cole, *Who's Afraid of Judy Chicago,* velour pillow,
collection of Fritz Janschka

Judy Chicago's Giant Shriek

All bad art is the result of good intention.

Oscar Wilde, *De Profundis*

The great show of women artists (1550–1950) at the Brooklyn and Los Angeles museums in 1977 did art history and the women's movement an immense service. The organizers, Ann Sutherland Harris and Linda Nochlin, presented their material in the light of modern scholarship, and if their indispensable catalogue shows signs of feminist bias—why not? At least they were careful not to jeopardize their cause with rash claims. As well as assembling an intriguing group of largely unfamiliar works, this exhibition was a milestone because it opened up unexplored territory and encouraged women to take pride in an artistic heritage virtually none of them knew she had. However, this admirable exhibit did not make more than a small dent in the swinish male conviction that, with a few exceptions, women are only marginally better painters than they are composers or bullfighters.

Two years after the Brooklyn show, Germaine Greer published her history of women's art, aptly entitled *The Obstacle Race*. Anyone

who had hoped that Greer would build up a full-scale historical reappraisal on the foundations so ably excavated by Harris and Nochlin was in for a disappointment. Not for the first time, Greer's prejudices ran away with her. *The Obstacle Race* is eye-opening insofar as it reveals the length to which feminists are ready to go in their manipulation of art-historical fact. Major claims are made for irredeemably minor figures, and the author harps too much on the familiar feminist contention that the lack of good, let alone great women artists is all the fault of men: dastardly husbands, overbearing fathers, biased teachers, envious colleagues, chauvinist critics, misogynistic dealers, sadistic rapists, fanatical mullahs, and the like. These brutes are accused of doing such damage over the centuries to the wills and wombs, the egos and psyches of women that the creative urge has been repeatedly nipped in the bud. Hence no Fran Angelicos, no Golda Rembrandts, no Blanchette Mondrians (to borrow a conceit of Robert Rosenblum's). The trouble with this contention is that it utterly fails to explain why, if the lack of artistic genius in females is the consequence of male chauvinism, there should have been so many women who were (to quote Brigid Brophy) "great *literary* artists."

Then again Greer leaves out of account the fact that some of the lesser painters she cites have acquired a reputation largely because they were women. If, for instance, that minor follower of Caravaggio, Artemisia Gentileschi, is now more celebrated than more accomplished *male* Caravaggisti, it is thanks to her gender, not her gifts.

In 1980, the Brooklyn Museum climbed back on board the feminist bandwagon. Spurred by the success of its women artists' exhibition, the director and the Education Department (as opposed to the Painting Department, which sponsored things in 1977) took the bold step of displaying Judy Chicago's ultracontroversial *Dinner Party*. Conceived as a monument to women's achievements, this elaborate installation piece consists of a large triangular table laid with thirty-nine place settings (made up of a commemorative dish in the form of a vagina plus an embroidered runner, goblet, knife, and fork), each of which is dedicated to a different goddess, saint, witch, queen, lesbian, pioneer, writer, or artist, from Kali to

O'Keeffe. On the occasion of *The Dinner Party*'s debut at San Francisco in 1979, Chicago declared her piece to be "one giant shriek." By the time the piece reached Brooklyn, there was not a shriek left in it, but then, in those days there were no crusading politicians around to denounce and thereby promote scabrous imagery as well as their own no less scabrous selves.

Judy Chicago, who claims descent from twenty-three generations of rabbis, was born in Chicago, hence her *nom de plume et pinceau* and the initials J.C., which she is said to have coveted. Early in life, she was married, widowed, married again—to a painter with whom she "used to joke about [their] being Braque and Picasso"—and finally divorced. Meanwhile, she had moved to California, where she worked as a Minimalist painter and sculptor who, according to Lucy L. Lippard, "prided herself on the 'fetish finish' of her work and the way she 'dance[d] on the edge' of technical disaster—to orgasm." She also became known as a teacher and promoter of women's causes.

In the course of her autobiography, *Through the Flower: My Struggle as a Woman Artist,* Chicago confesses to two formative influences: that simpering ninny Anaïs Nin ("one of my heroines"), whose narcissistic attitudinizing has addled many an adolescent mind; and the more overtly macabre Valerie Solanas, mastermind of SCUM (Society for Cutting Up Men) and also the woman who shot Andy Warhol almost to death. "Even though I thought Solanas extreme," Chicago writes, "I identified with all the material in those early tracts as I had never identified with anything in my whole life." As for painters, the one who inspired Chicago the most—through her life as well as art—was the late Georgia O'Keeffe, but the Sibyl of Taos kept her distance. "You mean Chicago's still alive?" was all the old lady would say when I tactlessly asked whether she enjoyed being the one live guest at this phantom feast.

Chicago's reputation as a "saint" in feminist circles dates from the early seventies, when she set up a women's program at Fresno State and also established two related projects: Womanspace, a gallery where women could congregate and exhibit, and Womanhouse, a community center that emphasized consciousness-raising. Group sessions in a kitchen curtained in plastic by Wanda Westcoast

included assemblages of an inspirational or provocative nature such as Chicago's *Menstruation Bathroom* and performances of "plays," among them a brief two-character charade called *Cock and Cunt.* This involved sexual organs made of Styrofoam and a lot of hand clapping in a brisk one-two, one-two rhythm: "very effective" if, as Chicago suggests, *Cock and Cunt* is performed by several teams, each team doing the play twice so that every participant gets a crack at being the villain as well as the heroine.

But Chicago's ultimate goal was to come up with a monument to "the history of women in civilization," a monument that would carry on from her *Great Lady* series—paintings of Christina of Sweden, Marie-Antoinette of France, Catherine the Great of Russia, and Victoria of England (an odd choice, since the latter could not bring herself to believe that women ever slept together)—as well as her *Reincarnation Triptych,* which honored Mesdames de Staël, Sand, and Woolf. Originally her theme was to be "Twenty-Five Women Who Were Eaten Alive," but she courageously abandoned the ridiculous for the sublime—for *The Last Supper,* no less. Not that Chicago is the first feminist with a eucharistic hang-up: in 1972 Mary Beth Edelson had already devised a feminist parody of *The Last Supper,* with Georgia O'Keeffe standing in for Christ. There had also been the *Sister Chapel,* a collaborative venture that threw together Artemisia Gentileschi, Frida Kahlo, Superwoman, Betty Friedan, and their big sister, God.

Chicago proved to be a no less ambitious hostess; not even hell was exempt from her guest list, only the third world. She set out to reinterpret *The Last Supper* from the point of view of women who, throughout history, had prepared the meals and set the table. "In my *Last Supper,* however, the women would be the honored guests ... There were thirteen men present at the *Last Supper.* There were also thirteen members in a witches' coven, and witches were also associated with feminine evil ... [Thus] the same number had both a positive and a negative connotation ..." This all-woman *Cena* had of course to be stylishly served. Since the seating posed insoluble problems, Chicago concentrated on the place settings and dinner service. "Thirteen plates," she soon realized, "were not enough to represent the various stages of Western civilization

and therefore the number tripled." Further corroboration for Chicago's "historical viewpoint" materialized on December 27, 1975, when the credulous artist came upon "a wonderful quote about how God changed sex in the thirteenth century."

By the time it was finished *The Dinner Party* cost over $250,000 ($36,500 from the National Endowment for the Arts) and necessitated five years' incessant work on the part of Chicago ("I can imagine how Michelangelo must have felt . . .") and over four hundred mostly dedicated but sometimes mutinous women, plus a few indispensable men, notably the chief ceramist and industrial designer. Odd that Chicago had recourse to a male ceramist: I had always thought of pottery as a "woman thing," and of pots as symbols of women—"female containers of air and art" (to quote Willa Cather)—and thus a particularly valid vehicle for the celebration of womanhood. Chicago failed to get clay to work for her, but this may have been the male ceramist's fault.

Sadly, Chicago's plates look a bit like those ornate psychedelic candles that used to adorn the shelves of Greenwich Village "head" shops. Only the organic form they take is rather more special. At first, Chicago had thought of making dinner plates that looked like butterflies—"metaphysical references to the whole issue of what it means to be feminine"—but she soon realized that what she really needed was a form that would not just flutter but "bend, and twist, and push, and thrust"—a form that would also avenge womanhood for all "those centuries of phallic imagery." She did not have far to search for such a form. There it was between her legs: the only symbol with enough "push and thrust," as well as charisma, to take on the entrenched, phallocentric establishment. And so with a backward look at O'Keeffe's vulviform flowers, Chicago embarked forthwith on a set of ceramic vaginas. The process turned out to be a taxing and tedious undertaking. Sometimes the kiln seemed hexed, she says. All the more regrettable, then, that far from living up to the sexual audacity of their conception, Chicago's artifacts not only bring to mind Kingsley Amis's hard lines on women's parts, "like the inside of a giraffe's ear or a tropical fruit not much prized even by the locals," they seem actually to illustrate it.

Questions of diagnosis inevitably suggest themselves. Why, for

instance, are deities such as Ishtar, Kalim, and the Snake Goddess suffering from *vagina verrucosa?* Why is Sacagawea saddled with that old bogey, *vagina dentata,* or Margaret Sanger with such an angry red condition? And, granted there was something odd about Elizabeth I's sexual nature, but why the flux of purple jellybeans? And what of the dinky plate with the ruched pink pussy nestling in a ruff of clay-dipped lace? This does not stand for Mae West—she wasn't invited—but for Emily Dickinson. This pink thing is doubtless what triggered the spot of trouble that occurred during the Brooklyn showing: two susceptible women had to be evicted for having a go at each other right there on the "Heritage Floor." So much for Chicago's powers of consciousness-raising.

My own reaction was less Dionysiac. I remember feeling in need of relief from the locker-room camaraderie of the project and finding it in Kynaston McShine's memorable retrospective of Joseph Cornell's work at the Museum of Modern Art. Here by contrast with Chicago was an artist who despite his gender had developed "an idealized empathy for women" and who exploited this empathy in a succession of magical boxes that enshrine the spirit of his heroines—among them Emily Dickinson. What a relief, then, to come upon one of Cornell's most evocative constructions with a Dickinsonian theme, *Toward the Blue Peninsula.* The subtlety and delicacy of the poet's psyche as well as her verse—so degraded by Chicago's dish—find a perfect echo in this taut, sparse shadow box. As is Cornell's way, he epitomizes the genius of a specific woman with a touch that is all the more effective for being mystifying, allusive, and curiously apt.

And then back, refreshed, to Brooklyn to compare Chicago's allegorical methods. Besides the mystery that Cornell generates, irony is missing; so is any hint of the sacred fire needed to sanctify the clumsy chalices and flatware—as big as jugglers' props—that are supposed to enhance the impact of the plates. The table runners are another matter. Thanks to hundreds of skilled embroiderers, quilters, weavers, stump workers, and the like, the runners are far the most rewarding aspect of *The Dinner Party.* By displaying virtually the entire gamut of needlework techniques, they constitute a mi-

crocosm of the craft: a microcosm that is the subject of one of Chicago's accompanying volumes. However, the banal designs and unimaginative choice of emblems (dinky waves in the case of Virginia Woolf?) are not up to the quality of the stitchery. Like much else about *The Dinner Party,* the runners are intended to have a ritualistic look, but far from invoking *l'éternel féminin,* they invite comparison with such badges of male chauvinism as Freemasons' aprons or the neofascist heraldry of motorcyclists' insignia.

Chicago wants *The Dinner Party* to be perceived as history, hence a series of texts that are dismally coy when they are not being strident: the outcome of a feminist technique known as "herstory." As practiced by Chicago and the twenty research workers who collaborated on the historical side of this project, "herstory" necessitates "reading through" the biased way women are usually presented in history books. Alas, "herstorians" turn out to be even more chauvinistic and even less concerned with accuracy than the most misogynistic male historian. The "reading through" technique results in texts that are as objective as entries in *The Great Soviet Encyclopedia.* Besides being shamelessly selective in their perceptions, Chicago's "herstorians" indulge in special pleading and inane speculation. They show themselves to be as blinkered as medieval nuns in their selection of 999 "women of achievement," whose names in gold "emanate like streams from beneath the place settings" all over the bathroom tiles of the Heritage Floor.

After ransacking "close to a thousand history books," the *Dinner Party* "herstorians" came up with a "roll of honor": a grab bag consisting of "Antoinette, Marie; Anu (a fairy); Aphrodite; Arachne; Arendt, Hannah . . . Maacah, Mabel, Macha, Macha (a Fury); Macha of the Red Tresses; Madderakka . . ." and so on. But too many of these female paragons disqualify themselves from serious consideration by being legendary (Python, Buto, etc.), fictitious (Lysistrata), spurious (Pope Joan), arcane (Properzia de Rossi, who carved peach stones), bogus (Madame Blavatsky), bigoted (Carrie Nation), foolish (Mata Hari), or unreadable (Radclyffe Hall). Chicago's list often reads like the parody devised by "Maria Manhattan," a rival artist who had asked the Brooklyn Museum to ex-

hibit her spoof, *The Box Lunch,* at the same time as *The Dinner Party.* When the museum refused, Manhattan set up her piece in a gallery on Wooster Street, complete with a catalogue honoring, among others: Lot's Wife, Amy Carter, Mary Hartman, Pat Nixon, Evita Perón, and, of course, Chicago. By reducing the Chicago piece to total absurdity, the Manhattan project scored a few easy points, but in the last resort *The Box Lunch* was redundant because the target is self-parodic.

As telltale as the inclusions are the exclusions, especially twentieth-century ones. For example, Karen Horney makes the list, not Anna Freud or Melanie Klein; Vita Sackville-West, not Ivy-Compton Burnett or Sylvia Plath; Louise Nevelson, not Eva Hesse or Agnes Martin. And then why no Garbo or Dietrich, no Callas or Piaf, no Claire McCardell or Chanel, and why, since the Amazon plate is a pretext for paragraphs of mythic claptrap, are there no references to the real McCoy—the *Amazones Dahoméennes,* who for at least two hundred years have formed a crack division of the Dahomean army? According to Bruce Chatwin, who claimed to have been one of their victims, these Amazons are still going strong, still filing their teeth to points, the better to devour their male enemies—authentic SCUM.

The biographical notes on Chicago's motley pantheon are a measure of the desperation that "herstory" imposes. For instance, Megalostrata, who "achieved prominence as a composer, singer and leader of girls' choirs in Sparta . . . Unfortunately none of her compositions have been preserved"; or again Honorata Rodiana, "who was the only woman fresco painter in fifteenth-century Italy. Unfortunately none of her works are extant, probably due to improper attribution . . ."

Even when a life is a matter of more or less public record, errors of fact and emphasis abound. Virginia Woolf is a notable victim. As a girl (to believe her nephew and biographer, Quentin Bell) she was fondled by her half brother, George Duckworth, but *not* raped by him. And Chicago oversimplifies to the point of travesty when she claims that "according to Woolf's philosophy, the subjugation of women was the key to most of the social and psychological disorders of Western civilization . . . [and] that the rise of Nazism was an

infantile reaction to women's demands for equal rights." Even Woolf's suicide is seen as a feminist martyrdom: "she could just no longer muster the energy to fight the structure of male-dominated society." To add insult to cant, Chicago memorializes this infinitely fastidious woman with a sallow flesh-colored vent—"luminous petals spread open to reveal Woolf's fecund genius."

Nevertheless, despite "herstory" and other feminist excesses, *The Dinner Party* deserved to be taken seriously, if only as gender-generated agitprop. It apparently proved of value to a great many women in search of feminine solidarity. It also served as a sorely needed rallying point in women's ongoing war of independence—what Chicago has described as the "class struggle based on the division between men and women." And, not least, it gave the people who worked on it a gratifying sense of communal fulfillment that proved an inspiration to women's groups all over the country.

Then again, such intense feelings of hope and identification rubbed off on *The Dinner Party* that it developed an almost palpable mystique. No one who saw the Brooklyn exhibit could fail to be struck by this phenomenon, also the monastic—sorry, conventual—hush in the gallery. So far as I could judge on my visits, the women (there were very few men) were an average cross section. All the more striking, then, that these women, many of whom might well have winced if shown a merkin, were shuffling past rows of cunts, as reverently as if they were on a pilgrimage. Come to think of it, they *were* on a pilgrimage. Brooklyn was briefly their Cnidos, the birthplace of Aphrodite. And so, while anything but touched by the piece itself, I was touched by the way it appeared to kindle and soothe women's spirits. At the same time I could not help but be concerned over the ideological influence of a movement whose sympathizers could derive so much uplift from so much bunkum.

———

From the outset Chicago maintained that she wanted *The Dinner Party* to be "so far beyond judgment that it (would) never be erased from history as women's work has been erased before." Twenty years later, this "symbolic history of women in western civilization"

has not prospered. Despite fifteen exhibitions all over the world, it has failed to find a permanent home. Chicago is, understandably, bitter at being faced with considerable costs of storage and conservation. According to her website, "mildew has already attacked the delicate millennium runners . . . I cannot bear the thought of *The Dinner Party* . . . molding in storage and sometimes I wonder if I should break it up in the hope that individual place settings might make their way into museums. To tell the truth, I do not know what to do." It is a tragically ironical situation. By Chicago's own admission, women's work is still undervalued by men, but it "is still not valued . . . even by women themselves."

However, Chicago should take heart. In the field of contemporary art, women have come to count for as much as men. Twenty years after her *Dinner Party* drew crowds to the Brooklyn Museum, this institution made yet another bid for artistic notoriety by putting on Charles Saatchi's *Sensation* show, which besides such controversial images as Chris Ofili's folk-art Madonna done in elephant dung and cute cutouts from sex magazines included works by Sarah Lucas, Jenny Saville, and Liane Lang that are much bolder and in-your-face than Chicago's ceramics. If women played a leading role in the Saatchi show and sexual organs a leading role in their subject matter, Chicago can take much of the credit. She gave women artists the courage to take their private parts back from pornographers and use them to their own iconic advantage. This is all to the good except that empowerment has come a bit too late. Contemporary art has turned into such a rat race that gimmickry masquerading as originality counts for far more and sells for far more than ideology. Women artists out to make a name for themselves are proving as adept at putting their own sex down as their phallocentric foes. From the vantage point of today, *The Dinner Party* looks more like a celebration of misogyny than a denunciation of it. Chicago's four hundred cohorts would have done their cause more credit if they had taken a leaf out of Christo's book and wrapped the Grand Canyon.

Truman Capote, by David Levine, 1987

À Côté Capote

Il ne faut jamais recevoir un homme de lettres chez soi.

Comtesse de Chevigné
(a model for Proust's Duchesse de Guermantes)

Some thirty years ago Truman Capote and I spent part of the summer in Venice. Although acquaintances rather than friends, we ended up seeing each other every day, thanks to my traveling companion, Virginia Chambers. Virginia was an elderly American widow who had lived in Paris since the twenties—hard-drinking, card-playing, and worldly, nonetheless intuitive and bright, and passionate about modern art. Truman was very fond of her: she was outspoken and, more to the point, a close friend of many of the "beautiful" people by whom he set such store. He was also captivated by her gutsy wit in the face of almost total blindness—an affliction that she handled so deftly few people noticed. For her part, Virginia was amused to have Truman around. Listening to embryonic passages of his long-awaited novel, *Answered Prayers,* made a change from Library of Congress records for the blind. A weakness that Truman had transformed into a strength was his voice: an insidious little girl's whine that he could modulate and color as

craftily as a lieder singer, and that he exploited in his writing so long as he or some credible extension of himself figured as the narrator. Indeed, to have *heard* Truman doubled the pleasure and occasionally the pain of reading him.

When one airless Venetian afternoon Truman had embarked on what he announced as "the true story of the Woodward murder" (about the hooker who married the old-guard banker's son and by-mistake-on-purpose shot him when he demanded a divorce), which he would use in *Answered Prayers,* I found it impossible not to be beguiled, as the tale slithered effortlessly out of him. No question about it, Capote was in the great tradition of homosexual raconteurs. Just as it took the paradoxical Wilde no more than five minutes to get a roomful of fox-hunting squires to declare "they had never met such an amusing fella," and just as the mercurial Cocteau could hold a roomful of senators or sailors as rapt as children at a conjuring show, so the outrageous Truman could wheedle his way into the graces of the most belligerent homophobe, thanks to the wit and the mischief of his chitchat. However, as so often happens, the raconteur stifled the writer. Truman allowed too many of his stories to evaporate in the fashionable air, like those scented candles with which his smart friends perfumed their rooms. Hence his books' vaporous *déjà lu* thinness.

If we had Truman to ourselves, it was largely because his Venetian friends, Count and Countess B., who had lent him an apartment in their palazzo, were away. So apparently were all the other grandees of his acquaintance. Or were they, I wondered, in hiding? For Truman was traveling with a man called Randy McCuan, a dim, very ordinary looking blue-collar worker—a former prison guard at Joliet whom "Little T." had enticed away from a wife of ten years and a job repairing refrigerators in Palm Springs. Instead of keeping this humble love object dark, Truman insisted on showing him off to his smart friends as a kind of trophy, "straight as a die and madly in love with me." When I pointed out that by virtue of falling for Truman, Randy could hardly be described as straight, "Little Tru" was most indignant. "Straight men are always falling in love with me," he said.

There had of course been problems. Randy's name was easily

confused with that of Rod McKuen's. And so a socially ambitious Palm Springs lady had assumed that Truman was bringing a celebrity to dinner when he accepted her invitation, and was dismayed to find she had organized an elaborate evening around a refrigerator repair man. The Italian friends who had been prevailed upon to invite Randy for a cruise on their yacht had done their best to put the Palm Springer at his ease, but it was all too evident that he would have been happier with the crew. Another of Truman's cult figures was less cooperative. He decreed that if Randy came to his apartment, "he better use the back elevator."

It was now our turn to cope. A run-through of some of the themes destined for Truman's work in progress turned out to be the reward for being nice to Randy—no problem except that in his passive-aggressive way all he wanted to do was complain about the lack of such necessities of life as comic books, air-conditioning, certain TV programs, and above all baked potatoes. At every meal, Truman would beg Cipriani to serve us *baked* potatoes—he would describe exactly what he meant—"in their jackets." Yet at every meal crisp little sautéed cubes would be served. Randy grew sulkier and sulkier. Finally I scoured the market for the nearest thing to an Idaho potato, and gave the chef very explicit instructions: no peeling, no chopping. Such was our anticipation that Truman for once stopped talking about himself in the same breath as Balzac, Proust, and Clark Gable; even Randy perked up. But we were out of luck. Once again the hateful cubes arrived. Randy buried his sad, thin face in a comic book. There and then he seemed to lose what little heart he had for travel and for Truman. A week or two later, the two of them headed back toward England, to stay with Lee Radziwill. On the plane Randy announced that he had developed an allergy to fashionable folk and would rather tinker with refrigerators than with Truman. This rejection brought on a traumatic breakdown— months of suicidal sobbing—from which the writer never totally recovered, nor did his writing.

According to Truman, *Answered Prayers* was going to be his masterpiece. *La Comédie humaine* and *À la recherche du temps perdu* were his principal exemplars, except that his book would of course be "better," that is to say more authentic, than Balzac's or Proust's.

Truman wasn't going to disguise his characters; he was going to put *real* people in just as they were. "So there!" he sniggered defiantly. Insofar as he, too, was a homosexual outsider who had crashed the beau monde, he copied Proust to the extent of soundproofing one room of his apartment in which "to retire from the world." But far from using his soundproofed room for work, he shut himself away in it to get drunk and pop pills. And far from keeping aloof from the world and not giving an inch like Proust, Truman allowed himself to be enslaved by Society—or rather café society, which was closer to hand and easy to crash—and became a court dwarf-jester to a lot of billionaires and a *cicisbeo* (what is now called a "walker") to their bored wives.

The little starstruck monster from Alabama was not going to forgive the beautiful people for being so beautiful, so remorselessly low-key with their mink-lined raincoats and their choice little dinners of tiny lamb chops and unborn vegetables followed by wild strawberries in a bath of blood-orange juice. Nor was he going to forgive himself for selling out to them. This became all too clear when Truman asked us whether we wanted to hear the "true story" of Clare Luce, or Mrs. Gilbert Miller, or whoever else was the *plat du jour.* Let's face it, we did. There would be a mean edge to the whiny voice, as he served up ever more brimstone and ever less treacle. *Answered Prayers* was evidently about people getting their comeuppance. Ironically, the book resulted in Truman getting his.

Everything, we were told, was going to revolve around the narrator, P. B. Jones—"sort of a Pal Joey with class," Truman said. And he provided a further clue—"just like our friend, Johnny X." He must have changed his mind: Johnny X bears far more resemblance to Aces Nelson, the "backgammon bum" who appears later in the book. In the course of the first and by far the best-written chapter, "Unspoiled Monsters," P. B. Jones comes more and more to resemble Truman, at least to sound like him—campy, snide, and a shade fractious, like a very spoiled, very manipulative child—but then, in the book everybody eventually suffers from this awful fate.

As for Kate McCloud, the irresistible red-haired, green-eyed heroine, Truman was very cagey about her identity. "Some old

booby from Colorado Springs was the only person to spot who she is," Truman said after this section came out in *Esquire*. "The rest of you will just have to go on guessing." Guessing was no problem at all. McCloud is compounded of two once-well-known café society beauties: Mona Harrison Williams (later Countess Bismarck), who, like Kate, was the daughter of a groom, married the boss, and had huge emerald green eyes—and Nina Dyer, the doomed *allumeuse* who was successively the wife of Baron Thyssen and Prince Sadruddin Aga Khan. Truman spun many a tale about the curse of "poor Nina's" aphrodisiac effect on men and women and how it ultimately drove her to suicide. After a few days in Truman's company, we realized that if and when the novel came out, a lot of reputations would be at stake.

The pyrotechnical display that Truman had given us in Venice was far more entertaining than the three surviving chapters that finally appeared in book form. *Answered Prayers* was more like the aftermath of fireworks—blackened Catherine wheels, fag ends of fusees, rockets that never made it to the sky. And whatever happened to all those other chapters that Truman discussed over and over again in such detail: "Yachts and Things," "A Severe Insult to the Brain" (a title taken from Dylan Thomas's death certificate), "Father Flanagan's All-Night Nigger-Queen Kosher Café"? How fascinating he made them sound! And what about the Hollywood chapter described so graphically to the editor of *Esquire,* Clay Felker?

The setting for this was to be Kate McCloud's bedroom at 550 Park Avenue. Kate and her lover, whom Truman identified to Felker, are in bed together and she answers the telephone. While continuing to have sex, she has a ninety-eight-page-long conversation with Jerome Zipkin (in those days Mrs. Reagan's walker), who is calling from Beverly Hills. In this chapter Truman promised to spill all the Hollywood beans he had been accumulating for years. Capote asked $30,000 for the piece, but he never gave it to Felker, eventually saying there was some confusion as to who owned the rights.

Joseph M. Fox, for many years Truman's editor at Random

House as well as a very supportive friend, surmises that "Truman did indeed write at least some of the above-mentioned chapters . . . but at some point in the early 1980s deliberately destroyed them." So much for Truman's stories that the complete manuscript was "either stashed in a safe-deposit box somewhere . . . seized by an ex-lover for malice or for profit, or even . . . kept in a locker in the Los Angeles Greyhound Bus Depot." Fox's theory was confirmed by the late "Slim" Keith, Truman's closest woman friend until his betrayal of her in the chapter called "La Côte Basque," which he published in *Esquire.* Lady Keith said that Truman insisted on reading certain sections of *Answered Prayers* to her in the early 1970s. "He nailed me to the cross," she [said]. "It was all a terrible mess and I couldn't understand where the book was going."

Compared to Truman's fastidious earlier work, *Answered Prayers* is dismayingly vulgar: vulgar in humor ("Lady Dudd Cooper"); vulgar in style (Kate McCloud wears the "best-fitted of Balenciaga's box-jacketed black bombazine suits"); vulgar in its shoddy exploitation of a potentially ironical theme—more tears are shed over answered prayers than unanswered ones—one of Saint Teresa of Avila's more questionable pronouncements. The only prayers that interest the author are crassly materialistic or libidinous ones: unscrupulous hookers of either sex out to entrap rich husbands—that sort of thing. Truman's campy salaciousness as he sets the sinful scene is only slightly less offensive than his moralistic gloating over the consequences.

Take Truman's portrait of the beautiful pre-1939 hustler Denham Fouts: so eternally boyish that he had been kept in jewelry, drugs, and Picassos by kings and queens and maharajahs; so naturally fragrant that at least one admirer made off with his linen; and so mystically inclined that he became a Buddhist, before overdosing on heroin. And then compare it to the darker portraits of this Jacksonville Antinous by Christopher Isherwood and Gore Vidal. Truman's characterization is cheap filigree. Isherwood, by contrast, takes material originally fashioned by Vidal into an amusing short story (1956) and transforms it into a full-length portrait (1962) of a

fallen angel as cool, perplexing, and alien as David Bowie. As for the plot of *Answered Prayers,* it, too, is cheap filigree. That Truman failed to develop it is not surprising. Only Judith Krantz could have done so. The scenario, such as it is, resembles nothing so much as one of those spoof movies about unbelievably glamorous women being victimized by unbelievably wicked billionaires in unbelievably sumptuous settings, which Manuel Puig used to much better effect in his *Kiss of the Spider Woman.*

The vicissitudes of the bog-Irish heroine, Kate McCloud—"so beautiful that she is some kind of freak"—boil down to her being the victim of two very rich, very jealous, very cruel husbands. The first, Harry McCloud, tears up a flower garden she has planted and then goes down to the stable and breaks her palomino's legs with a crowbar. Whereupon Kate flies to Sun Valley for an Idaho divorce; and although she swears she'll never marry again, she all too soon finds herself in Düsseldorf Cathedral marrying yet another evil cliché—this one from the pages of Harold Robbins. Axel Jaeger ("easily the richest man in Germany—and possibly Europe") had inherited an ammunitions fortune that he has astronomically increased. It goes without saying that he is a thin, almost emaciated man in his late fifties "with a Heidelberg sword-scar across his cheek"; a recluse living "in a colossal, and colossally ugly, château on a mountainside about three miles north of St. Moritz." "One year later, the prayed-for heir arrives." Heinie, he is called. For no apparent reason Kate is thrown out of Château Jaeger. She has to leave her child in the custody of two evil "old maid" uncles, and is granted very limited visiting rights. After "several months . . . cloistered at the Nestlé Clinic in Lausanne . . . she moves to Paris, and over the years, becomes a goddess of the fashion press; . . . on a bear hunt in Alaska, . . . at a Rothschild ball, at the Grand Prix with Princess Grace, on a yacht with Stavros Niarchos." Since Jaeger is a Catholic he cannot divorce her. Since this is pulp fiction, murder is his only other option; meanwhile Kate contemplates murdering him.

So ends the action of this book. True, there is one more chapter, "La Côte Basque," but it stands on its own. It is in fact a rehash of

the second of two articles entitled "Blind Items," commissioned by
Ladies' Home Journal in 1973. "A master writer turns gossip into an
art form," the *Journal* boasted when it published the first section in
January 1974. "Turns gossip into libel" would have been nearer the
mark. The "blind item" was a device made notorious by Truman's
hero Walter Winchell in the forties: the libelous story about the un-
named celebrity that contains enough clues to titillate the knowing
reader but not enough to give the victim grounds for legal redress.
That he should stoop this low confirmed that Truman's conscience
as a writer and friend had warped beyond hope of recovery. The
"blind items" were Winchellesque in style as well as content, and
four out of five of them libeled people who were very close to Tru-
man. "Can you guess who's who?" the *Journal* asked.

The feature did not find favor with the ladies of Middle America,
and the editor, Lenore Hershey, who had paid $50,000 for the two
pieces, decided not to print the second lot; too "terrible, scurrilous
and dirty." Truman had apparently made the mistake of sending
Mrs. Hershey a handwritten note identifying the people in the sec-
ond set of blind items: "an industrialist, a governor's ex-wife, Merle
Oberon, Kim Novak, Sammy Davis Jr., Mrs. William Woodward,
Sr., Mrs. William Woodward Jr., a publishing tycoon" and many
more.

During the next year, Truman recycled the five or six of the blind
items rejected by *Ladies Home Journal* into "La Côte Basque," the
third and last surviving section of this ill-fated opus. These items
have no relevance whatsoever to the plot or the characters in the
previous chapters. The only possible explanation is that Truman
saw them as exemplifying Saint Teresa's theme. For apart from
sharing the misfortune of the author's friendship, his victims had
each lived to regret some answered prayer or other. These little hor-
ror stories do nothing to further the plot or provide it with some
badly needed sense of depth. The ventriloquial device of putting
them into the mouth of Lady Ina Coolbirth, P. B. Jones's luncheon
companion at the Côte Basque restaurant, compounded the felony.
For, deny it though he might, the character of Lady Coolbirth was
based on his beloved "Big Momma," Slim Keith—one of the most

popular women in Truman's smart little set. Saddling her with his most scurrilous tales was the more heinous in that most of the people he had targeted were her closest friends, particularly the victim of the most repellent story: the one about the Jewish tycoon whose seduction of a WASP lady is avenged by her contemptuous bloodying of his bed.

When "La Côte Basque" came out in *Esquire,* Truman tried to defend himself against the opprobrium that showered down on him by invoking his right as a latter-day Proust to sacrifice friendship on the altar of art, but his once golden ear had turned to tin and the tittle-tattle was far too sleazy to justify any such argument. Socially speaking, Truman would never return from the Siberian circle of hell to which his outraged friends condemned him for betraying them.

The fact that all the characters in *Answered Prayers* sound exactly like Truman suggests that he had lost sight of the difference between the written and the spoken word. Campy little anecdotes that had titillated us as we sat by the Cipriani pool were acutely embarrassing when they appeared in print. Worse, in his hunger for social vengeance Truman could no longer distinguish between the pen as an instrument for good or for evil. Take his treatment of Ann Woodward (Ann Hopkins in the book, "Bang Bang" in conversation, who had by-mistake-on-purpose killed her husband). After she called him a "faggot" in the bar of the Palace Hotel, St. Moritz, Truman decided to destroy her and her sons with *National Enquirer*–like revelations. Hearing that "La Côte Basque" was coming out in the November *Esquire,* Ann managed to get hold of an advance copy. By the time the magazine was on the stands, the wretched woman had committed suicide, as eventually would both her sons. "Bye-bye, Bang Bang," Truman said, not displeased with himself.

Bereft of his fashionable constituency, Truman went more and more to pieces, thanks to drugs, drink, and down-at-heel Irishmen (as always straight as a die yet madly in love with him). Writer's block set in. There was no energy left for his vaunted high finish, even if there had been anything to lavish it on. Television appear-

ances confirmed that his addiction to Valium and cocktails of amphetamines and Demerol and a lavender pill called Lotusate had slowed and slurred his speech to a state bordering on blather. Rescue came, albeit briefly, from a surprising quarter: Andy Warhol and *Interview* magazine. Surprising because Warhol, formerly one of the writer's most assiduous admirers, had hitherto been treated with the dwarfish hauteur that Truman reserved for some of his homosexual fans. Hence a certain coldness between them, especially after Truman dismissed Warhol as "a Sphinx without a secret." But then in 1973, the two of them had done a long interview for *Rolling Stone*—an interview in which Truman went out of his way to attack the "Jewish intelligentsia," just as two years later he would go out of his way to attack café society. Now that so many downtown lofts as well as fashionable drawing rooms were off limits to him, Truman spent much of his time in discos, above all Studio 54, where he made a point of cultivating Warhol and more particularly Bob Colacello, who was editor of *Interview*. According to Colacello, Truman, who had always been fascinated by literary techniques, realized that the *Interview* formula could be a godsend for an author who found it easier to talk than write.

Warhol and Colacello gave Truman a tape recorder, and over the next year or two *Interview* published some twelve pieces, most of them in dialogue form. These make up the bulk of *Music for Chameleons,* though you wouldn't gather this from Truman's highfalutin preface to this, his last (1980) book, which fails to make any mention of Warhol, Colacello, or their magazine. A pity, because the formula was ideally suited to Truman's conspiratorial chatter. Indeed "A Day's Work"—his account of accompanying a black cleaning woman on her rounds—is closer to his ideal of "simple, clear as a country creek" prose than most of *Answered Prayers.*

When *Music for Chameleons* was published, Truman left New York on a book tour. No sooner was he off the leash that Colacello and Brigid Berlin had contrived for him than he went back to his old habits: above all cocaine, which he kept on the top of his toilet in a hollowed-out Bible. (Is this, one wonders, the same hollowed-out book in which his lover is said to keep Truman's ashes?) *Interview*

never saw him again. He was in and out of clinics and wrote nothing more of any substance. Shortly before he died, he told me that he was writing a novella to be called *Heliotrope* in memory of Babe Paley, who had broken his heart, he said, by dropping him after "La Côte Basque." Joanne Carson, in whose house Truman died, claims that on the day he died, he was at work on a piece about Willa Cather "for her." Paige Rensse thinks that he was doing it for her magazine *Architectural Digest.* No trace of it remains. As Gore Vidal said, death was a wise career move for "Little Tru."

The awfulness of Truman's end should not blind us to his former finesse. What a skillful writer he once was—less in his novellas and short stories than in his meaner, leaner reportage. The early fiction has faded and dated a bit; there is it too much fine sewing, too much Butterfly McQueenery, too much dew tinseling the leaves of the old China tree. But the whimsy evaporates when he moves away from the fairy-tale South and takes to the road. Try traveling to Russia with him and the cast of *Porgy and Bess* in *The Muses Are Heard.* One couldn't have a better—that is to say wittier, bitchier, more ironical—companion. Truman is clearly happiest when he manages to keep a certain mocking distance between himself and his subjects, as in *The Muses Are Heard,* where most of the characters are anything but WASP. The same goes for *In Cold Blood.* Truman is at his sharpest when writing about people—freaks, murderers, hicks—who are not of his world but who are every bit as twisted, alienated, and self-destructive as himself. In the last resort his problems were not brought about by his lack of stature as much as by his lack of depth, as well as his gossip-columnist's values. Truman had a way of reverentially looking up when he should have looked disdainfully down, and vice versa; in so doing he has remained an irredeemably *petit maître.*

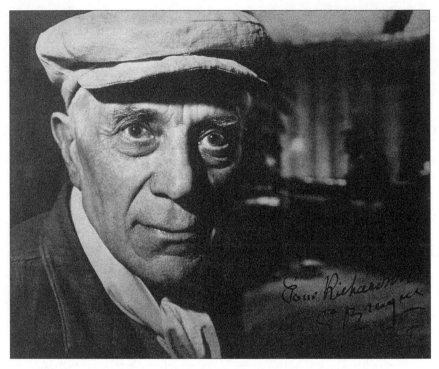

Georges Braque, 1955

Braque's Late Greatness

When I first published an article on Braque's *Ateliers* in *The Burlington Magazine* almost fifty years ago, I assumed that these symphonic masterpieces would take their place as the culminating achievements of Braque's career: more explorative in their handling of space and more profound in their metaphysical concerns than anything else being done in Western Europe at the time.

But somehow fame eluded them. Even in France these amazingly innovative works came to be perceived as irrelevant to modernism. However, the fastidiously orchestrated show that the British art historian John Golding put on at the Royal Academy in London and the Menil Collection in Houston in 1997 went a long way toward correcting this misperception. People began to realize that Picasso and Matisse are not the only artists of the School of Paris to have enjoyed a great late florescence. Before trying to understand why Braque should have fallen from favor, let us take a look at these unfamiliar masterpieces, particularly the *Ateliers*, *Billiard Tables*, and *Birds*.

Nowhere is the contrast between those former collaborators Picasso and Braque more apparent than in the work they each did in

the shadow of death. Picasso, who never quite outgrew his birth-
right of black beliefs and superstitions, put his faith in his miracle-
working paintbrushes and the death-defying images of carnality
that they engendered: those Gorgons of his, mooning, pissing,
fucking, masturbating with red-nailed fingers. However, there was
no exorcising mortality. Braque, who was an agnostic mystically ob-
sessed with the metaphysical nature of space, envisioned death as an
infinite spatial extension of life. Had he not, as Golding writes in his
catalogue preface, invented "the space in which Cubist objects
could live and breathe"? In the most haunting of his swan songs—
the bird pictures, which are less concerned with birds than the
heavens above—one feels the artist slipping meditatively away into
the empyrean. As he once said, *"Avec l'age l'art et la vie ne font qu'un."*
(As one grows older, art and life become one and the same.)

Before considering Braque's bird series (1955–62), we need to
look at the *Ateliers* (1949–56), where the birds first materialized. The
subject matter of these eight large pictures is nothing less than
painting itself, as practiced by the artist in the seclusion of his stu-
dio, which increasingly became a microcosm of his hermetically
private universe. There is no trace of a human presence in these *Ate-
liers,* neither of his wife nor of Mariette, his assistant; and although
Braque's spirituality permeates these paintings, he never actually
manifests himself in them. Just as well, since his evocations of peo-
ple are usually less palpable than his evocations of space.

Braque's *Ateliers* are true to their subject in that they are a distil-
lation of the carefully contrived clutter in the studio on the top floor
of his house in Montparnasse. This room was divided in half by a
pleated, cream-colored curtain, in front of which numerous recent
and not so recent works were arrayed on easels, tables, and rickety
stands. Some of the paintings were barely started but already signed;
some looked finished but lacked a signature; others dated back
five, ten, even twenty years, but were still "suspended in time," as
the artist used to say. Braque liked to "read" his way into them "like
a fortune-teller reading tea leaves." Sketchbooks ("cookbooks,"
Braque called them) lay open on homemade lecterns. Pedestals
contrived of logs and sticks picked up on walks were piled high with
materials: palettes galore, massive bowls bristling with brushes, and

containers of all kinds of paint (some of it ground or mixed by the artist with sand, ashes, grit, even coffee).

On the floor were pots of philodendrons, which Braque liked because their leaves "rhymed" with the shape of his palette, also simplistic sculptures carved from chalk—fishes, horses, birds—that make fragmentary appearances in the *Ateliers*. Elsewhere a shelf was set with tribal sculptures, musical instruments, and the large white jug that figures in so many paintings. The clutter that his work in progress entailed is thus the ostensible subject of these paintings. However, what they are really about is space. If many of the items are not readily identifiable, it is because many of them are in the process of being homogenized or dissolved in space. But then, as Braque explained to me at the end of his life:

> You see, I have made a great discovery: I no longer believe in anything. Objects don't exist for me except in so far as a rapport exists between them or between them and myself. When one attains this harmony one reaches a sort of intellectual nonexistence—what I can only describe as a sense of peace—which makes everything possible and right. Life then becomes a perpetual revelation. *Ça, c'est de la vraie poésie!*

This studio accumulation was crucial to Braque's modus operandi. Part of it had to be dismantled every summer and reassembled on a more modest scale in the studio of his country house at Varengeville in Normandy. Braque would roll up his canvases, stack them onto the roof of his car, and work away on them in his studio, or simply study them until he was ready to return to Paris in the fall. He took pride in the artisanal ingenuity with which the move was accomplished. "Little or no rope," he said. Braque also took pride in his skill at driving very fast cars. Because of the way it impinged on space, speed was another of his obsessions—on canvas as well as on the road.

The presence of an enormous bird in the *Ateliers* is less enigmatic than it might seem. It is not intended to be a "real" bird but a "painted" one, albeit one that detaches itself from its canvas ground. A large painting (later destroyed) of a bird in flight from the early

1950s had been lying around in the studio, and it is this image that appears in different guises in all but one of these paintings and generates what Braque called "tactile space." Hence the feeling that the *Ateliers* quiver "as though the air was fanned by invisible wings" (as Lord Curzon said of Gladstone's oratory). Since space—or rather his perception of it—was the principal subject, Braque was upset by suggestions that the birds might have symbolic significance—a Picassoesque dove of peace, an ectoplasmic materialization of the artist's inspiration, a sacred Egyptian ibis—or, silliest of all, that a real bird might have flown in through the window. These birds materialized on their own, Braque told me. "I never thought them up; they were born on the canvas."

I had the good fortune to see a lot of Braque in the early 1950s, when he was working on *Atelier VIII*, the culminant painting in the series. He claimed to have put all the discoveries of his life into this work. Its unusual brilliance of color, he said, was the consequence of doing some stained-glass windows for the church at Varengeville—a tribute to his wife's piety, which he respected but did not share. He was so proud of *Atelier VIII* that he allowed me to publish a photograph of it in an article in *L'Oeil* magazine before it was finished; and, more to the point, allowed Douglas Cooper, the British collector with whom I then shared a house in Provence, to acquire it for his great Cubist collection. Cooper saw the *Ateliers* as a long-delayed apogee of Braque's Cubism.

Braque agreed to this arrangement because he was anxious that the painting, which he regarded as his masterpiece, should remain in France. Cooper gave him a promise to this effect—a promise that was not honored once the artist was dead. Braque also insisted that the sale (August 1955) be handled by his dealer, Aimé Maeght. This made for trouble. Cooper loathed Maeght on the grounds that he had no understanding of his artists' work, but nevertheless kept back the best of it for his own collection. Cooper won the day by informing Braque that Maeght liked to differentiate *Atelier VIII* from the rest of the series by describing it idiotically as "the one with two large red armchairs."

And so the painting ended up hanging over Cooper's bed. Picasso, who was a frequent visitor to our house, never lost an oppor-

tunity to scrutinize it, and growl at it in a flatteringly envious spirit. Each time this happened, I would try to draw him out. "*Comprends pas, comprends pas*" was all Picasso would ever say, but it was evident that he regarded the painting as a challenge. There were still things Braque could do that Picasso couldn't. This evidently rankled. Sure enough, two years later, Picasso came up with a response—an oblique one that took the form of the most important of his variations on the greatest of all studio pictures, Velázquez's *Las Meninas*. Picasso did not draw on Cooper's colorful *Atelier VIII* but on one of Braque's earlier grisaille ones. He envisioned Velázquez's studio in the palpable gray light of Braque's.

There was one final interchange between the two painters. In his last year of life Picasso turned back to Braque (who had died nine years earlier) in what would be his penultimate painting: a barely representational work misleadingly entitled *Reclining Nude and Head* (1972). It depicts a recumbent figure (the artist?) in a contraption that partakes of both a coffin and a plow and is emblazoned with a cross. A rudimentary image of Picasso's wife, Jacqueline, rises dramatically out of the very center of it. The resemblance between this work and Braque's painting of a large rusty plow is no coincidence. Braque's observation that "the idle plow rusts and loses its usual meaning" evokes mortality, which is of course the theme of this harrowing *vanitas*—the aged Picasso's farewell to life and art and also, maybe, his former doppelgänger, Braque.

The Braque *Plow* and the penultimate Picasso are identical in width though not in height; both have been worked and reworked and encrusted with a heavy white impasto like a terminal fall of snow. The wheel of the two painters' relationship would seem to have come full circle. People who like to repeat Picasso's joke about Braque being his "ex-wife" should remember that Picasso referred to himself on occasion as "Madame Braque." We should also remember that in later years Picasso took a far more passionate interest in Braque's life and work than Braque did in his.

———

Braque's late paintings confirm his preference for working in a variable as opposed to an unvarying light. He liked his studios to face

south instead of north and his skylights to be veiled with thinnish, whitish material, which filtered the light and gave it a deliquescent look. In this penumbra the artist would sit looking, as hieratical as Christ Pantocrator in a Byzantine mosaic, his Ancient Mariner's eyes fixed on his work. The monastic hush would be broken only when he got up to make a slight adjustment to this or that canvas. As a young man on my first visit to the artist's studio, I felt I had arrived at the very heart of painting.

Although Braque became more and more withdrawn, he welcomed visitors from the outside world—welcomed them, as hermits do, without ceremony, curiosity, or fuss. Unlike Picasso, he did not mind having people around when he was painting. One afternoon in 1956 he let me stay for a couple of hours while he worked on *À Tir d'Aile* ("In Full Flight"), his eerie painting of a streamlined bird crashing into a cloud as if it were an F-16 breaking the sound barrier. For weeks, Braque told me, he had been adding layer after layer of pigment to the grayish-blueish sky to give it an infinite tactile density. In the end the canvas became so heavy he could no longer lift it on or off the easel. Compared to the immensity of the sky, the bird and the cloud have the substance of shadows. Braque told me he had been reading about black holes: hence, the concept of the cloud as a black void with a gravitational force that nothing can escape. The dark cloud might also signify the imminence of death. By the late 1950s Braque was in very fragile health. Mortality held fewer fears for him than it did for Picasso; if anything it challenged him, as here, to bring *le néant* within his grasp, and to that extent within ours.

Five years after he first exhibited this great painting in the 1956 retrospective at the Tate Gallery, the artist decided—to my mind mistakenly—that it "was too easy on the eye" and would benefit from "the creation" of what he called "a rupture." So he added the image of another, much smaller bird in a frame to one corner of *À Tir d'Aile* to simulate the way the smaller painting used to lean against the larger one in the studio. (It is typical of Braque that virtually the only time he pinpoints the species of one of his birds, as he does here, he gets it wrong: the smaller bird is called *The Duck,*

but it is surely a snow goose.) The inclusion of this so-called duck was also, I think, inspired by a postage stamp of a bird in flight, which Braque had recently designed for the French mail service. And its placement, like a stamp—significantly in the diametrically opposite (bottom left-hand) corner of *À Tir d'Aile*—hints that this representation of flight could, conceptually at least, be airmailed. In doing so, Braque thought he had "given [*À Tir d'Aile*] a more unusual existence." So he had, but at the expense of its former integrity.

Apropos the incursion of real birds into his paintings, Braque told me about a visit he had made in May 1955 to an ornithologist, Lukas Hoffmann, a son of his patron Maja Sacher, and in those days a neighbor of ours. An heir to the Hoffmann-La Roche fortune, Hoffmann has presided for the last fifty years or so over a vast private bird reserve in the Camargue. Besides visiting his celebrated ornithological station at La Tour du Valat, I used to help a friend round up the herds of black bulls and white horses that graze the surrounding salt marshes. This made it easier for me to enter into Braque's excitement at the flocks of flamingos around that huge lagoon, the *Étang du Vaccarès,* suddenly taking off in a cloud the color of the shrimps they lived on; or at the apparition of a heron flapping low across the marshes, as portrayed in the large *Bird Returning to Its Nest*—of all the very late paintings the one that meant the most to him. When Braque gave me an oil study for it, he told me that he could not forget how, on that still, gray day, the sky seemed to reflect the lagoons rather than the other way around, and the birds seemed to swim through the air. Nor could he forget the clouds of mosquitoes.

Why have these great paintings never received the acclaim they deserve? Picasso is partly the reason. After 1925, Picasso resumed playing Pied Piper to the avant-garde, whereas Braque settled down to a very low-key, unbohemian existence. At the behest of his dealer Paul Rosenberg, Braque devoted himself to painting still lifes of the utmost tactile appeal, in which the bloom on a peach, the grain of a tabletop, or the gleam on a jug are not so much simulated as evoked so sensuously that the beholder is tempted to reach out and touch

them. Hence their appeal to discriminating bourgeois collectors of the Fourth Republic and consequent lack of appeal to an avant-garde that looked to Picasso for leadership. When Braque finally found his way back to the modernist trail, he was accused of addressing artistic concerns that were no longer intellectually fashionable. For one thing, his work did not lend itself to semiological interpretation; and the fact that he knew more about the properties of paint and how to exploit them than any other great artist of the last hundred years was perversely held against him. Paint, it seemed, had had it.

Recently the tide has begun to turn, as Golding's magnificent show at London and Houston confirmed. That distinguished Minimalist Ellsworth Kelly has added one of Braque's late, paint-laden landscapes to his collection; and the Museum of Modern Art has finally acquired *Atelier IV,* the first major example of the series to enter an American museum. "Why ever Braque?" a very with-it collector asked me disparagingly. I pointed out that it was about time MOMA got around to buying a great late work by the great modernist that modernists are apt to forget.

FIN DE SIÈCLE

Andy Warhol's high school graduation photograph, 1945

Warhol at Home

———

Although he was the most famous and most recognizable artist in America, if not the world, Andy Warhol was paradoxically shy. To counter his shyness he did something typically Warholian: he took a position at the very center—what one might call the eye—of the social maelstrom. And there, in full view of everybody, he, as it were, hid. He hid his blotchy looks behind a smoke screen of windswept wigs, unevenly dyed eyebrows, heavy layers of calamine, and Harpo Marx mutism. (His vocabulary was usually limited to "wow," "gee," and "golly.") To believe the disingenuous Andy, this disguise was a consequence of pigmentation problems ("Andy the Red-Nosed Warhola" was his childhood nickname). To believe the envious Truman Capote, Andy was a Sphinx without a secret. In fact, he *did* have a secret, one that he kept dark from all but his closest friends: he was exceedingly devout—so much so that he made daily visits to the church of Saint Vincent Ferrer on the Upper East Side of Manhattan. Andy is said to have been celibate: "The most exciting thing is not-doing-it," he announced, long before AIDS made abstinence almost mandatory. Although famously thrifty, he

was also secretly charitable. Besides giving financial support, he often spent evenings working in a shelter for the homeless run by the Church of the Heavenly Rest. It was not soppy social consciousness or guilt that prompted Andy's good works; it was atavism as personified by his adored and adoring mother, the pious Julia.

As a change from the spotlight and the ballyhoo, not to mention the druggery and buggery of disco life, Andy liked, whenever possible, to hole up in his handsome hideaway of a house in the East Sixties—a house most of his friends were never allowed to visit, let alone photograph: a house that surprised me, the first time I went there, as having the gleam, the hush, and the peace of a presbytery. Significantly, there was not a single Warhol on the walls. According to Andy, his house had been lived in for decades "by somebody's WASP granny." And insofar as possible he preserved the traditional old-money look of the rooms. In this task he was helped by Fred Hughes, who masterminded Andy's career for the last twenty years of his life. Fred saw that the refurbishing was done with gentlemanly discretion: throw out the wall-to-wall carpeting, he said; refinish the floors and set them off with a few good rugs; install new air-conditioning; otherwise, repaint everything the original color, and leave the house the way it was. The formula worked. Even when Jed Johnson, Andy's companion in the seventies, discreetly gilded the lily, nobody would ever have suspected that a notorious Pop painter lived in a setting more suited to Emily Post's upper-class exemplar, Mrs. Toplofty.

Apart from a few Lichtensteins, Popism was banished from the house. Instead there was a most un-Pop collection of elegant Federal furniture—compensation for the inelegance of Andy's childhood, I suspect. This was displayed in a very grand dining room—sideboards creaking under huge silver garnitures—and a no less imposing Federal drawing room, painted pale pea green with pilasters picked out in gold. Andy preferred to spare himself the burden and boredom of entertaining. After dining upstairs once or twice, he decided he felt more at ease eating downstairs in the basement kitchen. As for the drawing room, Andy never spent more

than a few minutes in it. And so over the years the two "state" rooms—the dining room particularly—came to be used primarily as storage space. At first just a few crates and paper bags were allowed to accumulate in a corner, but by the time he died phase after phase of collecting had left successive high-tide marks in the form of debris. Andy's last mania was for kitschy nineteenth-century bronzes—Herculeses, Laocoöns, assorted Bedouins—which crept up the stairs and invaded every room. In the end Andy let his "collections" take over, and withdrew to the cozy kitchen or the sedate bedroom.

The bedroom could not have corresponded less to the popular perception of Warhol's way of life. True, there was a jumbo television set by the four-poster, stacked with videotapes of old movies (*Stage Door Canteen, My Man Godfrey, Grand Hotel*). But there was also a large bedside crucifix and a devotional book, as well as a box of Teuscher chocolate truffles. The furniture was mostly late-eighteenth- and early-nineteenth-century—what auctioneers describe as "important." Apart from a nymph-embellished chimneypiece after Canova, it was mostly American. There were an imposing chest and desk by Joseph Berry, the Philadelphia cabinetmaker; a megalomaniac's cheval mirror that would diminish anyone who wasn't wearing a full-dress uniform or a ball gown; a vast armoire for Andy's vast collection of blue jeans, leather jackets, and sneakers (some of them dyed black for evening wear); and not least the large Sheraton bed with its painted cornice and fringed hangings of cocoa-colored stuff. When I first saw the room, banked with pots and pots of Easter lilies, I could have imagined a Jane Austen–ish dowager ensconced there in a lace bed cap more easily than the maker of films like *Blow Job*.

The contrast between the private recto and the public verso of Andy's persona was further confirmed on the one hand by the pomanders and bowls of potpourri with orrisroot crumbled into them, which Andy was constantly freshening up; and on the other hand by the only self-referential "work" in the entire house: one of his countless grisaille hairpieces prettily mounted in a Kulicke frame. It looked like a large, furry spider that had been squashed in a book. Andy had envisaged an edition of these eerie artifacts, but

nothing had come of it. There were certainly enough wigs to choose from: a large drawerful in one of the Federal chests, and a whole lot more stacked in dark green wig boxes by the fireplace. Trust Andy to draw attention to a weakness rather than cast veils over it. By making a virtue of his vulnerability he forestalled or neutralized any possible taunts. Nobody could "send him up." He would have done so himself.

One last detail: the basket by the fireplace overflowing with dog's toys—rubber mice and bones that squeak—belonging to Archie and Amos, the two miniature dachshunds that were regularly shuttled between Andy and Jed Johnson after the latter moved out. The dogs were Andy's closest companions—poignant relics of happier times and the only living things to share his bed.

Jed Johnson's contribution to the look of Andy's rooms was as much in evidence as Fred Hughes's. This quiet Western Union messenger boy and his more outgoing twin brother, Jay, had been instantly adopted by the Factory when they had first appeared there in the very late sixties. Their clean-cut looks and low-key charm reflected the fresh new image that characterized Andy's entourage in the seventies (as opposed to the sleaze of the sixties). Jed had risen rapidly from assistant to love object, and had also proved to be a gifted and innovative decorator. Long before stenciled patterns came back into fashion, Jed had experimented with them on Andy's walls. It was he who had embellished Andy's bedroom with ornate ceiling borders and wall patterns culled from mad King Ludwig's Neuschwanstein. The enrichment was handled discreetly: it never looked overdone. Tragically, Jed would lose his life in the TWA Flight 800 air crash just as he was beginning to make a major name for himself.

Andy's other favorite room, the kitchen, was likewise so traditional that one expected to come upon Mrs. Beeton up to her elbows in flour, brandishing a rolling pin, rather than Andy's elegant Filipino maids, Nena and Aurora. In the last few years of his life these women had come to constitute Andy's family, and it was to them he made a last telephone call after his botched operation. Before going out to a fancy dinner, Andy would have them serve him

a simple meal—turkey and mashed potatoes for preference—on the colored Fiesta ware he kept in the old-fashioned glass-fronted dressers in the kitchen. That way he avoided eating a lot of rich food. After the assassination attempt in 1968, Andy became more and more of a health nut. Besides working out in his studio-gym at the Factory (an instructor came every day except Sunday), he constantly switched from diet to diet, and consumed megadoses of vitamins.

Besides Fiesta ware, Andy had numerous other collections salted away in his basement: for instance, an entanglement of Japanese baskets—the fruit of a relatively brief phase in his collecting career—which figure in the large prints of flowers he made in the 1970s. Stacked in yet another pantry were countless cookie jars in every conceivable pattern. I found them hideous, but Andy's examples were apparently the epitome of rarity and quality; they went for almost as much as Sèvres at his posthumous sale.

Many more collections were to be found scattered about the house and the Factory: some of value, some of no interest except as objets trouvés or Warholiana. For Andy collected on many different levels. There was the artist with whom other artists made generous swaps; the serious investor who made serious purchases from serious dealers, usually with his own work as currency; the auction addict who combed salesrooms to satisfy his current mania; and the serendipitous bargain hunter who ransacked flea markets and thrift shops for junk that might, or, more likely, might not become trendy.

Actually, the word *collector* doesn't begin to describe Andy's obsessive—what Freud called anal—hoarding. As a hoarder he was surpassed only by Picasso (who hung on to old envelopes, unopened solicitations, and empty cigarette cartons) and the notorious pack-rat Collyer brothers. Virtually everything—old wigs, junk mail, back numbers of *¡Hola!* magazine, you name it—was carefully conserved. A principal task faced by Andy's executors was the logistical one of sifting through the accumulations in the house, and even more so in the Factory, where he had crammed shopping bags and cartons (neatly taped and dated) with everything from important documents and photographs to theater programs and fliers

from Chinese restaurants. To Andy in his role of recording angel, every last scrap of rubbish had validity by virtue of being memorabilia. And I think he liked the prospect of playing a practical joke on overzealous researchers.

There were also some imposing items in the artist's collection. In the smaller of the two living rooms on the first floor the treasures included three remarkable Lichtensteins—including that early Pop icon the roundel of a cat—works by Jasper Johns, Klee, Man Ray, Renoir (a bronze), Cy Twombly, and much else besides, not least an incomparable ensemble of Art Deco furniture dominated by a pair of shagreen cabinets by Legrain.

You never knew what you would come upon. A closet on the second-floor landing turned out to contain a small library of books on the decorative arts, "sea-foam" glass pieces by Dale Chihuly, and rare artifacts from the Pacific Northwest rubbing shoulders with souvenirs from Disneyland. Elsewhere, Picassos confronted corny daubs of forties debutantes; first-century Roman busts glared disdainfully at trophies from penny arcades. One of Andy's most spectacular buys was the gigantic head that greeted you as you came through the front door: the original plaster of Canova's monumental head of Napoleon.

For Andy things became a substitute for lovers. Things don't leave you or die. After Jed Johnson moved out to pursue a career of his own, Andy withdrew further into his shell. A year or two later, he formed a relationship with another young man, but he contracted AIDS and moved back to California, where he died. Andy became ever more of a loner, ever more obsessed with the welfare of his body and his soul. He took to carrying around a magic crystal—a panacea for all ills, he said—and, like a medieval alchemist, delved into mysticism and magic, and (true to his Slavic heritage) folk wisdom and folk remedies, especially elixirs of youth. Not that these esoteric preoccupations put a halt to his social life. Andy continued to go out night after night, and entertain day after day at the Factory's lunch parties—the nearest thing to a "salon" to be found in New York at the time. By the eighties, the group had changed. Bright young people from the boondocks of NoHo and SoHo had

replaced the stars of café society whom Andy had chased after in the seventies.

For all that he was a loner, Andy loathed going out alone. And so a girl—preferably bright, attractive, and wellborn—was almost always on his arm. In the sixties he had paraded such "superstars" as Edie Sedgwick and Baby Jane Holzer. In the seventies his favorite playmate was a granddaughter of one of England's celebrated Mitford sisters, Catherine Guinness. After several years glued to Andy's side, Catherine returned to her roots, married Lord Neidpath, and left the supposedly cool artist more bereft than he liked to admit. Lady Ann Lambton was another of the Factory girls who came to be called "the English muffins." After Ann got engaged to Fred Hughes, Andy tried to persuade her to marry him. In the eighties a favorite companion was Cornelia Guest until, as debutantes go, she went. Latterly, Andy came to depend almost exclusively on Paige Powell, the attractive advertising manager of *Interview;* he was also in constant touch with his Boswell, Pat Hackett, whose *POPism* (written in collaboration with Andy) provides an absorbing account of Factory life. And then, throughout the constant comings and goings, there was always Brigid Berlin, most devoted of his friends and associates—and no wonder: he had rescued her from her seventies addictions.

One of Andy's last innovations was the aleatory "blind-date dinner." He and Paige and Tama Janowitz would line up blind dates for one another. That way none of them had any idea of what he or she was in for. The blind-date dinners, which were usually held at a glorified trinket shop and ice-cream parlor called Serendipity 3, were supposedly a success, but the instant friends never became more than instant friends. Back Andy would go to his fastness on Sixty-sixth Street, to the love of his dachshunds, the joy of his Betamax, and hours of narcissistic experimentation with wigs and dye pots in front of the bathroom mirror. No doubt about it, he had his world where he wanted it—simultaneously at his feet and at arm's length.

—

Our understanding of Andy's spiritual side requires some understanding of his ethnic background. This was more peculiar than

people realized. "I come from nowhere," Andy once said, and this was true insofar as the land of his forefathers, Carpathian Ruthenia (where Ukraine, Poland, Hungary, and Slovakia meet), has no national identity. Ruthenia is not marked on the average map, and its regions, such as Spiš and Už, are not listed in any Baedeker. Rusyns, as the inhabitants are usually called, have always been a minority ruled by one or another foreign power. For centuries Ruthenia was so exploited by absentee Magyar landlords that it was among the most culturally and economically backward parts of Europe, its peasantry mired in abysmal poverty and superstition. Small wonder that by the beginning of this century mass emigration threatened Ruthenia (then part of Hungary) with depopulation.

Villagers who had never moved more than a few miles from home now headed for the mines around Pittsburgh. But unlike immigrants from other parts of Europe, Rusyns had very little perception of the Old Country, for to all intents and purposes the Old Country did not exist. Even their language, which they touchingly call, among themselves, *"Po našemu"* (literally "in our own manner"), has no characteristics of its own. It draws on the dialects of the hated Hungarians and Ukrainians. A further obstacle to self-esteem: the language is always being confused with Russian, which is not at all the same thing as Rusyn.

Traditionally, the only comfort available to the downtrodden inhabitants of Andy's Dogpatch was the church: the Eastern or Byzantine rite of Catholicism, or various other Orthodox sects. And to this day it is thanks to their priests that Rusyn immigrants have been able to preserve anything of their meager culture and history. The church was particularly powerful in the Prešov region, where Andy's parents had their roots, in a tiny mountain village called Miková, just west of Medzilaborce. The Warholas were pious folk, above all Andy's mother. According to family tradition, Julia Warhola had the advantage of being marginally less poor than most of her ilk, and it was her dowry that enabled Andy's father to migrate to Pittsburgh sometime before 1914. During the war, husband and wife lost touch with each other, and it was not until 1921 that Julia plucked up her courage and went off to join (Andy said "look

for") her husband. The Warholas were finally reunited in the Ruska Dolina area of Pittsburgh, which the Rusyns had made their own. Over the next seven years three sons were born to them, the youngest, called Andrew, in 1928.

Life in the Ruska Dolina, where Andy grew up, revolved around the churches and church-run schools and community centers that the enterprising Rusyns had worked hard to set up in their ugly urban valley. Because their sense of identity was so tenuous, they kept to themselves and did what they could to preserve their native integrity and customs, above all their "Byzantine" faith. As it was in Pittsburgh, so it would be for Andy in New York. Even when he was sharing a basement on 103rd Street with seventeen roommates, he was forever sneaking off to church. Over the years his religion protected Andy: from the death-dealing highs and lows of the sixties, and not least the death-dealing gunfire of Valerie Solanas (founder of SCUM, the Society for Cutting Up Men), which he miraculously survived. In the last years of his life Andy attended Saint Vincent Ferrer ever more zealously.

Julia Warhola was the source of the tenacity and gentleness and down-to-earth resilience that were at the core of Andy's character. As soon as he made his name as a fashion illustrator, he sent for her to come and live with him in New York. For all her narrowness and lack of education, Julia struck those who met her as humorous, mischievous, and shrewd—like her son. The peasant whimsicality of Andy's earliest work is reflected in the artlessly charming book *Holy Cats,* which she wrote and illustrated. She it was who devised the spikily elegant calligraphy that is such a feature of Andy's fashion drawings. Julia Warhola was unquestionably the greatest passion of Andy's life, and her death in the early seventies was such a blow that months passed before he divulged the fact to anyone at the Factory. One of the things that touched Andy most about his stints at the soup kitchen was the resemblance of the little old ladies to his mother. He had an immediate rapport with them, not least because they had no idea of who, beyond being one of them, he actually was.

Although Andy was widely perceived as a passive observer, he could on occasion be a surprisingly effective proselytizer for the

church. He took pride in bringing about at least one conversion, and even greater pride in financing a nephew's studies for the priesthood. He was chagrined when the nephew ran off with a Mexican nun—chagrined, yet characteristically relieved when they got married. "The telephone calls to Mexico," he said, "were charged to the Factory and were getting very expensive."

The knowledge of Andy's piety inevitably shades our perception of a man who fooled the world into believing that his only values were money, fame, and glamour. True, Andy was starstruck, but in a tongue-in-cheek way. And once again his self-deprecation was a stratagem—like his pose of Pop coolness and little-boy dumbness—to forestall any possible criticism or mockery. The more Andy begged to be taken at face value, the less reason there was to do so. No wonder a lot of people mistook the detachment of a recording angel for the callousness of a voyeur.

Andy's detachment—the cordon sanitaire that he established between himself and the world as well as between himself and his subject matter—was yet another symptom of his Slavic spirituality. Hence his otherworldly, almost priestlike ability to remain untainted by the speed freaks, leather boys, and drag queens whose company he had sought in his early days and whose kinky activities he chronicled—for instance, the S&M dance that Gerard Malanga (later photo archivist of the New York City Department of Parks and Recreation) performed in Andy's movie *Vinyl*. This detachment is at the root of Andy's ability to defuse the highly charged images that play such an ambivalent role in his work—those intrinsically seductive images that never seduce; those intrinsically threatening images that never threaten. This ambivalence works better on canvas than on film. If one sometimes suspects that Andy walked away from the camera while it was turning, it is because he sometimes did. But then, as Andy said—tongue in cheek again— "my films are better talked about than seen." Not the least of his powers was to con people into accepting the boring, the trivial, and the inane as art.

How, I used to wonder, had Andy resisted the lure of the deep end? Why was he never destroyed, like his first crush (later a close

if disloyal friend), Truman Capote—someone he tried so hard to save from drink and drugs and writer's paralysis by "interviewing" stories out of him? The answer is that Andy was born with an innocence and humility that was impregnable—his Slavic spirituality again—and in this respect was a throwback to that Russian phenomenon the *yurodivyi* (the holy fool): the simpleton whose quasi-divine naïveté supposedly protects him against an inimical world.

In Germany the holy fool takes the form of *der reine Tor,* as in *Parsifal*—Andy's favorite opera. Russian literature's most renowned example is Dostoyevsky's Prince Myshkin. (Andy resembled Myshkin in that he had always been "delicate"—three nervous breakdowns before the age of eleven.) Thanks to his inner strength, Andy never felt obliged to cover up his effeminacy by "acting butch." On the contrary, he gave full rein to his swishiness and took ostentatious pride in his collection of Cabbage Patch dolls. It was this guilelessness that enabled him to shine out from the rest of the trashy throng like one of those mirrored balls in the discos he frequented. For all that holy fools are supposedly inviolable, they often turn out to be physically at risk, magnets for aggression, like the *yurodivyi* Nick, who is roughed up in Mussorgsky's *Boris Godunov.* True to form, Andy got shot by a demented feminist.

Yurodivyi magic was at the root of Andy's magical ability to italicize his subjects. His wand was a trusty Polaroid, which he used with a minimum of technical skill. And insofar as his work is less self-consciously artistic than that of colleagues like Rosenquist, whose campy gigantism harks back to Giulio Romano, and Lichtenstein, whose Benday dots refer to Seurat, it is more truly Pop. Granted, not all of Andy's miracles come off. Some of the paintings and a lot of the prints fail to transcend their flimsiness and emptiness. But to my mind his best work is the purest expression of Popism. And what an innovative sense of color!

Andy has been accused of standing by passively while his "superstars" self-destructed. Awful Edie Sedgwick, aglitter like a discarded Christmas tree with broken bits of mirror glass and tarnished tinsel, who O.D.'d on barbiturates, and nice Freddy Herko, the speed freak who put Mozart's *Coronation Mass* on the record player and

did a *grand jeté* out of a fifth-floor window, are the most obvious ex-
amples. (After spraying everything in the original Factory silver,
shutting himself up in the darkroom for two years, and then evapo-
rating into thin air, that other Factory speed freak Billy Name has
amazingly survived. When he reappeared at Andy's memorial ser-
vice, he told me that he was doing very nicely as a "concrete poet"
and a Poughkeepsie city official.) But most of the time Andy did
what he could to help. Saving souls—as opposed to chronicling the
excess and excitement, not to mention the boredom of the "silver"
sixties (silver was "an amphetamine thing," Andy wrote, "it was
spacy . . . Silver Screen . . . narcissism . . .")—was not exactly com-
patible with the existential detachment that was his special gift.
However, he *did* feel concern in his laid-back way and *did* rescue
many of his entourage from burnout. Indeed, he was busy doing
just that in the weeks before he died.

After Valerie Solanas's attempt on his life in 1968, Andy never felt
really safe from death, and the recent loss of so many friends to
AIDS made mortality all the more real. In the circumstances, it is
not surprising that this practicing Catholic finally got around to
doing religious paintings—Pop ones, of course. When Andy de-
cided, two or three Christmases before his death, to embark on a se-
ries of Last Suppers, he characteristically sought inspiration not in
Leonardo's original but in a linear image he discovered in an old
dictionary and a cheap plaster mock-up that he had found in Times
Square and, after a lot of haggling, finally bought. It was just the sort
of *bondieuserie* he remembered from the old days in the Ruska
Dolina. By virtue of being stripped of iconic beauty and mystery
and sanctity, this crass reproduction constituted a far better starting
point for Andy's religious venture than the real thing.

The Last Suppers that Andy executed and exhibited shortly be-
fore he died—where else but in Milan, the famous fresco's home-
town—reveal what a powerful source of inspiration kitsch can be in
the right hands. By harnessing Pop concepts to a sacred subject,
Andy breathed new life into religious art, while keeping it, as he
said, "real cool." The only problem with paintings of such evangel-
ical slogans as "Jesus Saves" is that by defusing them (just as he had

defused hammers and sickles and portraits of Lenin and Mao) he effectively deconsecrated them. It is thus ironical that Andy's last painting should consist of nothing but the phrase "Heaven and Hell are just one breath away." Ironical because, besides being premonitory, this was a precept by which Andy seems always to have lived until, without knowing he was about to die, he had purged it of both its menace and its promise.

Anthony Hopkins as Pablo Picasso in the
Merchant Ivory/Wolper film *Surviving Picasso*, 1996

Anthony Hopkins's
Stab at Picasso

After abandoning India and Indian subjects, Ishmail Merchant and James Ivory lost the delicate, ironical touch that made *Shakespeare Wallah* and *Blood and Dust* so memorable. However, they gained a vast new following with films of E. M. Forster's low-key novels, in which they sentimentalized the issues and overdid the sets. Their *Room with a View* and *Howards End* offered souped-up versions of Edwardian life: flower-showy gardens, lots of horse-flesh from the royal stables, and as much mahogany as there is in the halls of the Connaught Hotel. "Ralph Lauren's England," someone said. The glossiness evoked Galsworthy rather than Forster.

The team next moved on to biography, to the lives of two great men, Jefferson and Picasso. Achievements do not interest Merchant and Ivory as much as sexual relationships, especially ones to which they can give a prurient, censorious spin. The Jefferson movie upset Jeffersonians by portraying him as the philandering lover of a black slave girl. The Picasso movie is no less dismaying for its attempt to demonize the artist for his supposedly manipulative and sadistic

treatment of Françoise Gilot, his mistress from 1943 to 1953, and thus find favor with feminists and modern-art haters.

According to the credits, *Surviving Picasso* is based on Arianna Stassinopoulos's hostile scissors-and-paste biography *Picasso: Creator and Destroyer,* a book that Ivory claims to be "marvelously detailed and researched," although, as he must surely know, scholars gave it universally terrible reviews because it is nothing of the sort. (Not for the first time this author was threatened with a suit for plagiarism.) In fact, Merchant and Ivory's film is all too evidently inspired by Françoise Gilot's 1964 memoir *Life with Picasso,* from which Stassinopoulos lifted so much. In the hope of obtaining the film rights, Merchant and Ivory had originally approached Françoise, but were met with an adamant refusal. Faute de mieux they had to sign up Stassinopoulos and pretend that their film is based on *her* book, although several incidents in the film follow more or less exactly descriptions in Françoise Gilot's pages. After reading Ruth Prawer Jhabvala's soap-operaish script, Françoise and her son, Claude, who administers the Picasso estate, took legal steps to stop the film being made. Specifically, Claude refused Merchant and Ivory permission to show any of Picasso's works. Merchant and Ivory chose to impute Claude's refusal to rivalry: "People in France . . . say that Claude Picasso himself wanted to make a film about his father, so that we were really coming on his territory." Claude termed this an utter lie. Although they thought they would have won their case, Françoise and Claude decided not to proceed with it—too long and costly. They did, however, manage to have the Gilot name removed from the film.

In the face of the family's embargo on the use of the artist's imagery, anyone seriously interested in making a film about Picasso would have shelved plans for this inherently doomed project. But Ivory decided to go ahead using fakes: parodic doodles and daubs and assemblages by someone who was at art school with him many years ago. The makers of the film have tried to minimize the magnitude of their deception. "You see plenty of art," Ivory announced on the *Charlie Rose* show, "the film is full of art." Except for brief glimpses of authentic pictures by Braque and Matisse, the film is

riddled with shlock. This is the more regrettable in that people who know no better (including certain film critics) have mistaken the shlock for the real thing. But then, as Ivory admitted in an interview, "most people wouldn't know what was authentic or not." Besides demonizing the man, the film effectively defiles the work—so much for Ivory's claims to have been a painter with a lifelong admiration for Picasso's work. Are travesties his idea of a tribute? *Surviving Picasso* would suggest that they are.

Faking permeates the film. The actors who impersonate the artist and his mistresses bear as much resemblance to the real thing as the paintings in the film do to originals. People who never met Picasso think that Anthony Hopkins, who plays him in the movie, looks very like him. Despite look-alike makeup, poses, and clothes, he doesn't. Nor has Hopkins's wish to have "gotten the rhythm of the man," as he put it to an interviewer, been granted. His "rhythm" is closer to Henry Moore's than Picasso's. He comes across as British to the core; a sardonic, skittish don, whose teasing of girls gets out of hand. There are occasional echoes of Hannibal Lecter, but they hardly constitute the "magnetic appeal [and] a certain charisma" that Merchant had hoped his star would project. Might disappointment with his performance explain why the producer held up Hopkins's payments? "I was going to sue them," the star told the press. "I vowed I would never work with them again . . . I think it's good to blow the whistle on them."

The principal source of Picasso's magnetism was the pair of huge brown eyes, which he used to mesmerizing effect. So intently did he look at drawings that Gertrude Stein's brother Leo wondered whether there would be anything left on the paper. In old age his eyes would become a surrogate sexual organ. Hopkins does his best to duplicate Picasso's *mirada fuerte,* the "strong gaze" on which Andalusians famously pride themselves. He even wears contact lenses that turn his blue eyes brown—but all he can muster is either an arch twinkle or a sinister glint, as in an overdramatized owl-and-pussycat sequence, where Hopkins forces Françoise Gilot (Natasha McElhone) to watch a large owl sweep down on a stray cat and carry it off. "Not at all the way it happened," says Françoise. The trouble

is that Hopkins, like Boris Karloff, resonates with old roles, much as Stradivarius violins are said to reverberate with old melodies. Casting the actor who played Hannibal Lecter as Picasso demonizes the artist almost as effectively as the awful fakes we see him painting.

As for the misogyny that this film overstresses, Picasso was indeed a misogynist, like most Andalusian males of his time, but why judge an artist from another age and another culture—be he Picasso or the infinitely more misogynistic Rembrandt—by the light of today's cant? Nor should we ignore the paradoxes that are at the root of Picasso's character. Whatever one says, good or bad, about him, the converse almost always applies. Picasso was both gregarious and reclusive, penny-pinching and generous, wise and foolish, tough and vulnerable, saintly and wicked, cowardly and courageous—a great hero in the studio, but rather less of one in the rough-and-tumble outside. The same with his misogyny. Picasso had a sadistic streak, but he also had an intensely tender one; and, more often than not, he was affectionate and gentle with the women in his life. In his finest portraits, the recto and the verso of his feelings for a mistress fuse into images that are intensely poignant, at the same time, intensely disturbing. Therein lies their power. *Surviving Picasso* never addresses this dichotomy. It is all verso and no recto.

The film is not so much about Picasso as it is about Françoise. Much of the emphasis is on her role as a victim—someone to whom things happen. In fact, Françoise was the least submissive of the women in the artist's life and to that extent seldom invoked the darker side of his libido. The paintings in which she figures (I hesitate to say portraits) celebrate her youthful beauty and cool composure, but they rarely manifest any of the sexuality and angst that gives the images of her predecessors—Marie-Thérèse Walter and Dora Maar—such power. In her book, *Life with Picasso*, Françoise makes it very clear that she was not prepared to play the sacrificial role that Picasso wished on his women; that her own painting meant as much if not more to her than her lover's; and that she knew how to look after herself. The very fact that she published an outspoken memoir is a measure of her resentment and defiance.

For, as Françoise well knew, Picasso treasured his privacy to an extent bordering on paranoia. After trying and failing to have her book withdrawn, he avenged himself on Françoise by banishing their two children, Claude and Paloma, forever from his sight. Too wounded to discuss the personal issues raised by the book, Picasso complained to me that the lecturettes on art that Françoise had put into his mouth (they are all in quotes) bore little relation to what he had said. They were not colloquial enough—too full of long words, such as *architectonic,* which he could not have used because he had no idea what it meant. True, the pedagogical tone in which Françoise garbs his words is very un-Picassian, but the murderous quips, the baroque complaints—not to mention the outrageous paradoxes— that she quotes have a very authentic ring. Françoise's recapitulations of his views on painting did not bother Picasso nearly as much as her revelations of his tantrums—occupational hazards of his genius.

James Ivory allows that *Surviving Picasso* is "really the story of . . . I hate to say this, but a kind of starstruck young girl who falls in love with a great genius"; and this is how Natasha McElhone, who makes her screen debut as Françoise, plays her. She radiates a long-suffering sweetness, but too little of the sharpness, intelligence, and ambition that enabled Françoise to survive Picasso. Nor do her predecessors in the artist's life fare much better. Dora Maar's intensity, which ended up scaring Picasso, and Marie-Thérèse Walter's pneumatic sexuality, which obsessed him, are hardly evoked in the film. By contrast, the artist's first wife, the Russian ballerina Olga Khokhlova, comes across as a hilarious caricature; and the flashbacks in which she figures are sheer Monty Python. But then, as Merchant boasted to a TV interviewer, "an Indian producer is not just an Indian producer, [he is] a producer who . . . can do anything": the Indian rope trick, vanishing trick, balls-in-the-air trick. "Jim [Ivory] still has not . . . quite understood how many things I'm capable of handling."

———

Dottiest of the film's "balls in the air" sequences is a riotous Ballets Russes dinner at which epicene dancers dressed as peacocks prance

around while Diaghilev leers and Hopkins toys with what seems to be a large phallic jelly. No rope tricks, alas. The miscasting is redeemed by that excellent character actor Peter Eyre in the role of Sabartès, Picasso's Catalan curmudgeon of a secretary. "I thought of Judith Anderson," Eyre told me, "and gave it everything I've got." The thought of Sabartès as Mrs. Danvers would have delighted Picasso.

Films about great artists are a benighted genre in that they usually sacrifice art to *La Bohème*-ish sentimentality or a soap-opera story line. The trouble is that the workings of the creative process are too slow, too private, and too painstaking to be entertaining, let alone cinematic. The more over-life-size the performance, the less credible the artist. To my mind, no worthwhile art expert could possibly believe in Charles Laughton as Rembrandt, José Ferrer as Toulouse-Lautrec, George Sanders or Donald Sutherland as Gauguin, Charlton Heston as Michelangelo, and Anthony Quinn or Kirk Douglas as van Gogh. Minor artists fare better: for instance, Isabelle Adjani as Camille Claudel, or the fictional artist in Joyce Cary's *The Horse's Mouth* with, for once, remarkably credible paintings by the English expressionist John Bratby. I have not seen Gösta Ekman's 1978 comedy, *The Adventures of Picasso,* with two Swedish drag queens playing Gertrude Stein and Alice Toklas, but it, too, has been described as Pythonesque. Fortunately, anyone who wants to watch Picasso at work has only to rent Henri Clouzot's ingenious *Le Mystère Picasso,* in which one can actually observe images materializing on the screen. But even when, as in Clouzot's movie, the artist plays himself, the creative process still remains a mystery. Picasso complained to me of having to match the speed of his drawing to the speed of the movie camera. That is why it was impossible to come up with work of much thoughtfulness or depth.

In any film about a great artist the integrity of his work is at stake. In Picasso's case the revolutionary nature of the art and the paradoxical nature of the man call for very special skills: understanding of the workings of modernism and insights into the dark side—the *duende*—of Picasso's profoundly ambivalent, profoundly Spanish character. Maybe we should not expect these skills of James Ivory.

Commercial entertainment masquerading as culture is what he is best at. Alas, *Surviving Picasso* is neither entertaining nor enlightening; worse, it puts the artist and his work at considerable risk by playing into the hands of reactionary philistines, in this respect like the book on which it claims to be based.

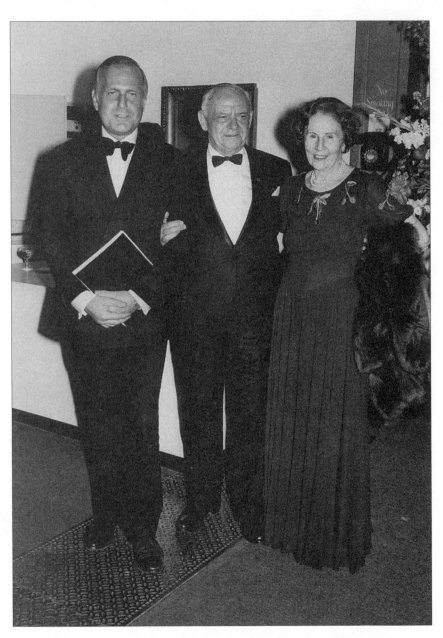

Dr. and Mrs. Armand Hammer with the author, 1973

Hammer Nailed

S ome thirty years ago, *le démon de midi*—a more expressive phrase than "midlife crisis"—propelled me from a nice, safe, prestigious job as Christie's U.S. representative into a job that was anything but nice or safe or prestigious. I went to work for a veteran con man, Dr. Armand Hammer. Hammer had recently taken over M. Knoedler & Co., the illustrious firm of international dealers. A conniving employee had maneuvered the gallery into financial difficulties in the hope of assuming control, but Hammer beat him to it. Since he had persuaded my old friend Roland Balaÿ, the last of the Knoedler dynasty and one of the best eyes in the art business, to stay on, I agreed to take over the gallery's nineteenth- and twentieth-century side. Hammer had also brought in a close associate, the colorful Dr. Maury Leibovitz, an accountant who practiced clinical psychiatry on the side—a great help, he said, in treating patients in the fat farms he ran in California. Patients were allowed to eat whatever they wanted, provided they spat it out before swallowing.

The fourth member of the team was Jack Tanzer, a sportswriter turned art dealer, whose geniality and canniness saw Balaÿ and my-

self through some very difficult times. Tanzer specialized in deals of infinite complexity. I loved listening to him at work: throw in the little Renoir to sweeten things, he would cajole another dealer, and the Doctor will let you in on the Eakins; or, give us a half-share of the Canaletto, and Warhol will do a portrait of your wife. Tanzer could turn a minor Vlaminck into two Frank Stellas and, after a few more permutations, end up with a Rembrandt drawing. He also had a knack of turning unsalable old masters into profitable assets. For instance, Tanzer knew that Walter Chrysler, Jr.—a rogue whose excessive tax deductions for blatant fakes had been disallowed by the IRS—needed to acquire some respectable old masters on the cheap. And so he arranged for Chrysler to take a number of discredited paintings, which had been on Knoedler's books for fifty years or more at huge valuations, in exchange for one superb Cézanne. This was a deal after Hammer's own heart: nothing tickled the old tortoise as much as getting something for free.

At first I was fascinated by Hammer, watching him fabricate something out of nothing. The boasts, the lies, the corners he cut! It was an education in abracadabra—like being backstage at a conjuring show and seeing how the tricks were done. Hammer turned out to be a master of illusion, sleight of hand, and unctuous, guttural patter. He could transform himself from Mr. Magoo into a Nobel Prize candidate in the blink of an eye. Nothing had any credibility, except possibly the Doctor's friendly wife, Frances, who stood obediently in the wings, ready if necessary to be mesmerized or sawn in half—anything to distract attention from the trickery center stage.

I was also fascinated by Hammer's ability to persuade a great many people who should have known better—Deng Xiaoping, Zia ul-Haq, Edward Heath, Prince Charles, Menachem Begin, and Bruno Kreisky, not to mention Leonid Brezhnev and Mikhail Gorbachev—that he was an amalgam of John D. Rockefeller, Henry Kissinger, and Mother Teresa. When he had a captive audience on his plane, he would claim to have saved the world by helping Franklin D. Roosevelt negotiate the Lend-Lease Act in 1941, or preparing Ronald Reagan for his Reykjavík summit meeting with

Gorbachev in 1986. Hammer would have you believe that he was one of the most farsighted entrepreneurs of his day, who had built Occidental Petroleum (familiarly known as Oxy) from nothing into a $21 billion company; that he had brought off the "deals of the century" (in asbestos, phosphates, and coal) with the Soviet Union and China; that his researchers were about to come up with a cancer cure; and that he was the last great collector of great art. This was virtually all a sham contrived out of smoke and mirrors and bullshit.

Hammer was full of surprises, not all of them disconcerting. His Godfatherish aura had not prepared me for the old-time charm of his New York quarters, a carriage house on West Fourth Street where he had been living since 1919. Nothing much appeared to have changed since the early twenties: the rooms were reassuringly cozy and seedy. Whoever lived there could not be all bad. And then he had a disarmingly louche side: a kink for redheads. This predilection surfaced at a party I had arranged in my London flat for him to meet the leading lights of the British art establishment. I had also asked various women friends, among them the unpredictable, uninhibited, very red-haired Nicky Lane (recently divorced from Kenneth J. Lane, the jeweler).

The moment Armand saw Nicky, he grabbed her and took no further interest in the distinguished guests I had assembled. He pulled her onto his knee, where she curled up like a marmalade cat. In an attempt to impress her, he put in a call to Brezhnev and seemingly got through. "Do stop talking to that boring old Bolshevik," she said, "it's *rude*," and she grabbed the telephone and put it back on the hook. Next thing I knew, she jumped off Armand's lap and ran over to me. "He's completely mad," she said. "He keeps saying I remind him of henna, but I don't use henna." Nicky had not realized that Armand was talking about Jean-Jacques Henner, the kitschy nineteenth-century French painter of redheaded nudes, whose work he collected. Back Nicky went to Armand's knee, and a brief romance ensued. There would be many more redheads in Hammer's life.

What sort of ogre was Hammer? Con man? Soviet spy? Crooked financier? It was not until my friend Edward Jay Epstein published

his brilliant investigative book, *Dossier: The Secret History of Armand Hammer,* some twenty years later, that I was able to discern the full Ian Fleming–ish scale of his criminality. Epstein's book delves deeply into Armand Hammer's convoluted Socialist past. He was born in New York on May 21, 1898, to a Russian Jewish family who had fled the pogroms in Odessa. Armand's mother, Rose, had been a formidable young woman who worked as a seamstress in a garment factory and also as a waitress. His father, Julius, had rallied to Socialism as a teenage laborer in a brutalizing New Haven foundry, and he named his son after the arm-and-hammer emblem of the Socialist party—not after the romantic hero of Dumas's *La Dame aux camélias,* as Hammer sometimes claimed. Julius Hammer turns out to have been an enterprising shyster devoured by two seemingly irreconcilable obsessions: fervent Socialist activism (he later helped to found the U.S. Communist party) and rapacious capitalist ambition. By his early thirties he was a power in the Socialist movement; he was also running his own pharmaceutical company and a chain of drugstores. Like his son Armand, Julius had few scruples. Although no criminal charges were ever brought, he took out bank loans in order to support Socialist causes and then declared bankruptcy so as not to have to pay them off. Later, Julius became a doctor and set up a successful practice in the Bronx. His ultimate undoing was an abortion business on the side. Armand followed closely in his father's footsteps.

Of all the skeletons in Hammer's closet, none rattled more insistently than that of the unfortunate Marie Oganesoff, wife of a well-off czarist diplomat, who died in July 1919 after undergoing a botched abortion at the hands of Julius. Although he paid a PR man to bribe a juror, Julius was sentenced to the maximum: three and a half to fifteen years in Sing Sing. He was out in just under three years. After a trip to Detroit to persuade Henry Ford, whose zealous anti-Communism did not preclude trading with the Soviets, to let him represent the Ford company in Russia, Julius left the United States for Moscow. Lenin rewarded him by putting a palatial thirty-room mansion, known as the Brown House, at his and his three sons', Harry, Victor, and Armand's, disposal. It soon became an un-

official trading office of the American embassy. Julius and Armand worked with the OGPU, the Soviet secret police, but were very careful to conceal these and other ties to the regime from the American VIPs who flocked to their door.

To explain away his father's felony, Armand would invoke the influenza epidemic, anti-Semitism, Tammany Hall pressure, and czarist intrigue. He even persuaded Lenin that the charge of manslaughter in the first degree against his father had been trumped up by the government as punishment for his having founded the U.S. Communist party. It would be many years before Armand divulged the truth to one of his mistresses. Julius was indeed innocent: he had taken the rap for his son. Armand was the one who had caused the death of Marie Oganesoff. He had been standing in for his father.

Although Armand, like Julius, had obtained a medical degree from Columbia and had been accepted as an intern at Bellevue, he never actually practiced. Still, he would always call himself "doctor" and have MD license plates on his cars. After the death of Marie Oganesoff, the prospect of running his jailed father's prosperous chemical corporation was a much more attractive option than practicing medicine. Young Hammer turned out to be a brilliant promoter—not so much of his father's surgical lubricants and saline laxatives as of a highly alcoholic tincture of ginger that pharmaceutical companies called "jake." Packaged as "medicine," this product sold so well during Prohibition that Hammer reportedly made $30,000 a day and employed 1,500 workers. This bonanza came to an end when "jake" was outlawed: thousands of people had suffered paralysis, and some had died.

In 1921, Armand defied the American authorities and traveled secretly to the Soviet Union, consumed, he would have us believe, by a philanthropic desire to alleviate famine in the Ural Mountains. Besides wanting to set up a new life in the Old Country for his father when he emerged from jail, Armand was out to establish an import-export business: shipping grain and pharmaceutical products to the USSR in exchange for furs, hides, bristles, hair, sausages, lace, rubber, and caviar. When Armand was received in November

1921 by Julius's old friend Lenin, the persuasive young capitalist used the fact that his father had been a founder of the American Communist party to get himself accepted as a concessionaire, a bridge between East and West, between Communism and Capitalism. According to Epstein, the State Department was already keeping an extremely mistrustful eye on him.

On his return to Moscow in 1922, Hammer further ingratiated himself by giving Lenin a comical bronze of a monkey perched on Darwin's *Origin of Species* examining a human skull that was always on exhibit in the Soviet founding father's office. This helped him win an asbestos concession, a pencil factory, and much else. These ventures would thrive but ultimately fizzle out because the considerable profits that accrued were in blocked rubles. Hence all the lavish parties in the Brown House. A farcical description of one of these affairs enlivens the pages of *Eimi,* e. e. cummings's Joycean novel about a visit to Moscow in 1931. Hammer appears as Chinesey, a mysterious trader who "retires (eyefully) behind thick glass; becoming swollenly a submarine mind." He makes "remarks in handcuffs" and is guarded by "a mighty mastiff cur [that he] personally releases late each night . . . to keep the comrades out."

Realizing that there was no real money to be made in Soviet Russia, the Hammer family returned to America to deal in spurious czarist treasures. These "crown jeweled objects of art" were actually a very mixed bag: assorted icons, a few flashy bits of Fabergé, and storerooms full of lesser artifacts—"the sweepings not so much of palaces as of hotels, restaurants, and junk shops." Despite its shaky provenance, the so-called Hammer Collection of Russian Imperial Art Treasures from the Winter Palace, Tsarkoye Selo, and Other Royal Palaces did surprisingly well when put up for sale at Lord & Taylor and department stores all over the country. The better to peddle this stuff, and to give his brother Victor a purpose in life, Armand opened an outlet in New York, which ultimately became the Hammer Galleries. Armand never really prospered as an art dealer, but he learned what a useful role art could play in his entrepreneurial machinations. It started him off collecting and also prompted him to buy Knoedler's.

It did not take me long to discover that the only thing the Doctor valued in a work of art was its potential for barter, money laundering, tax deductions, or personal publicity. His collection had been put together by his brother Victor; as a result it showed no discrimination whatsoever except in the one area—old-master drawings— where Hammer had taken expert advice. Compared with the magnificent collections of old and modern masters assembled over the same period by his infinitely more discriminating Los Angeles neighbor Norton Simon, Hammer's pictures were a motley lot, mostly bargains bought for name, not quality. To counter adverse criticism, he roped in a former director of the National Gallery and bought a few good things—Gauguin's *Bonjour Monsieur Gauguin* and a fine van Gogh—but he failed to weed out the many corny, ugly, or dubious works. Then again, instead of hanging them on his walls, Hammer used his paintings as a vehicle for his worldwide ego trips and as bait for his traps: he lent them to Fort Worth in the hope of corralling rich Texans into investing in a questionable Peruvian oil field; to Beijing to help launch a strip mine; to Edinburgh to curry favor with Prince Charles. After years in orbit, his pictures began to look jet-lagged. Even the better items lost their luster, not least the Doctor's most publicized acquisition: the Leonardo da Vinci Codex that he bought at auction in 1980 for just under $6 million. By renaming this manuscript the "Hammer Codex" and launching it on a world tour with its own armed guards, the showman effectively devalued it. When *Time* magazine's Robert Hughes pointed this out, the Doctor made vicious efforts to have him fired.

Hammer's entrepreneurial *folie de grandeur* was not reflected in his lifestyle. The house in Los Angeles (Holmby rather than Beverly Hills) where Hammer spent most of his time was downright dingy. Frances and her first husband, a rich man from Chicago named Elmer Tolman, had bought it from Gene Tierney when she was married to Oleg Cassini. This was its only distinction. Although Hammer described his wife as an artist, her taste was Middle America at its most motelish: 1950s Sunbelt furniture, wind chimes, and plastic flowers in need of dusting. (In those days Frances did most of the cooking and cleaning. Later, there would be

a maid.) After Hammer visited Beijing, the décor became more or-
nate—"Chinesey." Down a spiral staircase from their bedroom was
a dank pool where the old tortoise did his lengths every morning at
six A.M.—bare-ass because, as he said, "it feels better." For all that
Hammer regarded J. Paul Getty as an exemplar, he never went in
for Getty's grandiose, albeit miserly way of life, and for a very good
reason. Despite his claims to be a billionaire, Hammer never had
anything like as much cash. His principal indulgence was overac-
cessorized, oversize Cadillac Fleetwoods, until he persuaded the
Chinese to let him have Marshal Lin Biao's black Mercedes 600—
the Pullman model.

The only art in the Holmby Hills house was a horrendous fake
Modigliani hanging on the wall of the staircase. "Isn't that a great
painting?" the Doctor asked, a glint in his saurian eye. My noncom-
mittal mumble was interpreted as admiration. "That painting fools
all you experts," Hammer said. "It's a copy by Frances." His wife,
attired as usual in a vintage Pucci dress, stirred her iced tea and
preened. "So *you* were the one who painted all those beautiful pic-
tures in Armand's collection," I could not resist saying. Armand
drew my attention to another "work of art": an engraving after
Hammer's Rembrandt, *Juno.* Frances's face had been substituted
for Juno's.

The best thing about the Doctor was Frances: unassuming, un-
pretentious, unbright—but a far more effective foil for him than his
two previous wives. The first of these had been a well-known Rus-
sian entertainer, Olga von Root, who had been singing gypsy ballads
in a Yalta cabaret when Hammer discovered her. They were married
in 1927, and in 1929 she bore Hammer his only legitimate child, Ju-
lian. The mother turned out to be drunken and promiscuous, the
father shamefully neglectful, so the son can hardly be blamed for
growing up to be an alcoholic given to outbursts of insane violence.
Julian celebrated his twenty-sixth birthday, May 7, 1955, by getting
very, very drunk and having a quarrel about money with his former
college roommate, Bruce Whitlock, a Golden Gloves boxing cham-
pion. Back home in front of his wife, Glenna Sue, Julian took out a
pistol and shot Whitlock dead. When Julian was arraigned for mur-

der, Armand hired a demon defense lawyer, Arthur Groman (later the head of Hammer's legal team); he also invoked the help of his influential friend Senator Styles Bridges; and the murder charge was set aside on grounds of self-defense. Julian was never incarcerated; later, he would have to be institutionalized.

Armand's second wife was little better than the first. After divorcing the exceedingly unfaithful Olga in 1943, he married Angela Carey Zevely, an aspiring opera singer, who had lost her hearing and, like her predecessor, taken to the bottle. Angela was foolish enough to give Armand a 50 percent share in Nut Swamp, her New Jersey farm, where she and Armand raised Aberdeen Angus cattle. Later, in 1954, when relations between them had cooled, Angela suspected she was being swindled and filed for separation. Hammer sued for divorce. She claimed that he had tried to beat her brains out. He counterclaimed that she had been drunk and abusive at a cattle auction and threatened to burn his eyes out. After prolonged court proceedings, Angela was awarded a thousand dollars a month in alimony, but she avenged herself by making off with Armand's most valued possession: an inscribed photograph and three hand-written letters from Lenin. Next came Frances. True, her hair had once been red, but her main attraction for Armand was the sizable fortune that Elmer Tolman had left her. This enabled Armand, shortly after they were married in 1956, to buy into Occidental. Another asset was Frances's garden-club demeanor. Her reassuring warmth and niceness—like an upscale Edith Bunker in *All in the Family*—camouflaged Armand's nastiness.

Hammer had summoned me to his California home to discuss a little ploy he was working on. He had discovered that Knoedler's owned a Goya, a dreary but authentic portrait of Doña Antonia Zárate worth around $150,000. He had told me he was removing it from the gallery's stacks and shipping it to Leningrad because the Hermitage did not own a Goya. Hammer planned to squeeze all possible prestige out of the gift of "this million-dollar masterpiece from my private collection." To publicize the presentation, he had insisted that the Hermitage exhibit his lackluster paintings. He was also after further quid pro quos: a loan show of Russian master-

pieces for Knoedler's and something extra for himself. "What should I request in exchange for the Goya?" the Doctor asked me. "I have more than enough busts of Lenin."

"A Suprematist painting by Kazimir Malevich," I said. "The storerooms of the Tretyakov in Moscow are full of them. Since the Soviets won't let the museum exhibit them, you might be able to get one for your collection." Although Armand had been living in Moscow at the height of Malevich's fame, he had never heard of the man who is arguably the most innovative Russian painter of the twentieth century. "Suprematist? Forget it!" he said. However, as I described how rare and valuable Malevich's paintings were, how high they stood on every modern museum's list of desiderata, and then read him the relevant passages in Camilla Gray's book on modern Russian art, Hammer's distaste turned to greed. He had to have one.

Since Hammer had suborned the minister of culture, Yekaterina Furtseva, with a bribe of $100,000—a bribe that would result in her disgrace and suicide—he got his way. Despite the official embargo, the Tretyakov Gallery's curators revered Malevich and were outraged at having to disgorge a major early work, *Dynamic Suprematism*. True, it was not in the best condition, but it was far more desirable and valuable than the third-rate Goya Hammer had given the Hermitage. When, a year or two later, the curators learned that Hammer had put their Malevich up for sale, they were even more outraged. Long afterward, I learned from Epstein that the Malevich expert whom Hammer asked to authenticate the painting had confirmed that it was an important example of Suprematism, albeit in less than perfect condition. Rashly, he had communicated his reservations to a German museum interested in buying it, whereupon the museum had turned it down. Hammer unleashed a pack of ferocious lawyers on the expert and did not call them off until the painting had been sold for $750,000 to another German museum. The only acknowledgment I got from Hammer was a copy of Bob Considine's unctuous biography, inscribed to "my mentor in the field of art."

So much for Hammer's art patronage. His excuse for selling the

only major modern painting in his collection was that he loathed it. This is the more ironical given that, years later, after building his own museum at the expense of Oxy's shareholders, he would bombard the authorities in Moscow and Washington with requests to have the prestigious Malevich retrospective that was coming to the United States as its opening attraction. Hammer got his way, but the refusal of the exhibit's curator to sign her name to the catalogue, the absence of the directors of the National Gallery and the Metropolitan Museum of Art (the other museums involved) from the Los Angeles opening, and the withdrawal of a number of loans from other American institutions were a measure of the respect in which Hammer and his museum were held.

That Hammer was as piratical in his dealings with his Soviet friends as he was with his people in the West was one of the more entertaining revelations of a trip I took to Russia with him in March 1975. The purpose of our visit was to negotiate a second loan exhibition of masterpieces from Russian museums to the National Gallery, Knoedler's, and museums in various American cities, which had been chosen ostensibly by the Russians but, in fact, by Hammer, for his own strategic reasons. The selection of the old masters was the responsibility of J. Carter Brown of the National Gallery; the selection of modern masters was mine. Frances Hammer came along; so did a team of cameramen from the Doctor's film company, Armand Hammer Productions (a subsidiary of Oxy). Their job was to record the Doctor's state visits to one world leader after another. Press photographers likewise hovered; if the record was not to his satisfaction, Hammer would have people retouched into—or, more often, out of—photographs.

In this respect—the falsification of history—Hammer followed traditional Soviet practice. Had it suited him to have met Stalin, he would have boasted of it. As it did not, he denied having done so, although Sovietologists believe that Hammer could hardly have retained a power base in the USSR without some degree of access to the dictator. Hammer was equally ambivalent about Libya, Oxy's primary source of oil for some years. He adamantly denied that he had ever solicited a meeting with Qaddafi; according to Epstein, he

never ceased in his requests. If the colonel raised the price of oil, Hammer would condemn his rapaciousness; if he lowered it, Hammer would praise his "uncanny cleverness, idealism, perhaps fanaticism."

Shortly before our trip, Hammer had ingratiated himself with Brezhnev by giving him a couple of Lenin's letters he had purchased in New York. This gift, coupled with the emergence in the Kremlin archives of Lenin's written approval of Hammer's first projects in 1921, had made him persona gratissima with the Soviet hierarchy. Whether or not the Doctor ever spent more than an hour in Lenin's company, he was able, fifty years later, to parlay this contact into an international power base. Entreé to the Kremlin opened up to him not only the Great Hall of the People in Beijing, but also 10 Downing Street, the Élysée Palace, and, paradoxically, the White House.

We flew to Moscow in the Doctor's private jet, *Oxy One,* at that time the only noncommercial plane allowed into Soviet (and later Chinese) airspace. This privilege, of which Hammer was childishly proud, had been obtained through Cyrus Eaton, the maverick capitalist from Cleveland, who had forged close ties with the Russians long before the Doctor's second coming. In gratitude, Hammer had agreed to employ Cyrus Eaton, Jr. Once Hammer had plugged himself into Eaton's powerful Soviet contacts, he sacked the son.

As soon as *Oxy One* taxied to a halt at Moscow's Sheremetyevo airport, Hammer's Russian representative, Mikhail Bruck, rushed on board with unwelcome news. The downfall of Furtseva had deprived the Doctor of a key ally. Her successor evidently wanted to distance himself from Hammer's incriminating largesse, and he was prepared to grant him an audience of no more than thirty minutes—not nearly enough to discuss the complicated protocols that the loan show involved. From the defiant way the Doctor stamped off the plane, he had evidently seen how this reverse might be made to work to his advantage.

Off we sped in the cortege of Chaika limousines that had been drawn up on the tarmac. Although Hammer had been absolved from the usual customs and immigration checks, the cars carrying

our luggage arrived at the old Hotel National just off Red Square two hours after we did. Brezhnev had not as yet granted Hammer the privilege of a grace-and-favor apartment of his own near the Kremlin; however, he already had the use of a large office as well as the sinister Lenin Suite in the dingily grand Hotel National. To prevent the bugs in the chandelier from picking up the Doctor's gravelly voice and getting wind of his tricks, the TV was always on full blast, which made it almost as difficult for us as for the wiretappers to understand him. According to Epstein, the Doctor, too, had his own set of bugs: tiny ones in his cufflinks.

A day or two later, we assembled at the Ministry of Culture, camera crew and all. Hammer wasted twenty-five of his allotted thirty minutes on needless formalities and photo opportunities: take after take of himself presenting the minister with some Russian daub he happened to have on the plane. Although his Russian was fluent, he preferred to use an interpreter: "it gives me more time to think," he said. Hammer assured the minister that, despite the lack of time for discussion, they could go ahead and "ratify the protocols" in the presence of the American ambassador that very afternoon. Armand Hammer Productions would be filming this historic cultural event for American TV. The minister fell into Hammer's trap. Later that day, in the glare of arc lights, I watched the wretched functionary go ahead and sign the requisite documents, some of which, as he realized too late, the Doctor had covertly added to the stack. Believing he was appearing "live" on American TV, the minister dared not stop signing. Among other concessions, Hammer obtained an exclusive copyright to the Russian paintings for as long as they remained in America.

The two exhibitions that were the outcome of these discussions were not only enormously prestigious, they were also profitable. Hammer had brought off a substantial coup. At the height of the cold war he had persuaded the Russians to lend two groups of masterpieces: a show of Impressionist and Postimpressionist paintings (Renoir, Monet, van Gogh, Gauguin, Cézanne, Picasso, and Matisse) in 1973; and one of old and modern masters and Russian paintings in 1975. He had also greatly enhanced the image of

Knoedler's by arranging for it to share these shows with the National Gallery and other major museums. These achievements provided Hammer with a lot of badly needed clout in the art world, clout that would open a lot of doors hitherto closed to him. After the second show was over, I had had enough of Dr. Hammer and Dr. Leibovitz's deviousness. I decided to leave their employ but continued to keep an eye on things at Knoedler's.

In 1977, the gallery's London branch was the setting for one of Hammer's most providential encounters. To celebrate the Queen's silver jubilee, Hammer had put on a show of Winston Churchill's flashy, splashy views of the Riviera. Prince Charles was enticed to the opening so that Hammer could lay siege to him. At first rebuffed, Hammer soon snared the heir to the throne by presenting him with one of the great statesman's anything but great canvases.

From then on, the Polonius-like Doctor would pour honey into the royal ear and money into the more newsworthy royal projects, such as the raising of the *Mary Rose,* a man-of-war that had sunk in 1545. But the most costly of the princely projects that the Doctor supported was United World Colleges, the concept of Kurt Hahn, former headmaster of Gordonstoun, Prince Charles's alma mater. To ingratiate himself with the Prince, Hammer threw himself into establishing the first American United World College in an abandoned Jesuit seminary way up in New Mexico's Sangre de Cristo Mountains. Hammer saw to it that Prince Charles paid a flying visit and prevailed upon his cousin, King Constantine of Greece, to send his son there.

In 1985, Prince Charles flew in once more, this time with Princess Diana, to preside over a United World College charity ball in Palm Beach, organized by the Doctor. His idea of fund-raising was to charge upwardly mobile couples $50,000 for the privilege of being photographed with the Prince and Princess. This made for a financial rather than a social success. Palm Beachers were outraged that a Soviet sympathizer from out of town should exploit the British royal family at their expense for a cause that had no local appeal whatsoever. Worse, instead of having a local *grande dame* chair the event, Hammer opted for cheesecake: the partly Iraqi wife of

one of the Oxy directors, who had posed nude for a sex magazine. Local ladies who had never been asked to pose for a sex magazine boycotted the event. Governor Bob Graham's declaration that the day of the ball would be Armand Hammer Day was the final indignity.

Allowing Hammer to cozy up to him earned Prince Charles as much as $14 million for his charities, but the Prince was too fly to play Faust to Hammer's Mephistopheles. Rumors that Hammer expected to be one of the godfathers to the Waleses' second son, Henry, turned out to be unfounded, but that did not stop the Doctor having another go at the Prince a year or two later. What would Mephistopheles want but help in his quest for the Nobel Prize?

The Reagans had similar problems keeping Hammer at bay. Back in Beverly Hills, Ronald Reagan had been irritated to find Hammer always ensconced in the next barber's chair whenever he went for a haircut. In Washington the Doctor was even more of a pest. Despite the White House staff's attempts to block him, Hammer was constantly badgering the President to pardon him for his hefty illegal contribution to Richard Nixon's reelection campaign. Nancy Reagan made her distaste very clear at the 1988 Moscow summit meeting. When Hammer begged her for an invitation to the state dinner, she gave him an icy look and just said "NO." Nevertheless, the First Lady found herself outflanked when Hammer bombarded her with donations to her antidrug campaign, to the redecoration of the White House, as well as to the American College of Surgeons for a scholarship in memory of her father. These donations did not buy the Doctor a pardon, but they meant that he was no longer barred from the White House.

George Bush was more of a pushover. As a reward for a sizable contribution, Hammer was given a place of honor at the inauguration, next to the Reagans and Quayles. Two days earlier, he had held an inauguration of his own: an unveiling of some papers he was giving the Library of Congress—yet another move in his bid for a full presidential pardon. However, since Hammer had pleaded guilty at his trial; had an appalling record of indictments by the Federal Trade Commission and Internal Revenue Service; had copped a very light

plea instead of a three-year jail term; had faked mortal illness (in a wheelchair hooked up, via a monitoring machine, to a cardiovascular unit); and had failed to express the customary remorse, the President could hardly give him a full pardon. Hammer had to settle for presidential forgiveness.

Meanwhile, Hammer was doing unpardonable things to the widows of his two brothers, who had been foolish enough to appoint him executor. He sold off the family home of Harry Hammer's widow for $20,000 to spite her heirs. And he behaved even more cruelly to the family of his younger brother, Victor, an endearing buffoon who had spent his life loyally obeying Armand's dictates. With his perpetual smirk and patter and stage-door-Johnny outfits (he always wore a white bow tie and white carnation), Victor resembled a ventriloquist's dummy and often served his brother in that capacity.

After the Hammer Galleries' Soviet sources dried up, Victor, with Armand's backing, switched to dealing in minor Impressionists and Americana (then relatively undervalued), including primitives by Grandma Moses. Armand had not been pleased when Victor married Ireene Seaton Wicker, a famously fey entertainer who starred as the "Singing Lady" on a children's radio show; but he was downright furious with her in 1950 for getting blacklisted: she had entertained Spanish refugee children and sung Russian gypsy songs on the air. Joe McCarthy was the last person Armand wanted on his back, hence his disapproval of Victor's gallant attempts to keep Ireene's wrecked career afloat by buying her radio time on into the mid-1970s. By then Ireene had faded into an ancient infant out of a Diane Arbus photograph, her finery and many quaint rings looking all the more dusty and tarnished alongside the mountain of Vuitton bags and baggage that she used as a kind of defense when Armand was around.

Although Victor had left Ireene over $1 million in assets, including a $400,000 house in Connecticut, Armand, as executor, proceeded to disinherit the aged, ailing widow. He refused to pay her medical bills, and took steps to sell the family house over the heads of both her and her daughter, Nancy Eilan. To protect her mother,

Nancy played the only card left to her: going public with her tale of woe. A mistake. Armand prolonged the case, thus using up what was left of his sister-in-law's savings. Then, all of a sudden, after Ireene died in November 1987, the case was settled out of court. Nancy got to keep the house.

Far from having had a change of heart, Armand had begun to suspect that his wife's confidence in his probity was beginning to erode. By 1987 Frances could no longer stand the perpetual traveling (three continents in two days was typical of their schedule). Also, there had been an embarrassing incident in Moscow. She had slipped and fallen in the Kremlin, and Hammer had left her sprawled on the floor while he rushed over to embrace Gorbachev. Left alone in Holmby Hills, Frances brooded about her ninety-year-old husband's infidelities as well as his treatment of Harry's and Victor's dependents. What would become of her own considerable fortune? If she died first, would her family, notably a favorite niece, be treated as shabbily as Ireene and her daughter? Hammer's sudden settlement with Victor's stepdaughter was an effort to put his wife's mind at rest on this score. Too late. On May 12, 1988, Frances Hammer got herself a new lawyer and instructed him to draw up a fresh will. All Frances's separate property and her half-share of community property, including his collection, would now go to her niece, Joan Weiss.

The new will threatened to put an end to the Doctor's dreams of posthumous glory. As of 1988, these had taken the form of a private museum. After the trustees of the Los Angeles County Museum of Art, to whom he had promised his collection, refused to accept his megalomaniacal conditions—a separate wing, whose walls would no longer bear the names of previous donors; a curator answerable only to Hammer or his curator, Martha Kaufman (who doubled as his mistress); a large portrait of the Doctor on permanent display in a place of honor—Hammer announced that he was establishing his own museum in a building to be erected next door to Oxy's Los Angeles office.

Frances's half-share of his collection was crucial to Hammer's museum project. So was the collection of fifty mostly minor old

masters that Hammer had presented to the University of Southern California in the 1960s. He now proposed to buy them back. USC was agreeable, subject to a new appraisal. Negotiations stalled when the appraisers, who doubtless knew about the Malevich business, insisted on one condition: if their valuations were not to Hammer's satisfaction, he would not sue. Hammer refused.

Another problem: who would foot the bill for the $100 million or so that this museum was going to cost? Oxy's shareholders were fed up with underwriting the vanity of a megalomaniac who owned less than 1 percent of the corporation, so they sued Hammer and the directors for squandering corporate funds. The stockholders were in for another shock: it turned out that they, and not Hammer, had bought much of the art, specifically the Leonardo Codex, which was destined to be installed in a special shrine.

Hammer had to act quickly. Frances had to be induced to make over her interest in the collection to him. According to a complaint filed after her death on behalf of her niece and heir, Joan Weiss, the Doctor somehow prevailed upon Frances to sign three separate waivers in the few months before she died, on December 16, 1989. Since Frances had had no access to independent legal counsel and was not apprised of the property rights she was signing away, her niece's lawyers contended that these disclaimers were unenforceable. Furthermore, according to Joan Weiss, Frances had been alarmed to find her husband's sexy Mexican mistress, Rosamaria Durazo, an anesthesiologist by profession, hovering in her hospital room the day after her final operation. After Frances's death, Durazo moved into the Holmby Hills house. Hammer refused to allow an autopsy.

Despite these legal tangles and the fact that the shareholders had sued to impose a ceiling of $60 million on the museum costs, Hammer raced to get the place built. However, his great age and seriously declining health made for further problems. The building—a squat cube horizontally striped—was barely ready in time for the opening of the Malevich show in November. To raise funds, Martha Kaufman (who had taken to calling herself Hilary Gibson and wearing a wig so that Frances would not recognize her) organized a series of "hard hat and caviar parties."

While he was doing his best to defraud his wife's heirs, Hammer was in frantic pursuit of his Holy Grail, the Nobel Peace Prize. His "philanthropic" ventures were increasingly directed toward this end, but his record proved as resistant to cleanup as Love Canal—which Oxy had acquired as part of Hooker Chemicals on Hammer's recommendation. After the Doctor got himself appointed to the President's Cancer Panel, the investigative magazine *Mother Jones* observed that Sid Vicious might as well head a program for battered women, or Qaddafi direct the Jewish Relief Fund. As for the annual Armand Hammer Conference on Peace and Human Rights, the first of which significantly took place in Norway, where the Nobel Peace Prize is awarded, it generated little more than mindless adulation of its begetter. "If [the prize] can be bought," said Zbigniew Brzezinski, Jimmy Carter's national security adviser, "[Hammer's] chances of winning it are quite high." For once, Hammer failed to get his way. Prince Charles had seen the light and refused to sponsor him. Instead, Hammer, who had always shunned Israel and denied he was Jewish, turned to Begin for help. In return for a commitment to drill for oil in the Negev and jump-start Israel's aviation industry, Begin agreed to support Hammer's nomination. To no one's surprise, the Dalai Lama won out over Hammer.

After he reached ninety, Hammer started to falter. He no longer remembered whether he was in Bonn or Berlin, whether to address Zia as a Muslim or a Hindu, whether or not there had been a war in Korea. He was also in appalling pain. Rosamaria Durazo would minister to these and other needs. Hammer's energy was astonishing. Five days after open-heart surgery, he was back in his office. There was a certain bravado to the nonagenarian's defiance of death. When, at the age of ninety-two, he informed friends that he had just ordered twelve new suits and twenty-four pairs of pants, some of them actually believed him. Hammer also organized a mammoth fund-raiser to celebrate his return to the Jewish faith by having the bar mitzvah that his agnostic father had denied him. But Jehovah withheld his blessing. On the eve of the ceremony, He killed off this shameful old hypocrite before he could glorify himself at His expense.

Epstein is very good on the criminality of the last years and the aftermath. Far from being a billionaire, Hammer turned out to have been worth no more than $40 million, against which there were over a hundred major claims, including one for $440 million filed by Frances's lawyers. Although he had promised to support his kith and kin, legitimate and illegitimate, as well as sundry mistresses, the Doctor had done nothing of the sort. He had cut everyone, including his unfortunate son, out of his will. His grandson, Michael, was his sole heir. The day after Hammer died, Oxy's shares shot up nearly two dollars, and the new chairman set about cleansing the company of Hammer's taint. All $2.5 billion worth of the Doctor's pet projects, including the museum, would be phased out or scrapped.

Further evidence of Hammer's criminality would emerge a few years later. While remodeling the Holmby Hills house, which she had inherited from her aunt Frances, Joan Weiss came upon a Nixonian cache of tapes concealed behind bookcases in the Doctor's old library. According to Epstein, the tapes—surreptitiously made between 1969 and 1983—record "the disbursement of bribes and other secret payments." Now that all the other monuments that the Doctor had raised to himself have been obliterated, these tapes are virtually all that's left of his legendary deals. As such, they define the old con man's role in history: the builder of a conceptual bridge between East and West, which enabled Hammer to set up as a toll keeper and extort outrageous favors from gullible statesmen and corporate fools in exchange for a slice of a huge pie in the sky.

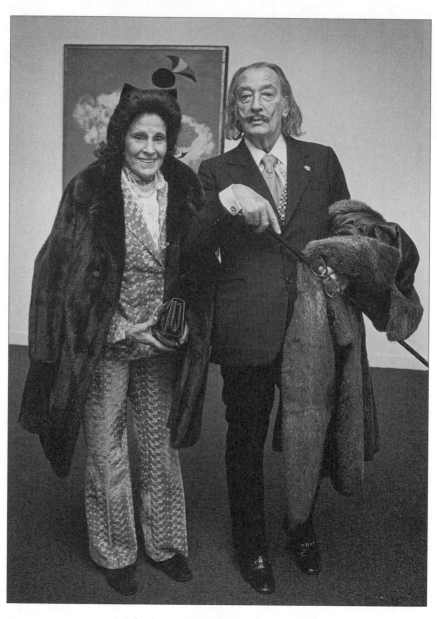

Salvador and Gala Dalí at the opening
of Knoedler Galleries' 1972 Dalí exhibition

Dalí's Gala

———

M ost people who had dealings with Salvador Dalí's Russian wife, Gala, would agree that to know her was to loathe her. In the course of a stint in the early 1970s as vice president of M. Knoedler & Co., the old established firm that acted as Dalí's dealer, I was obliged to contend with this woman, and no doubt about it, she was one of the nastiest wives a major modern artist ever saddled himself with.

One of my responsibilities was keeping the artist to the terms of his contract—a one-man show of new work, every two years. This was no easy task, given that his eye was so bleary and his hand so shaky that assistants had taken over most of his work. I could not help feeling sorry for the seedy old conjurer with his rhinoceros-horn wand, leopard-skin overcoat, and designer whiskers, not to speak of his surreal breath. The "Wizard of Was," as someone dubbed him, was all patter and very little sleight of hand. Gala, his virago of a wife ("The Spider Woman," we used to call her), and the creepy, conniving courtiers who were in charge of his affairs had reduced this former genius to a mere logo, a signature as ostentatious as his mustache.

Gala's business methods were very Russian: she did not haggle, she bullied. In a jet-black wig held in place by a Minnie Mouse bow, this ancient harridan would drive home her wheedling demands for money with jabs of ancient elbows and blows of mottled knuckles. After one gruesome dinner at Maxim's, which left me black and blue, I refused to deal with her ever again.

"Dalí need more money"—Jab!

"Then Dalí had better start painting again."

"Dalí paint every day. You give more money, he make more paintings."

"All our money got us last year were bits of paper covered with ink from an incontinent octopus. Ouch! Gala. That was my kidney."

To put one of Dalí's contractual shows together, I would be obliged to beg, borrow, and improvise: cover naked girls in paint and roll them on large sheets of paper; or add Dalinian trademarks—a swarm of ants or a soft watch—to kitschy marble busts, thereby transforming them into artifacts that were no less dud but much more valuable. Amazingly, the stuff sold. Red dots on picture frames induced the same voracious rapture in Gala that drops of blood supposedly induce in vampires. More money, you see, meant more sex.

—

Gala is sometimes said to have hailed from one of those Shangri-La valleys where sturdy yogurt eaters live to be over a hundred years old. According to Ian Gibson, Dalí's definitive biographer, Gala was born Helen Diakanoff Devalina in Kazan in 1894. Her father was a civil servant; her mother a member of the Moscow intelligentsia who wrote children's stories. According to Dalí, Gala was partly Jewish; according to her daughter, she was not. As a girl, Gala was delicate and had to be packed off at the age of eighteen (1912) to a Swiss sanatorium. And there this manic girl—the victim of "whorish" (her word) fancies, at the same time obsessively chaste—fell in love with a young French poet, Paul Éluard, who would win fame as one of the founders of Surrealism. The outbreak of war separated

them, but in 1916 Gala made her way back from Moscow to Paris to rejoin her poet lover.

Marriage to Éluard, a year later, triggered an attack of the nymphomania that would afflict her to her dying day. She did not allow the birth of a daughter, Cécile, in 1918, to cramp her style, either then or later. Apart from an unsuccessful attempt in old age to disinherit her, Gala paid Cécile little or no heed. Éluard prided himself on his sexual prowess, but even he failed to satisfy Gala, and she took lovers on the side. They had to be very young, very handsome, and very horny. As Gala had striking Slavic looks, an appetizing little body, and the libido of an electric eel, she had no difficulty finding them. One of her first lovers was the charismatic German Dadaist Max Ernst, who had recently moved from Cologne to Paris. At Gala's insistence, Éluard was obliged to let this hot young genius share their bed. Two men proved much better than one. Her only regret was that an "anatomical problem" ruled out simultaneous fore and aft penetration. Few of the other Surrealists could abide Gala. Much as they revered the works of the Marquis de Sade, they were appalled when an authentically Sadeian character manifested herself in their midst. Aroused, she would roar like a Siberian lion; amused, she would give a derisive smile.

In August 1929, the Éluards and a group of friends went to stay in Cadaqués, Dalí's hometown. The artist, who had yet to make a name for himself outside Spain, had already heard all about Gala's praying mantis proclivities, but his first sight of her in a bathing suit on the sacrosanct beach of his childhood left him bewitched. Gala was the demonic dominatrix of his dreams. For her part, she was in the market for a charismatic new husband. And in the twenty-five-year-old Dalí she had found the man of *her* dreams: someone who shared her passion for money, power, and notoriety, but also someone whose latest paintings—described by the artist as "hand-painted photographs of dreams"—with their references to Freud and Sade and their meticulous Vermeer-like finish, were destined to have an instant succès de scandale.

One small problem. Hitherto Dalí had been in love only once before, and that had been with a man: Federico García Lorca, who

had exerted a formative influence on his earliest work and was on the way to becoming Spain's greatest poet. Hearing that his former lover was involved with a woman, Lorca was incredulous. "It's impossible. He can only get an erection when someone sticks a finger up his ass," he told a friend. However, Gala turned out to be unfazed by Dalí's homosexual propensities or his anal and coprophiliac fixations. Thanks to her familiarity with the wilder shores of sex, she knew how to foster a man's fantasies without necessarily catering to them. She was also reassured to discover that her new admirer derived a vicarious thrill from her incessant infidelities. Sex for Dalí would always be conceptual or voyeuristic. Hating to be touched, he had become a compulsive onanist: a condition that engendered, this very summer, his early masterpiece *The Great Masturbator.* Gala was a great help, he said, in refining his autoerotic techniques.

Dali's respectable Catalan family was appalled by his obsession with this scarlet woman from sinful Paris. Wrongly assuming Gala to be a drug addict who had turned Salvador into a dope peddler, his father disinherited him, and his devoted sister, Anna María, embarked on a feud with Gala that would last until death. The following spring (1930), Gala and Dalí spent five weeks at Torremolinos—in those days an unspoiled fishing village—and scandalized the local women, who wore black and kept themselves covered, by wandering around the streets, tanned mahogany from sunbathing nude on the beach, caressing each other exhibitionistically: she barebreasted, miniskirted, on the prowl; he no less manic-looking, his skinny chest set off by a necklace of bits of broken green glass. In nearby Málaga the tourist office explained away this bizarre couple as Egyptians, which left them at the mercy of beggars crying for baksheesh: "Mohammed, one penny, Mohammed, one penny."

—

Dalí was a latecomer to Surrealism. An earlier generation of Surrealist painters—Max Ernst, Joan Miró, André Masson, Yves Tanguy—had paved the way for him. So had the Surrealist poets, above all André Breton, the control freak of genius who headed the move-

ment. Surrealism turned out to be made for Dalí, just as he turned out to be made for it: the twisted imagery churned up by his dysfunctional psyche corresponded to the iconography that Breton had envisaged for it, as would emerge at the artist's first one-man show in Paris, in November 1929. This and the two sacrilegious films *Le Chien Andalou* and *L'Age d'Or,* which Dalí made with the no less subversive friend of his youth Luis Buñuel, confirmed him as the last great star of Surrealism. No doubt about it, by coming into his life just as his career was taking off, Gala helped to *make* Dalí, just as in less than a decade she would be instrumental in *unmaking* him.

After their marriage in 1934, Dalí set about propagating the legend of Gala as his muse and collaborator as well as wife. She also served as his business manager and publicist, and in no time succeeded in turning him into as much of a monster of hype and megalomania as herself. Inevitably she loathed André Breton as much as he loathed her, and in the fight for possession of her husband's soul, she won. Her victory condemned Dalí to an extremely lucrative career of surrealistic hackwork—society portraits, Fifth Avenue window displays, hosiery promotions, Catholic porn—which was instrumental in bringing the Surrealist movement as well as his own art into disrepute.

With her White Russian hatred of Communism, Gala had also managed to subvert the liberal ideology that Dalí had shared with the luminaries of his student days, Lorca and Buñuel. Disdaining the Marxism of his fellow Surrealists, the former atheist and anarchist had gone over to totalitarianism and its concomitant, anti-Semitism. Far from showing any sympathy for the proletariat, Dalí announced, apropos his surreal penchant for disasters, that he "preferred train accidents in which the third-class passengers suffered most." He hailed the swastika as "the fusion of Left and Right, the resolution of antagonistic movements," and made no secret of his fetish for Hitler.

When Franco prevailed in the Spanish civil war, Dalí set about currying favor with the Caudillo by coming out in praise of the church and family values, which he had hitherto denounced. Breton, who had become a powerful force in French letters, anathema-

tized the artist as a counterrevolutionary and expelled him from the Surrealist group. He also devised a devastating anagram for him, "Avida Dollars." When Max Ernst refused to shake Dalí's hand—"I don't shake the hand of a fascist"—Dalí replied, "I am not a fascist, I am only an opportunist." Dalí's period of greatness had lasted little more than ten years—ten years in which he had come up with some of the most provocative and disturbing icons of this century. *The Persistence of Memory* and *The Specter of Sex Appeal,* to name but two of them, reshaped the way we dream. Dalí's "last scandal," he promised, would be a return to classicism, but he no longer had the requisite skill, let alone the time or the patience for it. Dalí's "classicism" turned out to be academic kitsch. Thanks to Gala, the rest of his life would be an ever-accelerating *dégringolade.*

———

The Dalís spent World War II in New York. Although Gala loathed the place, she made a fortune promoting her husband's commercial career. She kept him slaving away on commercial projects, interspersed with glitzy portraits of hard-faced society women in ball dresses posed, "surrealistically," against desert-island backdrops. These daubs effectively scuttled his reputation as an avant-garde artist. Away from his Catalan roots, Dalí's imagination atrophied and his work became slick and sleazy. Only his paintings of Gala have any of the old intensity.

When, in 1948, he returned to his surreal folly at Port Lligat (a short distance from the parental house in Cadaqués), he gave bombastic interviews in order to ingratiate himself with the church. And to the same end he embarked on the first of a series of utterly unconvincing devotional paintings: a sanctimonious image of Gala, entitled *The Madonna of Port Lligat.* The fishermen of Port Lligat, who liked Dalí but loathed Gala—she was always propositioning them—found the notion of her as the Madonna a blasphemous joke. Nevertheless the painting proved a useful prop when the Dalís had an audience with the Pope in December 1949. His Holiness liked it. On the other hand, friends of the artist's youth, who remembered his fanatical attacks on religion, were nauseated. For

them the seal of papal approval was tantamount to the mark of the beast.

By the early 1960s Dalí had to work ever harder on ever more degrading projects—sets of lithographs in which he desecrates the imagery that made him a genius—to support Gala's addictions to gambling and delinquent toy boys. One of her hustlers had arranged for friends of his to steal her car while he was dining with her. She had better luck with a handsome twenty-two-year-old junkie whom she had picked up on a New York street. Gala bought him new clothes, weaned him off drugs, and took him to Spain, then Italy, where she made him swear eternal love to her on the tomb of Romeo and Juliet. He even returned her love, which is probably why the affair lasted for some four years. It was only when he failed a screen test for a walk-on part in a Fellini movie that Gala gave him a one-way ticket back to New York. Gibson, Dalí's biographer, reported that he had died of an overdose. He turns out to be very much alive.

To entertain her lovers Gala had persuaded Dalí to give her a castle, part hideaway, part love nest. Pubol, it was called, and it was an hour or so's drive from Port Lligat. The artist was not allowed to set foot there unless he had a written invitation from the chatelaine. Thanks to a young man, Jean-Claude du Barry, described by Dalí as his "purveyor of ass," both of them had a constant supply of fresh flesh. The boys had to screw Gala. Woe betide them if they went after Dalí's girls, chicks with dicks for the most part, who had to do one another while the "Great Masturbator" watched. When Gala was almost eighty, she fell for a young student from Aix-en-Provence who gave her the illusion of eternal youth. After a year or two, he was displaced by Jeff Fenholt, the loathsome, long-haired protagonist of *Jesus Christ Superstar.* "Jesus Christ" proved a very expensive item. He persuaded Gala to give him a sizable house on Long Island and send him large sums of money in cash ("must have $38,000 or will die"), but showed her little or no gratitude. His impersonation of Jesus may have failed to redeem him, but it came in useful later on, when Fenholt switched to being a TV evangelist in California. Dalí was outraged at the expenditure and degree of

Gala's infatuation, which would last almost until her death. In 1981 the worm finally turned. Dalí beat up his eighty-seven-year-old wife so badly that she had to be taken to hospital with two broken ribs and severe bruises.

Gala was nothing if not piratical in her approach to money. She preferred payments to be made in cash; that way she could smuggle large sums into or out of Spain, Switzerland, or France. So full of banknotes were the Dalís' safe-deposit boxes at their Paris hotel that the manager begged them to move the contents to a bank. To the Dalís' dismay, much of the currency was no longer negotiable. Henceforth the artist confided the management of his affairs to a succession of "secretaries." He was too stingy to pay them, so they had to live off the commissions they earned on the deals they set up. All of them became multimillionaires at their boss's expense.

The first of the secretaries was a genial Irishman, Captain Peter Moore, who had worked in film. Besides lending Dalí his two ocelots, which the artist exploited to great public effect, Moore solved Dalí's, or rather Gala's, need for ready money by suggesting that they charge ten dollars for signing a blank sheet of paper onto which publishers or dealers could print whatever image they liked from the artist's repertory. Since Dalí could do a thousand signatures an hour, he relished this task. It was like printing his own currency. After the French customs stopped a shipment to a so-called art publisher of forty thousand sheets of lithographic paper, blank except for Dalí's signature, respectable dealers and collectors shied away from his later graphic work. Once again the artist had done himself in.

Gala made no bones about the people who trafficked in these sheets of paper. "They are *all* crooks," she said. "Who cares! They pay us cash, so what difference does it make? Dalí painted the work. He can sell the rights to anyone he wishes and as many times as he wishes." It was not even as if Dalí needed money: in 1974 he was worth $32 million. Gala *did* need money—as much as she could get—for toy-boy rentals and other luxuries. What little was left of Dalí's integrity as an artist had once again to be sacrificed to her nymphomania and greed for crass aggrandizement.

After the friendly, businesslike Peter Moore was squeezed out in 1974, things got worse. Gala insisted on replacing him with a former soccer player from Girona called Enric Sabater, a jack-of-all-trades with a flair for public relations and monkey business. When he went to work for Dalí, Sabater applied for a private detective's license and took to carrying a gun, which had the desired effect of terrifying his employer. Sabater set up a number of offshore corporations and proceeded to build up a business empire for himself, which eclipsed the artist's. To keep the Dalís isolated from protective friends, he instructed armed guards to let nobody into their house unless authorized by him. He also tapped their telephones. By charging around with a revolver in his belt, eavesdropping, and spying, Sabater reduced Dalí to a "trembling mass of jelly." According to Reynolds Morse, the artist's collector and friend, Sabater had worked "the greatest con game ever on the greatest con man in art." Besides a yacht and two luxurious Costa Brava villas, one with a lobster pond, Sabater managed to amass in four or five years a fortune of over a billion pesetas (about $14 million).

Meanwhile, Gala's passion for Fenholt had left Dalí more demoralized than ever. He was terrified she was going to run away with Jesus Christ. To alleviate his panic, Gala gave her husband excessive doses of Valium and other sedatives, which made him lethargic. She would then dose him with "unknown quantities of one or more types of amphetamine," thereby causing him "irreversible neural damage." Gibson suggests that in plying Dalí with assorted pills from her private medicine chest, she might have been trying to poison him. Indeed, why else would she have been at such pains to reduce him to a bag of quivering bones? When the King and Queen of Spain came to visit Dalí in 1981, he looked very battered: Gala had apparently dented his head with the heel of her shoe.

Gala died first—on June 20, 1982, aged eighty-eight. The fact that this occurred in a Barcelona hospital made for problems: she had wanted to die and be buried at Pubol. To avoid legal problems, Dalí's entourage decided that her body should be propped up, with a nurse beside her as if still alive, in the back of her old Cadillac and

driven, secretly, to Pubol. Doctors came from Barcelona to embalm her. Mummified in a favorite red Dior dress, she was entombed in the castle's crypt. There, a few nights later, Dalí was found crawling around on his knees, convulsed with terror. Although he had come to loathe Gala, he could not function without her. To be with her in spirit, he stayed on at Pubol. One of his nurses described him sobbing constantly and spending "hours making animal noises. He had hallucinations and thought he was a snail."

After Gala's death, Dalí's affairs went from bad to terrible. The new secretary, a seemingly harmless French photographer and self-proclaimed Dalí expert called Robert Descharnes, turned out to be every bit as untrustworthy as his predecessor. Since Dalí could not bear to return to the Port Lligat house, Descharnes moved his family into it and, according to nosy neighbors, proceeded to ship the more valuable contents—archives, drawings, objects—to his Paris premises. Descharnes's credentials as an expert did not survive the publication of a book in which he claimed that despite the uncontrollable trembling of Dalí's right hand (so bad that he took to signing things with a thumbprint), he had somehow managed, between 1982 and 1983, to execute a hundred paintings that resembled nothing he had ever done before. According to Gibson, most of these works are by an assistant called Isidor Bea.

For the last five years of his life, Dalí was an invalid—an invalid from hell. He screamed and spat at his nurses and lunged at their faces with his nails. To annoy them he would soil his bed or refuse to take a pill unless an attendant promised to take one too. His incessant use of an antiquated bell push nearly caused his death. It triggered a short circuit that set fire to his bed. A nurse who found him semiconscious on the floor summoned help, and he was dragged to safety. Despite his imprecations—"bitch, criminal, assassin"—the nurse managed to give him mouth-to-mouth respiration, which saved him. While Dalí was in the hospital's burn unit, his sister, Anna María, once closer to him than anybody, insisted on visiting him. He shouted at her to go away—that she was an old lesbian—and tried to hit her. A few weeks later he took steps to disinherit her. Evidently he was on the mend.

Not wanting to return to Pubol, Dalí decided to move into a spe-
cially prepared extension to the Theater-Museum that he had
founded to his greater glory in the nearby town of Figueres. And
there, except for spells in hospital, he remained, "swathed in se-
crecy," until his death. Because he refused to eat, doctors had
"equipped him with a grotesque nasal-gastric tube leading directly
to his stomach. The piece of apparatus made his speech even more
incoherent and his throat painfully dry."

In November 1988, Dalí was readmitted to hospital. Hearing
that the King, who had created him Marquis of Pubol y Dalí, was in
Barcelona, he requested and received a visit, which involved dust-
ing off the famous mustache. Death came a few weeks later, on Jan-
uary 21, 1989. To the surprise of his entourage, the artist was buried
not beside Gala at Pubol, but in his Theater-Museum. Twenty years
earlier, Dalí had assured me he was going to have his body refriger-
ated—in the hope of eventual resurrection. However, he ended up,
like Gala, embalmed, pacemaker and all. He had insisted that his
face be covered in death, but he was laid out in an open coffin in a
funeral chapel for all to see, his grubby fingernails showing through
his shroud.

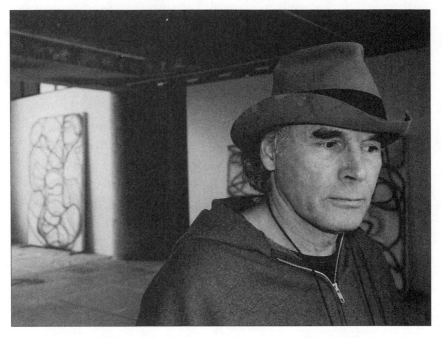

Brice Marden, photographed by his daughter Mirabelle, 2001

Brice Marden's Hidden Assets

At a time when modernist pundits were claiming that painting was dead—killed off by cameras, computers, laser beams, bull-dozers, and other technological devices—along came Brice Marden to resurrect this time-honored medium, which has been banned from certain museums of contemporary art on the grounds of ob-solescence. Marden has redeemed his medium of choice with such dexterity and authority that the paint surface—its color, texture, tonality, scale, and the way it absorbs or refracts light—constitutes his subject matter. His concerns go much, much deeper than mere surface attraction. As his perceptive friend and commentator Klaus Kertess has said, Marden "has pushed paint . . . to that edge where matter meets myth and spirit."

Marden would never have gotten where he is had he not been driven by an adamant belief in abstraction, an addiction to very hard work, a fiercely competitive spirit, and a compulsion to stay ahead of the game. This is not the side of his character that Marden pre-sents to the world. He has such charm, such lucid intelligence, such ironic humor, and such ageless movie-star looks—it is hard to be-

lieve he is over sixty—and one of our most formidable and innovative artists.

Brice Marden was born into the very heart of New England WASPdom—Briarcliff Manor, near Bronxville—to a likable Irish mother and a somewhat distant father, a Princetonian banker who, according to his son, enjoyed planting trees and "building beautiful dry stone walls." (To explain his work to his father, Marden cited these walls: "Everything has to fit together in order for it to stand," he said, "same as in the paintings.") Marden had briefly contemplated a career in hotel management—and, in wilder moments, the rodeo. However, by the time he was twenty he had decided to be an artist and enrolled at Boston University's School for the Arts. He proved to be so paint-obsessed that he would make off with the gray sludge cleaned from the students' brushes and see what he could do with it. In 1961 he moved on to the School of Art and Architecture at Yale, where such luminaries as Richard Serra, Robert Mangold, Chuck Close, Nancy Graves, and Janet Fish would be his fellow students. These future stars are said to have learned almost as much from one another as they did from their teachers, one of whom worried, presciently, that Marden might be painting himself into a corner. If that indeed is what he was doing, he made a great virtue of it.

After earning a Master of Fine Arts degree in 1963, Marden settled in New York. He rented a walk-up apartment in the East Village and lived mostly on yogurt. In due course he married the sister of Joan Baez, fathered a son called Nicholas, got a job as a guard at the Jewish Museum, and devoted the rest of his time to painting. The boredom of his museum job was mitigated by the stimulus of the exhibits that the progressive director, Allan Solomon, was in the course of organizing. For Marden, the 1964 Jasper Johns show was a revelation. Johns would confirm him in "his commitment to gray" and continue to manifest himself subliminally in Marden's work for another two decades.

In the summer of 1964 Marden quit his job as a guard and took off for Paris. Courbet and Manet had as much to teach him as Picasso or Matisse. Marden was struck by Manet's use of gray as an

active color and by Courbet's use of a palette knife to build up the lowering grayness of rain clouds, or the green sogginess of the Jura's wetlands—climatic effects made palpable in paint, and in that respect comparable to the weather in his own work. The visit to Paris coincided with André Malraux's well-intentioned but ill-advised campaign to scrub the face of Paris clean (ill-advised because the high-pressure cleaning left some of the older buildings susceptible to erosion). Never had Parisian limestone taken the light so gloriously. "The flat density of stucco, stone, and tile constantly drew Marden's attention," according to Kertess. "He sought to assimilate this wallness in his drawings . . . He made *frottage* rubbings in his notebooks, as well as scratching tracks with his comb."

Back in New York, Marden and his wife divorced and he went to work as an assistant to Robert Rauschenberg—"The most naturally intelligent man I've ever met," he says, "and he's very generous with his thinking." The job entailed little in the way of duties. Rauschenberg was not so much working as living it up—or should one say down? This was Rauschenberg's "dude period." He had taken to wearing a porcupine-quill jacket; his shoulder-length hair was elaborately coiffed; and he did little but drink too much bourbon, watch too much television, and gallivant around Europe. "It was really a weird job," Marden told Calvin Tomkins. "Technically you're his assistant, but also you're being paid to sit around and drink with him . . . [Rauschenberg] was very lonely then, and sort of shaky." Marden was already so committed to his own form of Minimalism that he had no need whatsoever of a mentor. What he gleaned above all from Rauschenberg was reassurance. He realized what it took to be a successful practicing artist. For years, the Mardens had a turtle called Rauschenberg.

Like Rauschenberg, Marden spent a great deal of time at Max's Kansas City, the ultrahip watering hole that opened on lower Park Avenue in 1965 and lasted until 1974. As William Burroughs said, "Max's was at the intersection of everything." Andy Warhol's claim that the place was "the exact spot where Pop Art and Pop Life came together" may also have been true; but to the abstractionists who congregated there, Pop art seemed like pretty thin stuff—just an-

other form of representationalism. Marden gravitated to the "heavy hitters"—Richard Serra, John Chamberlain, and Carl André—who hung out in the front part of Max's. Warhol and his superstars—Ultra Violet, Sylvia Miles, and drag queens such as Holly Woodlawn—hung out at the back. The "heavy hitters" were apt to refer to Warhol as "Wendy Airhole" and his associate, Bob Colacello, editor of *Interview*, as "Kooky Jello."

That heady 1960s-ish fusion of sex, drugs, and rock 'n' roll is what fueled the creativity at Max's. At first it was primarily an artists' hangout. Later, musicians would perform in the upstairs room—Bruce Springsteen, Iggy Pop, Billy Joel, Alice Cooper, the Velvet Underground, and Kinky Friedman and his Texas Jewboys were just a few of the performers who appeared there. The rock 'n' rollers and the artists got along marvelously together. Max's was the only place in New York where it was possible to hear great music, get infinite credit, score drugs, and there and then make out with gorgeous groupies under the tables or in the bathrooms. The waitresses in their little black miniskirts and black tops were a major part of the attraction—"more appetizing than the food," Dennis Hopper said. According to Yvonne Sewall-Ruskin, who lived with the proprietor, Mickey Ruskin, the waitresses "were treated like celebrities instead of indentured servants." They made so much money that some of them went to Europe when they had a few days off. One of the liveliest of these beauties was an adventurous English girl named Helen Harrington, an aspiring painter who had swept in from Morocco. Marden was very taken with her. They were married in 1967. Despite sporadic separations (Helen is a character to be reckoned with), they are still very much together. Now that their two daughters are away at college, Helen finally has more time to devote to her own work.

Helen figures repeatedly in Marden's imagery. The year of their marriage, he paid tribute to her in a painting entitled *For Helen*, which consists of two panels that are both five feet nine inches in height, as is Helen (Marden is five feet eight and a half), and painted a wonderful orificial pink. (Helen claims that the pink was actually inspired by a color Marden had never seen—the color of

the wet sand at low tide in Cornwall, which she had described to him.) Later, after Helen temporarily deserted him, Marden dedicated seven more of these five-foot-nine paintings to her, this time single-panel ones, which are as obdurate as a slammed door. These are known as the *Back Series,* to signify that she had turned her back on him. (A photograph of Helen's naked back figured on the poster for the exhibition of this series.)

Before he married Helen, Marden had found inspiration in another of Max's girls: Nico, an Andy Warhol superstar who also sang with the Velvet Underground. Ironically, this big, blond German sexpot, who had spent much of her life on heroin, died falling off a bicycle on Ibiza. *For Niko* is painted in a tone somewhere between hair and flesh—so physical you want to touch it. During one of his postmarital separations, Marden commemorated his love for two other fascinating singers—the raw-voiced superstar Janis Joplin and the rock 'n' roll poet and songwriter Patti Smith. Both of these "portraits" consist of three monochrome panels that are tightly jammed together, without the vertical gap that endows *For Helen* with a more overtly physical presence.

Among the other heroes and kindred spirits that Marden memorialized around this time, pride of place must go to the great horizontal painting—a darkish, purplish gray the French would describe as *taupe*—in which Marden adulates the great Bob Dylan, the poet as well as the singer. No less powerful is a pair of dark gray vertical "portraits"—the self-referential *For Me,* which Rauschenberg acquired, and a painting Marden was working on when he heard that Otis Redding had died and turned into what is now called *For Otis.* Another major memento mori done the same year, entitled *T.K.B.,* after one of Marden's closest friends who died of an overdose, is especially terrifying: darkness, maybe death made palpable. Like several of Marden's major works of the period, *T.K.B.* has a strip along the bottom that is free of the night-colored impasto covering the rest of the canvas. This device (borrowed from Jasper Johns) permits the artist to take up one edge of the skin of paint, as it were, and reveal the Jackson Pollock–like splotches and dribbles underneath. These aleatory marks hint at the secrets—memories,

false starts, aspirations, accidents—that are buried, like so many bees in amber, under the matte impasto, conjured out of beeswax and oil paint and months of toil.

In the summer of 1971, Helen steered Marden to the Aegean island of Hydra—a much wilder, more hippyish place then than it is today—and they have spent most of their summers there ever since. Their first house was so tiny Marden had to work out of doors at a rickety table under a grape arbor. Over the years, they have increased their Hydriot holdings: a clump of whitewashed cottages on the hill above the town, known as the Up House, and a more traditional sea captain's residence above the port, known as the Down House. Helen has her studio above; Marden his principal studio below. For the first twenty summers on Hydra, Marden did no paintings, only drawings, but the light and color, the sea and sky and the mythic aura of the Aegean inspired a number of works that he did back in his New York studio—notably his celebrated *Grove Group*, in which he dissolves the sacred groves of Hydra in layer after layer of pigment.

These five *Grove* paintings (1973–80) are executed in a name-defying color, a kind of celadon, which varies from silver to pewter to lead and evokes the recto and verso of the olive leaf. Sea and sky contribute to this color, so possibly do the prevailing wind (the *meltemi*) and the prevailing thistles. These seemingly blank, monochromatic paintings are a kind of distillation. They put me in mind of a ritual that took place every autumn in the Provençal wine country where I used to live. After the grapes had been pressed, the residue—grape skins, pips, leaves, twigs, and heaven knows what else—would be fed into an antiquated steam engine. Out would come marc or some other spirit, which I liked to think of as a distillation not just of the grapes but of all the other elements—sun, soil, rain, dew—that went into the making of it.

Hydra, or rather the boat trip to and from the island, inspired several of the works in the *Sea Painting* series, which play the blues on the port side off against the ever so slightly different blues to starboard. While exploring the mainland, Marden had become engrossed in the study of archaic Greek architecture. Little by little he

saw how its simple, sacrosanct proportions could give his Minimalist work a semblance of structure. By adding a horizontal panel to the top of his two-panel compositions, he could evoke the post and lintel doorway of a temple, and confer a measure of monumentality on his basic rectangles without the addition of any superfluous elements.

In 1975, the Guggenheim Museum gave the thirty-five-year-old Marden a retrospective, which established him as a major Minimalist and also as a romantic visionary in the American tradition of the sublime. His stock rose even higher when Pace Gallery showed his *Annunciation* series (1978–80)—five large compositions, each consisting of four vertical panels of varying width and color—which celebrates the conception of his elder daughter, Mirabelle. These panels, in which the sacred joins forces with the profane, were inspired by a fifteenth-century sermon describing the five successive stages of the Virgin Mary's Annunciation: *Conturbatio* (disquiet), *Cogitatio* (reflection), *Interrogatio* (inquiry), *Humilitatio* (submission), and *Meritatio* (merit). Marden has no specific religious beliefs: however, as a child, he was an altar boy and "very much involved in the ceremonial aspect of the [Episcopalian] church." Later, at college, he discovered how "much of western architecture and art is based on [Catholicism]. It's all about what's supposed to happen mystically. I've always been very intrigued by that." John Russell, the *New York Times* critic, claimed that the *Annunciation* series is "one of the richest, clearest and most fulfilled of our century's grand designs. It is a misfortune for us all that it was not bought for an American museum and is now widely dispersed."

While working on the *Annunciation* series, Marden accepted a commission to design eleven stained-glass windows for the cathedral in Basel. After slaving away for seven years (1978–85), he was obliged by the stinginess of the reactionary city fathers to shelve the project. However, the experience was valuable in that it obliged Marden to move on from his opaque monochrome rectangles and experiment for a change with planar transparency and the juxtaposition of symbolic colors (reds, yellows, blues, and greens, which stand for fire, air, water, and earth). Hence the series of incandes-

cent *Window* studies, which allow for a play of light and a breath of air and—a new departure—a variety of shorthand symbolic signs. Nonfigurative purists denounced this foray into figuration as counterrevolutionary, but Marden forged on, regardless. "I wanted to find something . . . melodious," he said.

Marden's preoccupation with paint does not rule out a preoccupation with drawing. "They are not very far apart," he says, "but they *are* very far apart." After drifting away from austerity, drawing enabled him to find new solutions to the problems of Minimalist imagery. He took his lead from Jackson Pollock. Besides a baster, Pollock had used sticks to apply paint in a radically new way. Marden applied this idiosyncratic technique to drawing. Instead of making marks on paper with a conventional pen or pencil or brush, he takes sticks he has picked up on the street—sticks up to three feet long from the weedlike ailanthus trees that have invaded New York's vacant lots—and dips them in ink or paint. These sticks allow Marden to work at roughly the same distance from his sheet of paper that an observer would normally adopt. He says that they "literally forced [him] to learn to draw all over again." The sticks have enabled Marden to adapt drawing to his own special needs and introduce a hint of ghostly figuration into his work, also to come up with drawings that are incisive yet sensuous, instinctive yet controlled. For all their seeming spontaneity, these drawings have often been worked on for two or three years—like Marden's paintings— which explains the smallness of his output. Even when he has handed over a painting to his dealer, Marden will sometimes insist on its return and spend months reworking it.

In the early 1980s Marden suffered what he called a midlife crisis. It was as if he had turned the clock back to the wild days of Max's Kansas City. He took a lot of drugs. He broke up with Helen, who had recently given birth to a second daughter, and embarked on an affair with Heather Watts, the reigning star of the New York City Ballet. And although his work was attracting enormous attention and enormous prices, he took a dislike to his gallery: "I would work on a single painting for a year [his eighteen-panel *Thira*], just as a fuck-you to my gallery . . . it got boring." And then Marden lost

his appetite for *Sturm und Drang* and went back to Helen and the kids and the house in Greenwich Village and the summers on Hydra. He also switched dealers, ultimately joining the sympathetic and enterprising Matthew Marks.

To put their lives back together again, the Mardens took their children on a yearlong trip around the world. This coincided with Marden's newfound passion for Asian art, which he had hitherto been at pains to steer clear of. He set about studying Oriental calligraphy, an abstract blend of imagery and script that has had a decisive influence on the figuration in his recent work. Another revelation came about on a visit to a "shell museum"—more of a shell bazaar—on the coast of Thailand, where Marden became fascinated by the speckled surfaces and the structure of shells. Their markings have engendered some of his finest drawings. So that he can continue working on these drawings, Marden takes them with him from New York to Greece, also to Pennsylvania, where he has a four-hundred-acre estate called Eaglesmere.

Marden's preoccupation with Chinese calligraphy inspired what are perhaps his finest, certainly his most ecstatic paintings: the *Cold Mountain* series (1988–91). These commemorate the so-called Cold Mountain poet, a ninth-century Chinese hermit, named after the sacred mountain where he had his hermitage. In these six huge paintings (not to mention numerous related drawings and a suite of etchings) Marden animates the calligraphic characters in the poet's formulaic couplets and transforms them into a layered tangle of dancing, proliferating strands. In their gestural intricacy, the *Cold Mountain* paintings recall Jackson Pollock, one of whose dried-up pots of silver paint Marden keeps as a sacred relic in his studio.

In 1995 Marden harnessed his work to yet another Oriental art form. On a trip to China he visited the Garden for Lingering in Suzhou with its revered centerpiece, the Cloud-Capped Peak, a natural rock formation like a column of petrified smoke. The "flow of energy" from the Cloud-Capped Peak has fueled much of Marden's recent work. He was also very taken with the cave paintings at Duannhuang—especially the ones depicting the "Ribbon Dance," which engendered his joyous *Chinese Dancing*. This kind of move-

ment, Marden says, is figural. "You're painting it with a long brush, so you're moving. In a sense it becomes a transference of your own dance to the canvas."

Marden's dancelike allusions were partly inspired by Robert Graves's *Greek Myths:* "I like it when [Graves] talks about the Muses as maenads, these Bacchanalian women wildly dancing in the mountains. That's what I was working with in *The Muses.* Just a group of figures dancing, the Peloponnesian landscape, Dionysian madness . . ." Look hard into this painting and you will be able to sense in the tangle of lines an emanation of the nine muses, who stand for literature and the arts (too bad there are no muses of painting or sculpture). This painting also envisions something more personal: the artist's maenadic daughters cavorting on the slopes of Hydra much as the muses supposedly did on Mount Olympus. As for the "Dionysian madness," I suspect that is what this reticent artist keeps hidden under all those volcanic deposits of paint.

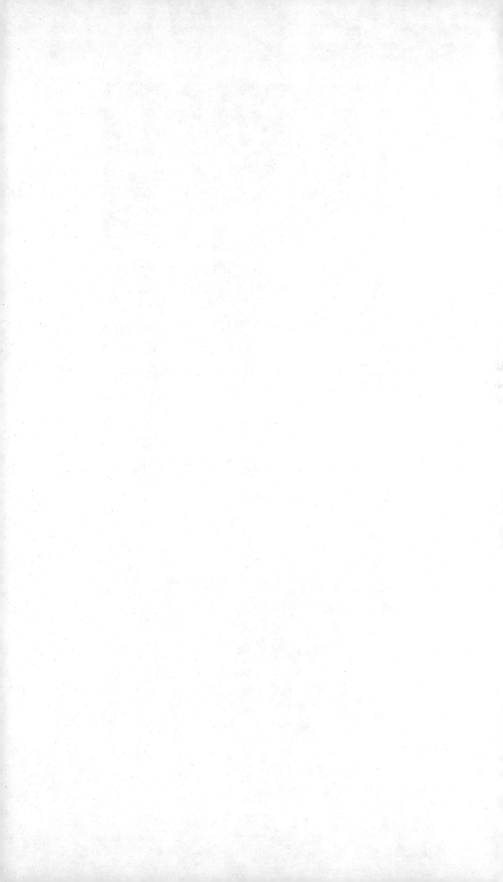

Nina Kandinsky wearing some of her
Van Cleef & Arpels jewelry, 1976

Nina Kandinsky's
Deadly Diamonds

A streak of Oriental fatalism—a quality that Vassily Kandinsky may have inherited from one of his great-grandmothers, a Mongolian princess—makes itself felt in many of the artist's early cosmological paintings (1911–14). This belief in the workings of fate is something that the artist shared with the woman he was about to marry. In her memoirs, Nina Kandinsky recounts how thcy both believed in astrology and frequently had their horoscopes read. Indeed, before her marriage, Nina had consulted a woman fortune-teller, whose predictions were so uncannily accurate that the police threw her out of Moscow. After informing Nina that she would marry a famous man, the fortune-teller asked her to come back for more predictions. She stayed away, which was as well. Had she returned, she might have discovered that her long life would end in a grisly murder, brought about by her own vanity.

Like other foolish, once pretty women, Nina lied about her past and her age. She seems to have been in her early twenties when she became the second wife of the fifty-year-old artist (Kandinsky's first marriage, to a cousin, had ended in amicable divorce) and, as she

whimsically put it, brought spring into the autumn of his life. It was a turbulent time. While the Kandinskys were honeymooning in February 1917, revolution broke out in Russia. It turns out that Nina was two months pregnant when she got married: a boy, Volodya, was born in September 1917, but he died of a virus in 1920. It was only after Nina's death that anybody outside Russia was privy to this fact, according to Vivian Endicott Barnett, the Kandinsky scholar who was the first to publish it.

If we believe Nina's self-aggrandizing memoirs, she was of noble descent, the daughter of a General de Andreevsky. She is also rumored to have been Kandinsky's maid. Whatever her origins, Nina proved to be the perfect wife for an exigent, often moody intellectual who had turned down a professorship of jurisprudence to fulfill himself as a poet, theoretician, and painter of genius. Kandinsky was the least bohemian and most bourgeois of modern masters—contemptuous of the disorder endemic to most artists' studios. "A dirty studio," he once remarked priggishly, "is a sign of bad taste . . . I could paint in a dinner jacket." Kandinsky kept his workroom as neat as a high-tech lab.

Nina had little or no culture, but she took great pains to be a credit to her husband. Always elegantly dressed, she was an exemplary housekeeper and bookkeeper as well as an affectionate and attractive wife. For better or worse, she banished *Sturm und Drang* from Kandinsky's life. Henceforth his work would be more joyful, albeit a touch dry. It could not have been easy for Nina to leave Russia and start life anew in Germany. If the Bauhaus, where the artist went to teach in 1922, was a paradise for teachers and students, it was less so for faculty wives. The Bauhaus women—Lili Klee, Julia Feininger, Tut Schlemmer, Nellie van Doesburg, Lucia Moholy-Nagy—liked Nina well enough, but, as one of them said, she had no real understanding of the modern movement. Kandinsky's decision to squander part of his first Bauhaus paycheck on a pair of black-and-white pearl earrings for Nina must have struck these daunting women as a measure of his indulgence and her frivolity.

Kandinsky proved to be one of the Bauhaus's most effective teachers. Besides being technically inventive, he had a highly orga-

nized mind and a profound knowledge of philosophy, music, and the art of other cultures. Because he was also a great communicator, students revered him. The Kandinskys stayed on at the school until the Nazis shut it down. In 1933 they moved to Paris and set themselves up in a modest apartment on the sixth floor of a new building in Neuilly. Despite Kandinsky's growing fame—particularly in the United States, where Solomon Guggenheim was stockpiling his paintings—the artist's work failed to find favor in chauvinistic Paris. He and his wife were never in want, but they were obliged to live simply, more so than ever when war broke out. Visits to the cinema and occasional concerts were virtually their only treats. It was not until after his death, shortly before the end of World War II, in 1944, that Kandinsky's work began to appreciate in value. Hitherto overshadowed by her husband's genius, demure little Nina now had the means to be a celebrity in her own right.

Unscrupulous dealers have developed all kinds of strategies for the exploitation of artists' widows: women who have often sacrificed happiness, health, security, even sanity on the altar of the husband's art; women who have been too busy ministering to the master—washing his brushes as well as his clothes, acting as muse, model, cook, secretary, agent, driver, even procuress—to have a life of their own. Madame Cézanne is a prime example. After posing for years on end as still as an apple in the same black dress—"All she thinks about," the artist once said, "is Switzerland and lemonade"— the widow was ready for plucking. On being invited to a wily dealer's plush villa in Monte Carlo, she demurred on the grounds that she didn't have the right clothes. No problem: the dealer's wife fixed her up with Worth, the couturier. When Madame Cézanne lost more than she could afford at the casino, the host generously agreed to settle her debts in exchange for some of the "worthless" watercolors stored away in her attic.

Nina Kandinsky was not as gullible as Marie-Hortense Cézanne. She was canny about money and fearful of being ripped off or robbed. Unfortunately, she was also vain and susceptible to men, younger men especially. The sharp and unctuous dealer Aimé Maeght, who had recently transferred his gallery from Cannes to

Paris, soon wormed his way into her confidence. By bartering black-market butter and eggs from his in-laws' dairy business for paintings and drawings from Bonnard, Matisse, and other artists on the Riviera, Maeght had done very well during the war. He did even better when he moved to Paris and signed up Braque and Miró. Once he had his foot inside Nina's door, he encouraged her to splurge—enjoy herself for a change. The more she splurged, the more art she was obliged to sell, and the more Maeght profited. After all those years of hardship, why shouldn't she treat herself to a car and driver and clothes from Balenciaga? Since she was Russian, why shouldn't she play Lady Bountiful, treat her friends to vodka and caviar, and wear a sable coat? And why, above all, shouldn't she indulge her as yet unindulged passion for jewelry? Rubies, sapphires, above all emeralds reminded her of Kandinsky's resplendent sense of color.

By treating Nina as deferentially as the potentates to whom they traditionally cater, Van Cleef & Arpels became her favorite jewelers. They created a number of eye-catching pieces for her. "Van Cleef and Arpels are my family," Nina would declare, and in retrospect it seems as if their jewels, too, became a surrogate for this lonely woman's long-dead son. She was especially fond of the late Pierre Arpels, who saw to it that she always had the pick of the finest emeralds, sapphires, and rubies on the market. Nina liked to participate in the creation of her jewelry; she also liked it "to tell a story." One of the most sumptuous ensembles Van Cleef made for her was a parure—necklace (complete with a pear-shaped diamond pendant of more than twenty carats), bracelet, earrings, and ring—of different-colored diamonds, each one reminiscent of a different-colored drink: Rémy Martin, Dubonnet, Lillet, Chartreuse. Although she was so terrified of being burgled that she dealt with Van Cleef under a coded name, she would go out to restaurants, theaters, and gallery openings sparkling like a chandelier. On planes and trains she would hide her treasures away in a plastic bag. When she built a chalet in the supposedly ultrasafe resort of Gstaad, she unwisely drew attention to her jewelry by naming the house Esmeralda, after her favorite stone.

Heinz Berggruen, the eminent art dealer and collector, who has a chalet in Gstaad, knew Nina well. "Even in her eighties," he says, "she was very coquettish with young men—waiters, anyone who gave her a smile. But I'm sure nothing came of these flirtations. She was a curious mixture of shrewdness and naïveté, of sweetness, silliness, and self-importance. She wanted to call her memoirs *I and Kandinsky* until I told her that *Kandinsky and I* would be more discreet." Berggruen rates Nina as a hard bargainer. Woe betide anyone who fell afoul of her, as Maeght found to his cost (she replaced him with the Swiss dealer Ernst Beyeler). When official recognition and honors were involved, she could be most generous. She loved lunching with President Georges Pompidou at the Élysée Palace and was so proud of her Légion d'Honneur ribbon that she even wore it on her lingerie. If slighted, Nina could be resentful. Knowing this, the organizers of a Kandinsky exhibition in Cologne sent a deputation headed by the mayor to greet her at the airport. "I am most appreciative," she said, "but where is Herr Adenauer?"

Over the years, Pontus Hulten, former director of the Musée National d'Art Moderne (absorbed in 1977 into the Centre Georges Pompidou, better known as Beaubourg), wined and dined Nina so assiduously that she gave his museum fifteen major paintings and fifteen watercolors. In 1979, less than a year before her murder, she deeded the rest of her holdings, including the stash of unframed Klees that she kept under her bed, to the same institution. Appropriately, the signing took place at the apartment of Nina's great friend Claude Pompidou, the President's widow. She even persuaded Madame Pompidou to succeed her as president of the Société Kandinsky, which she had founded for the protection and study of her husband's work. In all, Nina eventually gave the museum 113 oil paintings, 741 watercolors and drawings, numerous works by other artists, and a huge and valuable archive.

As Kandinsky's prices soared in the seventies, so did his widow's expenditure on gems. At one important jewelry sale in Geneva, Nina bought a diamond necklace by Cartier for $930,000. She could not wait to flash it around Gstaad. Vanity, says Berggruen, "would be the old lady's downfall." On September 1, 1980, Klee's

son, Felix, and another Bauhaus relic, eighty-nine-year-old Tut Schlemmer, arrived in Gstaad to dine with Nina. She loved to cook elaborate dinners (caviar, borscht, beef Stroganoff, and a very heavy Russian cake). As usual, lots of food was left over, so she invited everyone to return the following evening at seven. On getting no response to repeated knocks, the worried guests alerted their hotel. The concierge alerted Walter Matti, Gstaad's leading builder, who had put up the chalet Esmeralda and had a key to it. He in turn alerted the police. They found Nina's little corpse on the bathroom floor. She had been strangled.

Since there was no sign of a break-in, Nina presumably knew her murderer. None of the paintings had been touched, but all of the jewelry was taken, some $2 million worth, including the famous diamond necklace. There was one clue: a package of the flower reviver that Swiss florists include with their bouquets. No flowers turned up, but a bouquet would have been just the thing to put the suspicious but flirtatious old lady's mind at ease. Since Nina was rumored to have been seen in the company of a young man a day or two before, and since Gstaad is a very small place, the case should have been easy enough to crack. Trust the Swiss, no perpetrator was ever found.

Friends of Nina suspected that the authorities were dragging their feet: after all, the resort's sacrosanct image was at stake. If some of the richest people in the world choose to winter in Gstaad, it is as much for its famed security and seclusion as for the famed skiing. There had not been a murder in the village in seventy years, and burglaries were very rare. God forbid that a local person be accused of the crime. Sure enough, rumors started to circulate about a mysterious Russian who had been seen skulking around the village— out to get Nina, it was said. If detectives came up with no leads, it was supposedly because their opposite numbers in the USSR would not cooperate. The suspicion that this was a red herring and part of a cover-up was strengthened when the case was officially closed after only eighteen months. In 1986, two youngish men—a German, Peter Michalik, and an Austrian, Otto Turker—went on trial in the canton of Solothurn for the murder of a Swiss police-

man. Although this was the first the public ever heard of it, both had been suspected in the 1980 killing of Nina Kandinsky. The Swiss police, it seems, were less interested in pursuing these men for the murder of a silly, susceptible old woman than in avenging one of their own.

Nina was soon forgotten. At her funeral in Paris a few days after her murder, only fourteen people turned up. Whether she had been eighty-five or eighty-six or eighty-seven, nobody seemed to know. Three years later, on June 16, 1983, her effects were auctioned off at the town hall in Puteaux, a suburb of Paris. A dazzling diamond parure (it sold for $567,000) was on the cover of the catalogue, which listed all the jewelry—some seventy pieces—that she had not taken to Gstaad. The last lot in the sale was the Spartan bedroom suite that Marcel Breuer had designed for the Kandinskys at the Bauhaus. There were also some tawdry Russian knickknacks and battered suitcases stenciled with very large *WK*s. These disparate items might be said to allegorize Nina's long voyage through life, from selflessness to self-indulgence and a callous, cautionary end. As an interviewer for *Die Welt* commented in 1976, so far as the world of modern art was concerned, Nina was "nothing more than a pretty accessory in a white feather boa."

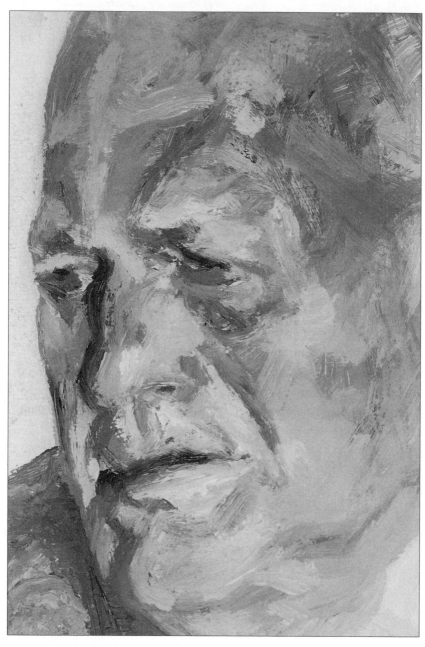

Lucian Freud, *Portrait of John Richardson,* oil on canvas, 1998

Lucian Freud and His Models

I first met Lucian Freud a little over fifty years ago, when we were both art students in wartime England. He reminded me of Dargelos, the charismatic schoolboy whom Cocteau deified for his audacity and insolence and brooding gamin looks. Lucian was already something of a legend for running away to sea at the age of eighteen, also for setting Cedric Morris's art school on fire by smoking in the studio at night. He expressed himself then, as he does now, with devastating candor, in an infinitely subtle, inimitably inflected voice. Contemporaries like myself prized Lucian for his mercurial intelligence, wit, and panache; for the wiliness he had acquired as a child in Berlin, where he was brought up by his architect father (the youngest of Sigmund Freud's three sons); and for having had the initiative, by the age of twenty, to forge a style that was refreshingly original, cunningly tailored to his emergent skills, and not in the least beholden to the giants of the School of Paris. Lucian's oft-quoted claim to have started off with "no natural aptitude for art whatsoever" should not be taken too seriously. It was merely a ploy to counter his mother's boasts about his prowess. The modesty turned out to be the more effective for being false.

As a young man, Lucian seemed acutely self-conscious—shy and a touch exhibitionistic, yet resentful of the attention that this sometimes triggered. One of his haunts was the ornate, 1890-ish bar of London's Café Royal, which was still redolent of the *Yellow Book* ("Scent of Tutti-Frutti-Sen-Sen / And cheroots upon the floor," to quote John Betjeman's poem about the place). I remember watching Lucian across the bar one wartime evening, as thin and sharp-profiled as a cutout, standing on one leg like a stork, his eyes lowered in intense wariness. And I remember someone comparing Lucian to E. M. Forster's description of Cavafy: "A gentleman standing at a slight angle to the universe."

A few years after the war, Lucian married the sculptor Jacob Epstein's daughter, Kitty Garman. Their household was rumored to include a condor with a six-foot wingspan. Untrue. Besides owning a number of sparrow hawks, Lucian had once acquired a large, vicious kestrel. "Either me or it," Kitty said, so he had to take it back on his bicycle to Palmer's, a pet shop reputed to sell snakes by the yard. In his studio there was also a stuffed zebra head that appears in two of his most memorable early paintings. The zebra consoled Lucian for no longer having any horses around; horses had been a passion of his since childhood, and still are. He seems to have shared his grandfather's interest in zoology (the subject of Sigmund Freud's first research was the gonads of an eel), for he proceeded to do drawings of dead monkeys, one of them a gift from the Rimbaudian poet Olivier Larronde, whose addiction to opium involved a certain negligence toward his pets. Lucian's spiky, sharp-focus drawings of birds and beasts were acclaimed, much to his irritation, for their naïveté. "People took an inability for an affectation," he says.

In the late forties and early fifties, Lucian was often to be found in Paris. Sigmund Freud had had the foresight to give one of his grandson's earliest works, a sculpture of a fish, to his favorite pupil, Princess Marie Bonaparte (a great-niece of Napoleon), in the hope that she would become Lucian's patron. In due course, she did. She kept a watchful eye on him, bought some of his drawings, and commissioned him to illustrate one of her books. Like many another

good-looking young man of promise, he was also taken up by Marie-Laure de Noailles—the most munificent and manipulative of Parisian art patrons. Marie-Laure, who prided herself on being the great-granddaughter of the Marquis de Sade, asked Lucian to accompany her on a trip to Vienna. She wanted to have a commemorative plaque placed on Sigmund Freud's house and also to have the great man's grandson meet a descendant of Baron Sacher-Masoch, who gave his name to masochism. *"Du bist Masoch, er ist Freud, und ich bin Sade,"* Marie-Laure announced portentously when the three of them got together. Masoch fled. Lucian drifted off to take a look at the city he had not seen since a visit to his grandfather on the eve of the Anschluss, ten years earlier.

In Paris, Lucian became a friend of Giacometti, Balthus, and Christian Bérard, as well as the young Spanish painter Xavier Vilató, who would often take him to see his uncle, Picasso. Giacometti would become something of a hero to Lucian, and Bérard a model for one of his finest early portraits. Lucian appeared to fit so naturally into postwar avant-garde Left Bank life that some of us wondered whether dismal, philistine London might lose him. But the very dinginess of England turned out to be more conducive to the practice of art. By the mid-1950s, Lucian had settled permanently in the then run-down, bombed-out, boarded-up neighborhood of Paddington. Since then, he has kept mostly to the British Isles. And if in the course of the 1960s English painting—not to speak of the English art world—finally lost the provincial air that had driven progressive artists to seek inspiration abroad, it was largely thanks to Lucian and two other painters, both of them close friends of his: the Irish-born Francis Bacon and the German-born Frank Auerbach. The so-called London School—a concept thought up by the Ohioan painter R. B. Kitaj—proved to be about as English as the School of Paris was French or the New York School American.

London, or, more specifically, Paddington permeates Freud's early painting as deeply as Primrose Hill, a few miles to the north, permeates Auerbach's. Whether or not it manifests itself in Lucian's imagery, the funkiness of the place, as of an unmade bed, and its slightly shabby light seep into much of his earlier work and

Londonize it. But then foreign-born artists—Holbein, Van Dyck, Sickert, to name the most obvious—have often captured the Englishness of the English better than native ones. Apart from Constable and Sickert, British art never impinged on Freud's vision. Nor, surprisingly, did Picasso and Matisse cast much of a shadow on his work. Freud has always been good at protecting his style from contagious influences. Cézanne may have been "the father of us all" to Picasso and Braque but not to Freud (though he has recently based a large painting on the composition of an early Cézanne he happens to own). Degas has been more of a mentor—especially in his later, looser drawings.

Freud's roots are, for the most part, in German art: not, he is adamant, in Expressionist melodrama or the bitter social realism of the Neue Sachlichkeit group, or the windy ebullience of Lovis Corinth, or the spirituality of the Nazarenes (the German equivalent of the Pre-Raphaelites), though some of their work has an inner intensity akin to his. No, the obsessive graphic detail and the brooding quality of his early portraits and figures owe more to Dürer, whose watercolors of small animals, grasses, and wildflowers hung in reproduction on his parents' walls and inspired his own spiky studies of similar subjects. And the life-size paintings of very naked men and women that are a recurrent feature of his later work can be seen to descend from Dürer's *Adam and Eve*. Freud also has a great love for Ingres—for the rigor of his discipline, the intensity of his observation, and the elegance with which he imparts a mass of detailed information. To judge by the massive back view of Leigh Bowery that the Metropolitan Museum acquired, Freud is still beholden to this artist. Yet another mentor is Rodin. The full-length naked *Balzac* used to stand guard outside Freud's studio, and the more flagrantly naked bronze *Iris, Messenger of the Gods*—the headless torso with the splayed-apart legs—used to welcome visitors to his house.

Why Rodin? One has only to look at Freud's recent figures, seemingly sculpted out of paint, to realize that he, too, is intent on rendering the tensions concealed in the model's psyche as much as those at work beneath the skin. Freud says that he finds the *Balzac*

"exciting" in that it embodies the writer's spirit and prodigious creative energy as well as his physicality. Freud has also looked long and hard at Velázquez, Rembrandt, Hals, Daumier, Géricault, and Courbet. However, as he says, "My method is so arduous that there has never been much room for outside influence."

———

It is difficult to write about Freud without referring to Francis Bacon. Before their friendship wore thin and came to grief, some twenty years ago, the two painters were very close, as their exceedingly perceptive portraits of each other confirm. Though thirteen years younger, Freud was one of Bacon's earliest supporters; he acquired, or was given, a number of Bacon's paintings (including the great *Two Figures on a Bed,* familiarly known as "The Buggers") and nudged him into the limelight by finding him a gallery. Bacon, for his part, helped to transform Freud from someone who thought primarily in terms of drawing to someone who thought primarily in terms of painting. "He talked a great deal about packing a lot of things into one single brushstroke, which amused and excited me, and I realized it was a million miles away from anything I could ever do," Freud has said. No longer. Nowadays Freud's brushstrokes are packed with more information and sensation than most of Bacon's.

At the height of their friendship, in the 1950s and '60s, Freud and Bacon were as inseparable as Picasso and Braque in the years before 1914. Although the two were as different from each other in formation and temperament, not to mention sexual orientation, as they were in artistic style, they shared certain characteristics: Baudelairean dandyism (in intellect and manner as well as clothes); a quirkish and mordant wit; a keen ear for fine writing and an incisive but irreverent eye for fine painting; a rejection of middle-class values in favor of very low and, on occasion, very high life; and, not least, a passion for big-time gambling. Bacon, a former croupier, who saw each brushstroke as a gamble, played roulette to win. "Francis was beautiful to watch in a casino," Freud says. "He would dash from table to table laying out stacks of chips in complicated permutations." Freud, no gambler when it came to painting, played

the horses obsessively, not exactly to lose but for the aristocratic pleasure of—here he chooses his words carefully—"purging myself of superfluous cash by losing as much money as I can get hold of."

Why did their friendship peter out? "For years, Francis seldom did any bad paintings, and for years I was always telling him how good they were," Freud explains. "As his inspiration began to fail him, Francis's rigid belief in his own supremacy as an artist left me feeling unconvinced. What had been the subject matter of his pictures became paraphernalia. Things were included in a painting because they had been in the previous one. With the urgency gone, some elements just seemed to be in the way, like bits of gauze left inside a patient's stomach by a forgetful surgeon." For instance, those pointless arrows and patches of trompe-l'oeil newsprint, which Bacon repeatedly used to camouflage inert areas; and those aleatory gobs of paint on which the artist had once gambled the fate of canvas after canvas.

As for Bacon, he denounced Freud for being too "careful." Although this was not intended as a compliment, it should, I think, be seen as one. Diligence, sensibility, and iron control—some might add an ironclad ego—are at the root of Freud's mastery. It is this combination that has enabled the tortoise to end up way ahead of the hares who wrote him off thirty years ago. Freud remembers the seminal Pop painter Richard Hamilton in the mid-sixties dismissing "my work as pointless and suggesting I give it up." Freud's recent paintings return, as it were, the compliment. If he had not always chosen the long, cautious, courageous haul over tempting Baconian shortcuts, he would never have arrived at the great late period that every artist dreams of.

Eyesight plays a small but important role in this autumnal flowering. Freud, who uses glasses to read but never to paint, admits having a "lazy" left eye, for which his left-handedness helps to compensate. Like many people over the age of sixty, he probably suffers mildly from presbyopia, an inability to focus sharply on nearby objects. For an aging painter of tremendous scope and technique—one thinks of Titian, Rembrandt, and Cézanne—this refractive failing can be a blessing in disguise. Presbyopia is at least partly re-

sponsible for the pervasive breadth of handling and richness of *matière* and the presentation of pictorial information on a sumptuous rhetorical scale that are such distinctive features of Freud's late work.

Freud is not much given to talking about his famous grandfather, who died when he was sixteen. He claims to be ignorant of psychoanalysis and deems it "unsuited to the life span." He prefers to discuss the old man's humor and generosity and conspiratorial side. This last is a trait that Lucian seems to have inherited, though not to the extent of convening a secret committee, as Sigmund Freud permitted his disciple and biographer, Ernest Jones, to do in 1912, with the sole purpose of shielding him and his work from prying outsiders. These days, Freud could do with such a shield. The fact that so many of his recent paintings depict the women in his life—friends, daughters, mistresses—without any clothes on has generated much prurient curiosity about his personal life. Since he is very defensive about his privacy—"It matters enormously to me whom I see and whom I don't see," he says—he is at pains to control journalistic access to his studio and also to his family and friends. (Almost no one knows his ever-changing telephone numbers or his home address; those who wish to reach him must go through his lawyer.) Unfortunately, the cordon sanitaire with which he tries to protect himself has at times proved self-defeating. Stymied by the artist's loyal coterie and in quest of a story, more than one journalist has turned to disgruntled figures from the distant past—"pilfering roommates and ex-girlfriends paying off old scores," he says. The resultant fabrications might conceivably have succeeded in demonizing the artist (Lucifer Freud!) and his work if they hadn't been so wide of the mark. A misogynist? When feminists try to pin this label on Sigmund Freud's grandson, he goes on the attack. "The idea of misogyny is a stimulant to feminists," he says. "It's rather like anti-Semites looking for Jewish noses everywhere."

Susceptible critics have likened Freud's nudes to victims of train wrecks, terror, or rape, and have called the painter a misogynist for portraying them that way. He is unfazed by this reaction. To the extent that many of the women in his paintings are literally—indeed,

blatantly—*à poil,* they are at our mercy, but they have not been eroticized or otherwise degraded; even the ones lying side by side are minding their own business, not each other's. To whom do they relate? The artist, of course.

Freud acknowledges that posing is arduous and that "painting a nude deepens the transaction," and he explains, "that is why I do my best to see that my models are having a good time, lying in positions that come naturally to them, essentially being themselves. I want my models to look as un-set-up as possible." As for painting his daughters in the buff, Freud is amazed at all the fuss. "What could be more natural? I paint only people who are close to me. And who closer than my children? If I had thought it odd to paint them, I would never have done so. For me, painting people naked, regardless of whether they are lovers, children, or friends, is never an erotic situation. The sitter and I are involved in making a painting, not love. These are things that people who are not painters fail to understand. Besides, there is something about a person being naked before me that invokes consideration—you could even call it chivalry—on my part: in the case of my children, a father's consideration as well as a painter's."

Freud is particularly outraged by accusations that his well-known painting *Large Interior: Paddington* (1968–69)—of his eight- or nine-year-old daughter, Isobel, lying on the floor of his studio under a large potted plant—reeks of guilt and terror and sexual anxiety. Some critics have even suggested that the child looks as though she had been raped. These pernicious attacks, which first arose when the painting was exhibited at the Hirshhorn Museum in Washington, in 1987, resurfaced at the time of his Metropolitan Museum show in 1995. Freud points out that Isobel is posed in the fetal position—a customary position for a child who is asleep or, as here, at rest. True, she looks a bit pensive, but that is no reason to invoke angst and guilt and terror.

"Of course I hope people will be strongly affected by my pictures," Freud says. "But the way they affect people has more to do with the beholder than the painter. I remember reading about someone who was frightened to death by looking at an egg." Signif-

icantly, Freud's most fierce and remorseless images are of himself.
His devastating naked self-portrait reminds me of nothing so much
as Delacroix's demonic image of Paganini. The English poet Thom
Gunn's terse little poem about this painting includes the following
lines:

> *Vulnerable because*
> *naked because*
> *his own model.*
>
> *Muscled and veined, not*
> *a bad old body*
> *for an old man . . .*
> *you observe the down-*
> *turned mouth: and*
> *above it,*
> *the assessing glare*
> *which might be read as*
> *I've got the goods on you*
> *asshole and I'll expose you.*

Freud has been no less senselessly criticized for making his sit-
ters look old. He suspects that this impression stems from his desire
to give maximum variety of expression and mood to the people in
his portraits. "If they look old, it's probably because I allow for mo-
bility and other eventualities." He adds that biology plays a role in
his work: "It comes from my fascination with watching animals,
from having worked with horses as a boy. I like people to look as
natural and as physically at ease as animals, as my whippet." Not
that Freud has any intention of bestializing people, as Picasso often
did. Biological and psychological truth is his objective, not meta-
morphic manipulation. A sitter's feelings and reveries are as much
the subject of his figure paintings as is the structure of a face or
body. He simply wants to tell as much of the truth about them as he
possibly can. "Aesthetic and biological truth-telling is what my
painting is all about," Freud says. This "truth-telling" process can

leave the model feeling very vulnerable. Freud sets such store by vulnerability that he obliged one of the women who poses for him to strip, even when he was painting only her head and shoulders.

"Vulnerable! Of course a model—above all, a naked model—is going to feel vulnerable," Freud says. "The fact that a model would never find himself or herself in this particular situation were it not at the painter's behest makes for vulnerability. So does being scrutinized by me for weeks at a time—some paintings require as many as eighty hours of posing. Vulnerability would not be an issue if I used professional models. But I don't, because professional models have been stared at so much that they have grown another skin. When they take their clothes off, they are not naked; their skin has become another garment."

The principal subject of Freud's large paintings of the early 1990s was his mammoth (six foot two and overweight) Australian model, Leigh Bowery. A fixture in the artist's studio from 1990 until the model's death from AIDS in 1995, Bowery had been born into the Salvation Army, where both his parents were soldiers. Bowery was homosexual—like several of Freud's other male models. "I am drawn to them because I respect their courage," Freud says. However, I cannot help feeling that vulnerability is also a large part of their appeal for him. "An unusually big heifer carting around sixteen or seventeen stone" is how Bowery described himself. By profession, he was a performance artist—an exhibitionistic dancer who transformed himself into weird pieces of human sculpture. Sometimes Bowery performed naked, but more often he squeezed his considerable bulk into fantastically inventive costumes that he designed and mostly made himself: works of art in their own right, which carried transvestite kink to new heights—some might say depths—of surreal subversion.

For an appearance at the Wigstock drag festival in downtown New York one Labor Day, Bowery came onstage in a foam mask and a preposterous *tailleur* of puce and violet checks—the sort of thing Dame Edna might wear. When he had finished singing, he lay back on a table and went into labor. From his skirt emerged a squirming pink caul. It contained a very thin, very naked girl—Bowery's part-

ner, Nicola Bateman—covered with fake blood and attached to him by a plastic umbilical cord.

These two, the man-mountain and the sliver of a girl, were the subjects of what is to my mind Freud's masterpiece, *And the Bridegroom*. Bowery and Nicola lie naked on a bed, turning away from each other ambivalently in what could be taken—or more likely mistaken—for postcoital repose. Compared with the other large paintings in which Bowery figures, this one seems actually lyrical—less genitally obtrusive, and leavened by the presence of the girl. The figures are smaller—not so much in our face as Freud's figures usually are—and are suspended in a vast, light-filled space. The title has been taken from A. E. Housman's *A Shropshire Lad*. It enhances rather than elucidates the painting's mystery:

> *Lovers lying two and two*
> *Ask not whom they sleep beside,*
> *And the bridegroom all night through*
> *Never turns him to the bride.*

"Leigh's wonderfully buoyant bulk was an instrument I felt I could use in my painting," Freud says. "Especially those extraordinary dancer's legs. After seeing him perform, I asked him to pose. When he stripped for me, I told him to leave the nipple rings in if he felt too naked without them, but out they came, and they never reappeared." The only trace in the paintings of the performance artist is a pair of barely visible plugs in Bowery's dimples, which prevented the holes drilled in his cheeks (to take safety pins and other punkish embellishments) from healing over. And then, as the paintings reveal, his appearances as a performance artist obliged him to keep his head and entire body shaved, to facilitate "body modifications." Freud approved of the shaving: it enhanced this huge man's sculptural look as well as his vulnerability.

"I thought of Leigh's chubbiness as generosity rather than bulk," Freud says. "He was a remarkable model, because he was so intelligent, instinctive, and inventive, also amazingly perverse and abandoned. Because he was a performer, he instinctively knew how to

edit himself, instinctively knew what I wanted to see." And indeed Bowery became so adept at tailoring his exhibitionism to Freud's painterly needs that the artist's life-size, bare-ass images of him have a far more profound, more existential impact than the man himself ever achieved in full fig onstage.

Through Leigh Bowery, Freud met this model's female counter-part—in bulk, that is—Sue Tilley, familiarly known as Big Sue. She worked at the Islington Labour Exchange by day and posed for Freud by night. After finishing *And the Bridegroom,* he embarked on an only slightly less monumental painting called *Evening in the Studio,* in which he contrasts Big Sue's bean-bag breasts and buttocks with his whippet, Pluto, and his whippet-thin model, Nicola. This outrageous composition draws equally upon the ridiculous and the sublime. The cartoonish side derives from the wonderfully vulgar Donald McGill, who was famous for his raunchy postcards of fat women with wimpy little husbands, which are still sold on the promenades of Britain's less posh seaside places. The postcard that inspired this painting depicts a whale of a woman in a bathing suit about to be swamped by the incoming sea: "Move over, Bessie, and let the tide come in," a lifeguard tells her.

At the same time, *Evening in the Studio* also plays tribute to Velázquez. Freud admits that Velázquez plays a role in his recent paintings. I detect his presence in the light that animates every square inch of the picture surface; in the intense inner life with which each figure is endowed; in the variety and beauty of the texture; in the discretion with which Freud manipulates drama and mystery; and in the color that looks so right, so natural, that at first it draws no attention to itself.

Freud would have us believe that his *Evening in the Studio* depicts exactly that. But like all the most memorable studio paintings—Rembrandt, Courbet, Picasso, and Braque come immediately to mind—it is as much about painting as it is about human relationships or conditions, and perhaps more so. Isn't the potential of paint to *become* flesh and not merely to simulate it what all Freud's late works celebrate? Hence their amazing palpability. Transubstantiation through art.

Since the death of Leigh Bowery and the departure of Big Sue—
to write a funny yet touching biography of Leigh, *The Life and Times
of an Icon*—Freud has reverted to using more conventional-looking
models; and I must confess to a certain relief that he is no longer in
danger of being misinterpreted in the light of a performance artist's
exhibitionism. Freud, too, must be relieved to receive no more let-
ters from people lacking limbs, ears, and, in one case, an eyebrow
proposing themselves as models. "I'm not interested in cripples or
freaks," he told the British critic William Feaver. "I paint people not
because of what they are like, not exactly in spite of what they are
like, but how they happen to be . . . I don't want to have a type any
more than I want to have habits. If I wanted to do the circus, I'd ap-
proach it differently."

Freud's new models are peculiar only insofar as they are peculiar
to him. True, some are a bit on the fat or the thin side, but they usu-
ally turn out to be his children or other members of his extended
family, or old friends, or ordinary-looking people in whom he de-
tects some special sensibility or singularity. In the last few years
Freud's attitude to his subjects has subtly changed. There is less em-
phasis on outer oddity, more delving into inner sanctums. He also
shows them more mercy than he did in the past—Colette's attribu-
tion of artistic insight to "the titillating shock of hurting" no longer
comes to mind—but this does not imply any loss of his customary
intensity or acerbity. Quite the contrary. Take, for instance, *Aline,*
the small, poignant painting of one of his friends, whose husband—
wisest and most eloquent of British thinkers—had died before the
artist had been able to finish a portrait of him. The restraint with
which Freud hints at the complexity of this reticent sitter's interior
life is a feat that no other painter of our time could equal, let alone
surpass.

One of the largest and most intriguing of the new paintings is en-
titled *Large Interior—Notting Hill.* The interior is in fact the second
floor of the artist's house, and it is composed in such a way that you
feel the artist is behind the canvas pushing everything (including, in
this case, the traffic outside the window) down and out at you. The
back of the room is suffused with light that bounces off the white-

ness of the bed onto a naked young man (Freud's assistant, the gifted painter David Dawson) who disconcertingly nurses a baby. Shooting out toward you in the foreground is a wonderfully shabby red leather sofa. On it sits that most perceptive and least prolific of British authors, Francis Wyndham, reading Flaubert's letters. At his feet lies Pluto, the artist's oddly named whippet bitch. The element of alienation came about by chance. Jerry Hall, whom Freud had painted during her pregnancy (a small study entitled *Eight Months Gone*), was originally portrayed suckling her newborn son at the back of the room. Unfortunately, she was unable to continue posing; Freud was obliged to leave David holding the baby.

David stars in yet another recent painting, the no less disconcerting *Eight Legs*. His skinny body is set off against the even skinnier Pluto, whom he holds in his arms, her four legs splayed out toward us in an almost identical pose. Despite the Géricault-like intensity of the central group, Freud felt that it needed something incongruous in the foreground, a "hello-what's-this?" element, in order to finish it. After rejecting the logical solution of a pile of clothes or a pair of shoes, he decided that the missing element should be organic. One night he called me in New York, very excited, to say that he had found the solution—something he had tried once before. He was going to have a pair of legs protruding from under the bed. The contrivance works brilliantly.

Asked whether the disembodied legs are anecdotal or symbolic, Freud says that the idea of a story does not bother him because everything is a story. But the idea of symbolism or mystification does. He goes on to castigate Andy Warhol's boast that there was never anything behind his (Warhol's) imagery. "I want there to be everything behind mine," Freud says. "The reason I used David's legs rather than somebody else's was precisely because I didn't want mystification. I thought, by using his legs, it would be rather like a hiccup or a stutter or a nervous repetition and therefore the legs would refer back to David."

Having sat for both Freud and Warhol, I can vouch for the disparity in their methods. When Warhol "painted" my portrait, all he did was aim his huge Polaroid at me and take a few photographs.

One of these was the basis for three large portraits that resemble me as much—and as little—as the image on a movie poster resembles the star. With Warhol, what one sees is what one gets: an advertisement for oneself—a passport to fifteen minutes of factitious fame.

Freud never works from photographs—"useless as sources of information," he says. The information that he requires can be obtained only from meticulous observation of his model. Memory, too, plays a very important role in his work. He sometimes does drawings of sitters, but these seldom relate to the finished portrait. Freud likewise disdains the traditional portraitist's method of squaring up a preliminary sketch for subsequent magnification on canvas—"too mechanical," he says, "like an architect with a plan." He always has to have his model in front of him.

Although he has been married twice and is the father of several children—among them Bella, the designer, and Esther, the novelist—Freud lives alone, monastically but comfortably, and devotes virtually all his time and energy to work. Since he seldom quits his studio before midnight, he has very little social life, but he stays in close touch with a few old friends. He has their telephone numbers; they do not have his. From time to time he will cook a brace of grouse or partridge for them. He does so to perfection.

Freud's paint-encrusted studio is a clutter of easels, stacks of canvases, mountains of paint rags, and that recurrent prop: an iron bedstead. The studio sits at the top of a house at the top of Holland Park, a quiet residential area to the west of Notting Hill Gate. Light streams through a skylight onto the artist's model of the moment. Most of Freud's paintings, above all the very large ones, are executed here; and since they require countless sittings, each work necessitates a schedule as rigorous and sacrosanct as a surgeon's. As a rule Freud has five or more sitters on the go. Therefore, daytime and nighttime posing sessions have to be planned weeks ahead. Woe betide the model who cancels.

Freud also owns an elegant, early-eighteenth-century town house, where he mostly lives and sometimes works in yet another studio. At the back there is a garden steeply shut in with creeper-covered walls. When he accidentally locked himself out one New

Year's Eve, he very nearly froze to death before he was able to climb out. It was in this hideaway of a house in the fall of 1998 that Freud, in a race against the first frosts, executed his amazing portrait of a buddleia bush. A year later, it was my turn to pose there for a portrait.

There had been talk of Freud drawing me over half a century earlier, when we were both in our early twenties. Nothing ever came of the project, because I went off to live in France and later the United States. Then, on a visit to London, a few years ago, I was once again asked to sit for him. Much as I wanted to, I hesitated. I was seldom in London for more than a week or so, and Freud usually requires several months for a portrait. "Of course I *could* do a drawing or a very small painting," he said, "if you came every morning for ten days or so." I told him I could manage that—for a painting. On my next trip to London I would arrive at the artist's house at eight A.M., have some breakfast, and then pose until lunchtime. I did this for nine consecutive days—forty-five hours of sustained pleasure.

Although the canvas for my portrait was the smallest he had ever painted, Freud decided to use largish brushes. Had he used smaller ones, he said, the portrait would have ended up looking like a miniature—the last thing he wanted. Largish brushes made his task harder, but the roughness and richness of the paint give the six-by-four-inch head a monumental air and great palpability. As Freud applied the last brushstroke, a cab arrived to take me to the airport for my flight back to New York.

Sitting for Freud was a riveting experience. Despite a reputation for being exigent—a tightly coiled spring—he is remarkably considerate toward his sitters. He wants them to relax and open up to him. And since he is something of a wizard, sitters find themselves doing exactly that: confiding their secrets and fears to him. Freud talks enough to keep his subjects animated without losing any of his bird-of-prey concentration. What he says is always surprisingly put, as if italicized.

Like Picasso, Freud prides himself on his almost total recall. He likes to take random dips into his and his sitters' memories. Morn-

ings flew by as we discussed mutual likes and dislikes, above all, painters good and bad—not least Francis Bacon. And we reminisced about such cherished black sheep as Mrs. Edomy Johnson, known as "Sod," a wonder woman who emerged from nowhere in the middle of the London Blitz. From a vantage point in the bombproof basement bar of the Ritz, Sod set about putting lonely people—soldiers and sailors and predatory civilians—in touch with one another before going off to sleep on the top of an all-night bus. When I got carried away and talked too much, Freud would peer hard at my about-to-open mouth and courteously, wordlessly, impose silence.

The artist's memory for poetry—English, German, and French—and song lyrics of the thirties and forties amazed me. One morning he would recite Yeats and A. E. Housman. Another time he would launch into Morgenstern, followed up with renditions of Nat King Cole's "There's Gotta Be Some Changes Made." And on one especially memorable day, he recalled whole sections of Rudyard Kipling's "The 'Mary Gloster,' " a gritty set piece in which a tough old shipowner, on his deathbed, reviles his wimpy son. I still cannot get it out of my mind.

> I've paid for your sickest fancies; I've humored your crackedest whim—
> Dick, it's your daddy, dying; you've got to listen to him!
> Good for a fortnight, am I? The doctor told you? He lied.
> I shall go under by morning, and—Put that nurse outside.
> Never seen death yet, Dickie? Well, now is your time to learn . . .

And so on for some two hundred lines.

Freud does not diagnose or analyze; he scrutinizes and specifies. In this respect he resembles his famous grandfather—not, however, the psychoanalyst but the zoologist, which is how the great man's career began. As my portrait proceeded, I was fascinated to watch an inner as well as an outer likeness slowly emerge from Freud's chrysalis of paint. And then, finally, on the ninth day, I was confronted with the real me—apprehensive, not to say fearful—which I usually try to conceal under a mask of confidence and geniality. I

cannot praise the painting too highly. People close to me confirm the accuracy of the artist's insights. It helped, Freud said, that he had known a cousin of mine, Maurice Richardson, an idiosyncratic journalist whose fields of expertise were murder, boxing, and snakes, and who used to hang out, like Freud and Bacon, at Muriel Belcher's sleazy, addictive Colony Room.

The fact that Freud could finish a portrait, albeit a small one, in much less than three months was a revelation to him, so much so that the suggestion that he might paint a portrait of the Queen—something that had been mooted some years earlier and then ruled out by lack of time for sittings—came back into focus. Surprising? Not really. The Queen has decorated Freud with the two highest civil orders in her gift: the Companion of Honor and the Order of Merit. Hence his rapport with the Queen's former secretary Lord Fellowes; hence also the small, fine portrait of him that captures to perfection the integrity and intelligence of a cultivated English gentleman—a type that serious painters have long since ceased to commemorate.

Freud is one of the very few people outside of the staff to have access to London's National Gallery at all hours of the day or night. When the enlightened director, Neil MacGregor, accorded him (and a few other artists) this privilege, he asked Freud whether there was anything specific he wanted to study. To copy the gallery's Chardin of a nursemaid and child, he replied. And so, late at night, when he has finished working in his studio, Freud makes his way to the National Gallery, where an easel and spotlights have been set up in front of this miraculous painting. Once when I was in London, Freud asked me and a friend to accompany him on one of these nocturnal visits.

Outside the National Gallery, Freud's assistant waited in his car. Like Times Square, Trafalgar Square attracts a rowdy nighttime crowd, some of whom had mistaken David's small red, illegally parked car for a minicab. That night, before retrieving Freud's etching equipment from the car, he had to fend off a posse of drunken Australians. The turmoil outside made the calm and quiet and emptiness inside the darkened galleries all the more sacrosanct.

Why Chardin? I asked. Freud gave much the same answer that Matisse had given a journalist eighty-eight years earlier. "Whose work do I study the most? Chardin's," Matisse said. "I go to [the Louvre] to study his technique." Freud was a bit more forthcoming. "I don't want to copy the Chardin," he told me, "I simply want to get as near to it as I can. It's a labor of love." Love, I would imagine, for Chardin's paint surfaces, which are so rich and dense, yet so precise and delicate—never meretricious like those of so many *dix-huitième* artists. Love, too, for Chardin's genius at distilling the sublime from the ordinary. We left Freud hard at work. As we returned through the hallowed dimness of the old-master-filled galleries, I looked back at Freud's hunched figure silhouetted in a pool of light. Although supposedly dead, painting seemed very much alive.

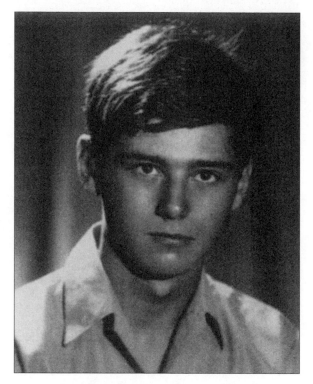

Pablito Picasso in early adolescence, c. 1963

In Memory of Pablito Picasso

If Marina Picasso has sold off more of her holdings of her grand-father's work than any of the other heirs, it has been for the best of reasons. She has several hundred children to support and the memory of her beloved elder brother, Pablito, who committed sui-cide in 1973, to perpetuate. The story of how all this came about is as disturbing as it is heartening.

Marina and Pablito were the children of Picasso's only legitimate son, Paulo, and Paulo's first wife, Émilienne Lotte. As she recounts in her touching book, *Les Enfants du bout du monde,* Marina and Pablito had a nightmarish childhood at the hands of their irrespon-sible parents: a mother who was violent and vindictive; a father who was nice enough but irreparably damaged by his parents' marital mayhem.

Paulo had been overprotected by the neurotic Russian mother, a former ballet dancer, he came to loathe, and repeatedly rejected by the all-powerful father he resented yet revered. As a young man, he had aspired to be a racing bicyclist or motorist, but ended up an al-coholic, chauffeur to *"le père,"* as he always called Picasso. *"Le père"*

had no patience with Paulo's alcoholism, even less with his insistence on marrying the unsuitable and unstable Émilienne. When the marriage turned out to be even more of a disaster than anyone had predicted—it ended in less than three years—Émilienne and her children received minimal monetary support. All Picasso paid for was Marina's and Pablito's tuition at a private school, which was inconveniently far from where they lived. Marina says that the money would have been better spent on food. Since they bore the Picasso name, nobody believed they were penniless. Why were they penniless? Their father was too terrified of *his* father to plead their case. By the time Pablito and Marina were twelve and thirteen, family history was repeating itself. Just as Paulo had fallen from favor by virtue of being the hated Olga's son, and just as his half brother and sister, Claude and Paloma, had suffered a similar fate by virtue of being Françoise Gilot's children, Marina and Pablito would now have to atone for *their* mother's shortcomings. Like their uncle Claude and their aunt Paloma, they would be banished for good from their grandfather's presence. Marina holds the artist's second wife, Jacqueline, responsible for this ukase.

In 1955, Olga Picasso, from whom the artist was separated but never divorced, died. Under French law her only son, Paulo, was entitled to his mother's half-share of her husband's estate. However, for fear of upsetting his father, he never asserted his rights, and so the plight of his children remained as dire as ever. In 1962, Paulo would get married again, to the charming and attractive Christine Pauplin, who had already given birth to their son, Bernard. Picasso's preference for Christine and her baby meant that Pablito, who was thirteen, and Marina, who was twelve, had less access than ever to their grandfather. Pablito, who was extremely sensitive, took this neglect to heart. As he grew up, he became morose, avoided his friends, and vanished for days at a time. In despair at Picasso's continued rejection of him, he drew attention to his plight by spending the night in a sleeping bag outside Notre Dame de Vie, the artist's house at Mougins.

On a later occasion, in August 1972, Pablito broke into Notre Dame de Vie, carrying a banner declaring his intention of remain-

ing there until his grandfather agreed to see him. Jacqueline apparently set the dogs on him and called the police, who threw his *motocyclette* into a ditch. When I asked Jacqueline why she had not allowed Pablito into the house, she said that he was "crazy" and that she could not allow anyone so disturbed to distract Picasso from his work. Meanwhile, Pablito's sister, Marina, had also been rebuffed. She aspired to be a doctor and had applied, through Jacqueline's lawyers, for funds that would enable her to attend medical school. Inevitably, she was turned down, which added to her brother's chagrin. Instead of studying medicine, Marina decided to look after handicapped children—a decision that would change the course of her life.

The day after Picasso died (April 9, 1973), Pablito returned once again to Notre Dame de Vie in the hope of paying his last respects to his grandfather. Once again he was ejected. Even more harrowing, his father, now head of the family, went along with Jacqueline's insistence that neither Marina nor any other of the artist's children and grandchildren be allowed to attend his funeral at another of his properties, the Château de Vauvenargues. They had to watch the ceremony from a distant vantage point. These successive rejections broke what was left of Pablito's spirit. The day after the funeral, he swallowed a bottle of bleach, which burned away his intestines. Marina describes finding her brother hemorrhaging on the kitchen floor. Pablito took three excruciating months to die. His father, who was also in very poor health, never came to see him, never provided any financial help. The only member of Picasso's entourage to raise a finger was the artist's former mistress Marie-Thérèse Walter, who had taken pity on Émilienne. Although Marie-Thérèse's means were limited, she set about selling some of the drawings Picasso had given her in the hope of saving Pablito, but it was too late. Marina claims that the parents of one of Pablito's school friends paid for his coffin, but her half brother Bernard has assured me that their father did. Marina felt too resentful ever to see her father again. He died of liver cancer two years later—too soon to benefit from his prodigious inheritance.

Paulo's death meant that Marina became one of six heirs to Pi-

casso's estate. Since she had not as yet received any money, her uncle Claude, who had assumed control of the family's affairs, paid her fare to Paris so that she could attend the lawyers' meetings. The Picasso estate took seven years to settle. In 1990, Marina and Bernard wound up sharing five eighths of what was left, after the French state had taken its share for the future Musée Picasso in lieu of inheritance taxes, and Jacqueline had taken her quarter share as a widow. Because they were the legitimate children of Picasso's one legitimate son, Marina's and Bernard's shares were more than double what the three illegitimate children, Claude, Paloma, and Maya, would each receive after taking legal steps to have themselves recognized.

Before the actual share-out took place, each of the beneficiaries was allowed to pick out specific works of personal or sentimental value. In addition, Marina won the right to have further control over her selection. Picasso's enormous accumulation of paintings, drawings, sculptures, prints, and ceramics was then divided into a great many separate "parcels," varying in size but equivalent in value, for which the heirs proceeded to draw lots. Realizing that she knew little about the value of her grandfather's work, Marina had the good sense to seek expert advice. Jan Krugier, the Geneva dealer who had helped Marie-Thérèse Walter when she came to Pablito's rescue, was the obvious choice. Krugier not only masterminded Marina's selection; he has continued to act as her agent and has also arranged for portions of her vast and varied collection to tour the world. As Marina says, "Despite the resentment I felt for my grandfather, I owe this to his memory." And for students of modern art in cities that have never seen a Picasso retrospective, these traveling exhibitions have been a revelation.

—

It has taken Marina many years—"years of darkness," she says—to exorcise the pain of Pablito's suicide. At first she could not bear even to see the treasures she had inherited, let alone hang any of them on her walls. Everything remained in storage in Paris. But after moving to Switzerland to escape an abusive relationship with the father of her two children, Marina underwent prolonged analy-

sis and managed to put her life together again. She came to accept her inheritance as a force for good rather than "a burden." She also decided to adopt a child, but her efforts met with no success. After failing to obtain a Thai baby, she was directed to an orphanage in Ho Chi Minh City, Vietnam.

War had left the orphanage overcrowded, underfunded, and very dilapidated. Malnutrition was rife. Marina was so moved by the plight of the children she found there that she decided to take action. Here was a cause worthy of Pablito's memory. Vietnamese officials were very cooperative. Within three months Marina signed the protocols and made the necessary arrangements, and little more than a year later (June 1991) she was able to inaugurate Le Village de la Jeunesse de Thu Duc, a self-sufficient village big enough to house 365 children. She went on to build clinics, schools, vacation homes, and facilities for training the children after they were obliged to leave her orphanage at the age of fifteen. In 1995, she embarked on yet another project: an agricultural settlement at Kontum, five hundred miles to the north, for children whose parents are lepers and therefore not allowed to raise them. Marina is also starting up centers that will provide care and shelter to some of the 25,000 orphaned or abandoned children who roam the streets of Ho Chi Minh City.

To support these ambitious schemes, Marina has been obliged to liquidate part of her collection. On her behalf Krugier puts small groups of Picassos on the market every year. However, she has retained any works that pertain to her own circumstances or interests. On occasion she has even bought back drawings or paintings that have a special significance to her. Besides works of art, Marina's inheritance included the grandiose villa Le Californie, back of Cannes, which her grandfather had acquired in 1953. She has done the house over from attics to cellars and lives there happily with her five children, three of whom she adopted in Vietnam. A magnificent portrait of her grandmother Olga—the one family member she loved, not least because she, too, had a raw deal from the artist—has pride of place in the living room that was once Picasso's studio. Marina has finally been able to exorcise her demons.

INDEX

Earlier versions of the essays that appear in this work have been previously published as follows: "Vita's Muddles," *The New York Review of Books*, November 1973; "From James to Jan," *The New York Review of Books*, May 1974; "The Sitwells," *The New York Review of Books*, April 1979; "Peggy Guggenheim's Bed," *The New York Review of Books*, November 1979; "Judy Chicago's Giant Shriek," *The New York Review of Books*, April 1981; "Mario Praz's Good Eye," *House & Garden*, January 1983; "The Sad Case of Mr. Taste," *House & Garden*, May 1983; "Sibyl Colefax, Lion Hunter," *House & Garden*, September 1983; "Beaton and Garbo," *Vanity Fair*, August 1986; "The Stettheimer Dollhouse," *Vanity Fair*, December 1986; "Klee's Inheritance," *Vanity Fair*, February 1987; "The Madness of Scofield Thayer," *House & Garden*, February 1987; "Picasso's Other Mother," *House & Garden*, April 1987; "Warhol at Home," *Vanity Fair*, July 1987; "À Côté Capote," *The New York Review of Books*, December 1987; "Carlos de Beistegui, the Miserly Magnifico," *House & Garden*, October 1990; "Hammer Nailed," *Vanity Fair*, March 1991; "Beastly Dr. Barnes," *Vanity Fair*, August 1991; "Miró, The Reluctant Surrealist," *Vanity Fair*, September 1993; "Lucian Freud and His Models," *The New Yorker*, December 1993 and *Vanity Fair*, May 2000; "Nina Kandinsky's Deadly Diamonds," *Vanity Fair*, February 1995; "Anthony Hopkins's Stab at Picasso," *The New York Review of Books*, October 1996; "Braque's Late Greatness," *The New York Review of Books*, March 1997; "Bonnard's Amphibious Wife," *Vanity Fair*, May 1998; "In Memory of Pablito Picasso," *Picasso on Paper*, catalogue, Gerald Peters Gallery, Santa Fe, New Mexico, August 1998; "Dalí's Gala," *Vanity Fair*, February 1999; "Brice Marden's Hidden Assets," *Vanity Fair*, March 1999; and "Killer Collector," *Vanity Fair*, March 2001.

After starting up Christie's U.S. operation and working at other art-related jobs, JOHN RICHARDSON, who is British, settled permanently in New York, where he devotes himself full-time to writing. He is the author of *A Life of Picasso,* volumes I and II, and of *The Sorcerer's Apprentice,* a memoir. He also works out of his house in Connecticut.

ABOUT THE TYPE

This book was set in Bembo, a typeface based on an old-style Roman face that was used for Cardinal Bembo's tract *De Aetna* in 1495. Bembo was cut by Francisco Griffo in the early sixteenth century. The Lanston Monotype Company of Philadelphia brought the well-proportioned letterforms of Bembo to the United States in the 1930s.